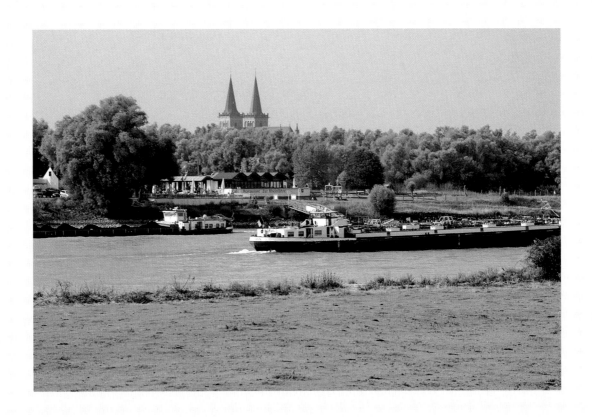

Journey through

NORTH RHINE-
WESTPHALIA

Photos by
Brigitte Merz

Text by
Georg Schwikart

Stürtz

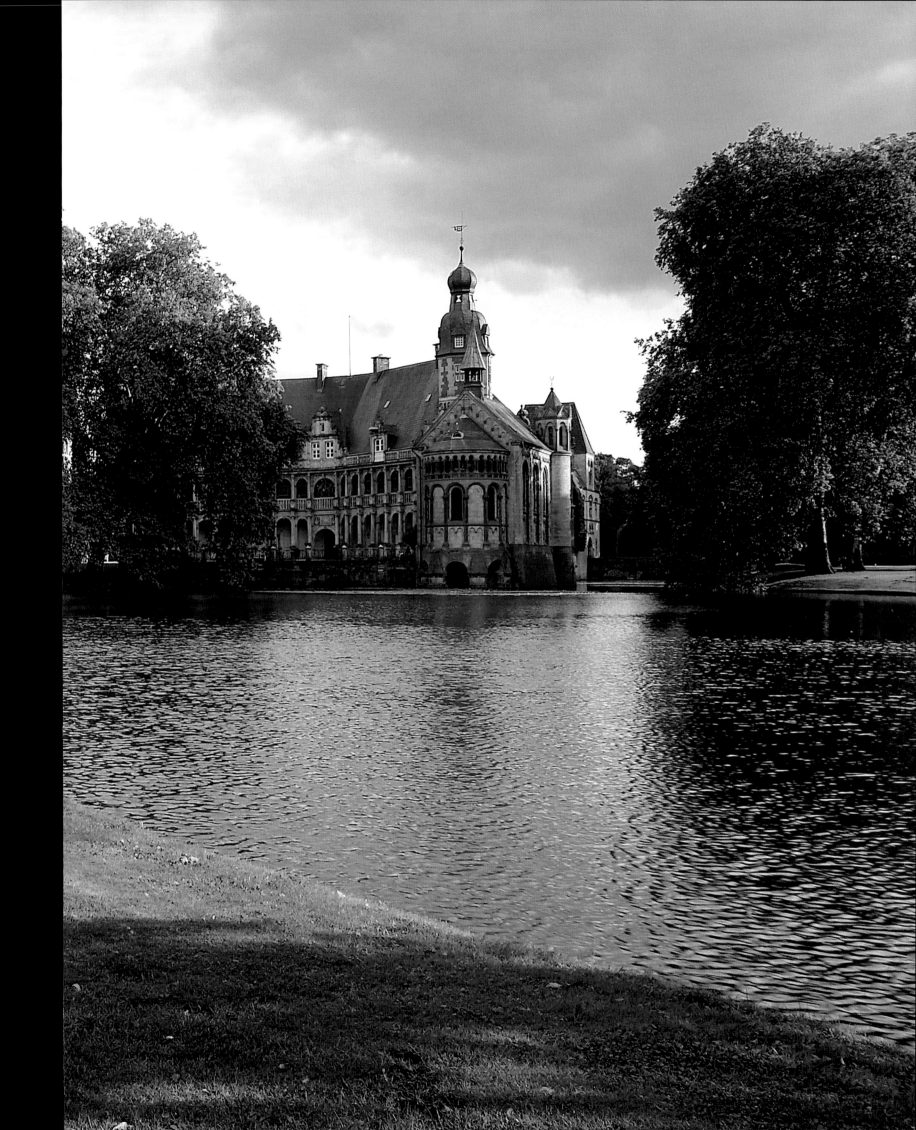

First page:
On the Rhine near Xanten, with the spires of the city cathedral in the background, completed in 1544. St Victor's is heralded as the largest cathedral between Cologne and the sea.

Previous page:
35 kilometres (22 miles) northwest of Münster is Darfeld. The moated castle was built as symbol of power and prestige at the beginning of the 16th century, its glittering lake more scenic than defensive.

Below:
Wandering through Cologne on a warm summer's evening there are plenty of bars and pubs where you can try some Kölsch, the local beer.

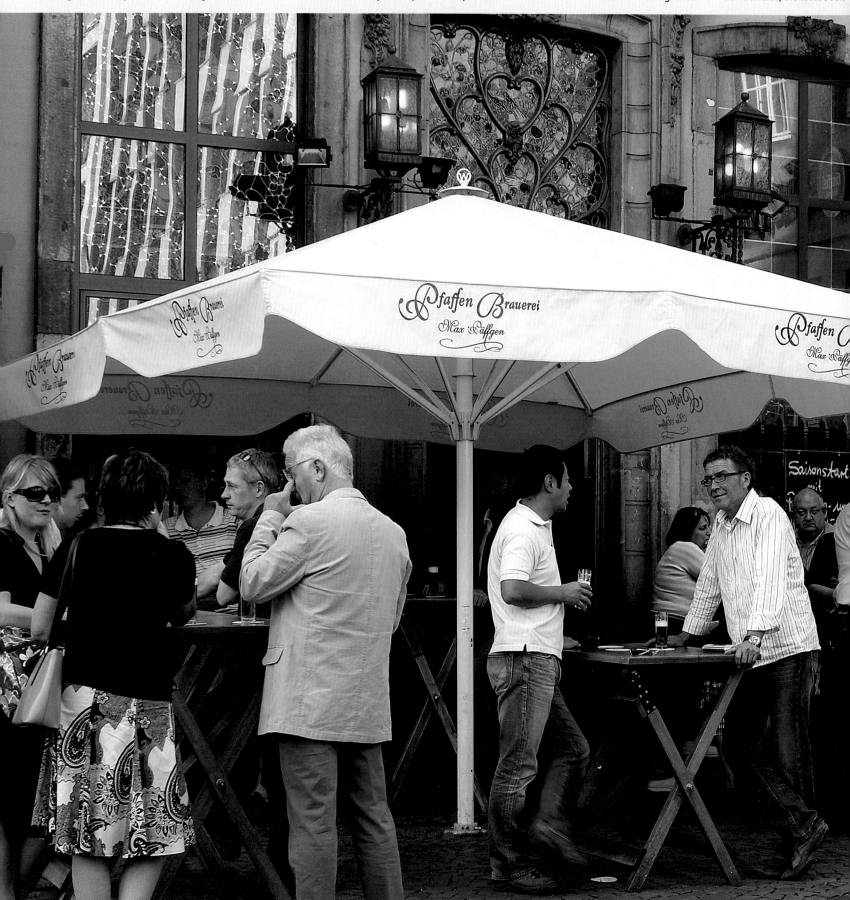

8

Page 10/11:
Das gastliche Dorf in Delbrück west of Paderborn is an ensemble of old *farms from the 16th and 18th centuries which have been moved here to create a museum.*

Content

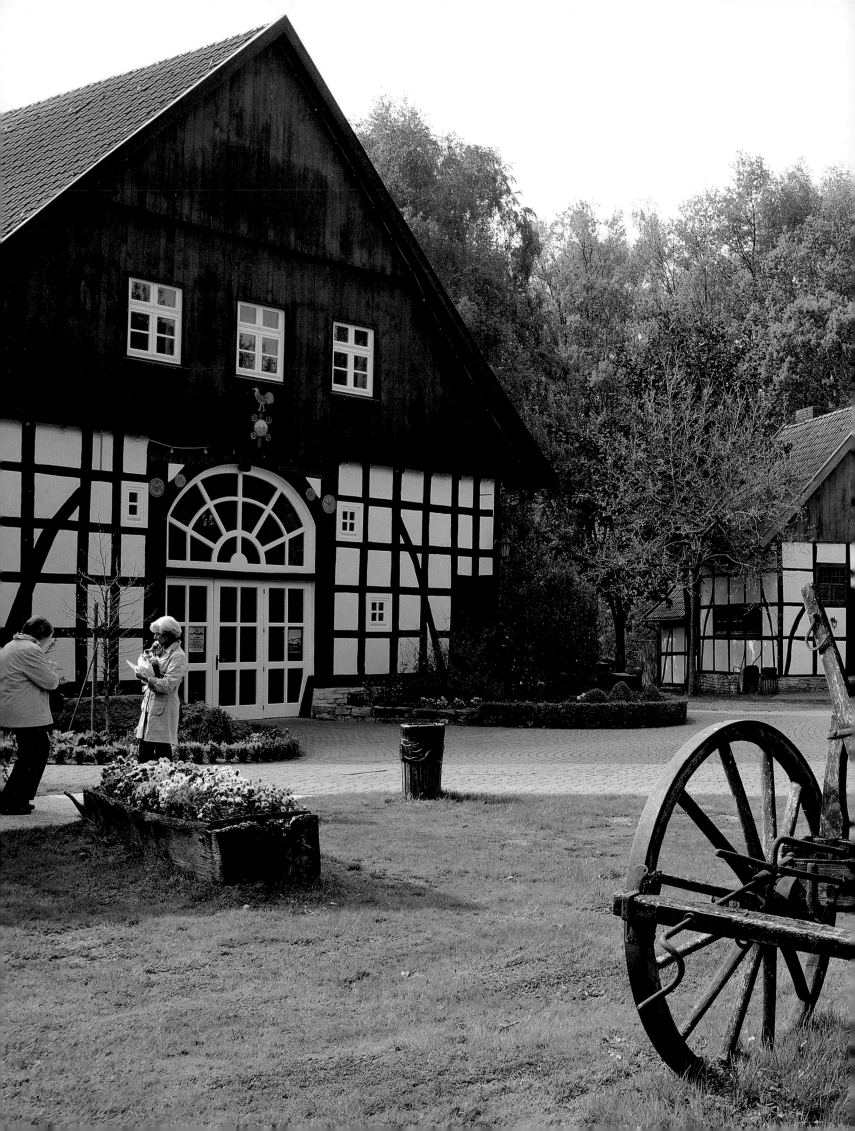

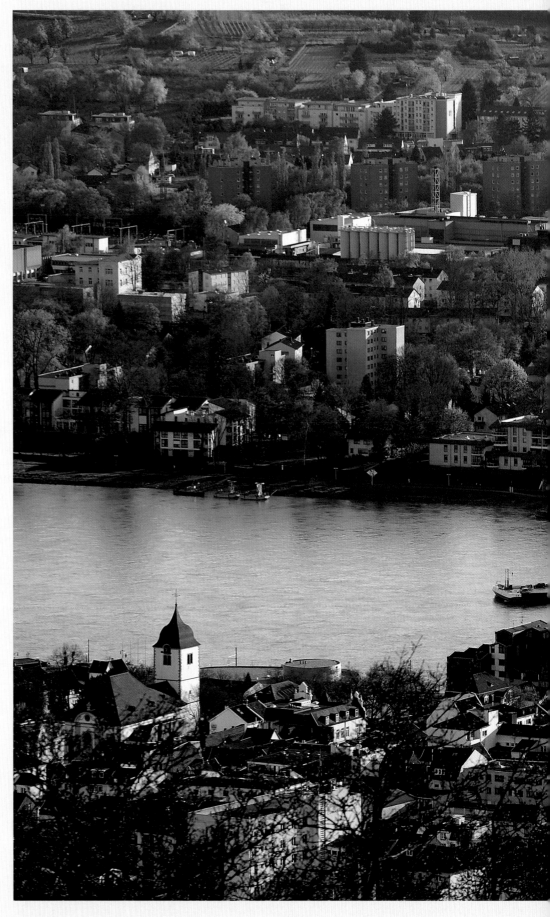

North Rhine-Westphalia is a land without a historical predecessor, created at the end of the Second World War. At 34,088 square kilometres (13,161 square miles) the federal state, abbreviated locally to "NRW", is slightly larger than Belgium. It is the most densely populated state in Germany, with more inhabitants (a good 18 million) than the Netherlands. About half of the region belongs to the North German Plains and the Rhineland; bits of the south and east are hillier and attributed to the nation's medium mountain ranges. The biggest elevation is the Langenberg (843 metres / 2,765 feet) in the wooded Rothaargebirge and has the highest natural waterfall in North Rhine-Westphalia, the Plästerlegge (30 metres / 98 feet). In the mountainous areas of the south there are around 70 dams. The lowest point has been created not by nature but by man: the Hambach brown coal mine near Düren is the deepest opencast mine in Germany at 293 metres (961 feet) below sea level.

Three of the state's five big cities – Cologne, Düsseldorf and Duisburg – are on the Rhine that snakes 266 kilometres (165 miles) through the *Bundesland*. The countryside is largely charac-terised by the Rhine and its tributaries of the Sieg, Wupper, Erft, Ruhr, Emscher and Lippe.

The Romans on the Rhine

Father Rhine or Rhenus Pater was the name the Romans gave to the mighty waterway. In the 1st century BC they began their attempt to conquer Germania and make it part of their empire. They fortified the left banks of the Rhine with camps, among them Castra Vetera near what is now Xanten, Novaesium (Neuss), Bonna (Bonn) and Colonia Claudia Ara Agrippi-nensium (Cologne). In 9 AD the army under Publius Quinctilius Varus was heavily defeated

by the Germans led by Cherusci chieftain Arminius (Hermann the German). It's the subject of debate as to exactly where the Battle of the Teutoburg Forest was fought; several sites in East Westphalia have been suggested, as has an area in the Osnabrücker Land in Lower Saxony.

From this point forward the Rhine (and in South Germany the limes) formed the boundary of Imperium Romanum. The few Roman settlements right of the Rhine were abandoned following Varus' failure in battle. Westphalia remained rural while the Rhineland prospered, its many towns serving major roads and trade routes. In c. 50 AD Cologne had approximately 20,000 inhabitants and was the administrative capital of Germania Secunda. In order to supply it with water, Roman engineers built 100 kilometres (62 miles) of aqueduct from the Eifel Hills to the city, creating the greatest Roman structure north of the Alps. It channelled 24,000 cubic metres (almost 848,000 cubic feet) of fresh spring water a day into the pipes and baths of Colonia. A hiking trail now follows the course of the Roman aqueduct from Nettersheim via Kall, Rheinbach and Hürth to Cologne-Sülz.

Part of the Frankish Empire

In the 4th century the Franks seized and destroyed parts of Cologne. By the beginning of the 5th century Colonia Claudia Ara Agrippinensium had been reduced to a mere outpost on the River Rhine, only just under Roman control. On their ultimate demise the Romans bequeathed many Latin place names to the towns on the left banks of the river – and also the vineyards of the Rhine, Moselle and their tributaries. In the year 775 the word Westphalia was first used in a chronicle linked to Charlemagne who made the area part of his Frankish Empire. Following his coronation as holy Roman emperor in 800 Westphalia was systematically converted to Christianity. Münster, Minden and Paderborn became diocesan towns and monasteries were founded.

Between 1300 and 1500 the region was a pastiche of bishoprics, counties and duchies. In the High Middle Ages the cities began to grow in importance and make their own politics. The Reformation hit Westphalia in 1525, slightly later than in the south of Germany. Following the Peace of Augsburg in 1555 the Protestant and Catholic areas of the Rhineland and Westphalia were split both religiously and culturally, a divide still evident today. Parts of Westphalia were also affected by the Thirty Years' War, with the local population forced to surrender food and land and become victims of plunder-

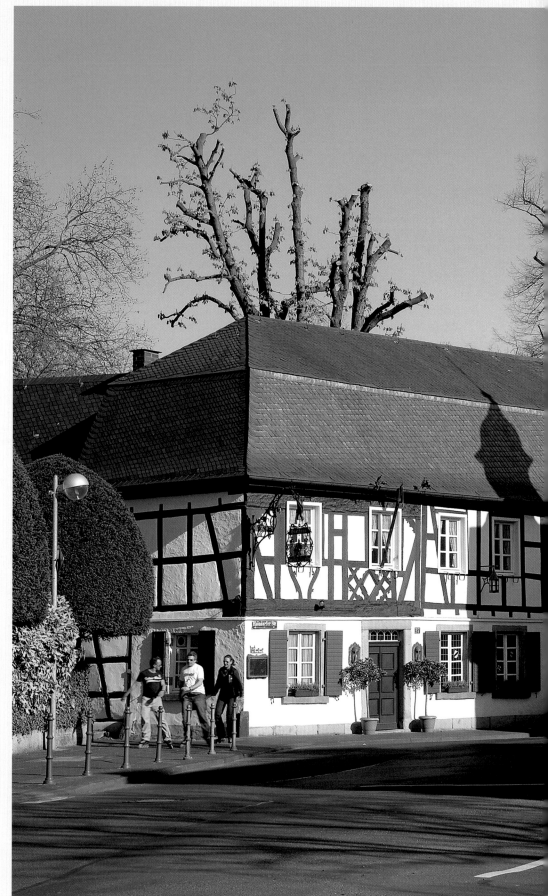

In Rhöndorf, a suburb of Bad Honnef, this tiny chapel from 1716 is dedicated to the visitation of Mary. The splendidly half-timbered house next door is a traditional pub.

ing, starvation and disease. Ten to thirty percent lost their lives. The Peace of Westphalia of Münster and Osnabrück finally put an end to the war; the Gothic town hall on Münster's Prinzipalmarkt was where the peace treaties were ceremoniously exchanged between Spain and the Netherlands.

Regent with an appreciation of art

Under the rule of elector and archbishop of Cologne Clemens August I of Bavaria (1700–1761) parts of what is now North Rhine-Westphalia were united. Clemens August was from the House of Wittelsbach and it is to his appreciation of art that the region owes many of its sights. He had the buildings begun by his predecessor Josef Clemens completed (Schloss Poppelsdorf and the electoral palace). He also built himself a summer residence in Brühl (Schloss Augustusburg) and a hunting lodge (Falkenlust), both of which are now UNESCO World Heritage Sites.

Up until the French Revolution of 1789 Westphalia was sliced into countless tiny dominions. In October 1794 Napoleon's troops seized the left banks of the Rhine. The annex was officially recognised by Holy Roman Emperor Franz II in 1797 and henceforth the Rhine was the eastern frontier of France. In 1794 the French marched into Cologne and occupied the city for almost twenty years. The final decision made by a special commission charged with dividing up Napoleonic territories in Germany in 1803 handed over the ecclesiastical principalities of Westphalia to worldly rulers. In the wake of the 1815 Congress of Vienna, in 1816 what had been independent enclaves with their varying traditions and confessions were lumped together to form the Prussian province of Westphalia. Its provincial capital was Münster. Cologne and the Rhineland between Bingen and Kleve also fell to Prussia, becoming the province of the Rhine in 1822 with Koblenz as its capital city. In the decades that followed Cologne became the second most important city in the Prussian kingdom after Berlin – not least for its many banks. In 1842 the Protestant king of Prussia Friedrich Wilhelm IV and

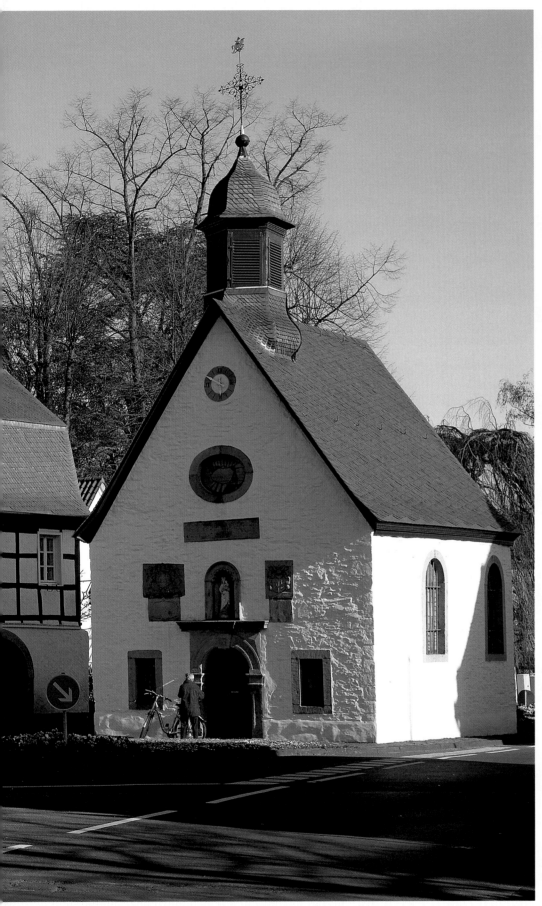

the later archbishop of Cologne together laid the foundation stone for the continuation of Cologne Cathedral, which was finally finished in 1880 after 632 years of construction – not counting the ceaseless repairs it has since undergone.

From village to city

In the Ruhr area the Industrial Revolution made major cities of many a tiny village. In 1800, for example, Bochum numbered just 2,200 inhabitants; by 1905 this figure had risen to 117,000. The demand for increased means of transporting coal and steel led to the expansion of the railways. The Ruhr subsequently became the largest centre of industry in Europe.

During the First World War the Ruhr was known as the armoury of the German Empire, its synonym Krupp. In 1914/1915 the first bombs fell on Cologne and Essen. At the end of World War I the kingdom of Prussia was made a free state – and a parliamentarian democracy. In 1918 the Rhineland was occupied by Allied troops, with the last of them only withdrawn in 1930. In 1936 Hitler remilitarised the area with his occupation of the Rhineland.

The concentration of raw materials and mining in the conurbations of the Rhine and Ruhr also made the area a popular target for the bomber commands of the Second World War. Even in the final days of the conflict many of the small towns and cities on the edge of the Ruhr were demolished during heavy air raids. The last British blanket bombing of March 27, 1945, for example, reduced 85% of historic Paderborn to ashes.

Operation Marriage

Once hostilities had ceased the victorious powers were not agreed on what should happen to the Ruhr. France wanted to give it special status like the Saar; the Soviets bid for a four zone solution as in Berlin. On June 6, 1946, the British, under whose occupation the area fell, launched Operation Marriage – a union between the Rhineland and Westphalia that was blessed by the Americans. The Ruhr was to be part of a future German state in an attempt to avoid a repetition of the hyperinflation and instability that wracked the country after the First World War. Merging the industrial Rhine and Ruhr and its socialist leanings with rural, Catholic Westphalia promised to strike a good balance. On August 23, 1946, on the order of the British military government, the northern sector of the Prussian Rhine Province and the province of Westphalia became the new federal state of North Rhine-Westphalia.

Marina Duisburg is the yachting harbour integrated into the city's inland harbour. It was built from plans by Lord Norman Foster in 2001 and is on a themed tourist route dedicated to industrial culture (Route der Industriekultur).

Also at the instigation of the British, in 1947 the small state of Lippe renounced its 800 years of independency and joined North Rhine-Westphalia. The rose of Lippe was included on the state's coat of arms in 1953, tucked in beneath the Rhine and the Saxon horse that stands for Westphalia.

Cultural identities

Even half a century after entering into this marriage, the three different parts of the state have kept their individual cultural identities. The Rhineland, Sauerland, Münsterland and Paderborner Land are still traditionally Catholic, with East Westphalia, the Bergisches Land and the Siegerland Protestant. Immigration has tipped the balance somewhat; during the 19th century Polish Catholics moved to the Ruhr and after the war Protestant refugees sought a new home in the Rhineland. About 42% of NRW is Catholic, with 30% members of various Protestant denominations.

Some figures in the church are still very much present, such as Protestant pastor Friedrich von Bodelschwingh, who in the second half of the 19th century reformed Protestant social welfare, and Pastor Theodor Fliedner, to whom the church welfare centre and hospital in Kaiserswerth are attributed. The association of journeymen founded by Catholic priest Adolph Kolping formed the basis of the International Kolping Society that now works towards improving social welfare in the world of work.

Two local cardinals are also held in fond remembrance here. Count Clemens August of Galen, known as the "lion of Münster", publically spoke out against the Nazis' brutal annihilation of "lives not worth living" – in their interpretation, the disabled. And in the bitter post-war winter of 1946 Josef Frings, archbishop of Cologne, declared theft of comestibles for personal consumption morally acceptable – a concession which has since earned itself a linguistic homage in the verb "fringsen", meaning "theft of food".

The Jewish communities of NRW were emaciated or totally eradicated by the Holocaust. Immigration has now brought the number of Jews back up to around 30,000. About one million people are followers of Islam, constituting

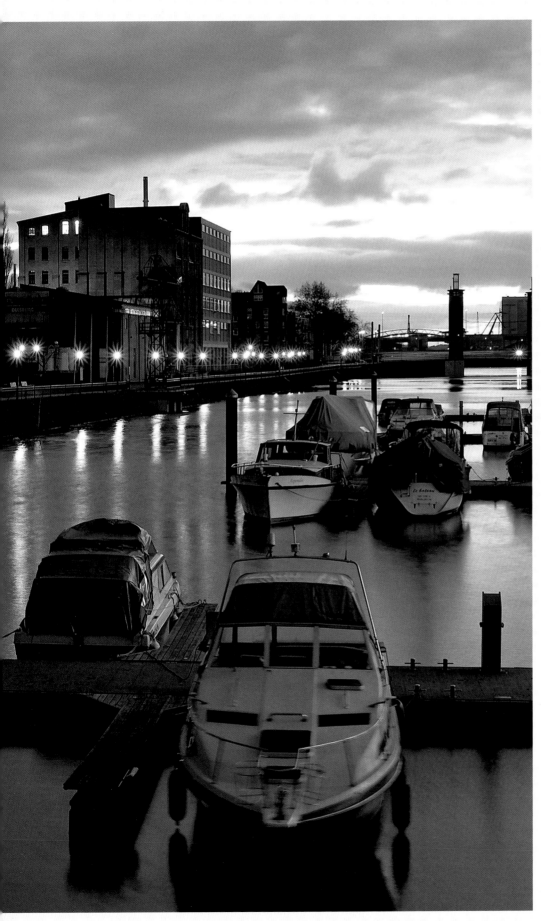

approximately a third of all Muslims in Germany. Far Eastern religions make up a small percentage; Düsseldorf, however, boasts the largest Japanese community in Germany and Europe's second-largest Hindu temple in Hamm-Uentrop makes you feel as though you're in the middle of India.

The nation's coal mine

The nation's 'coal mine' – the *Kohlenpott* or Ruhr Basin – has drastically altered its appearance in the past few decades. Actual miners are a dying breed; the Ruhr has been transformed from a black sooty hole into model green countryside, with the valley of the River Ruhr now a verdant recreation area. For about a hundred years the identity of this part of the country between the Lippe and Ruhr has been determined by its football teams who are now an indispensable component of the local culture. Footie in Germany would be unthinkable without world-famous clubs Borussia Dortmund and FC Schalke 04, both German FA Cup winners several times over and also European Cup champions to boot.

What was once the centre of heavy industry in Germany is now marked by an even balance of industry and services. Together with Pécs in Hungary and Turkish metropolis Istanbul, this exemplary transformation has earned Essen – acting on behalf of the entire Ruhr area – the title of Cultural Capital of Europe 2010.

Nature and art

The state has hundreds of sights, from UNSECO World Heritage Sites to CentrO. in Oberhausen, in its own words "Europe's biggest shopping and leisure centre". Despite the industrial areas there is plenty of nature here, too, much of which is protected by a conservation order. The list is long: on December 31, 2007, there were a total of 2,881 protected areas in North Rhine-Westphalia. NRW also has fourteen national parks, the largest being that of the Teutoburg Forest and Eggegebirge in East Westphalia-Lippe.

Among the most famous natural spectacles in the state are the dripstone caves of Attendorn, the cave at Balve and the Externsteine, an impressive rock formation in the Teutoburg Forest. In Merfelder Bruch, a few kilometres west of Dülmen, you can find the only wild horses on the European continent. And if you'd rather study the natural world in closer detail, there's the Koenig Natural History Museum in Bonn and the Aquazoo in Düsseldorf.

The region also has a multitude of castles and palaces. One classic site popular since the mid 19th century is the ruined Burg Drachenfels

in the Siebengebirge between Königswinter and Bad Honnef, to which Heinrich Heine paid poetic homage in 1819. The 100 Schlösser Route, 960 kilometres (ca. 600 miles) long, is a themed castle cycle track that winds its way through the lanes and fields of the Münsterland, past moated mansions, manor houses and mighty fortresses.

If you're more interested in fine art, there are over one hundred galleries to visit. The best known are the Bundeskunsthalle and art museum in Bonn, Kunstsammlung North Rhine-Westphalia and the museum kunst palast in Düsseldorf, the Wallraf Richartz Museum and Museum Ludwig in Cologne and the Museum Folkwang in Essen.

One of the most frequented museums in NRW is the Haus der Geschichte der Bundesrepublik Deutschland (history of the Federal Republic of Germany) in Bonn; entrance is free! You can step back further in time at the Neanderthal Museum near Mettmann. The life and achievements of the Romans can be explored in a number of places: at the Römisch-Germanisches Museum in Cologne, for example, at the Roman museum in Haltern am See or at Germany's largest archaeological open-air museum, the Römerpark, in Xanten. There's also no lack of museums devoted to special subjects, from the Beethoven Haus in Bonn to the Imhoff museum of chocolate in Cologne. NRW has almost 700 museums eager to welcome visitors!

Rhinelanders and Westphalians

As the double-barrelled name suggests, the federal state of North Rhine-Westphalia is the place two different local peoples call home. How does this work? Is there not a massive conflict of interests, both linguistically and culturally, between Rhinelanders and Westphalians? Dietmar Damwerth once described the latter thus: "If local clichés are to be believed, the Westphalians are generally totally loyal and reliable, yet also extremely stubborn and reserved. The Westphalian absolutely detests exaggeration and pomposity, boasting and gossip. He is thus also silent in his humour."

In the above the author quotes Bismarck of Prussia who once remarked, "The Westphalian is and always will be, well, Westphalian". Westphalia – according to Damwerth – is definitely not a land of *Quaterköppe*, a derogatory term used to describe someone who talks loud and long about everything under the sun. In the eyes of the Westphalian, however, one indisputable species who is is the Rhinelander.

As opposed to his rather taciturn neighbour, the talkative Rhinelander has an opinion on just about everything. The genus has been studied in depth by cabaret artist Konrad Beikircher, himself from South Tyrol, a region not only far removed from NRW but also one of two cultures and languages (Austrian German and Italian). To help him find his way in this unfamiliar northern territory, he compiled his own law of the Rhineland, his *Rheinisches Grundgesetz*, from his in-depth examination of the local genus. Other 'scholars' of the indigenous population Rainer Pause and Martin Stankowski provide us with a concrete example of typical Rhinelander behaviour, analysing how a conflict is settled. "Let's put it like this: when the Rhinelander finds himself facing an opinion other than his own, especially when he has the feeling that his opposite number knows more than he does, he simply says, 'Oh, I don't care anyway!' Equilibrium is thus restored – or "Ejalité", as they say here. The French had to fight a revolution for it."

A matter of great importance

From this we could deduce that the Rhinelander is a peace-loving member of the human race. In the face of such intercultural harmony, it thus seems incongruous if not downright odd that there is a fierce battle in permanent progress between Düsseldorf and Cologne – one with a long tradition. Waged with grim determination, the object of the ongoing feud is very close to local hearts and a matter of great importance: beer! Be on your guard and prepared to meet with some resistance if in a pub in Düsseldorf you make the mistake of ordering a *Kölsch*, the tipple specific to Cologne. The same applies the other way round; asking for a glass of Düsseldorf's *Altbier* in Cologne is likely to earn you some very bemused – if not hostile – looks indeed!

Caution is advised in a more general sense, too, for we cannot simply talk of "the Rhinelander" as such. The nearer you get to Holland and the start of the Lower Rhine, the more the people change. One local, Hanns Dieter Hüsch, puts it as follows: "We are our own philosophers. When asked 'How are things going?', the Rhinelander answers 'Fine' – but the Lower

Harvest time near Langenhorst, a suburb of Ochtrup in Westphalia. In the 12th century a monastery dedicated to St John the Baptist was erected here. The collegiate church with its twin spires was built between 1180 and 1230.

Rhinelander replies 'How should they be?' Oh yes, you don't get anything out of us that easily! And the answer 'How should they be?' could also be interpreted as 'How would you like them to be?' The Lower Rhinelander, I always say, is the Mongol of the Rhineland."

Johannes Rau, former president of Germany and head of NRW before that, was familiar with the idiosyncrasies of his federal state and its inhabitants. As a politician he was always keen to reconcile his flock; with a soupcon of Wuppertal humour he once said "that the strength for this state lies in the unique combination of its people's characteristics: the reliability of the Rhinelander, the light-footedness of the Westphalian and the generosity of the Lipper ..."

Personalities

Several famous people come from NRW: four German presidents (Heinrich Lübke, Gustav Heinemann, Walter Scheel and Johannes Rau) and two German chancellors (Konrad Adenauer and Gerhard Schröder) were born in the present federal state. Its most influential politician and thinker was probably Friedrich Engels; one of its contemporary philosophers to enjoy world acclaim is Jürgen Habermas. To the world of science NRW has bequeathed such great names as Ferdinand Sauerbruch and Wilhelm Conrad Röntgen.

German literature has profited from the likes of locals Heinrich Heine, Annette von Droste-Hülshoff and Nobel Prize winner Heinrich Böll. NRW artists worth a mention here include August Macke, Ludwig Mies van der Rohe and Joseph Beuys. Actors Gustaf Gründgens, Heinz Rühmann and Willy Millowitsch have their roots here, as does the dancer Pina Bausch. The festivals of the Ruhrfestspiele, RuhrTriennale, Lit.Cologne and Internationale Kurzfilmtage in Oberhausen are heralded across the nation.

Music past and present

Musical history in NRW is dominated by one man: Ludwig van Beethoven, born in Bonn in 1770. The Schumanns also had connections with the Rhineland, with Robert Schumann

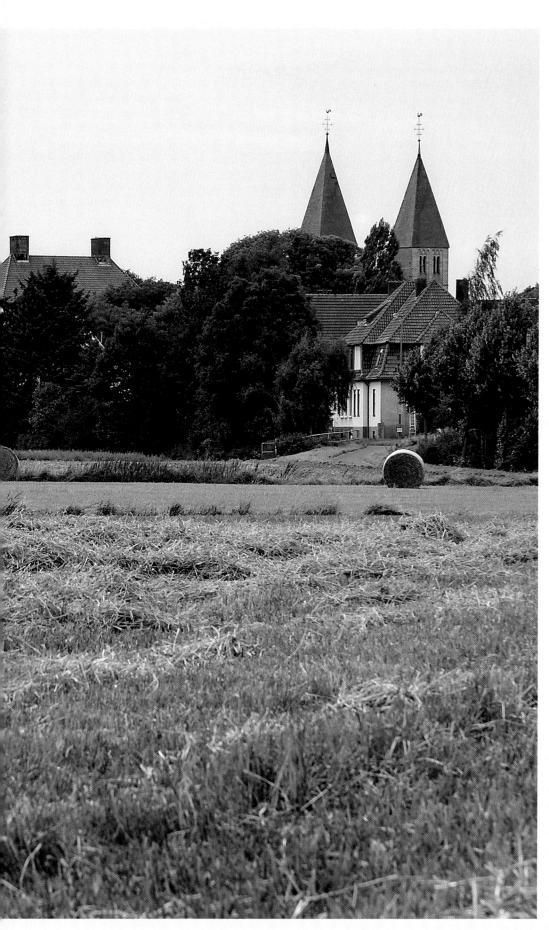

made musical director of the city of Düsseldorf in 1850 and dying in Bonn-Endenich in 1856. Düsseldorf is also home to such diverse pop stars as Die Toten Hosen, Marius Müller-Westernhagen and Heino. Cologne is famous for its bands who sing in the local dialect, such as rock band BAP with Wolfgang Niedecken, performers of German and international pop songs Bläck Fööss and carnival party-rousers Die Höhner. The Ruhr also has its very own superstar: Herbert Grönemeyer, born in Bochum. Old rocker Udo Lindenberg, equally famous in Germany, may have made a career for himself elsewhere but was originally from Gronau in Westphalia.

North Rhine-Westphalia is a "patchwork of mentalities, dialects and topographies" (Thomas Schaefer). It hardly seems possible that Euskirchen and Herford, Castrop-Rauxel and Kevelaer, Lüdenscheid and Sankt Augustin all belong to the same federal state. Yet it is precisely this fusion and diversity which make NRW the harmonious whole that it is – and one that is definitely worth a visit.

Page 22/23:
The Düsseldorf skyline, seen from the left bank of the Rhine in Oberkassel. The elongated Rheinturm (241 m / 791 ft) with its viewing platform and revolving restaurant attracts around 300,000 visitors a year.

Page 24/25:
The sights of Cologne at night. The Hohenzollernbrücke is aligned with the central axis of the cathedral. Museum Ludwig southeast of the famous edifice has art from the 20th and 21st centuries on display.

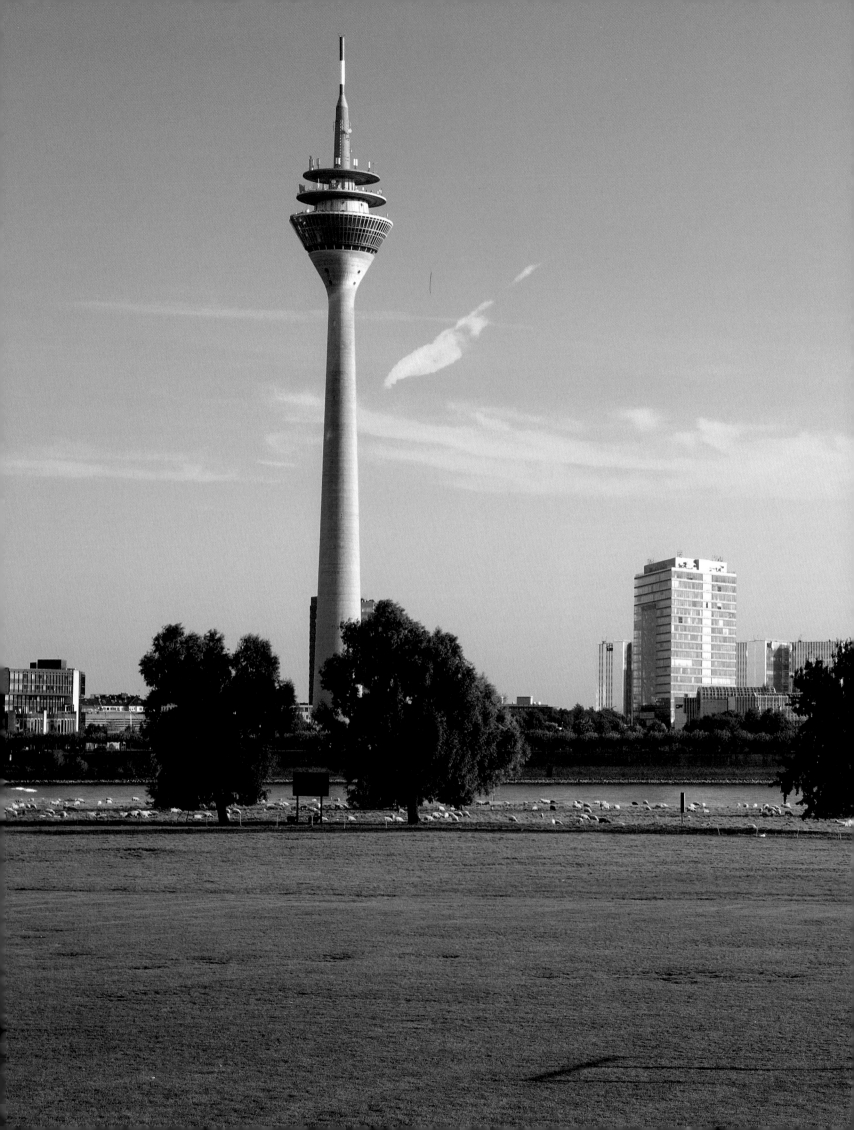

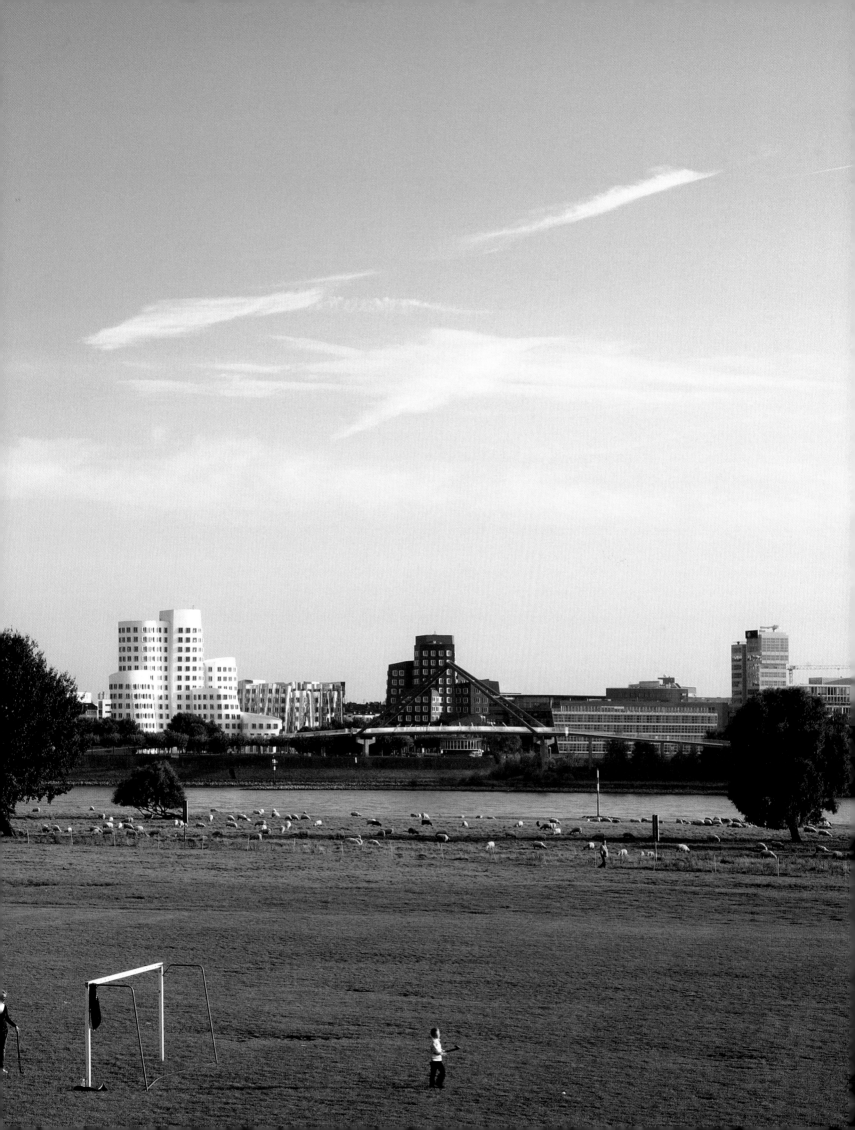

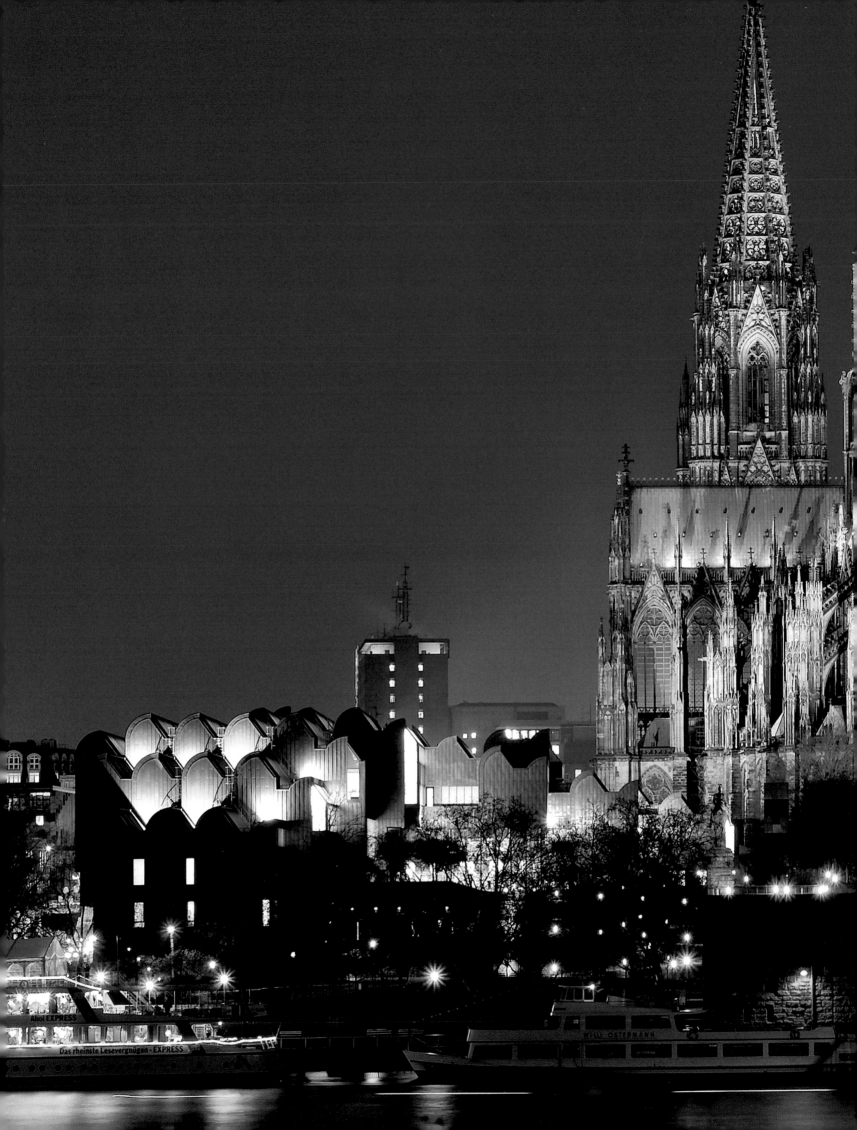

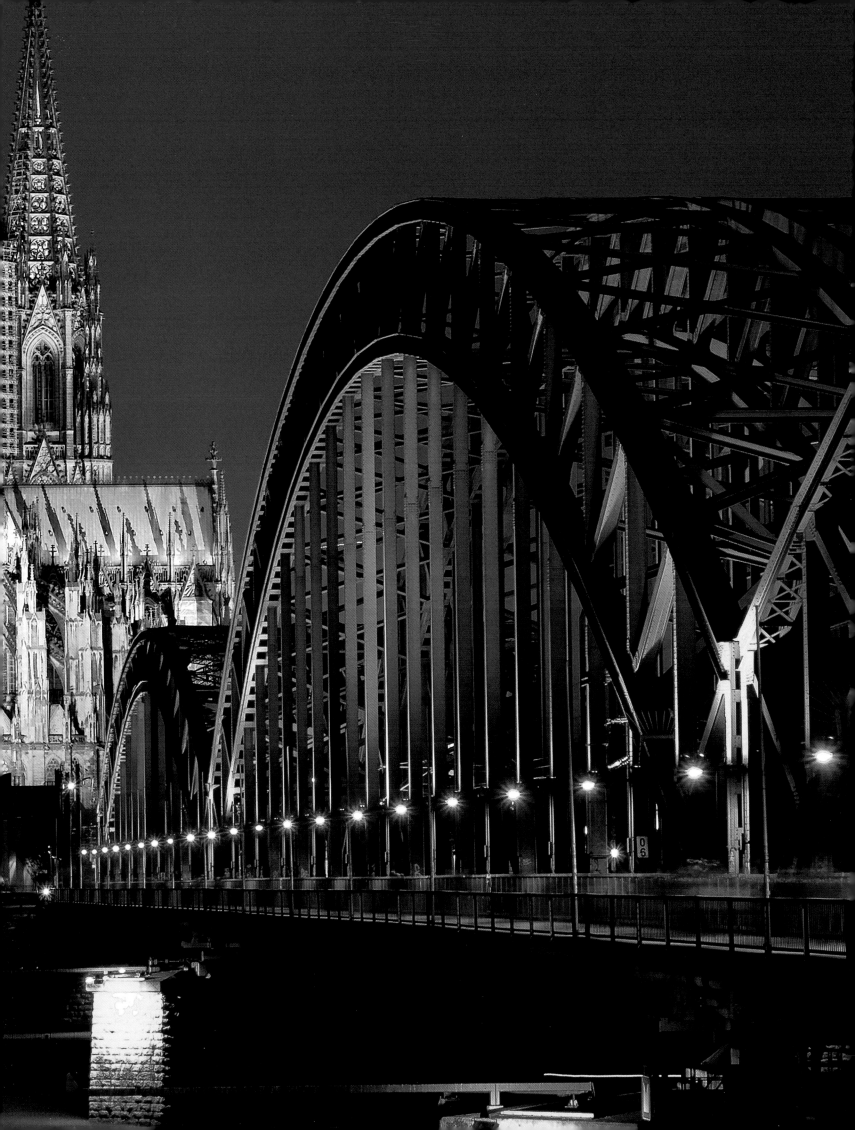

A river runs through it – the Rhineland

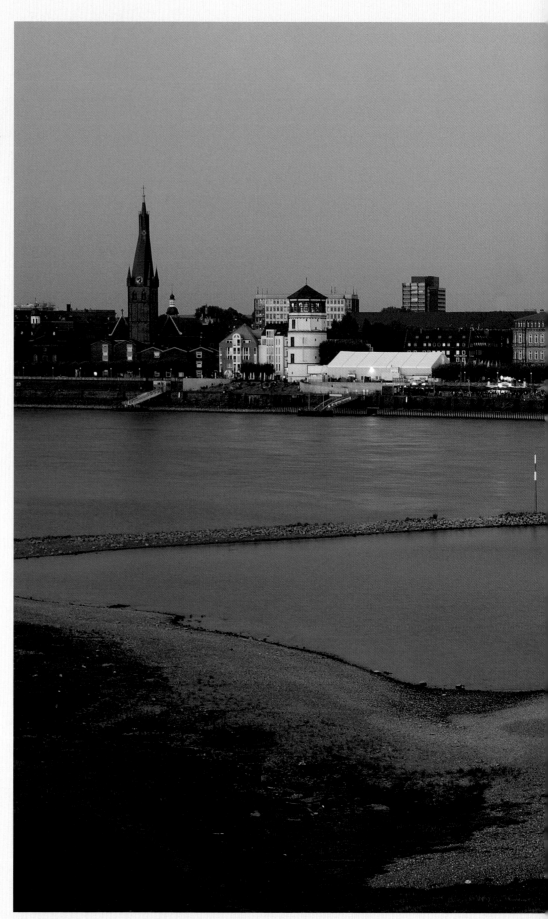

Evening in late summer on the Rhine near Düsseldorf, seen from Oberkassel. View of the banks of the Schlossufer, Rathausufer and Mannesmannufer.

From its two source rivers in Switzerland to the point where it flows into the North Sea the River Rhine snakes over 1,300 kilometres (800 miles) through several countries of Europe. It cuts across North Rhine-Westphalia from the Siebengebirge to the Dutch border north of Kleve. Up to Bonn it's known as the Middle Rhine; once it's left the Rhenish Massif behind it, it becomes wider and lazier, since time immemorial both a natural boundary and also a giver of life and bringer of trade to the peoples who settled along it. As to which side is the better one is still a bone of contention, with locals affectionately ridiculing their neighbours on the opposite bank for living on the "schäl Sick" or wrong side ...

Big cities line its banks like a string of pearls: Bonn, Cologne, Leverkusen, the provincial capital of Düsseldorf and Duisburg on the edge of the Ruhr. Further downstream the countryside and towns are more tranquil, among them Wesel, the Roman city of Xanten and Emmerich with the longest suspension bridge in Germany. The Cozogne Lowland between Bonn, Aachen and Düsseldorf is the densely populated conclusion to the Lower Rhine Plain and one of the warmest and most fertile regions in Germany. West of it is the Eifel with its rolling hills and interesting towns and villages, one of them being Monschau which boasts no less than two hundred listed buildings.

On the right of the Rhine the Cologne Lowland rises up into the Bergisches Land, once the historic Duchy of Berg whose rulers settled in Düsseldorf during the 14th century. Cities such as Bergisch Gladbach, Remscheid, "town of blades" Solingen and Wuppertal with its world-famous suspension railway can all be found in the Bergisches Land, whose national park provides the local townspeople with a scenic and readily accessible recreational outlet.

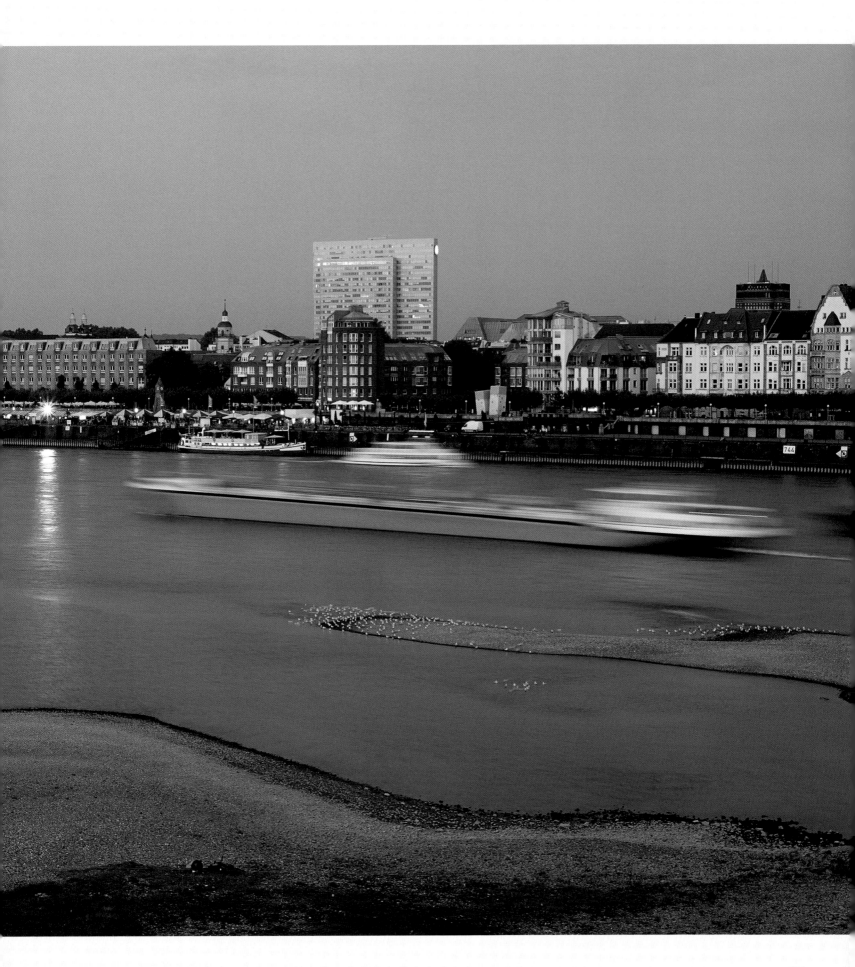

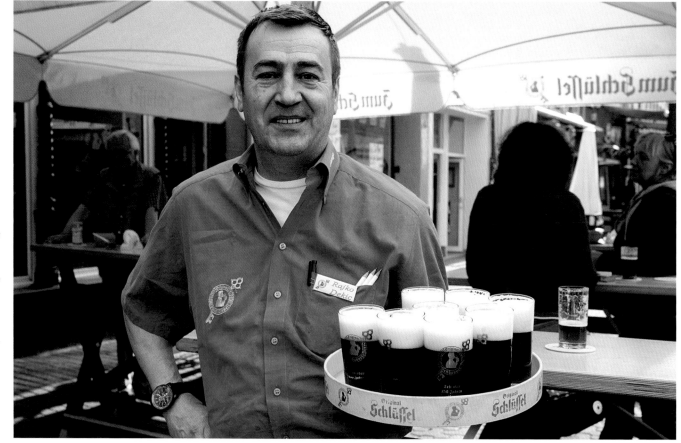

Right:
The Zum Schlüssel brewery in the heart of Old Düsseldorf is just one of the many great places you can enjoy a glass of the local Altbier.

Below:
Bolkerstraße in the heart of Düsseldorf is one of the most popular streets in the old town and also known as the "longest bar in the world" for its many pubs and cafés.

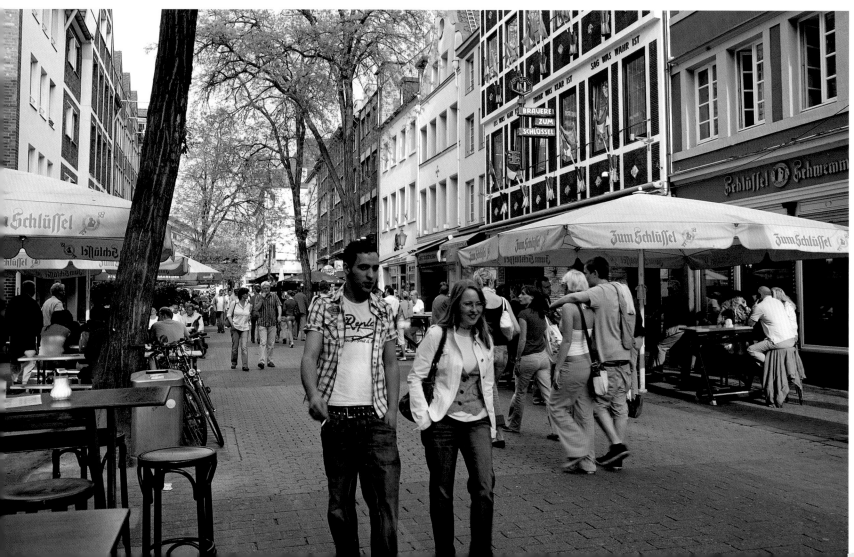

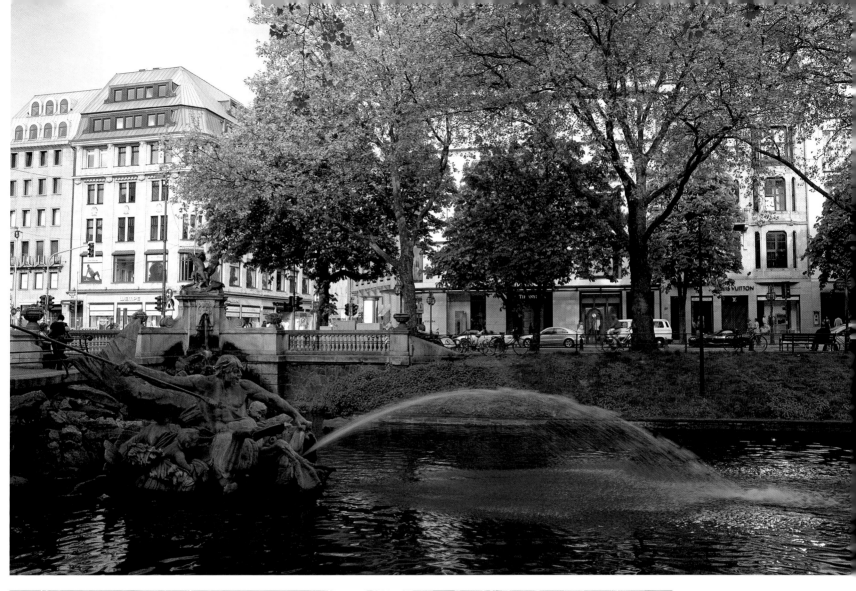

Above:
On Königsallee or the "Kö" in the centre of Düsseldorf. Along its middle runs a channel of water that culminates to the north in this fountain from 1902.

Left:
In 2004 Königsallee celebrated its 200th anniversary. The east side is made up of elegant shops while the west of the street is its quiet side, where trees and benches invite you to sit down and rest.

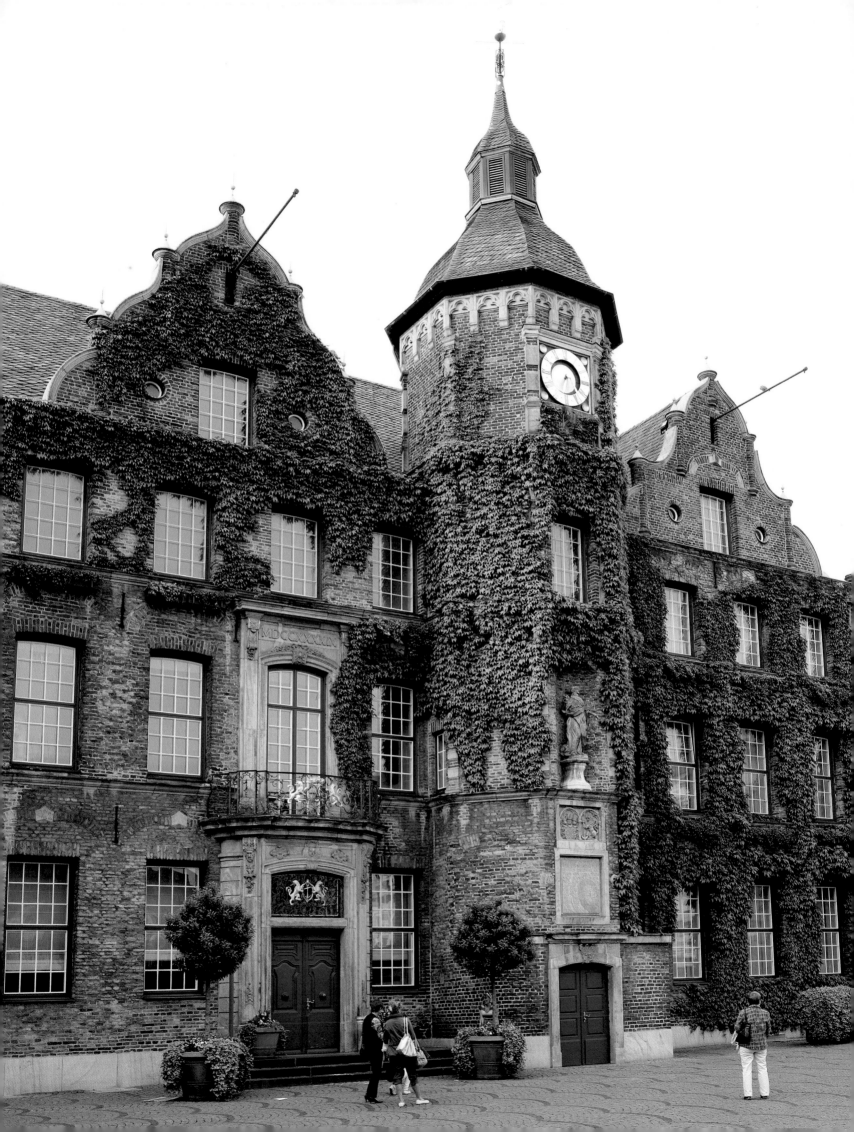

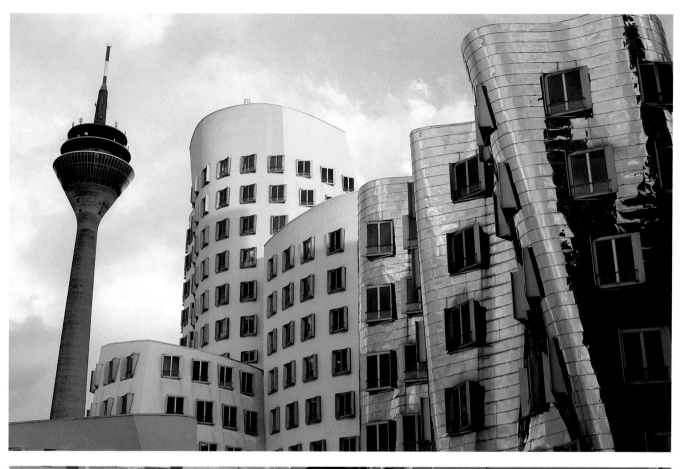

Left page:
The Rathaus of town hall in the city of Düsseldorf. The middle section with its two gables and turret dates back to the 16th century.

The MedienHafen ("media harbour") in Düsseldorf, designed by award-winning architect Frank Gehry, is a modern office and residential complex. On the left the Rheinturm towers high into the sky.

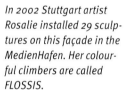

In 2002 Stuttgart artist Rosalie installed 29 sculptures on this façade in the MedienHafen. Her colourful climbers are called FLOSSIS.

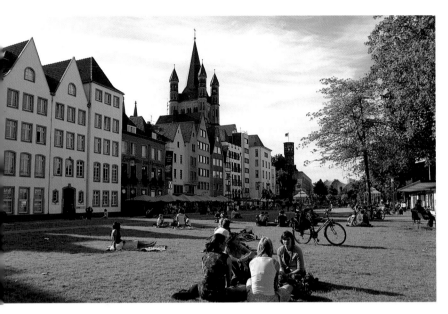

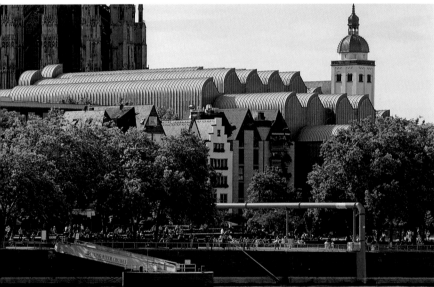

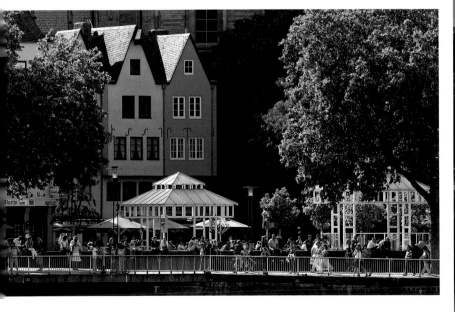

Left:
Summer evening on the banks of the Rhine in Cologne. In the centre the spires of Romanesque basilica Groß St Martin pierce the sky, with the staircase tower on the south front of the Stapelhaus beyond.

Centre left:
A Rhine promenade runs along the river bank beneath Cologne Cathedral and Museum Ludwig. The pale pink steeple belongs to the church of St Mariä Himmelfahrt.

Bottom left:
Summer in Cologne on the Rhine promenade, with the impressive church of Groß St Martin watching over the proceedings.

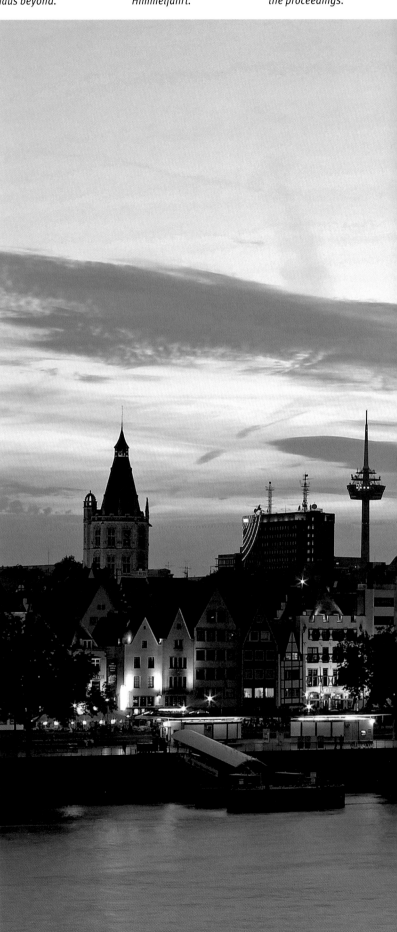

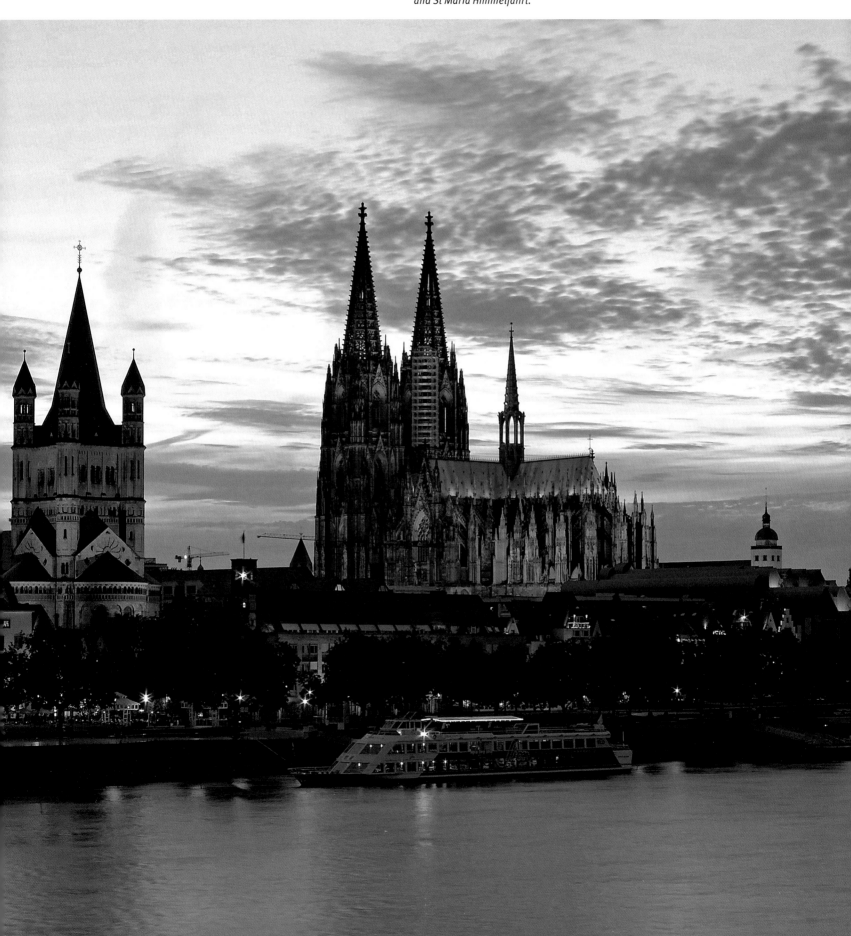

Below:
The spires of Cologne against an evening sky. From left to right: the town hall, the Colonius telecommunications tower (266 m / 873 ft), Groß St Martin, the cathedral and St Mariä Himmelfahrt.

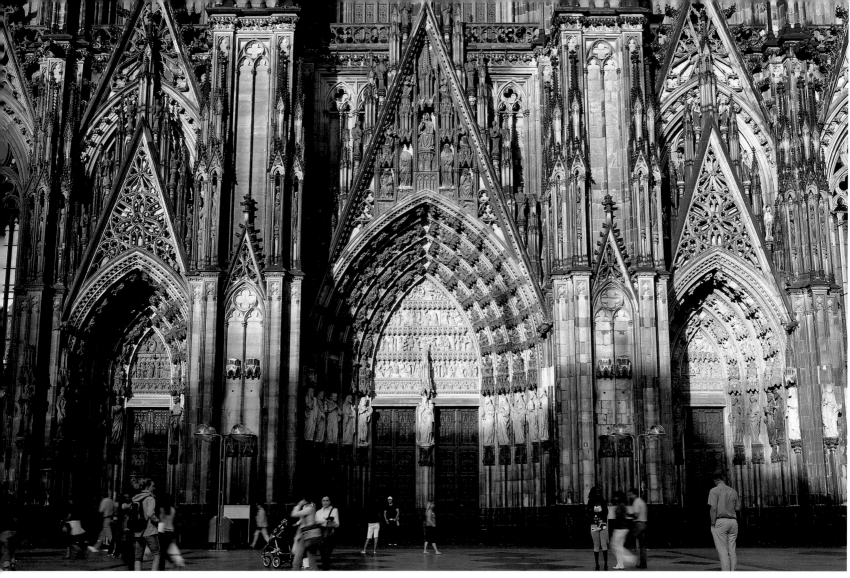

Above:
The west façade of
Cologne Cathedral has
three entrances. The
south entrance on the
right is the only one of the
twelve cathedral portals to
be finished in part at least
during the Middle Ages.
It acted as a model for
the other doors, added in
the 19th century.

Right:
From the everlasting to
the short lived: pavement
art on the square outside
Cologne Cathedral.

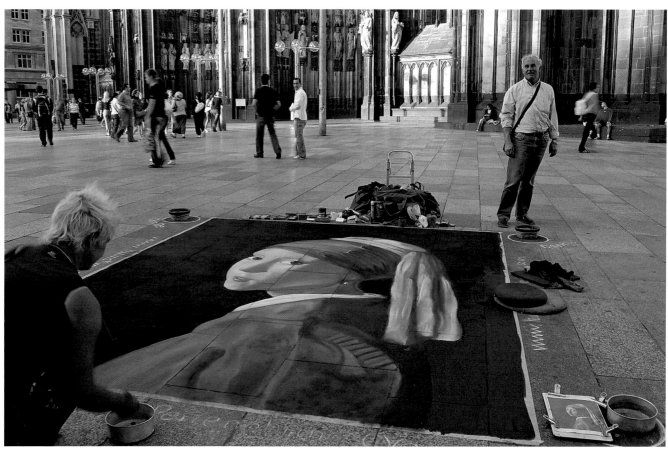

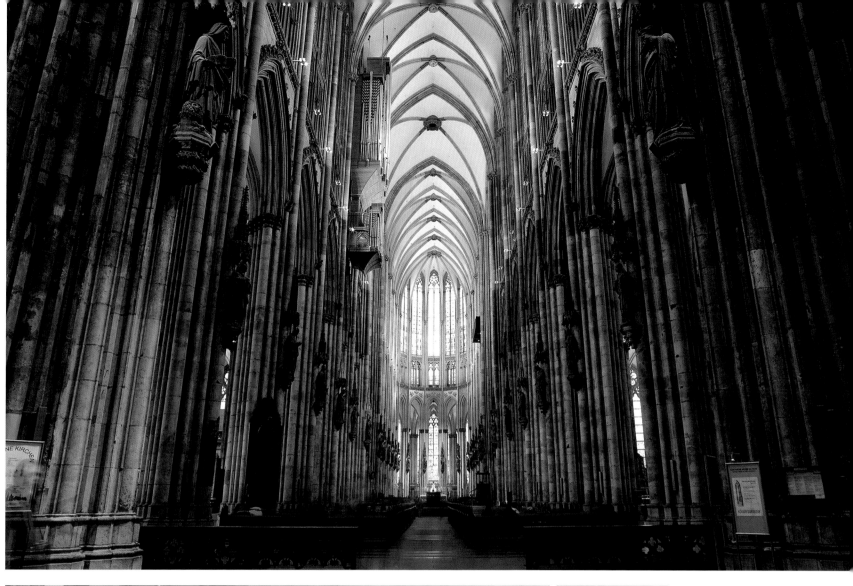

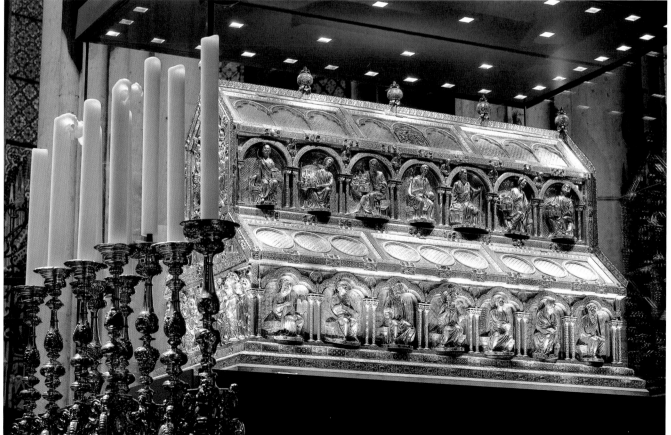

CARNIVAL, SHOOTING MATCHES AND VILLAGE FETES – NRW FESTIVALS

When cries of "Helau!" and "Alaaf!" fill the air, you know the Rhineland's silly season has begun! *Karneval* starts on the Thursday before Mardi Gras when the women symbolically emasculate the men by cutting their ties off. Lots of firms shut down for a few days – as do all the schools. Local town halls are stormed and mayors 'forced' to hand over their powers to the carnival fools.

The fifth season of the year officially begins on the 11th day of the 11th month. Members of carnival clubs dress up in uniform in parody of the region's former Prussian rulers and form a council made up of eleven members. These hold 'meetings of state' at which soap-box orators and teams of girl dancers – also in (short) uniform – entertain the audience. Each year a prince is elected who trawls from party to party with an entire entourage in tow. At the *Karneval* in Cologne he comes as a threesome, together with a maiden and a famer (both men). The alleged desire harboured by all men of Cologne is to one day be their city's carnival prince – or at least that's what one famous song claims ...

Carnival takes to the streets on the aforementioned Thursday (*Weiberfastnacht*). And it's not just the children who dress up as cowboys, clowns and princesses. The adults also don fancy dress – even if it's just a false nose. In the pubs people drink, sing, dance, laugh and kiss, in many cases with all caution thrown to the wind in these few days of mad activity. The climax is the huge *Rosenmontag* procession on the Monday, rescheduled for Sunday or Tuesday in many of the smaller towns and villages. Young and old come out in force to catch the goodies hurled from the floats. These used to be just sweets; nowadays you can catch anything from dishcloths to parking discs to bits of sausage. The Rhineland goes completely wild until Ash Wednesday, when the celebrations come to a sudden end.

Such jollities seem quite alien to the people of Westphalia whose festivity of choice is the shooting match. In the Sauerland nearly every village has its own clubhouse, with rifle guilds and battalions dating back to the medieval militia once responsible for protecting their home towns. Today they see themselves purely as shooting clubs for sport, with the best marksman of the match being crowned king and given a ceremonial chain as a badge of office. One competition involves shooting at a wooden bird on a pole; the person who manages to fire the last bit to the ground earns the title. The biggest shooting match of the year is held on the last weekend in August in Neuss, with 6,000 riflemen and 1.2 million spectators. Düsseldorf, on the other hand, can claim to have the largest festival on the Rhine, with its *Kirmes* attracting no less than four million visitors to the city each July. The history of the event goes back to the veneration of local patron saint Apollinaris of Ravenna and patron saint of the church of St Lambertus.

Religious roots

There's hardly a village here that doesn't have its own *Kirmes* or village fete, most of them with a religious background, such as the Annakirmes in Düren at the end of July, the Fronleichnamskirmes in Oberhausen (Corpus Christi), Pützchens Markt in Bonn and the Allerheiligenkirmes in Soest (All Saints). The Cranger Kirmes in Herne dates back to a horse market, with the oldest fete in the region, Libori in Paderborn, rooted in the transfer of the relics of St Liborius from Le Mans to Paderborn in 836.

Before Christmas gets going, the calendar of traditional events in North Rhein-Westphalia peaks on St Martin's Day (November 11). In the evening the children walk the streets with their homemade paper lanterns, singing of St Martin and how he shared his cloak with a beggar. At the end of the parade they receive a *Weckmann*, a man with a clay pipe and sultana eyes made of sweet yeast dough, or a *Martinstüte* full of sweets. In some places the custom of *Schnörzen* or *Gripschen* has been upheld, where the kids go from door to door singing songs and hoping for something yummy to eat as a reward.

Of course, on November 11 at 11 minutes past 11 the Rhinelander has something completely different in mind: the start of the next *Karneval* season ...

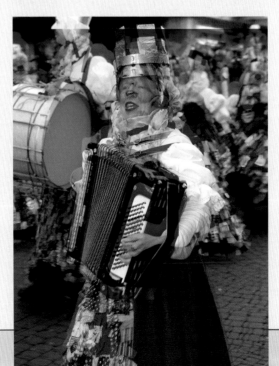

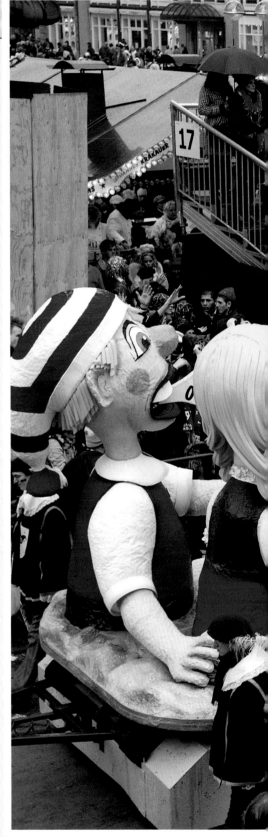

Left:
Music plays a major role in the proceedings in Cologne. Seasoned carnival-goers naturally know all the words to the songs ...

Above:
One of the floats at the Rosenmontag procession in Cologne. Not even rain can dampen the spirits of the crowds, as here in 2008.

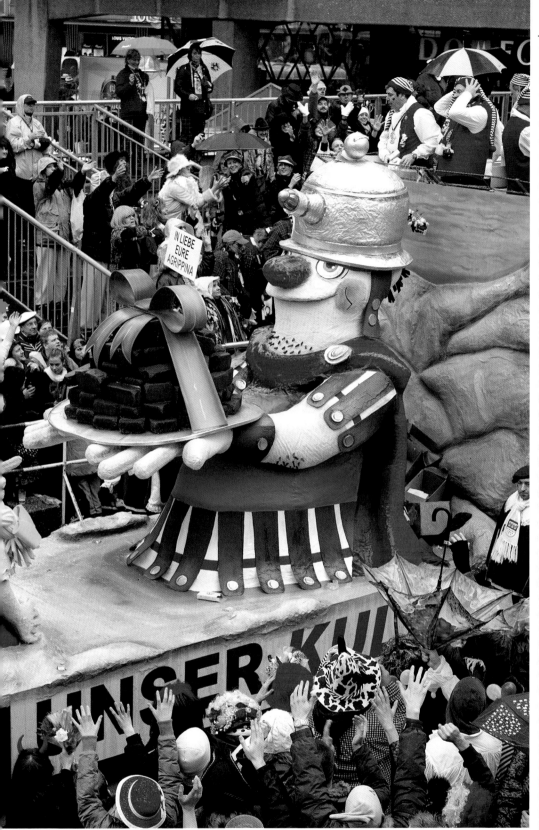

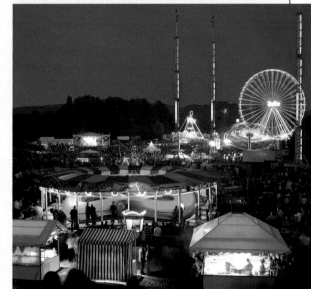

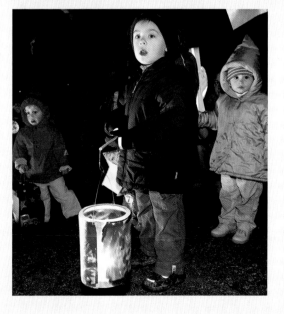

Top right:
"The brighter the better"
is one of the mottos
of Rhineland Karneval –
one these two ladies
quite happily live up to!

Centre right:
Funfair at the Rheinaue
amusement park near Bonn
which took up the space
occupied by the national
garden show in 1979. The
fair is truly gigantic, with
46 km / 29 miles of path-
ways lined with attractions
to explore.

Right:
On St Martin's Day children
parade their lanterns
through the streets and
look forward to their pastry
Weckmann or bag of
sweets.

Above:
The Kommern open-air museum in the Eifel demonstrates what life used to be like in the Rhineland.

Right:
Tünnes and Schäl, two legendary comic figures, as life-size bronze statues in the old town of Cologne. It's said that if you rub Tünnes' nose and make a wish, it will come true!

Far right:
Waiters at breweries in Cologne are called "Köbes" after the name Jakobus or Jacob. They traditionally wear long, blue linen aprons and carry glasses of beer in special round trays with a handle.

Left:
When the street sweepers are out and about, things are usually pretty quiet in the old centre of Cologne. Here Buttermarkt near the enormous Romanesque edifice of Groß St Martin.

Below:
Savouring the end of the day (and a freshly pulled Kölsch) at one of the typical pubs and breweries on Heumarkt in Old Cologne. Here the Pfaffen Brauerei Max Päffgen.

Left:
Crafts market on Münsterplatz in Bonn. The main post office in the background has been installed in a baroque palace from the 18th century.

Centre left:
The Altes Rathaus on the market square in Bonn was built between 1737 and 1780. From its steps heads of state Theodor Heuss, Charles de Gaulle and Mikhail Gorbachev have waved to the crowds.

Bottom left:
People-watching on Münsterplatz in Bonn, with Ludwig van Beethoven up on his stone pedestal also keeping an eye on the goings-on.

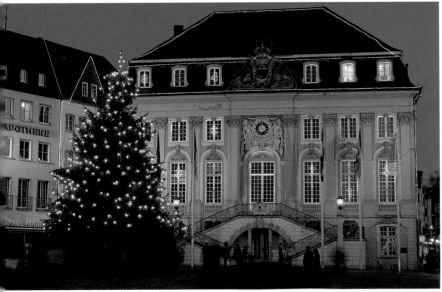

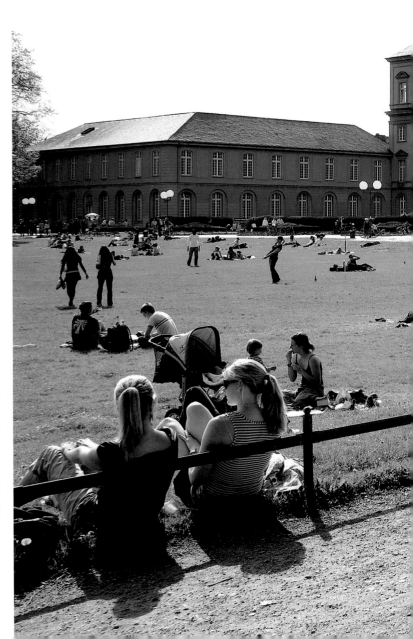

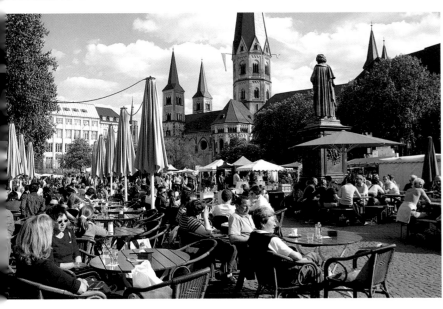

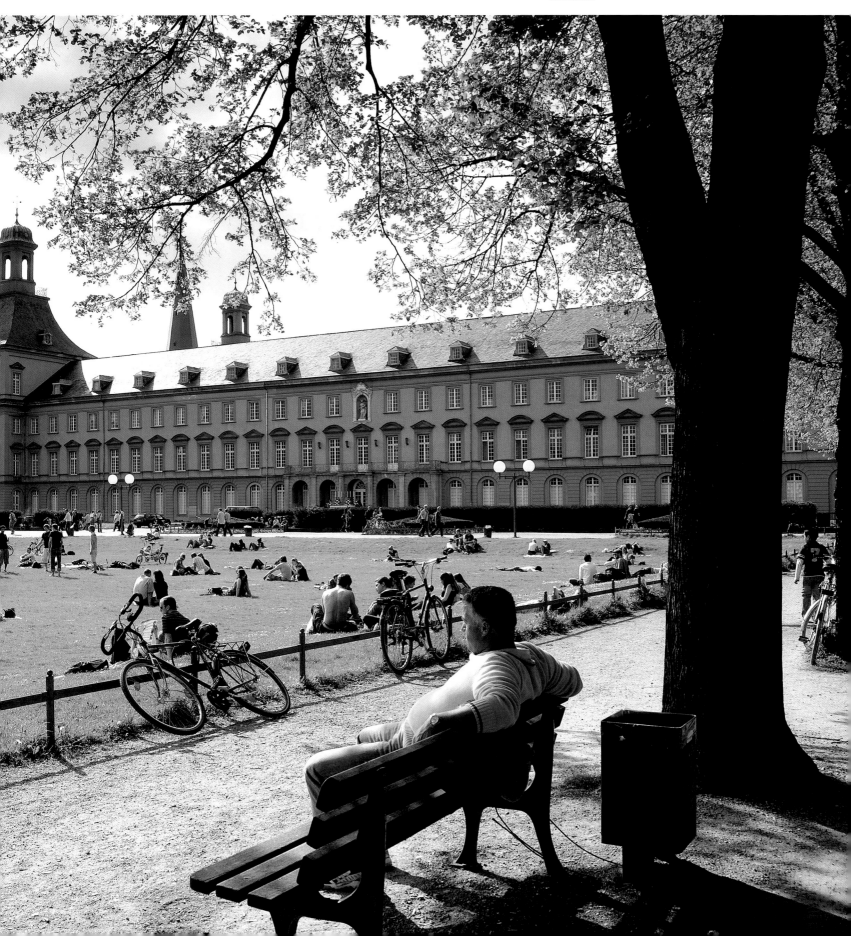

Below:
The main building of the university of Bonn was once the electoral palace. Here in the grounds visitors soak up the spring sunshine.

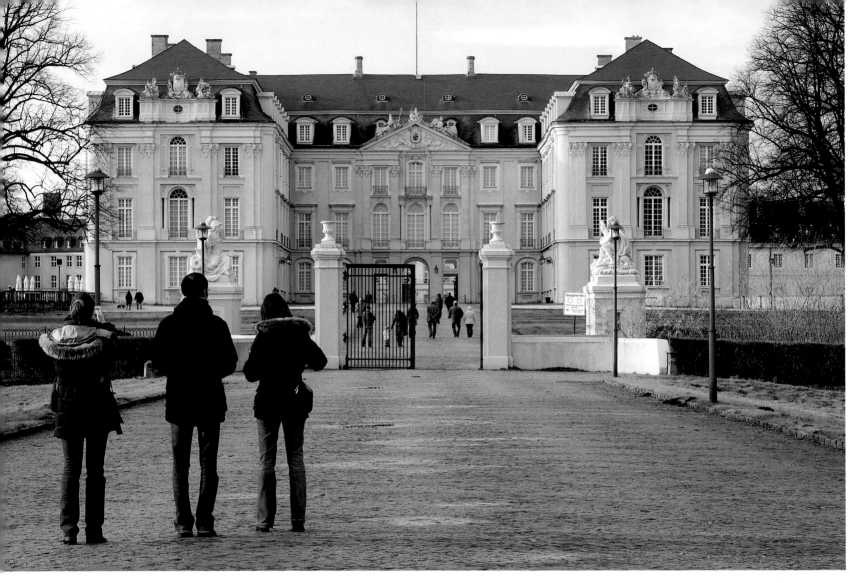

Above:
Schloss Augustusburg
in Brühl, built from
1725 to 1768, is a Rococo
masterpiece and has
been a UNESCO World
Heritage Site since 1984.

Right:
High up above the
Rhine, perched on the
Drachenfels in Königs-
winter, is Schloss Drachen-
burg, built between 1882
and 1884 as an opulent
private villa for a banker
in Bonn.

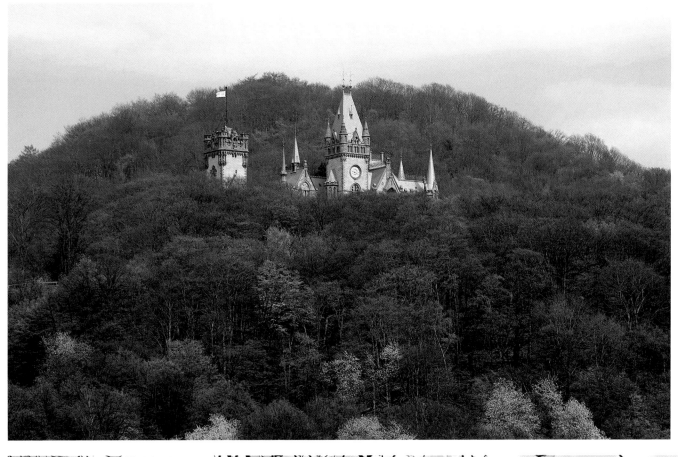

Left:
The late neoclassical Villa Hammerschmidt or 'White House' of Bonn was made the second official home and residence of the president of Germany in 1994. His first home is Schloss Bellevue in Berlin.

Below:
Schloss Benrath in the Düsseldorf suburb of the same name is a popular concert and exhibition venue. It is also used for state receptions.

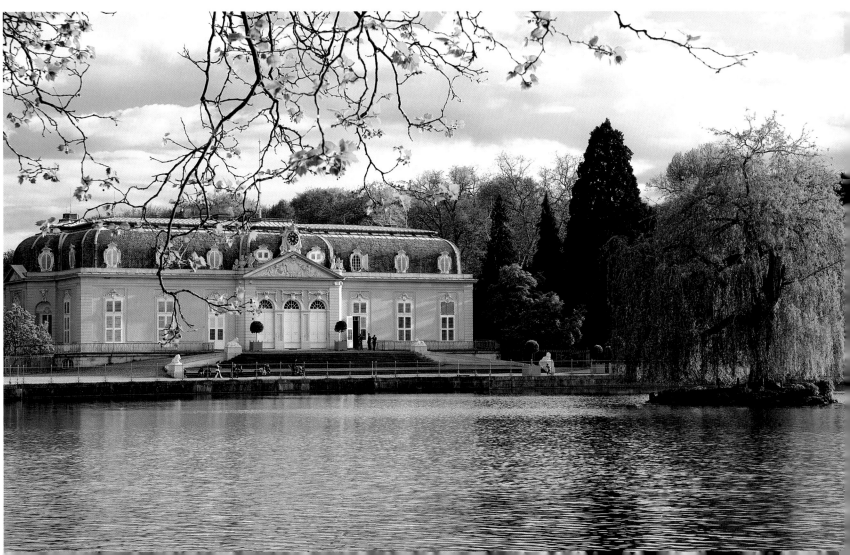

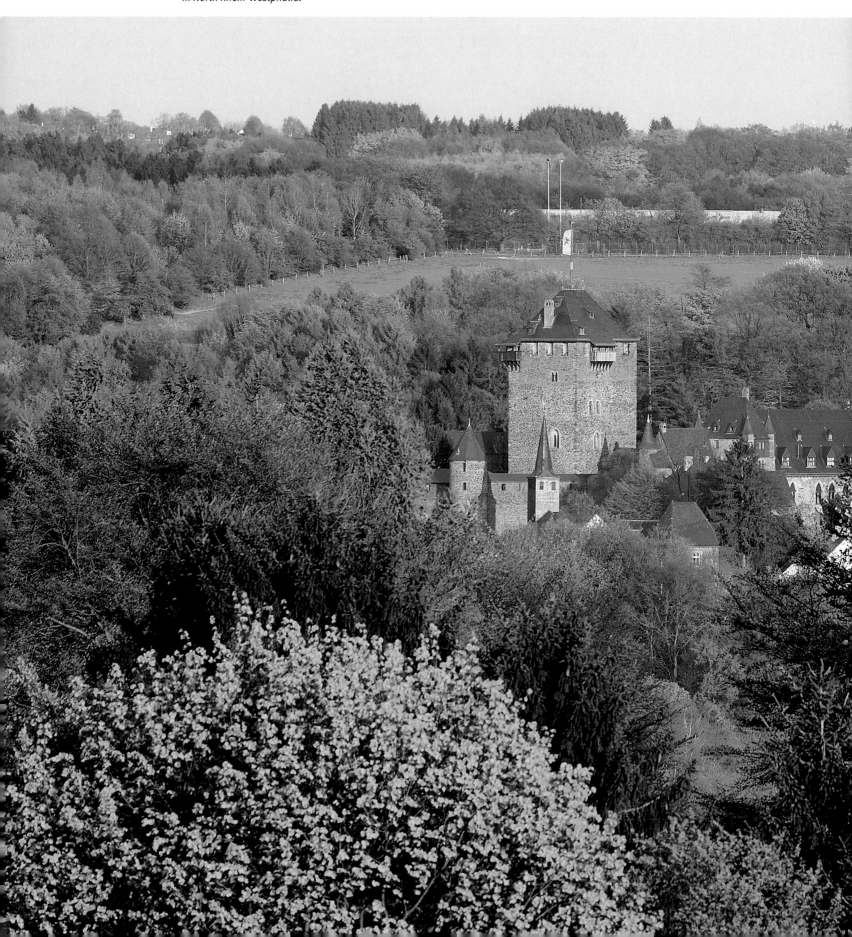

Below:
Schloss Burg can be found in the Solingen suburb of Burg an der Wupper in the Bergisches Land. It is the biggest reconstructed castle in North Rhein-Westphalia.

Top right:
At Schloss Burg events such as medieval tournaments, bazaars, markets, exhibitions, concerts and plays are frequently staged.

Centre right:
The café and restaurant at Schloss Burg, aptly named Zur schönen Aussicht ("nice view"), serves the original Bergische Kaffeetafel, almost a meal in itself!

Below right:
A traditional Bergische Kaffeetafel includes a waffle, rice pudding, sugar and cinnamon, and also cheese, sausage, plum jam, quark and a special, sweet pretzel from Burg, only served here.

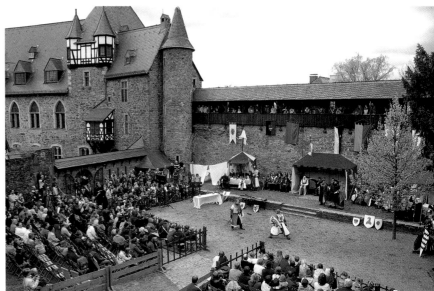

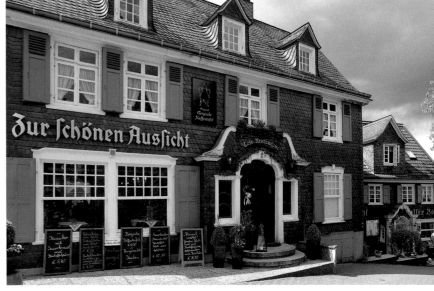

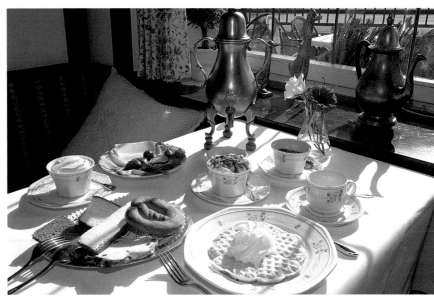

45

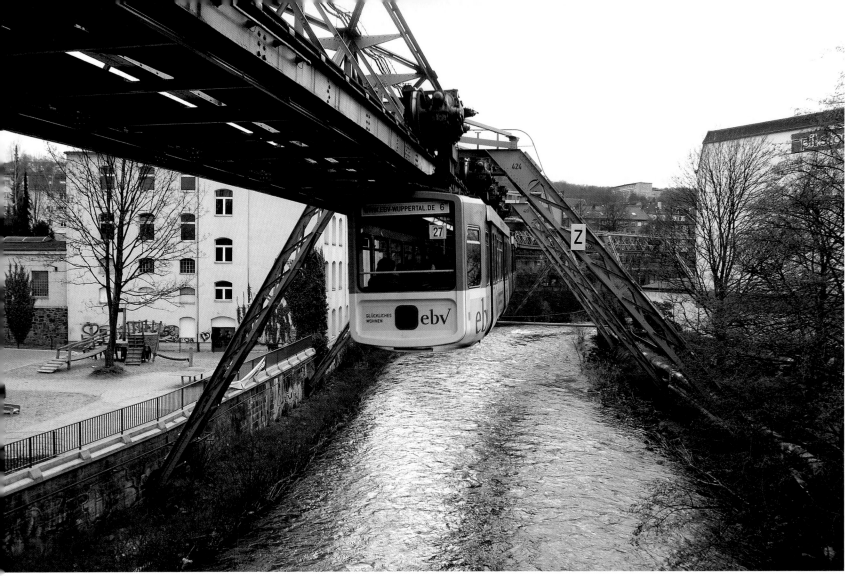

Above:
Wuppertal's absolutely unique landmark is its monorail suspension railway, built in c. 1900 by MAN. Here the rails run ca. 12 m / 40 ft up above the bed of the River Wupper.

Right:
One of the museum sites managed by the Landschaftsverband Rheinland and scattered about the area is the Hendrichs drop forge in Solingen.

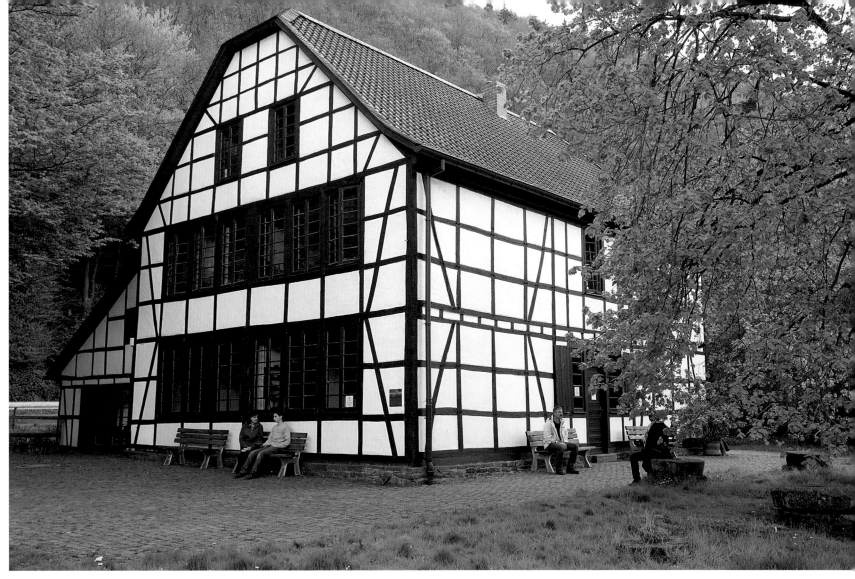

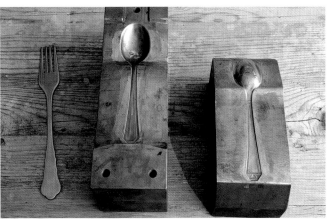

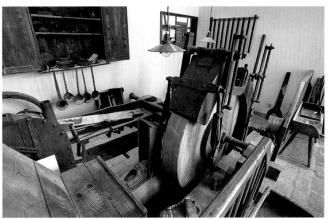

Above and left:
Balkhauser Kotten on the Wupper in the Solingen suburb of Höhscheid is now a museum of grinding. The grinding stones once used to make utensils here were driven by the force of the river.

Far left:
Cast for a spoon in the Balkhauser Kotten museum of grinding.

Far left:
A gift for life: cutlery from Solingen.

Left:
All over the world the name Solingen is synonymous with top-quality metal goods.

Above:
Spring in the Bergisches Land, formerly the ancient territory of the duchy of Berg. View from Ketzberger Höhe near Wermelskirchen.

Right:
The merry month of May in the young beech forest near Solingen-Burg. Geologically speaking the Bergisches Land is part of the Rhenish Massif.

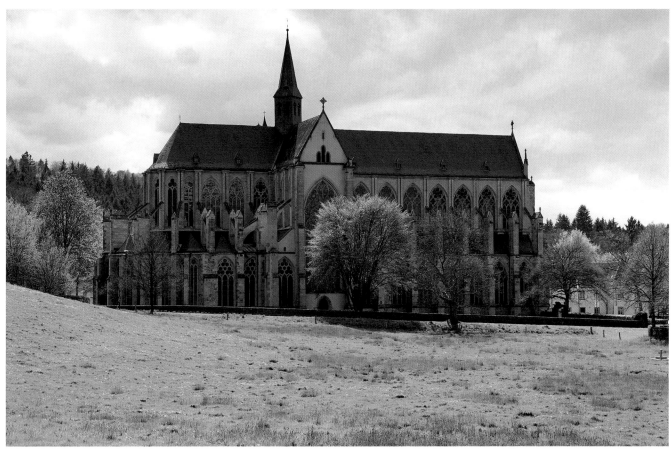

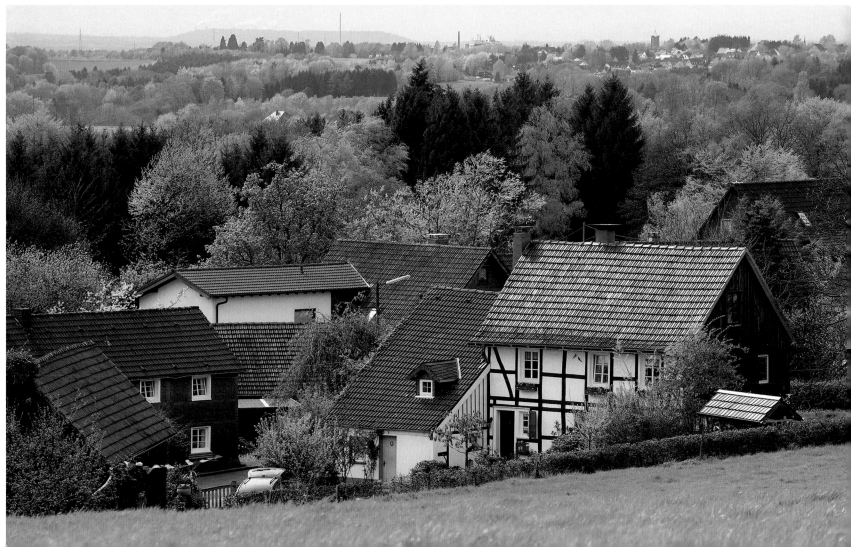

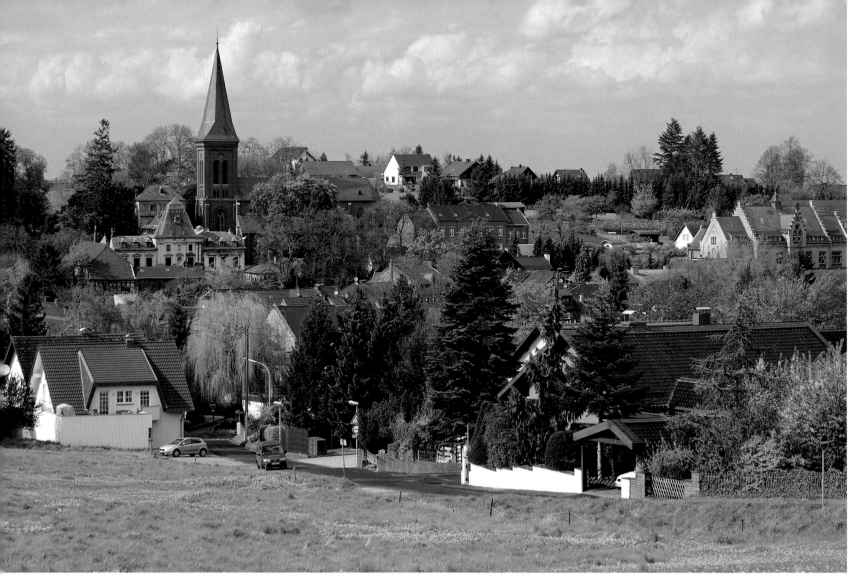

Above:
On the northwest edge of the Eifel is Kommern, famous for its historic centre. In the background on the left is the castle of Burg Kommern.

Right:
In the Eifel near Euskirchen is Burg Satzvey, a moated castle from the 12th to 14th centuries, the best preserved stronghold of its kind in the region. Its most popular events include jousting tournaments and medieval markets.

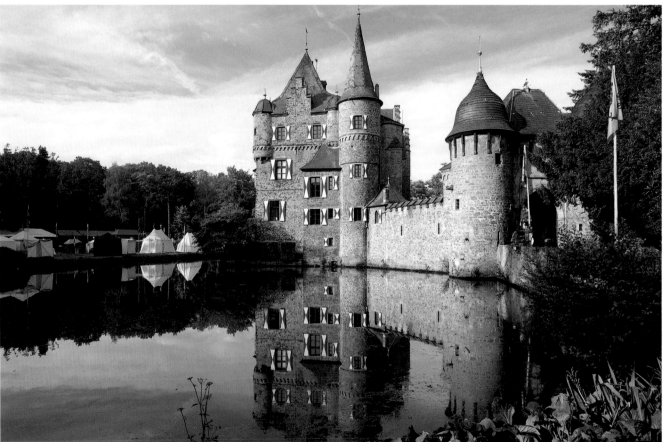

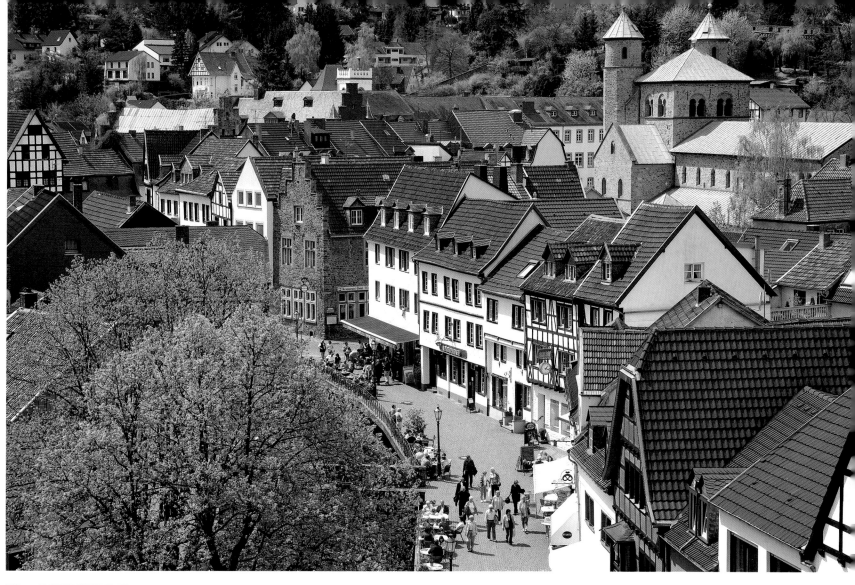

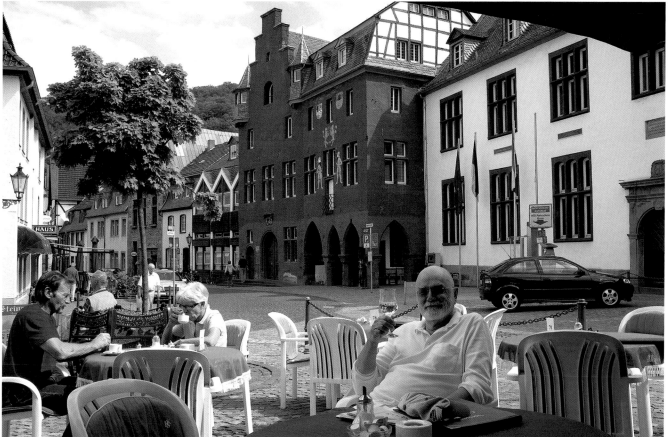

Above:
The pretty little town of Bad Münstereifel has a full set of town walls dating back to the Middle Ages. From the castle there are grand views of the town centre and the collegiate church from the 12th and 13th centuries.

Left:
The town hall in Bad Münstereifel (centre) was a 15th-century cloth hall where merchants exhibited, sold and stored their various fabrics.

Above:
A winter's evening in Blankenheim in the North Eifel. Until 1794 the castle was home to the counts of Blankenheim who also built the late Gothic parish church between 1495 and 1505.

Right:
The castle village of Reifferscheid is not far from Hellenthal in the Eifel. As a terrible fire destroyed much of the village in 1669, most of the existing buildings are from the 17th and 18th centuries.

Left:
*The little town of
Monschau is in an area
called the Rureifel. The
Rotes Haus from c. 1760
is worth seeing, once
home to the Scheibler
family who were big in
the textiles industry. The
house is now a museum.*

Below:
*Monschau enjoys a
scenic setting on the
gentle slopes of the Rur in
the Eifel. To distinguish it
from the much larger River
Ruhr, in c. 1900 the "h"
was simply removed from
its name.*

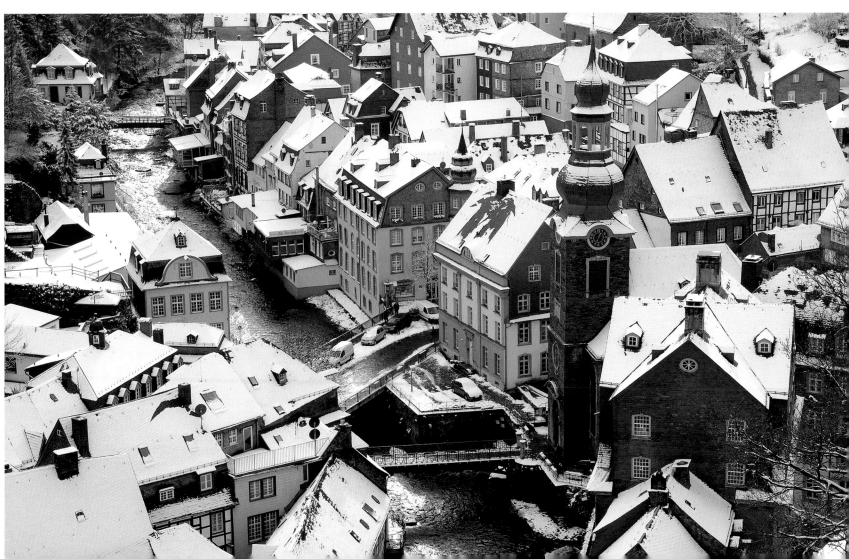

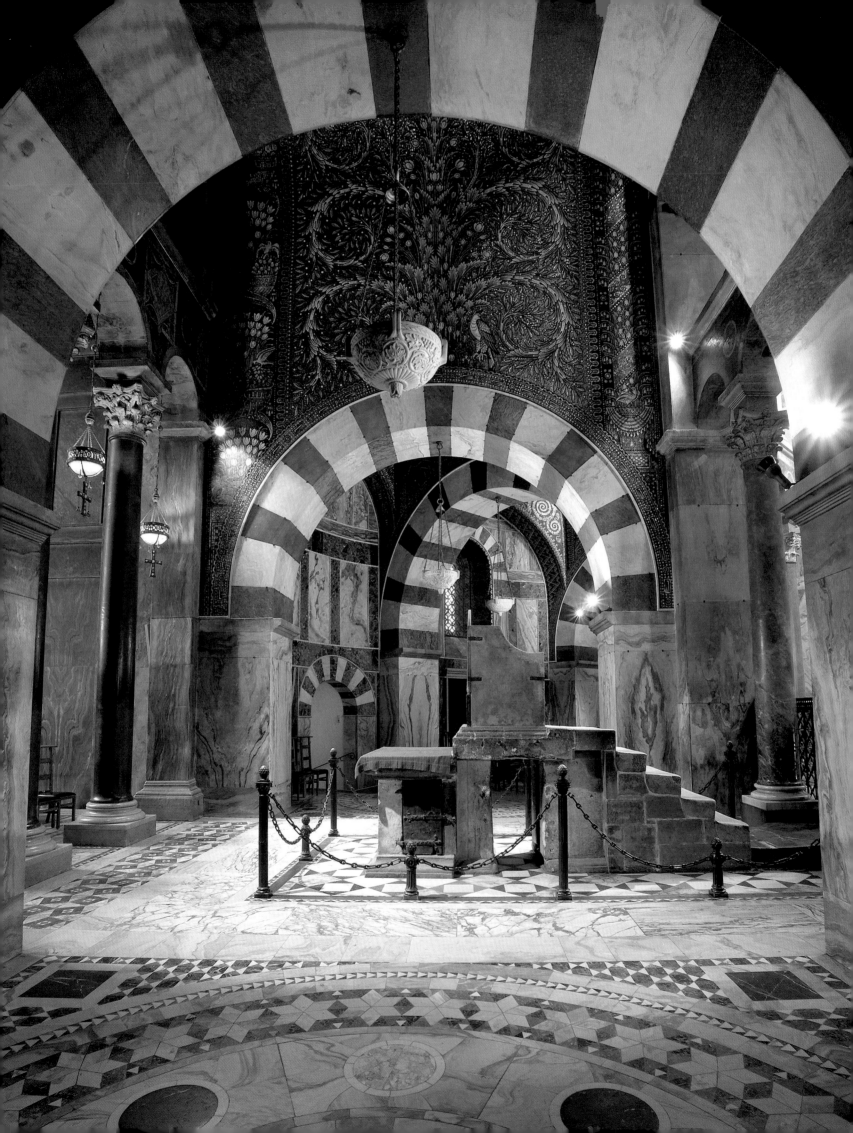

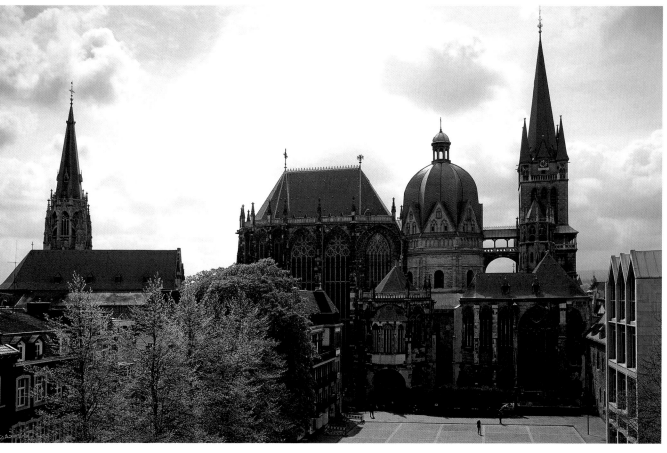

Left page:
The octagonal chapel at the heart of Aachen Cathedral was built in the 790s and modelled on similar Byzantine edifices in Ravenna (San Vitale) and Constantinople. The chapel was built to serve Emperor Charlemagne's imperial palace in Aachen.

Left:
The north side of Aachen Cathedral, seen from the town hall. The space between the cathedral and Rathaus, Katschof, is where markets, festivals and concerts are held. On the left of the picture, along a narrow alley from the cathedral, is the city's parish church of St Foillan.

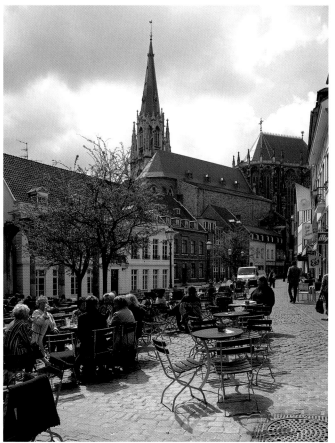

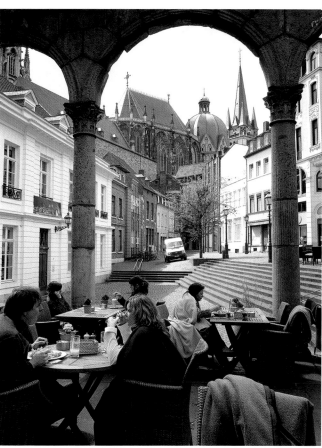

Far left and left:
This tiny square in the middle of Aachen is simply called Hof or yard. Here you can enjoy your lunch with teasing views of St Fiollan and the cathedral tucked away behind listed buildings.

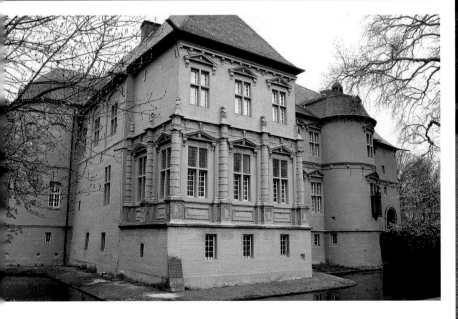

Left:
The state museum of Abteiberg in Mönchengladbach was built by Viennese architect and designer Hans Hollein between 1975 and 1982.

Centre left:
St Vith is the oldest inn in Mönchengladbach, in existence for over 400 years. St Vitus is the patron saint of the city.

Bottom left:
Schloss Rheydt, built between 1558 and 1570, is the best-preserved Renaissance palace on the Lower Rhine and after the minster the most famous building in Mönchengladbach.

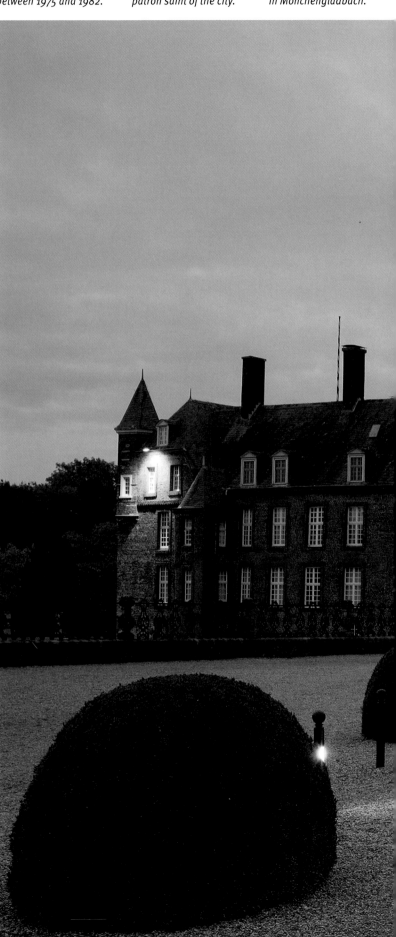

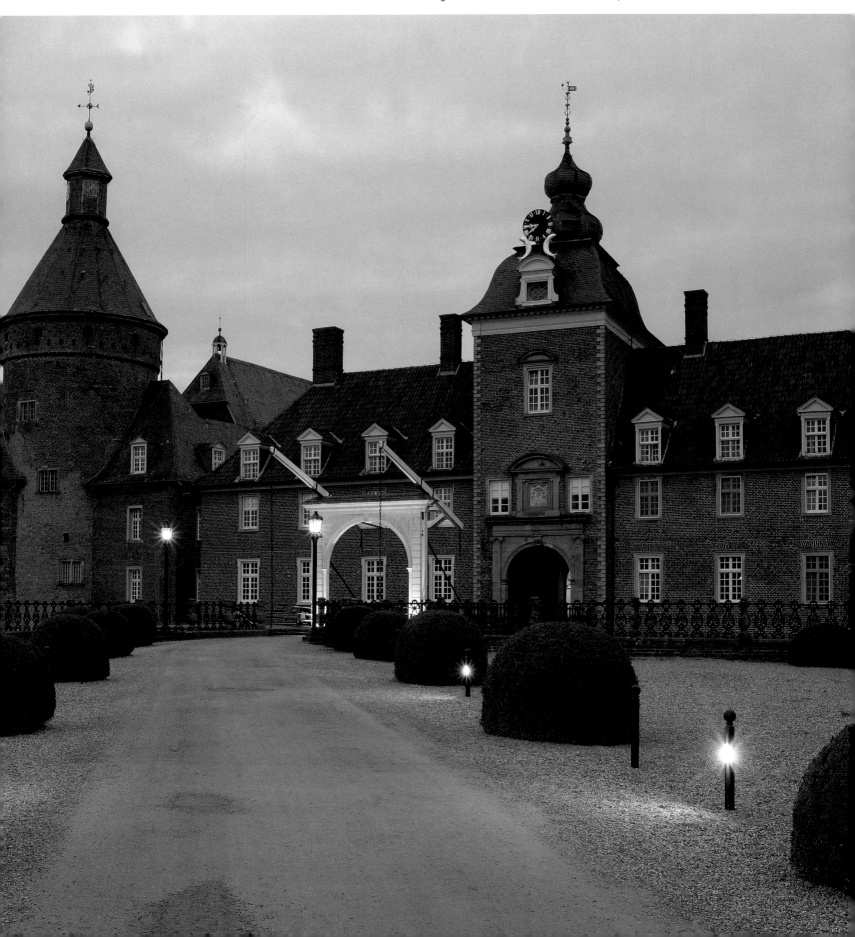

Below:
Close to the Dutch border in the Isselburg suburb of Anholt you can visit one of the largest moated castles in the Münsterland. Burg Anholt dates back to the 12th century. It was turned into a splendid baroque residence in c. 1700.

Right:
View across the Rhine flood plains of Rees, the oldest town on the Lower Rhine. The church of St Mariä Himmelfahrt with its distinctive towers was erected in the neoclassical vein between 1820 and 1828.

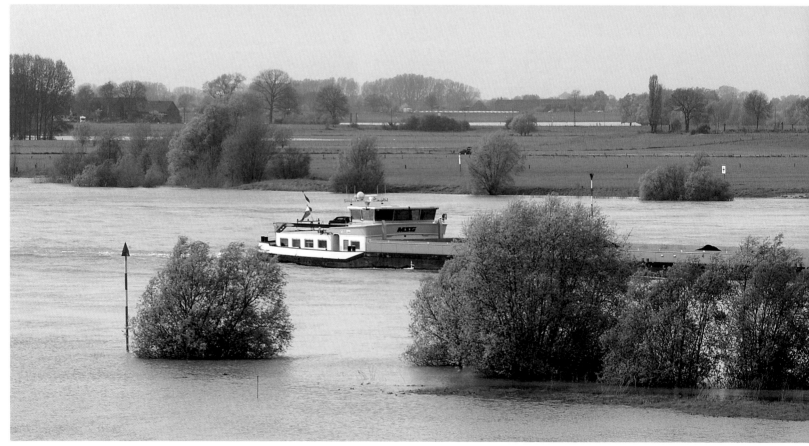

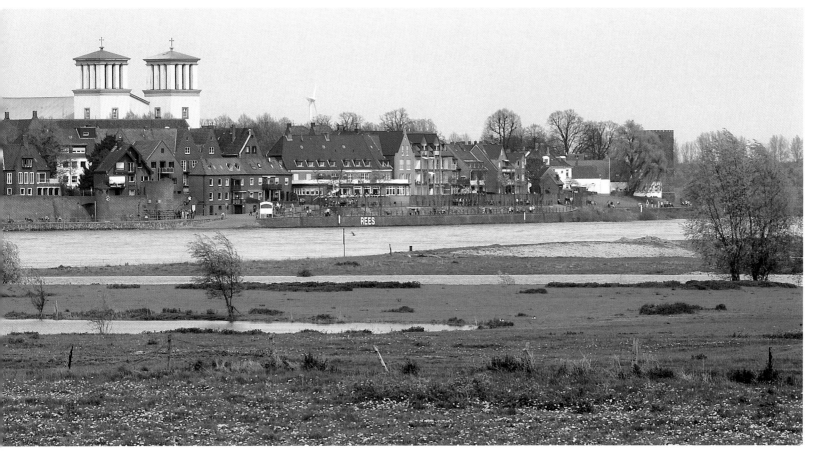

Left:
Spring on the flood plains near Rees. The Reeser Schanz nature reserve between Kalkar and Xanten is home to many rare plants and animals.

Above:

Kriemhildmühle in Xanten was built at the end of the 14th century as a watch-tower and part of the town defences. In 1992 the mill again began grinding corn for the bread and cakes made at the bakery next door.

Right:

The Gothic cathedral of St Viktor in Xanten bears the epithet of "the largest cathedral between Cologne and the sea". It was con-structed between 1263 and 1544 to also include these peaceful cloisters on the north side of the building.

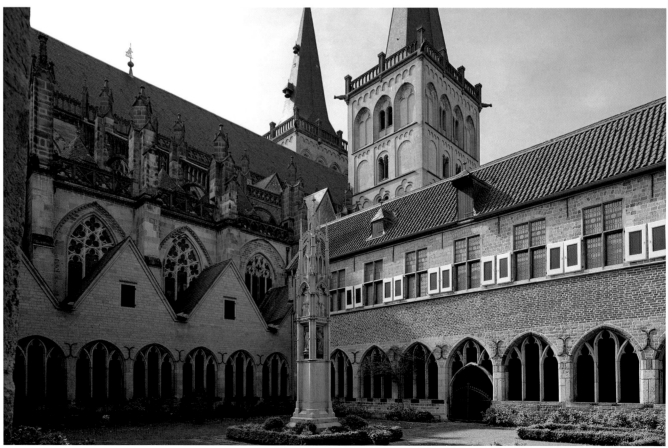

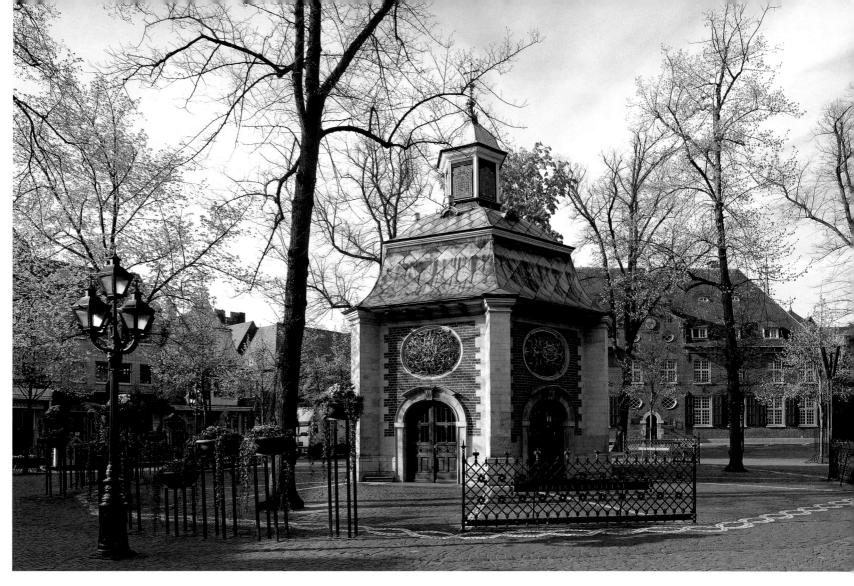

Above:
Kapellenplatz in the centre of Kevelaer is named after its chapel of mercy, 350 years old. In 1642 a merchant had a vision of the Virgin Mary here, making Kevelaer one of the chief sites of pilgrimages to the Madonna in northwestern Europe.

Left:
An Oratorian monastery was erected opposite the chapel of mercy in 1647. Now the seminary, this is the oldest stone building in Kevelaer. The inscription above the door urges you to seize the day: "Carpe Diem!"

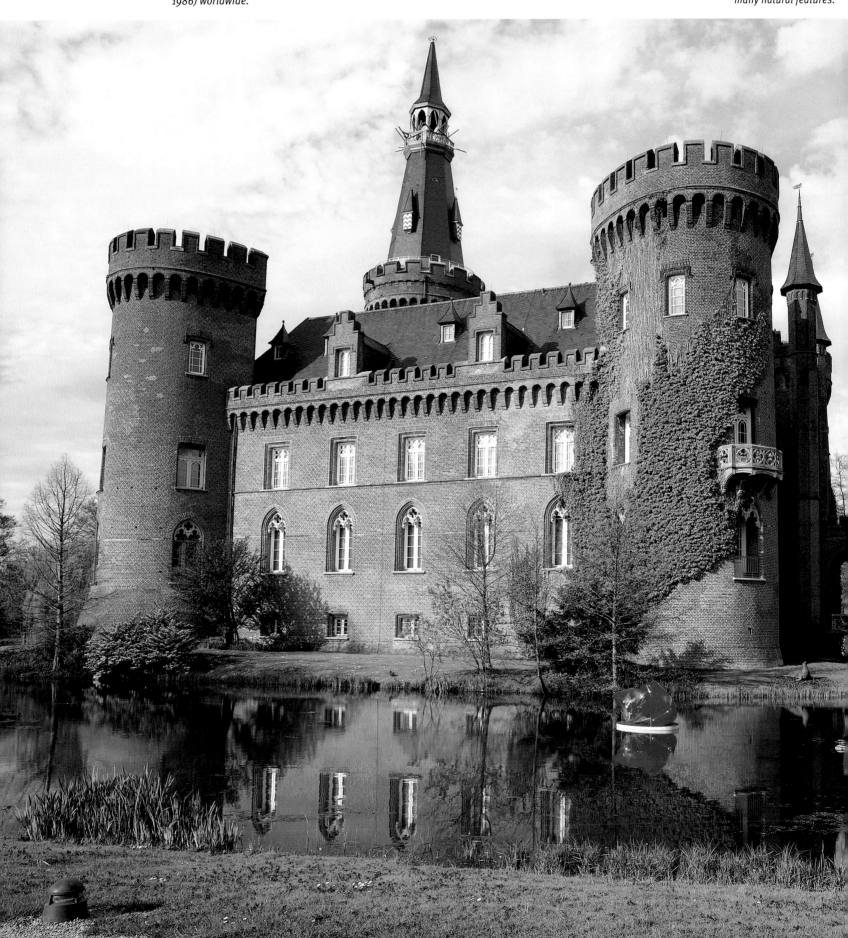

Below:
Schloss Moyland, a neo-Gothic moated castle near Bedburg-Hau in the district of Kleve. It's now a museum holding the largest collection of works by Joseph Beuys (1921–1986) worldwide.

Top right:
Haus Caen is a palatial manor house in Straelen. It is surrounded by informal landscaping, of which this ancient oak is one of the many natural features.

Centre right:
Much of the Niers, a tributary of the River Meuse, can be toured by paddle boat. Cycling tracks and hiking trails trace its banks.

Bottom right:
Schloss Dyck between Grevenbroich and Mönchengladbach is one of more famous moated castles of the Rhineland. This avenue of chestnut trees was once the great driveway leading up to the big house.

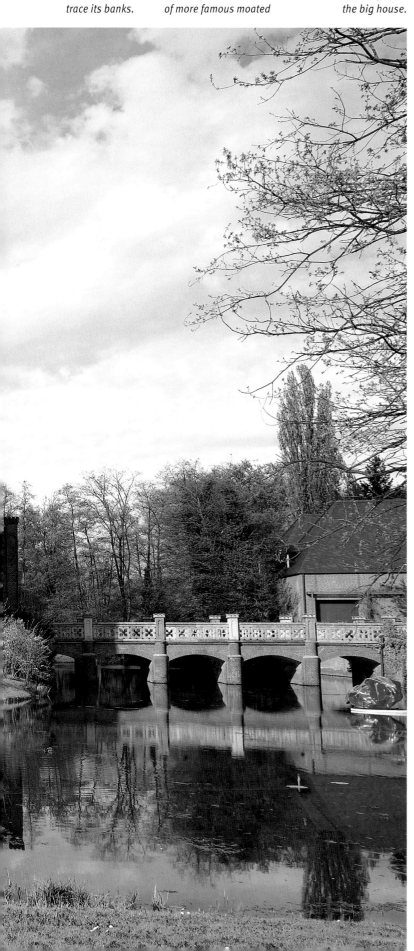

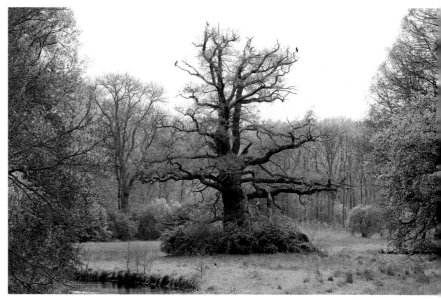

63

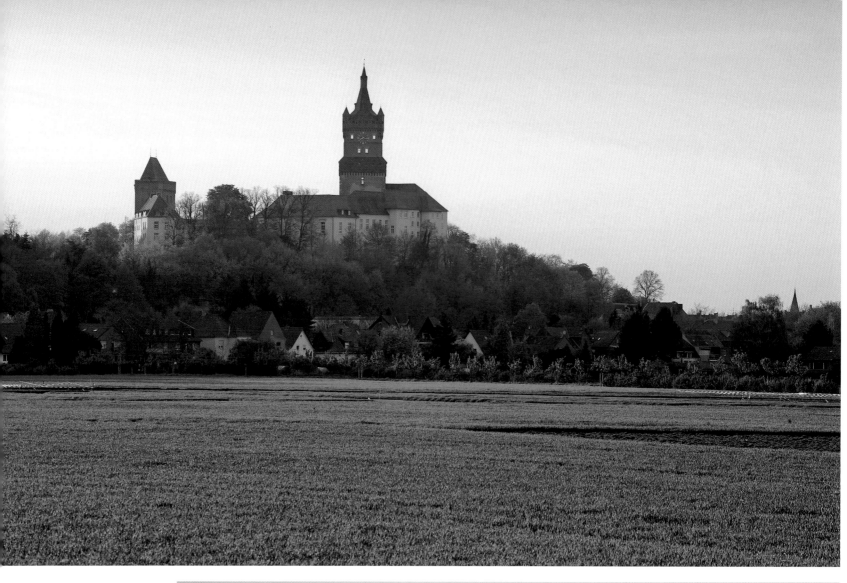

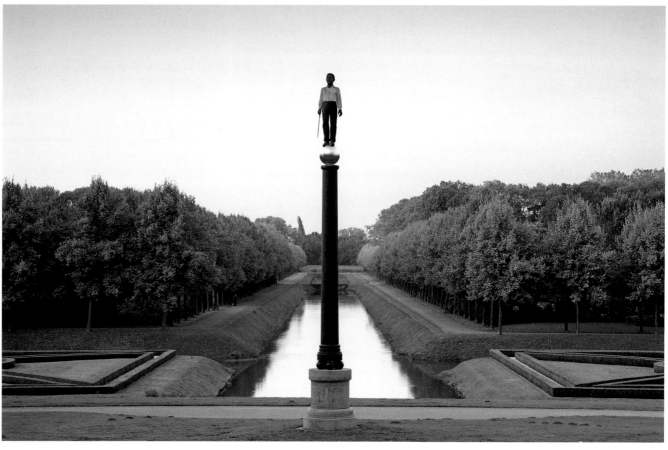

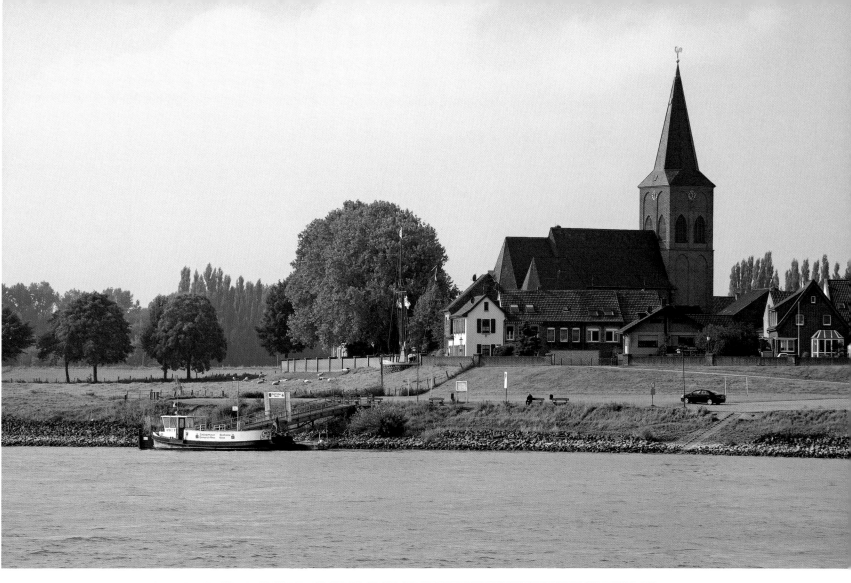

Above:
Late summer on the Rhine near Grieth, a suburb of Kalkar. The village is dwarfed by its late Gothic, 15th-century aisled parish church dedicated to Saint Peter and Saint Paul.

Left:
The Hanseatic town of Emmerich am Rhein. On the left is the 'Golden Gate' of the Lower Rhine, built between 1962 and 1965, and at 805 m / 2,635 ft the longest suspension bridge in Germany.

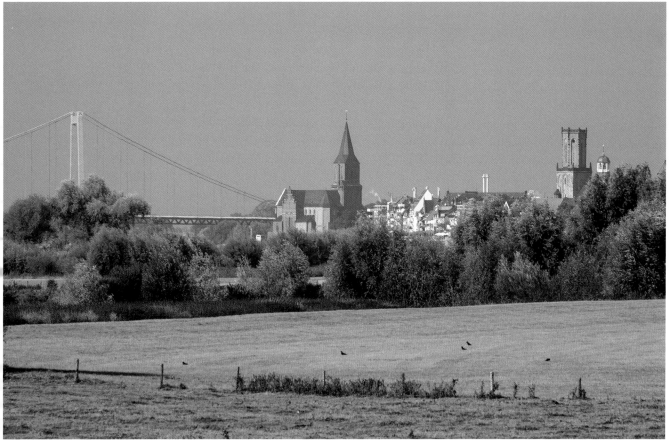

Industry, mining and more – the Ruhr

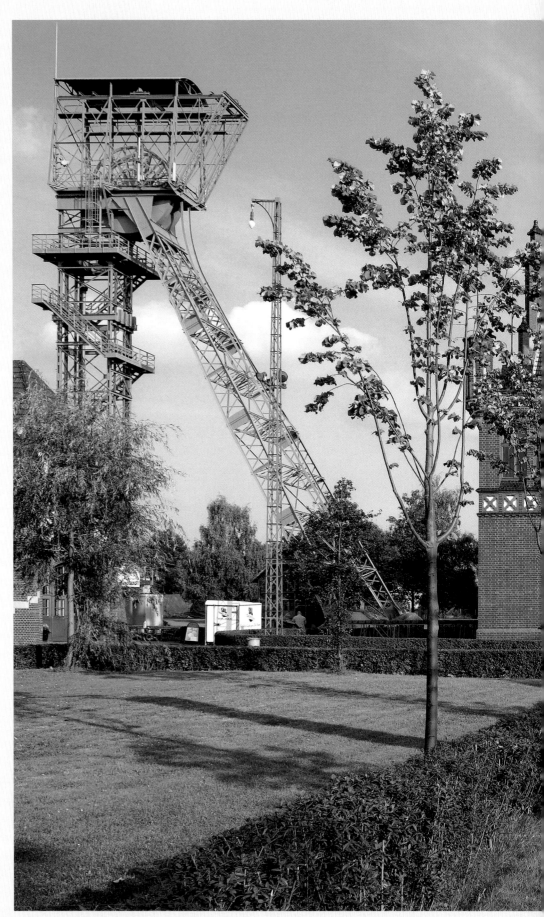

With its Historicist and Jugendstil elements the Zeche Zollern II/IV colliery northwest of Dortmund is a most unusual industrial monument and one of eight sites belonging to the Westphalian museum of industry which is based here.

The Ruhr Basin between the Ruhr and Lippe and Duisburg and Hamm is the third-largest conglomeration in Europe. It owes its importance primarily to hard coal which since the 19th century was used to make the coke burned in the blast furnaces of the region's many iron and steelworks.

5.3 million people live here in cities that run into each another almost as if they were one: Duisburg, Oberhausen, Mühlheim, Bottrop, Essen, Gelsenkirchen, Bochum, Herne, Recklinghausen and Dortmund.

What work was like down in the pit can be investigated at the industrial museum of Zeche Zollverein in Essen, made a UNESCO World Heritage Site in 2002. Around 400,000 visit the German museum of mining in Bochum each year. The miners' museum in Lünen on the northeastern edge of the Ruhr documents the life and times of the people who once lived here. The historic centres of Hattingen-Blankenstein and Herten-Westerholt, still completely intact, look back to the quieter days of the Ruhr before coal and steel began their loud and dirty dominance of the region.

The cathedral in Essen is over 1,000 years old. Villa Hügel in Essen is the former family home of the industrial Krupp dynasty, built in 1873. Art exhibitions of international acclaim have been regularly staged here since 1953. The Folkwang Museum in Essen is one of the major venues for 19th and 20th century art. Gruga Park in Essen contains Friedensreich Hundertwasser's Ronald McDonald House. The Henrichenburg ship hoist on the Dortmund-Ems Canal is also worth seeing, opened in 1899 by none other than Kaiser Wilhelm. A favourite with the inhabitants of Dortmund is the castle of Hohensyburg south of the city.

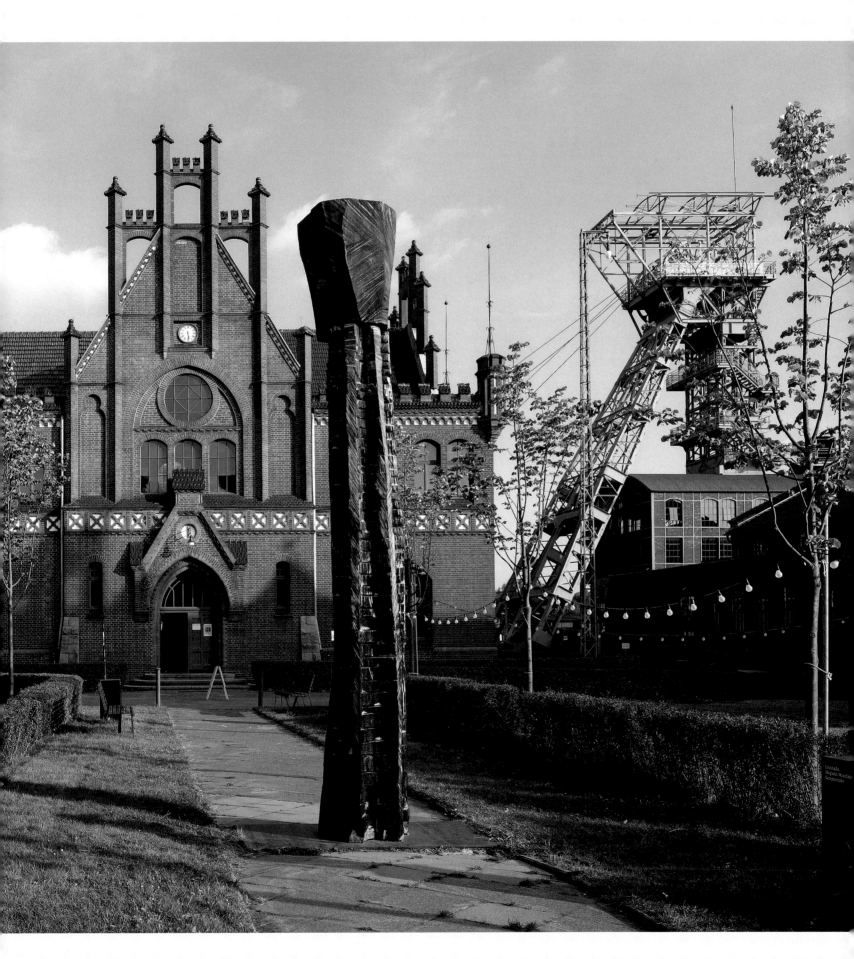

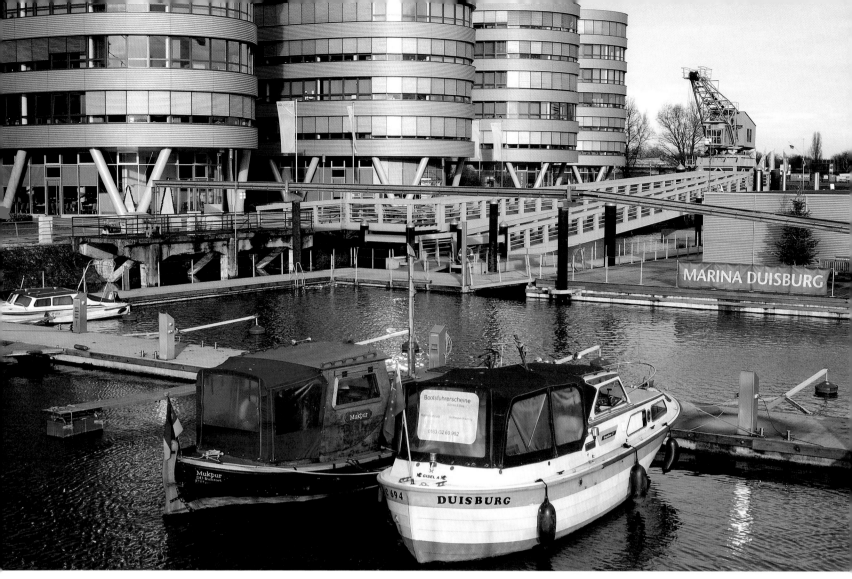

Above:
A sunny, wintery day at Lord Norman Foster's Marina Duisburg. Redesigned and opened fairly recently, the yachting harbour is a good stop-off point on the themed industrial history route.

Right:
The harbour in Duisburg is the largest inland port in Europe. Changes in infrastructure have cheated it of its original purpose; it's now an industrial monument and a place where people can work, live and indulge in various cultural and leisure activities on the water front.

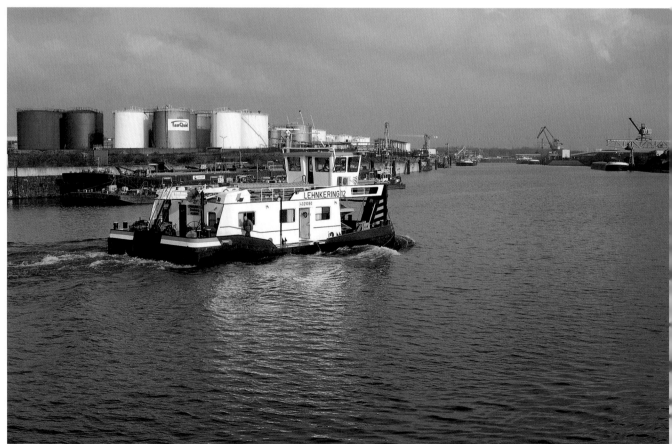

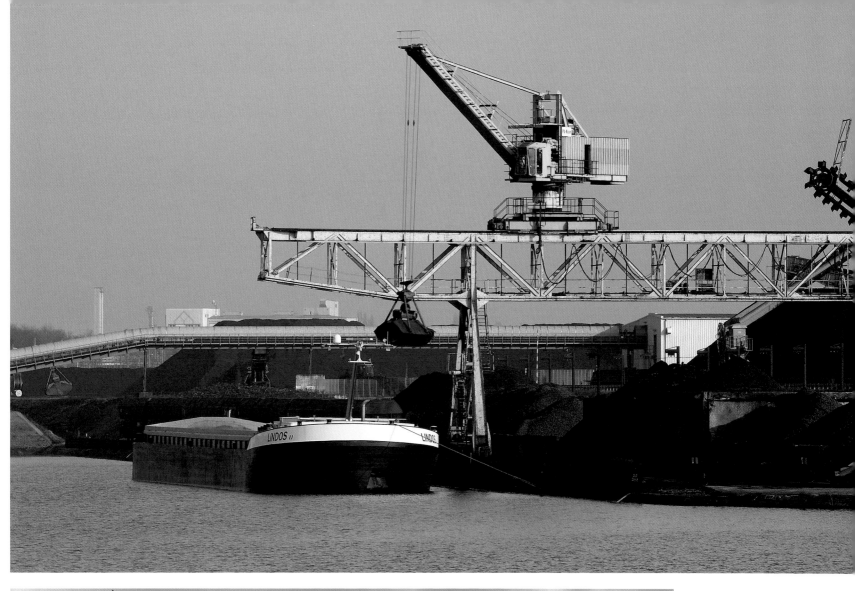

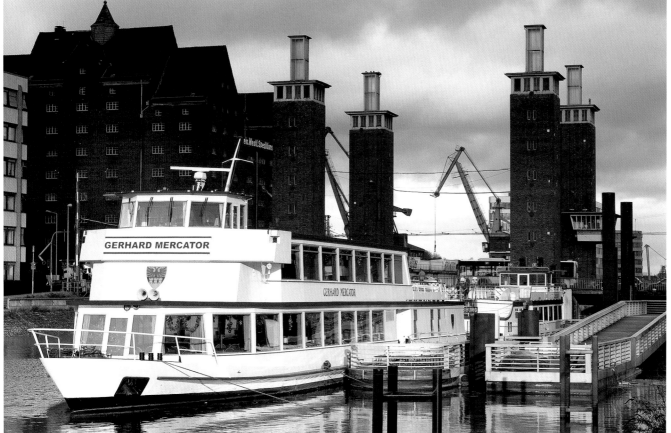

Above:

In the past few years coal imports have become more and more important. Up to eight million metric tonnes a year can now be processed through the harbour in Duisburg – still the chief port of call for the steel trade in Germany.

Left:

Despite all the industry Duisburg also has a fleet of white ships! This member of the Weiße Flotte is named after geographer and cartographer Gerhard Mercator, born in 1512, who lived in Duisburg from 1552 up until his death in 1594. He is buried in the city's Salvatorkirche.

Above:
The Zeche Zollverein mine in Essen, closed in 1986, has been a UNESCO World Heritage Site since 2002. Visitors to the museum and the many events held here can grab a bite to eat at the Café Kohlenwäsche.

Right:
Art and culture have breathed new life into the old plant and machine halls at the Zeche Zollverein. This building is home to PACT Zollverein, for example, a choreographic centre for the performing arts in NRW.

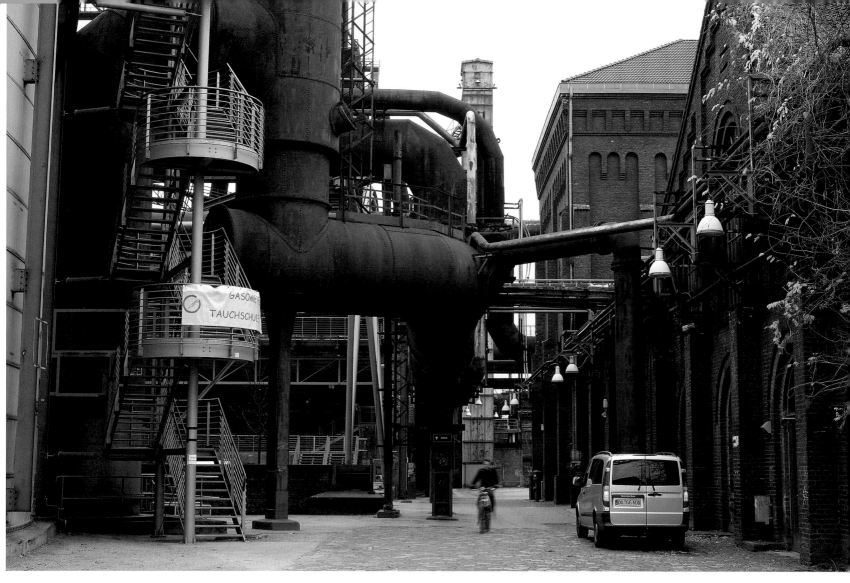

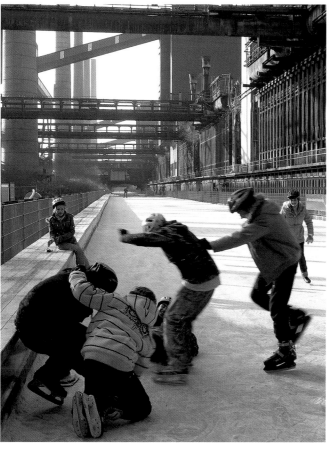

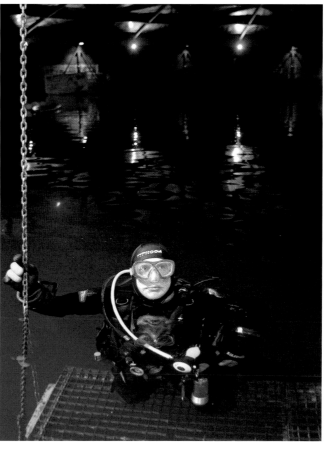

Above:
The old Thyssen steel works in Meiderich, founded in 1902, now forms the centrepiece of the Duisburg-Nord landscaped park and is the second most frequently visited tourist site in North Rhein-Westphalia after Cologne Cathedral.

Far left:
Having fun on the ice rink at the old coking plant of the Zeche Zollverein.

Left:
The gasometer at the old Thyssen steel works has been turned into a diving pool.

Below:
Halde Rheinelbe is an overburden dump in Gelsenkirchen-Ückendorf that has been made accessible to the public. Local artist Herman

Prigann (1942–2008, b. Recklinghausen) has made a "forest of sculpture" here and in the grounds. The photo shows his "Himmelsleiter" (Jacob's Ladder).

Right:
A winter's evening on the Schurenbachhalde, an old overburden dump in the Essen suburb of Alten-essen, 45 m / 148 ft high.

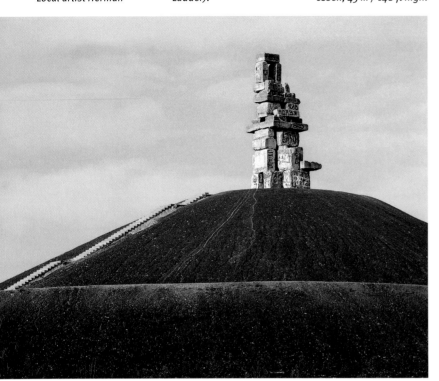

Above:
In 1998 the Schurenbach-halde mine dump was crowned by this 15-m / 50-ft sculpture by American artist Richard

Serra (b. 1939). Entitled "Slab for the Ruhr", the slab is question is a block of raw steel used to make sheets or strips. This one weighs 67 metric tonnes.

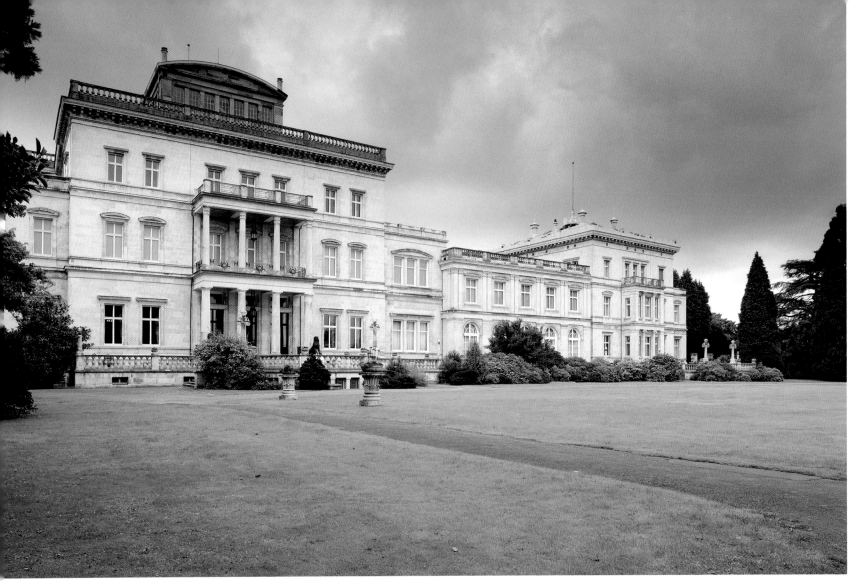

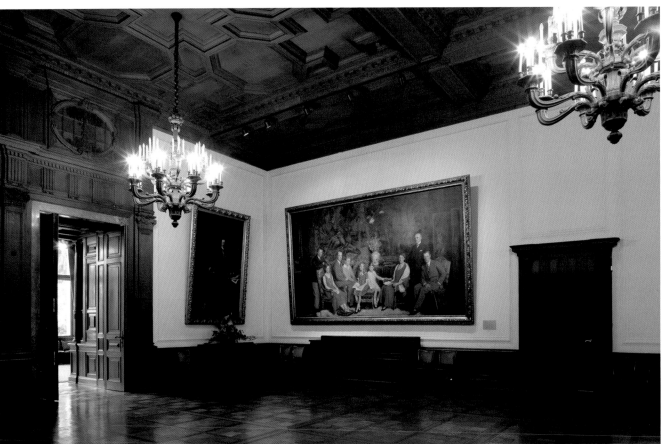

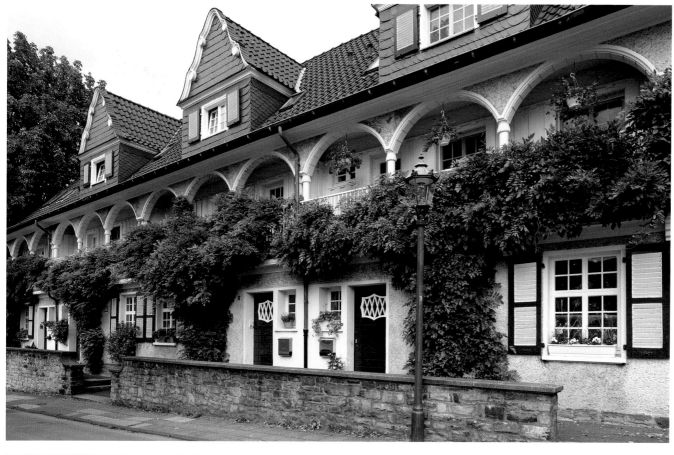

Left:
The Margarethenhöhe estate in the west of Essen, founded in 1906 by Margarethe Krupp, was built between 1909 and 1938 as a garden city for workers' families. It's now listed.

Small photos, left:
You can see what life was like for the average miner's family between 1930 and 1935 at the museum of mining in Lünen-Brambauer. The décor is original, complete with bath tub, embroidered cushions, earth closet and rabbit hutch, the latter providing the Sunday roast.

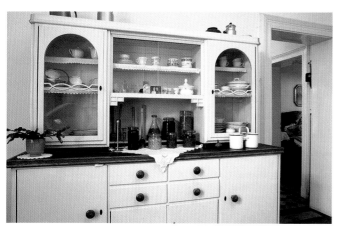

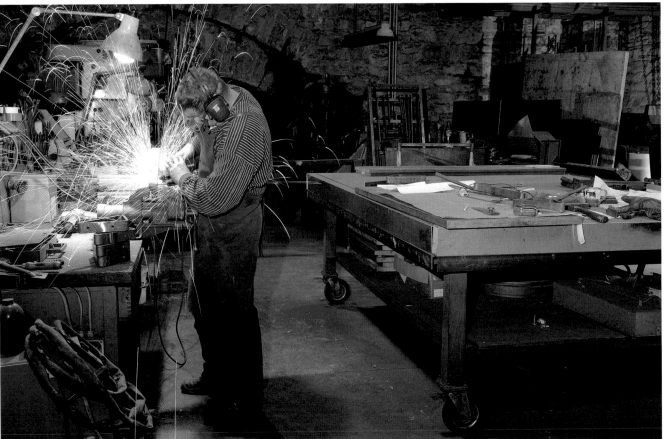

Above:
Kupferdreh is a suburb to the southeast of Essen on the River Ruhr. There is documented evidence that there was a copper mill here in the mid 16th century, hence the name Kupferdreh ("Kupfer" = "copper"). The old hammer works (listed) is now a metalwork shop.

Right:
At Michael Stratmann's metalwork shop forge and locksmith work is executed for public and private clients and for churches, including railings, fences, gates, grating for organ lofts ...

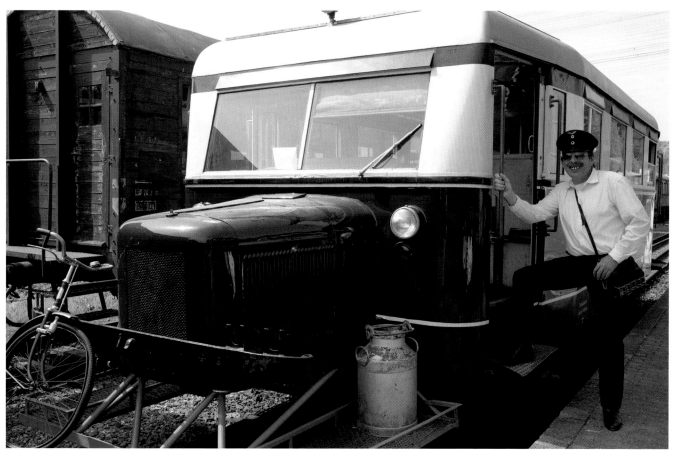

Left:
The railway museum at Bochum-Dahlhausen is the largest private museum devoted to trains in Germany. This railbus, built in the 1930s in Wismar, is nicknamed "pig's snout".

Below:
The Henrichenburg ship hoist on the Dortmund-Ems Canal was opened in 1899 by none other than Kaiser Wilhelm. It originally covered a difference in height of 14 m / 46 ft. A new one went into operation in 1962.

Above:
Essen-Werden, a suburb in the south of Essen, is affectionately known as the 'pearl' of the Ruhr for its many historic buildings which came through the war unscathed. The Romanesque and Gothic abbey church, for example, dates back to 799.

Right:
The old collegiate church in Essen, Essen Minster, is a Gothic hall church erected after 1275. Its impressive works of art include the famous Golden Madonna, over 1,000 years old and thus the oldest free-standing statue of Mary north of the Alps.

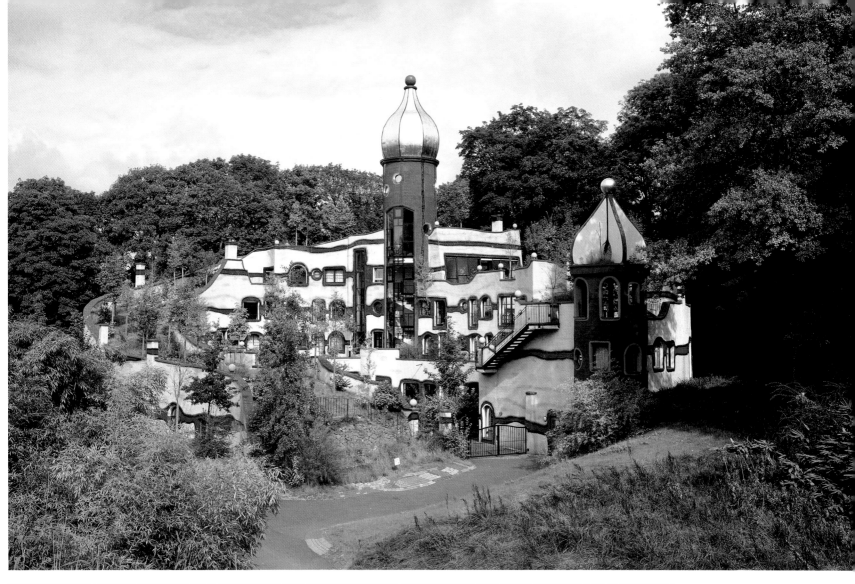

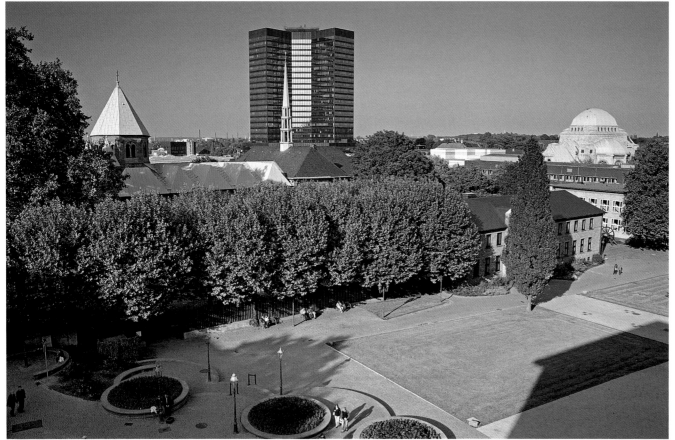

Above:
Gruga Park in Essen contains Friedensreich Hundertwasser's Ronald McDonald House, right next to Essen's university hospital. Families of very ill children stay here while their offspring are treated at the clinic.

Left:
The skyline of Essen is dominated by the truly enormous town hall, with the steeple of the minster to the left and the domes of the Old Synagogue to the right, built in 1911. Made of reinforced concrete, the latter survived the Nazi period and the Second World War largely unscathed and is now a meeting place and memorial.

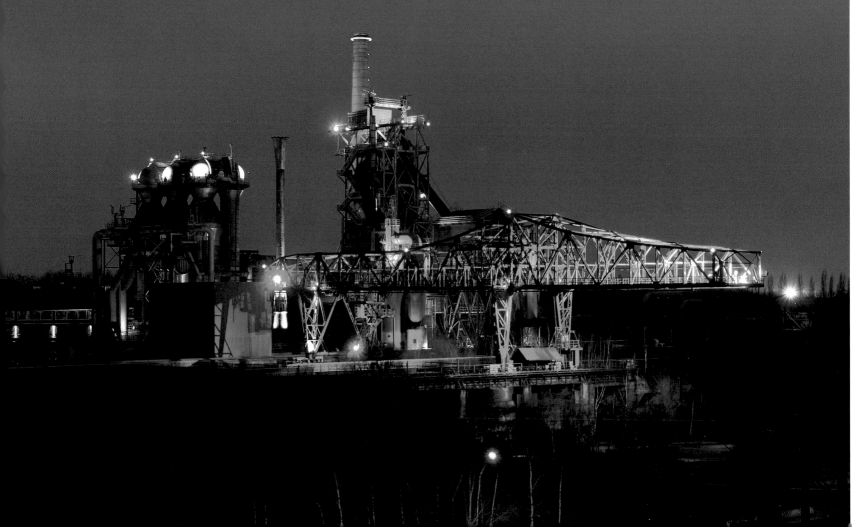

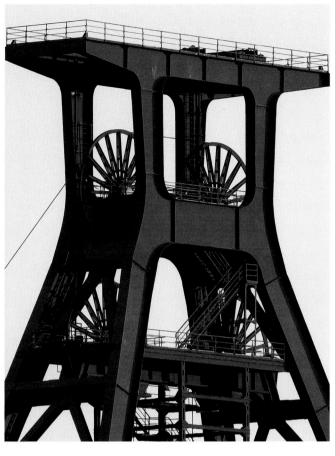

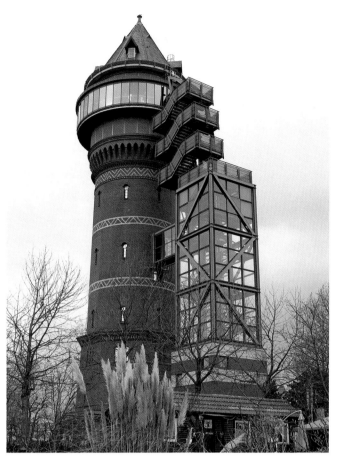

Top left page:
The gasometer in Ober-hausen, built in 1928/29, is a city landmark. It was shut down in 1988. After extensive conversion it is now used as a venue for exhibitions, concerts, theatre and much more.

Far left:
The symbol of the Zeche Zollverein in Essen, a UNESCO World Heritage Site since 2002, is the winding tower of mine shaft 12.

Left:
This disused water tower in Styrum, part of Mülheim an der Ruhr, is now the Aquarius water museum.

DEUTSCHES BERGBAU-MUSEUM

Far left:
In Lünen-Brambauer the Lüntec centre of technol-ogy was set up on the site of the closed Minister Achenbach mine. The Colani 'egg' on the top of the winding tower is the centre's novel set of offices.

Left:
The German museum of mining in Bochum is one of the most famous museums of its kind in the world and with 400,000 visitors a year also one of the most popular museums in Germany.

Bottom left page:
The old Thyssen steel works in the Duisburg suburb of Meiderich, now Landschaftspark Duisburg-Nord, all lit up at night.

Coal, steel and technology – the Ruhr Basin

Smoking chimneys, slag heaps and air pollution; hard-working miners with blackened faces; winding towers that pierce the permanently yellow-grey sky like giant metal skeletons, legs astride: this is how people used to see the Ruhr Basin. In his book *Schwarzes Revier* (The Black Ruhr) from 1929 writer and photographer Heinrich Hauser (1901–1955) reports: "Your vision is never clear; even on the brightest sunny days it is like looking through dirty glasses, as the air is so thick with smoke from the countless chimneys."

The Ruhr is one of Europe's chief industrial areas. With approximately 5.3 million inhabitants and a surface area of 4,435 square kilometres (1,712 square miles) it's the biggest conglomeration in Germany and the third largest in Europe. The present area stretches from the district of Wesel in the northwest via Recklinghausen and Unna to Hamm in the east and from Duisburg in the south, Mülheim an der Ruhr and Essen to the Ennepe-Ruhr district and Hagen. A positive cluster of cities makes up the heart of the region: Oberhausen, Bottrop, Gelsenkirchen, Bochum and Dortmund.

Up to the end of the 18th century the Ruhr was primarily farming country with a population of around 300,000. The largest towns were Duisburg and Dortmund with over 5,000 inhabitants. Places like Gelsenkirchen and Herne were mere villages with a populace of just a few hundred.

In c. 1000 people began mining for coal in the Ruhr Basin. In the mountains of the Ruhr the seams run almost to the surface, meaning early pitmen didn't have to dig particularly deep to find hard coal. In other places moles were used to pinpoint possible seams; where there were black molehills, there was coal.

Coal was mostly used in smithies, with it only occasionally serving as fuel. Scattered ironworks, such as the St Antony in Oberhausen-Osterfeld, founded in 1758, and what was to become the Gutehoffnungshütte in Oberhausen-Sterkrade, opened in 1782, formed the nucleus of the later mining industry.

The advance of technology

Systematic mining of Ruhr coal began at the beginning of the 19th century. In 1793 the first steam engine was put into operation in the Aachen mining district to pump water out of the pit. This made it possible to dig for seams at greater depths. Technological advance accelerated the industrialisation of the area. Within the space of a few years over 220 mines were opened, with the number rising to almost 300 by 1850. Coal was used to make coke needed in the blast furnaces to produce pig iron and steel. In 1808 brothers Haniel and Heinrich Huyssen acquired what was later known as the Gutehoffnungshütte; during the 20th century this grew into the biggest mechanical engineering company in Europe and what is now MAN AG. In 1811 Friedrich Krupp set up a crucible steel works. The increasing demand for manpower encouraged many to move to the Ruhr from the surrounding rural districts and also from further afield, especially in the second half of the 19th century. In their number were many working immigrants from the eastern provinces of Prussia who spoke Polish and saw themselves as Poles. 536,000 people lived in the Ruhr in 1871; by 1910 this figure had risen to three million. Half a million were of Polish origin. These Ruhr Poles were completely assimilated; today just their Polish surnames remain, many of them now Germanised.

For one hundred years mining dominated the Ruhr Basin; Germany is still the second most important manufacturer of steel in Europe after Russia. Yet the region has changed; the coal dust has gone from the faces here. A mere six mines employing less than 30,000 workers have survived, plus three of what were originally over a hundred coking plants and just six blast furnaces (in 1968 there were still eighty). The air and the water are, however, clean again, with nature reserves and industrial monuments attracting crowds of fascinated visitors where their ancestors once toiled the land underground.

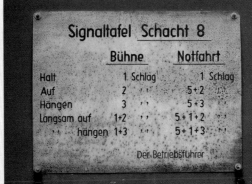

Left:
Signal board outside mine shaft 8 at the Zeche Zollverein in Essen.

Above:
The disused Zeche Zollern II/IV colliery in Dortmund-Bövinghausen is worth a visit for its remarkable Jugendstil architecture. It also has a restaurant that caters for hungry visitors!

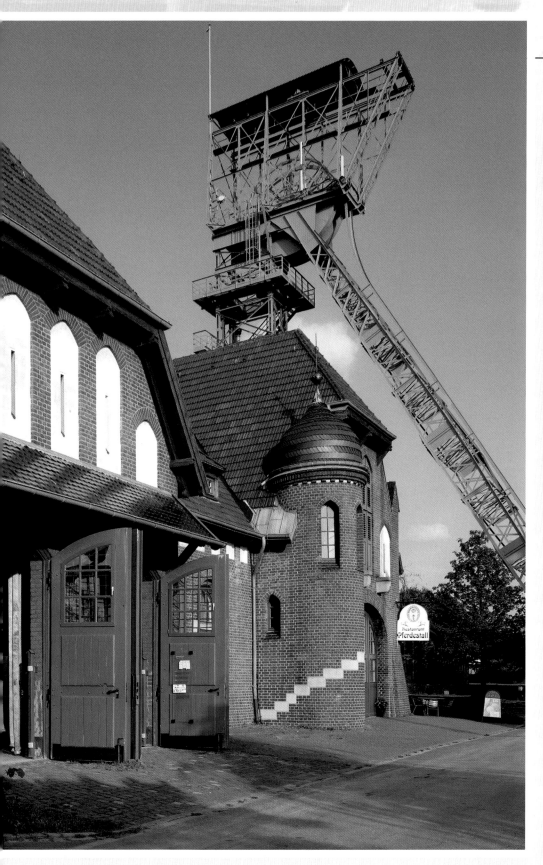

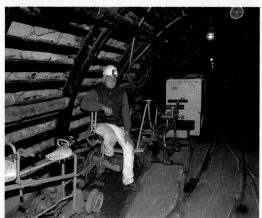

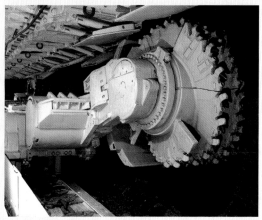

Pictures right, from top to bottom: The exhibits at the Schloss Rheydt museum trace the history of textiles manufacture in Mönchengladbach.

The museum also has a textiles machines depot which is open to the public. The photo shows a machine used to print fabric.

At the German museum of mining in Bochum you can go down up to 22 m / 72 ft in an excavated mine.

The techniques of hard coal and iron ore mining are demonstrated in the visitor's mine along 2.5 km / 1½ miles of mine shaft.

Casino Hohensyburg near the Hohensyburg in Dortmund has the biggest turnover of all the casinos in Germany.

Right:
One of the many kiosks licensed to sell alcohol that were to be found outside the gates of the mines and factories, here in Dortmund.

Far right:
Garden in Gelsenkirchen. As the shed proudly proclaims, here people support their local football team: Schalke 04!

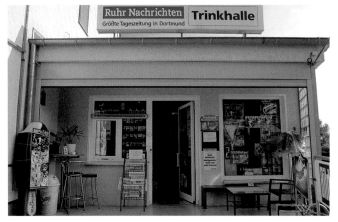

Right:
Busy shoppers at the Hansa Carré in the pedestrian zone in Dortmund.

Far right:
There are about 18,000 Trinkhallen left in the Ruhr, the kiosks typical of the region. This is where people can buy their newspapers, hand in their lottery tickets and top up their mobile phones.

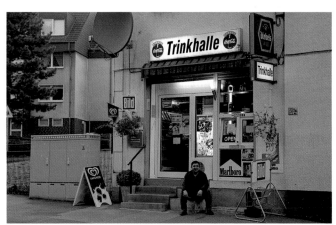

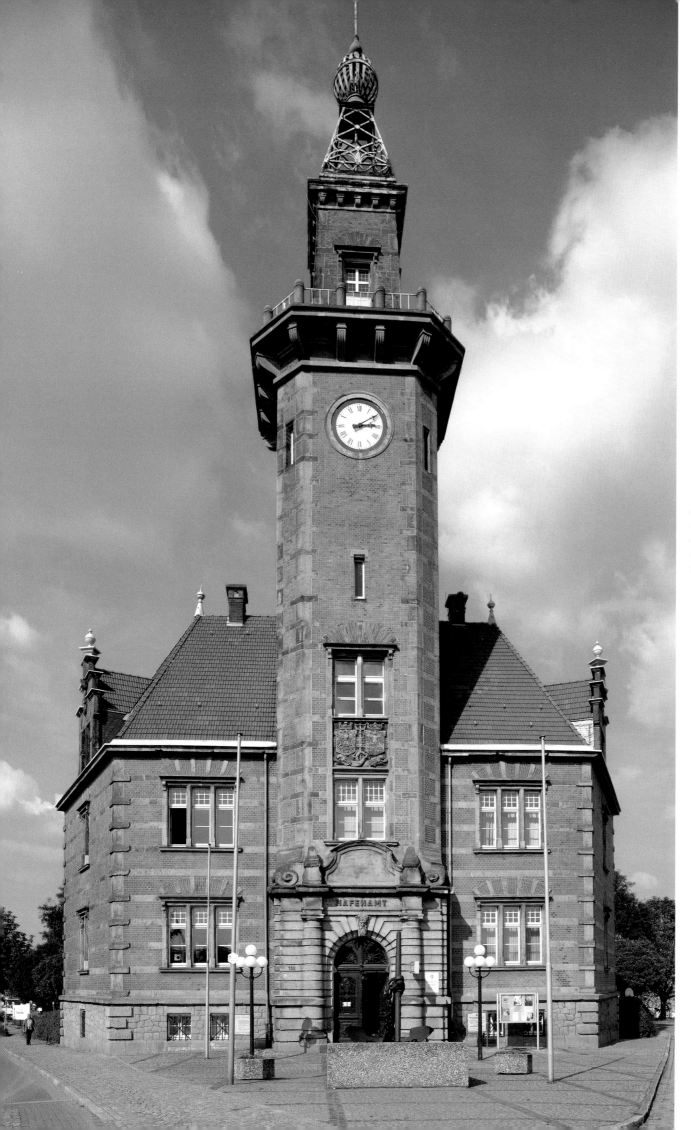

The Altes Hafenamt in Dortmund was built in 1898 in neo- Renaissance in what was then the new harbour in Dortmund. The tower is 38 m / 125 ft high.

85

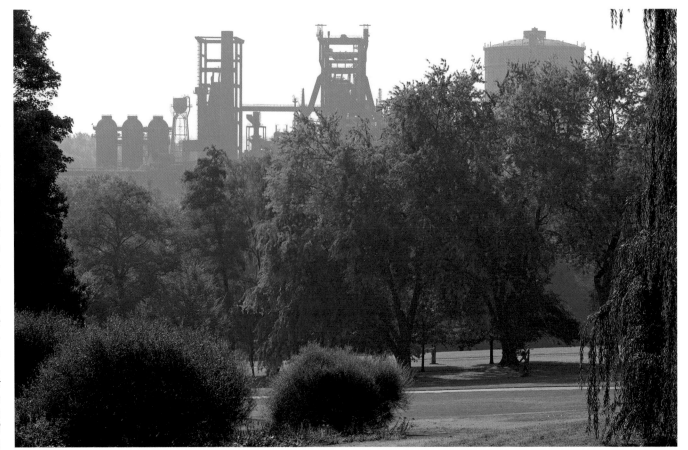

Right:
Westfalenpark Dortmund, opened in 1959 for the first of three national German garden shows held here. In the background is the old blast furnace plant Phoenix-West and the Hoesch gasometer, 77 m / 253 ft tall.

Below:
Dusk in the Ruhr Valley near Witten. In the foreground is the Hohenstein hydroelectric power station, built in the Expressionist style on an island in the river in 1922–25. It was classified as a historical monument in 1987.

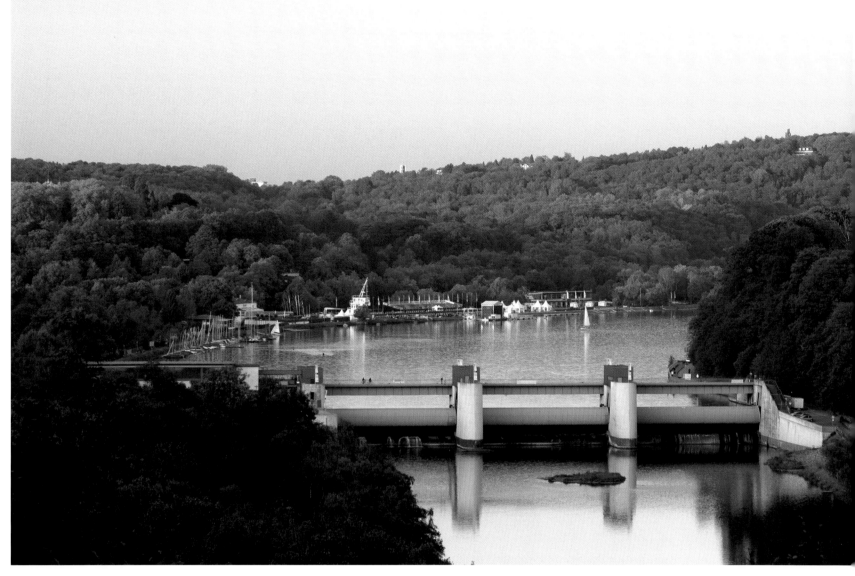

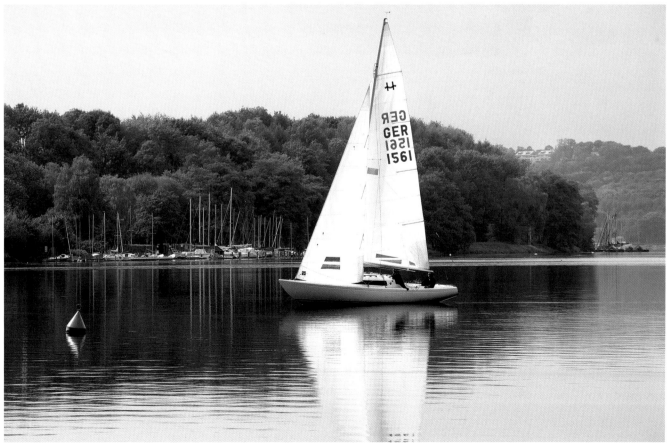

Above:
The Baldeneysee in the south of Essen is the largest of the six Ruhr reservoirs. About 8 km / 5 miles long, it's used to make electricity, as a recreation area and for water sports.

Left:
Sailing on the Baldeneysee which has its own yachting harbour. In summer the boats of the Weiße Flotte also regularly traverse the lake, once used as a deposit for suspended matter.

From Münsterland to Siegerland – Westphalia

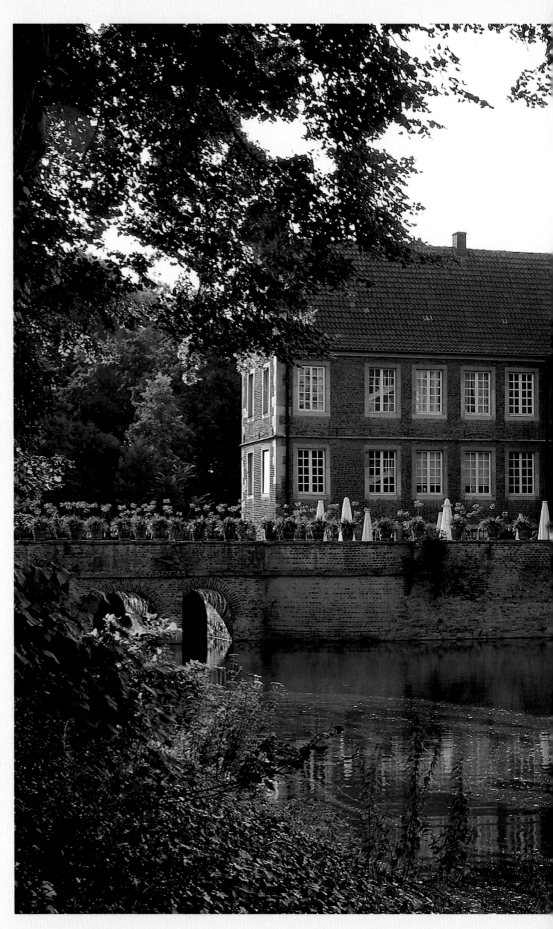

Burg Hülshoff is a moated castle in the Münsterland. It has been the ancestral home of the Droste zu Hülshoff family since 1417 and is where poet Annette von Droste-Hülshoff was born.

With its natural landscaping and over 4,500 kilometres (ca. 2,800 miles) of signposted cycle tracks, flat Münsterland in the North German Plains is sheer heaven for cyclists. At its centre lies Münster, the old capital of what used to be the Prussian province of Westphalia. Its main attraction is the old town with its many churches and town hall where in 1648 the terms of the Peace of Westphalia were exchanged. Local history can be explored further at the Mühlenhof open-air museum in Sentrup.

The northeast of Westphalia is dominated by the wooded ridge of the Teutoburg Forest where in 9 AD the battle fought by Publius Quinctilius Varus is thought to have taken place. A monument near Detmold honours the victor, Cherusci chieftain Arminius or Hermann the German. Detmold was the seat of the princes of Lippe from 1468 to 1918 and subsequently the capital of the free state of Lippe until 1947. The residential palace built in the style of the Weser Renaissance is open to the public.

The city of Paderborn is famous for its 13th-century cathedral with its window of the three hares. The Heinz Nixdorf MuseumsForum looks back on 5,000 years of communication techniques and information technology.

The Rothaargebirge runs through the Siegerland and Sauerland in the south of Westphalia, the highest points of which are the Langenberg (843 metres / 2,765 feet) and the Kahler Asten (842 metres / 2,763 feet). The rather sparsely populated Sauerland is characterised by its spruce forest and dams. The name "Sauerland" probably comes from "südliches Land" or the south country. The international winter sports venue of Winterberg can be found in the district of the Hochsauerland. The word "Siegerland" is derived from the River Sieg which also lends its name to the city of Siegen.

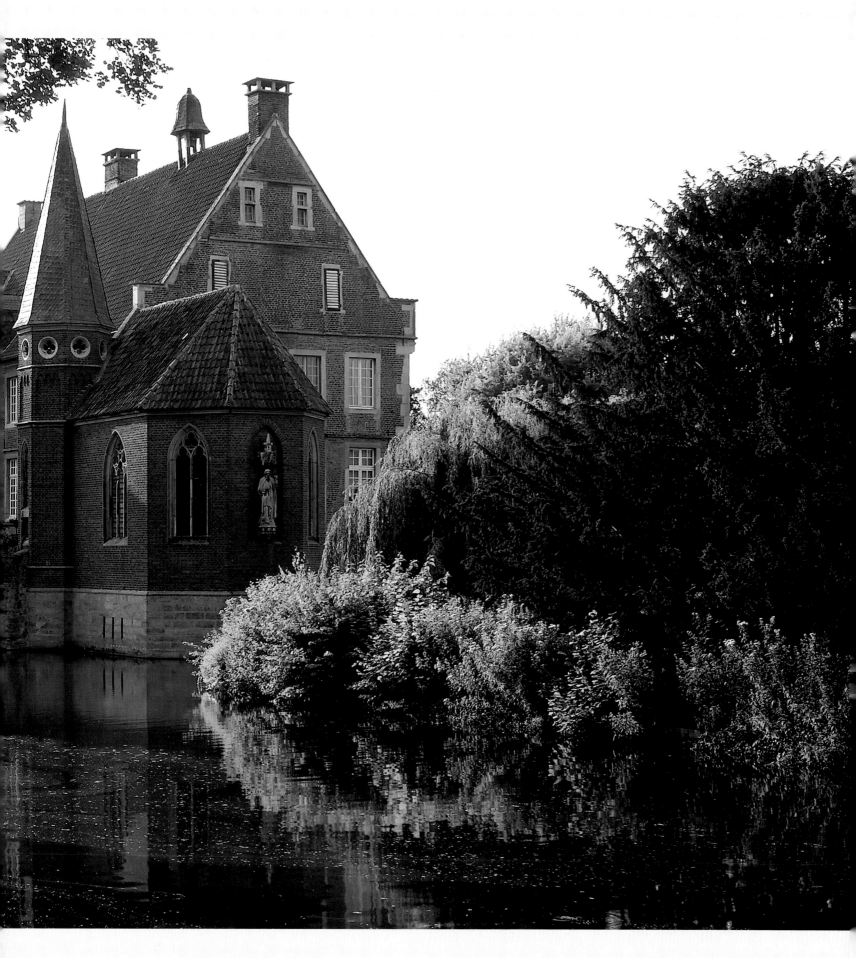

Below:
Alter Flecken, the half-
timbered centre of Freuden-
berg in the Siegerland, is
a historical monument of
international importance,
as there is no town centre
quite like it anywhere else
in the world.

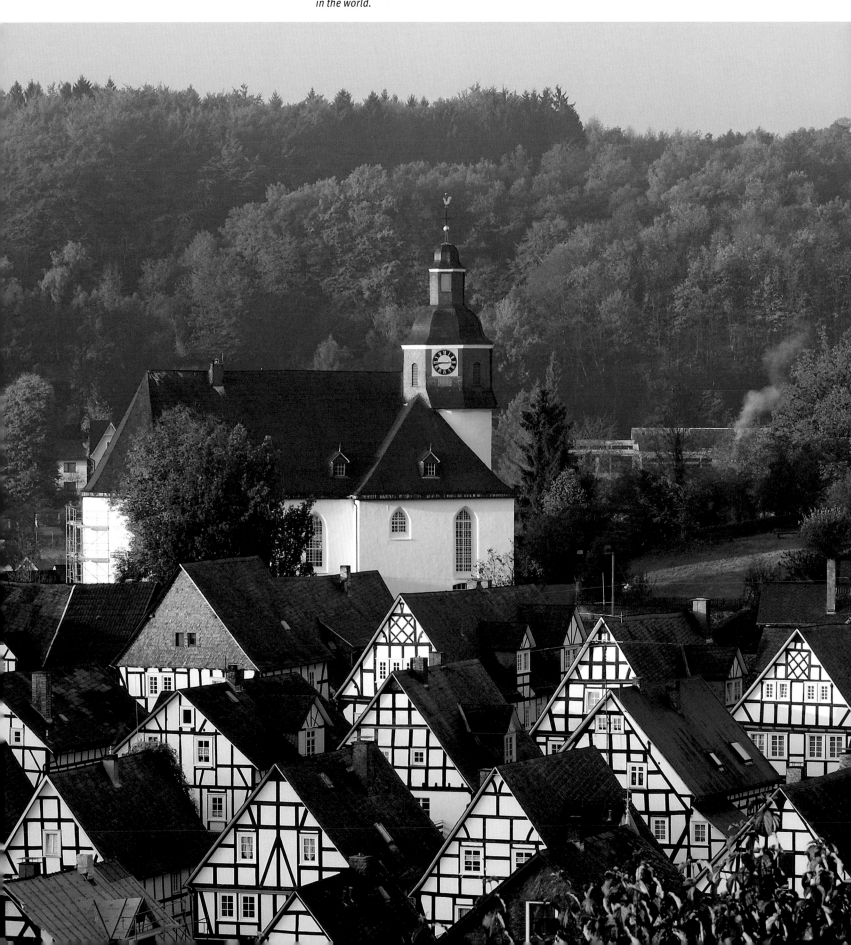

Top right:
This antiques shop is perfectly situated amongst the historic half-timbered houses of Alter Flecken.

Centre right:
Pfarrweiher in Freuden-berg-Oberholzklau with the old 17th-century bakehouse. Only the local priest and teacher were allowed to use it; the villagers had their own.

Bottom right:
This historic building is dedicated to up-to-the-minute works of art (painting, photography, video and various installations) at the museum of contemporary art in Siegen.

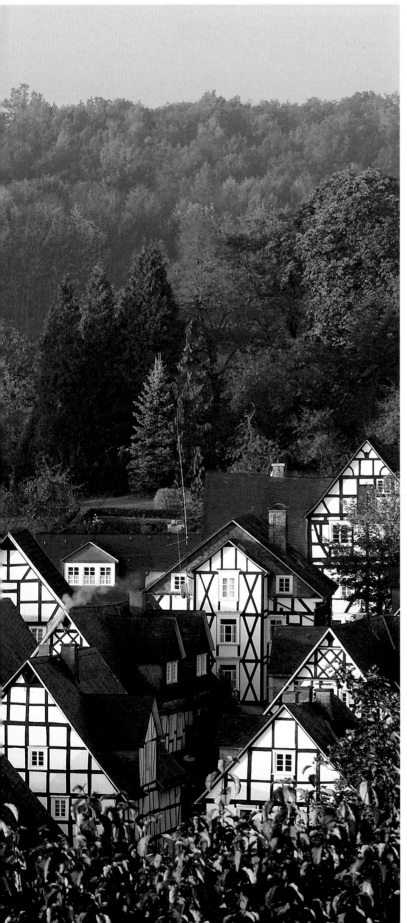

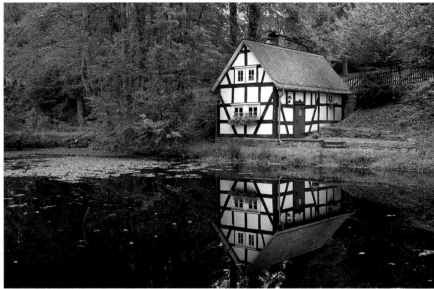

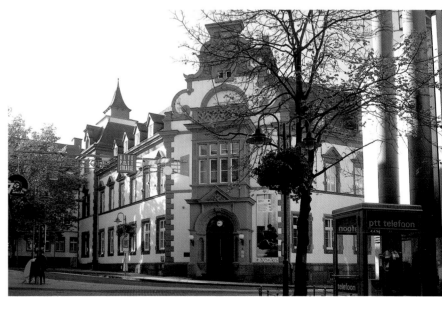

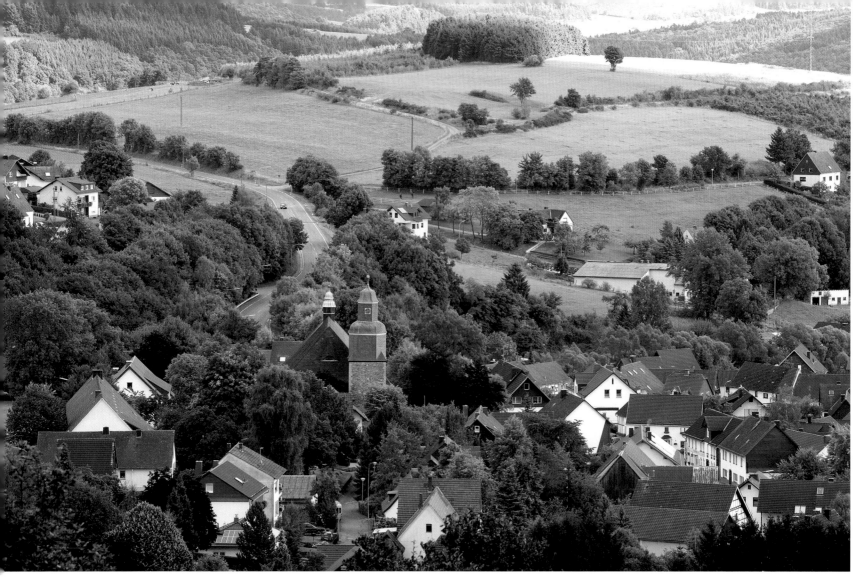

Above:
Hesborn is in the Hoch-sauerlandkreis north of Hallenberg in the foothills of the Rothaargebirge. The village can be seen from the nearby lookout tower on the Bollerberg, 758 m / 2,487 ft high.

Right:
Half-timbered house in Kirchhundem on the Rothaarsteig in the Sauerland. The parish is in the national parks of the Ebbegebirge and Rothaargebirge.

Above:
Bad Berleburg is surrounded by the hills of the Rothaargebirge. The castle on the mound above the town was built between the 13th and 18th centuries and is now a museum.

Right:
View of Arnsberg in the Hochsauerlandkreis. The old town is encircled by a loop in the River Ruhr, its local landmark the belfry (left) that belongs to the parish church of St George's.

Left:
Winterberg is a small town in the Hochsauerlandkreis famous for its winter sports both within and beyond the region.

Below:
Bad Laasphe in the Upper Lahn Valley is a Kneipp spa and climatic health resort. Its old town has been almost completely preserved, with the distinctive steeple of the town church marking its centre.

Above:
October day on the Lister Reservoir between Attendorn, Drolshagen and Meinerzhagen in the south of the Sauerland. The dam was built between 1908 and 1912.

Right:
Möhnesee is on the northwestern edge of the Arnsberger Wald national park. It is one of the biggest artificial lakes in North Rhein-Westphalia. The MS Möhnesee catamaran can carry up to 600 passengers.

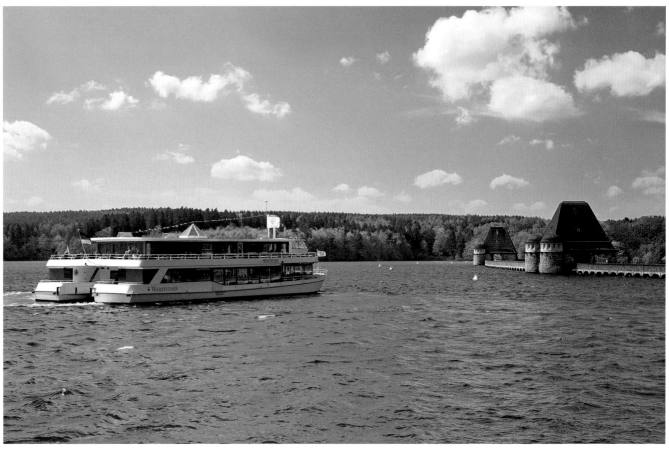

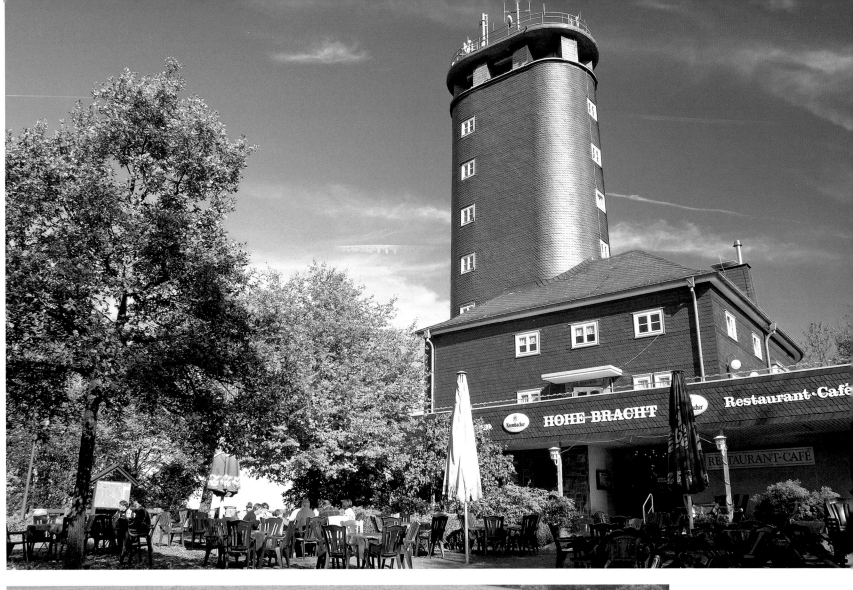

Above:
The Hohe Bracht is a large hill in the Olpe district, 588 m / 1,929 ft above sea level. The observation tower, complete with a restaurant and clad in slate, was erected in 1929/30.

Left:
Farm in Wenholthausen in the heart of the Sauerland. The little village southwest of Meschede has been used as a summer holiday resort for over a hundred years.

Sweet gingerbread, braised beef and sugar beet syrup – culinary NRW

There is also plenty to discover in the region of food in North Rhine-Westphalia, from sweet gingerbread to braised beef to sugar beet syrup. The traditional fare of the Rhineland and Westphalia is largely based on what can be produced locally and is both simple and filling. One such dish in circulation since the 18th century is *Himmel und Erde* or heaven and earth, with apples from the tree the celestial component and potatoes from the ground symbolising the fruit of the earth. Depending on the region these are mashed together or, especially in the Rhineland, cubed and boiled. *Himmel und Erde* is often served with fried black pudding or liver sausage, fried onions and bacon.

Potatoes are also used to make fritters (*Reibekuchen* or *Kartoffelpuffer*) that are eaten with apple puree. One variation from the Bergisches Land is *Pillekuchen*, where potatoes cut or grated into thin strips are cooked in pancake batter. *Reibekuchen* go well with a serving of pear, apple or sugar beet as prepared in the region of Bonn. We're not talking about a serving of the fruit or vegetable here but of a sweet brown syrup made from the thickened juice of the above.

In Westphalia *Schinkenbegräbnis* (literally: a "ham burial") is a popular pasta bake containing pieces of ham, cheese and cream. *Spanisch Fricco* is a stew consisting of meat, potatoes and onions. It possibly dates back to the 16th century when the Benelux countries were under Spanish rule.

Panhas or *Röstpfanne* is a traditional meal eaten after the pigs have been slaughtered and is a carnivorous combination of mince, liver sausage, black pudding and ground buckwheat. The cold mixture is cut into slices and fried. Westphalia's *Stippgrütze*, also known as *Wurstebrei*, is similar; now a speciality, this concoction of scraps of meat, offal, barley groats and fat was once a staple of the poor.

The epitome of Rhenish cuisine

Sauerbraten or braised beef is one of the absolute highlights of Rhenish cuisine. Traditionally it was made of horsemeat; now it's usually a cut of beef. The meat is marinated for several days in vinegar, wine, vegetables, herbs and spices. Sultanas, sugar beet syrup and even bits of gingerbread or *Aachener Printen* are added to sweeten the sauce yet still leave it slightly sour. Although in season at Christmastime, the latter ingredient with its pieces of candied sugar is popular all year round.

Besides the main meals there are also hearty snacks to be had. A slice of *Flönz* or black pudding is a favourite, served with a good dollop of mustard, with the hot variety from Düsseldorf quite capable of bringing tears to your eyes. Add to this a roll of rye bread and a few onion rings and your *Kölscher Kaviar* is ready to eat!

Cologne is also home to the *Halve Hahn* – which is not the half a chicken you might expect. The uninitiated will be surprised to find a rye roll with butter, gouda, gherkins and mustard on their plate. There are several explanations as to why it's misleadingly called a *Halve Hahn*. One version has a financially disadvantaged bridegroom ordering his wedding guests cheese rolls instead of chicken. Another claims that a guest presented with a whole roll only wanted half a one (in local slang "ne halve han"), hence "Halve Hahn".

In the Bergisches Land coffee is served with popular Bergisch waffles. Another favourite snack is *Kottenbutter*, bread and butter with smoked sausage, onion rings and mustard. The posh version, also coveted in the Sauerland and Siegerland, is *Krüstchen*, a schnitzel and fried egg sandwich. To finish, we should also mention Westphalian ham on the bone or *Knochenschinken*, famous for its good quality throughout the entire nation. This tastes best served on a slice of pumpernickel, Westphalia's famous black bread.

The number one drink in NRW is beer. Cologne and Düsseldorf are in constant competition as to who has the best: *Kölsch* or *Altbier*, both of them top fermented. Westphalia prefers bottom-fermented pilsner. In the south of the Rhineland there are wine taverns selling Rhine wine. As a digestive both *Korn* or *Steinhäger*, a juniper schnapps from Steinhagen, are popular. Cheers!

Left:
The Gaffel Becker & Co microbrewery in Cologne fills two thirds of their Kölsch in barrels.

Above:
Making gingerbread in Aachen at the Klein bakery. The trade name Aachener Printen is legally protected – and the recipe a carefully guarded secret!

Pictures right, from top to bottom: These splendid hocks of Westphalian ham are being left to mature at Schinken Hartmann in the Münsterland.

A typical Westphalian platter, served in the Altes Backhaus hotel restaurant in Arnsberg.

The speciality of the Diebels brewery in Issum on the Lower Rhine is top-fermented Altbier.

This hearty snack, served in a frying pan, consists of fried black pudding and liver sausage, slices of apple and fried potatoes.

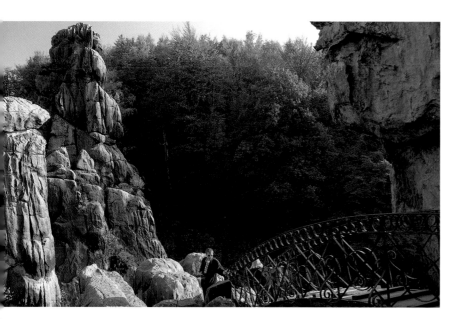

Left:
This natural monument in the Teutoburg Forest is known as the Externsteine. It's not clear where the name comes from; it certainly has nothing to do with "external". The sandstone rock formation is several hundred metres long and up to 48 m / 157 ft high.

Centre left:
At the pond beneath the Externsteine there is a very well preserved tomb carved into the rock, said to have been made by monks from Paderborn.

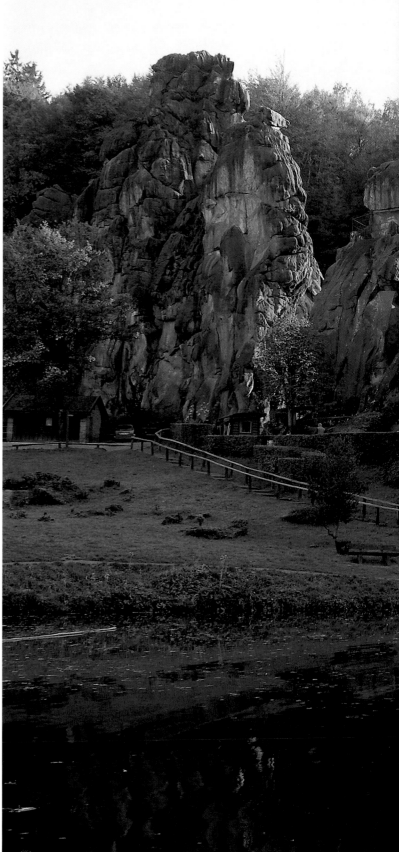

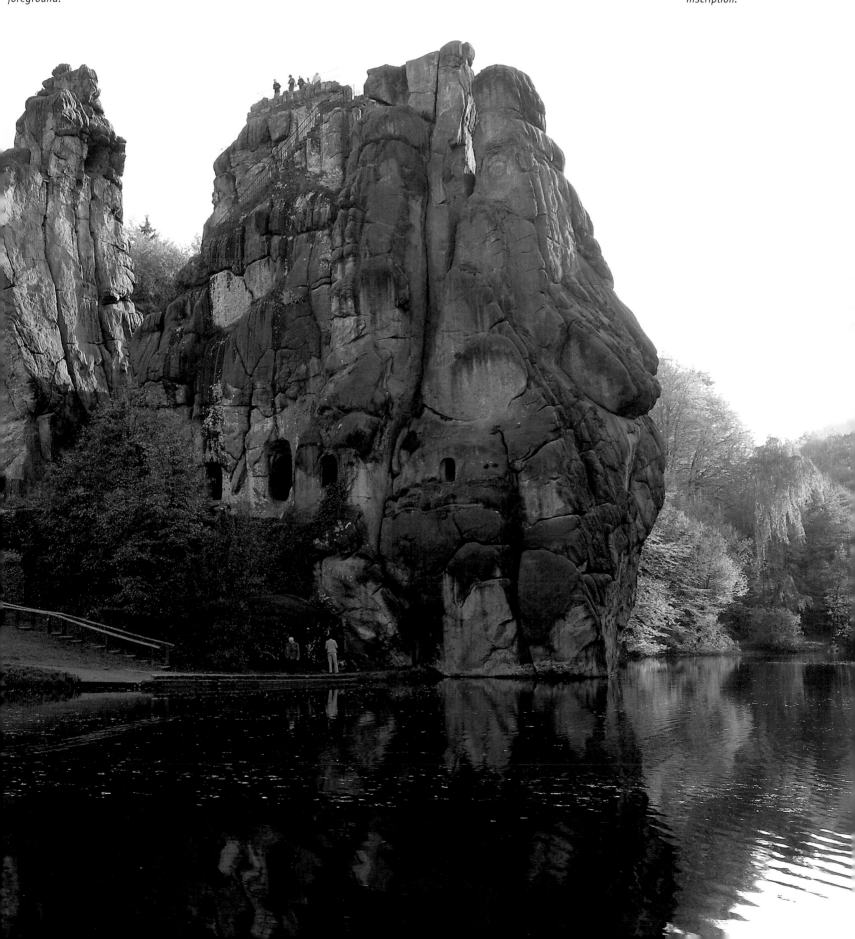

Bottom left:
The Teutoburg Forest decked out in its October colours, with the mysterious shadows of the Externsteine in the foreground.

Below:
Many man-made caves have been cut into the rocks here, including this chapel, consecrated in 1115 according to the inscription.

Above:
Höxter is in the very east of North Rhein-Westphalia in the upper valley of the Weser. Its medieval centre is extremely well preserved. The old deanery on the market place from 1561 boasts over 60 carved and painted half rosettes, all of them different.

Right:
The town centre of Schieder-Schwalenberg also has many half-timbered buildings, the oldest of which date back to the 16th century.

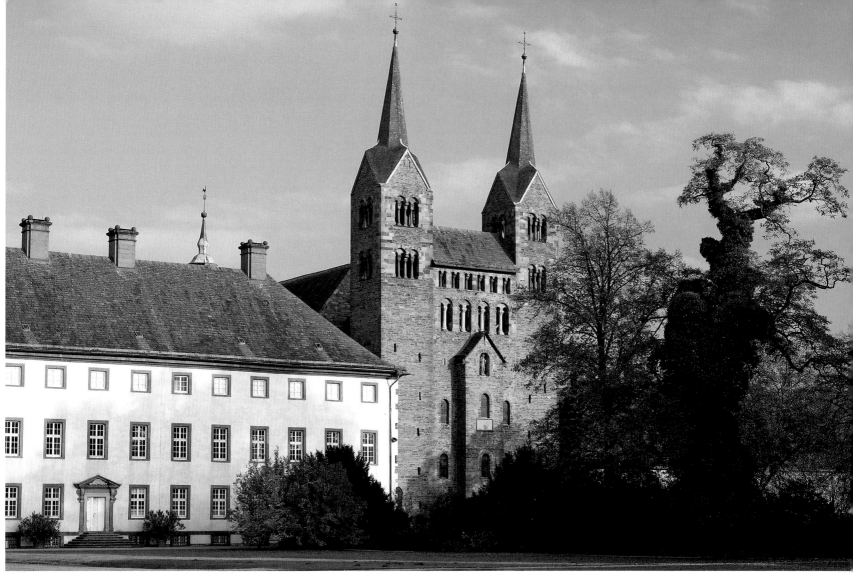

Above:
The former Benedictine monastery of Corvey near Höxter was one of the chief monasteries of the Carolingian period. Its westwork was built between 873 and 885 and modelled on the one flanking the Palatine chapel in Aachen.

Left:
About 20 km / 65 miles east of Detmold is Blomberg. The town hall on the market square was put up in 1587. The town survived the Second World War with very little damage.

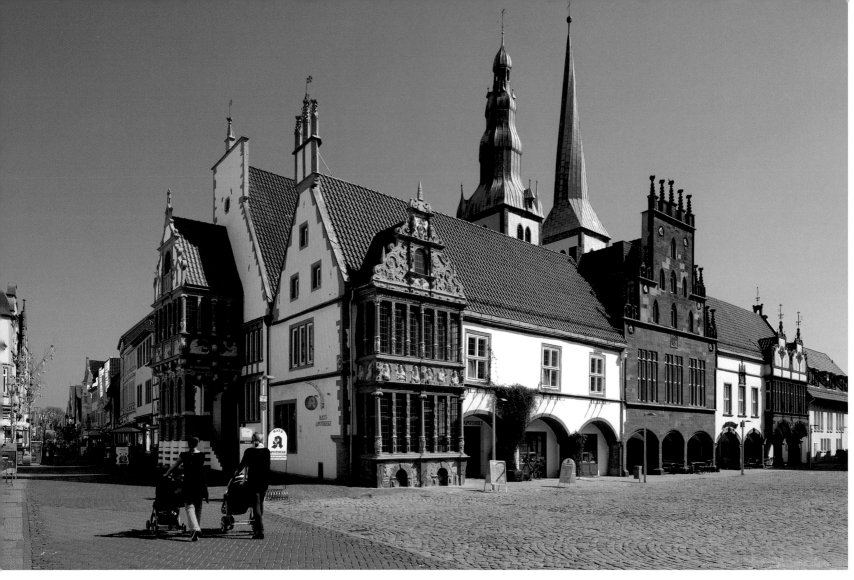

Above:
The Rathaus in Lemgo in the Lippe district was once a Gothic market hall that evolved into the town hall between the 14th and 17th centuries. Behind it is the Lutheran parish church of St Nicholas, its two different towers the local landmark.

Right:
In 1986 Schloss Brake in Lemgo became the museum of the Weser Renaissance devoted to the art and culture of the 16th and early 17th centuries in north and west Germany.

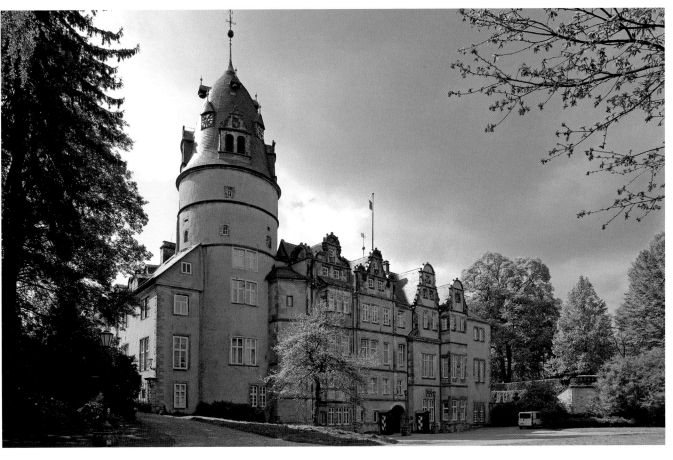

Left:
The residential palace in the city centre of Detmold is also a product of the Weser Renaissance. There are guided tours of its sumptuous state rooms.

Below:
This half-timbered edifice in Rietberg in the Güters-loh district was first built in c. 1800. In 1977 it was completely demolished and then rebuilt in its original form. The 'people' beneath the steps are statues by Witten artist Christel Lechner, the group entitled "Augenblicke" or moments.

This monument on Porta Westfalica, opened in 1896, was erected in honour of Emperor William I of Germany on the eastern flanks of the Wittekindsberg high up above the River Weser. The architect was Bruno Schmitz; the statue of the kaiser was fashioned by sculptor Kaspar von Zumbusch.

View from the Wittekindsberg out across the valley of the Weser towards Vlotho.

Chamber lock on the Mittellandkanal in Minden, the second largest waterway junction in Europe. Here the Mittellandkanal is routed across the River Weser.

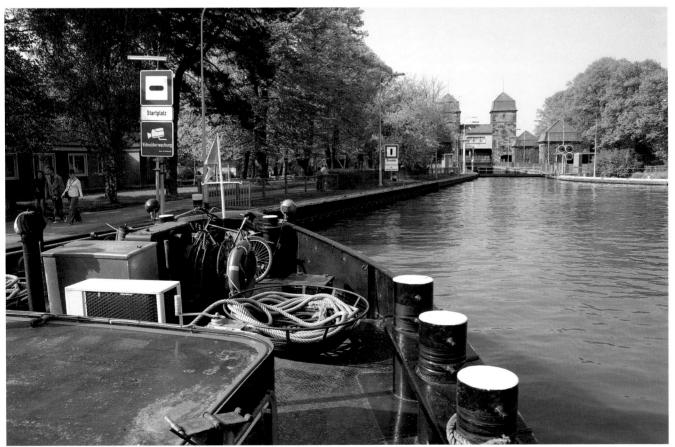

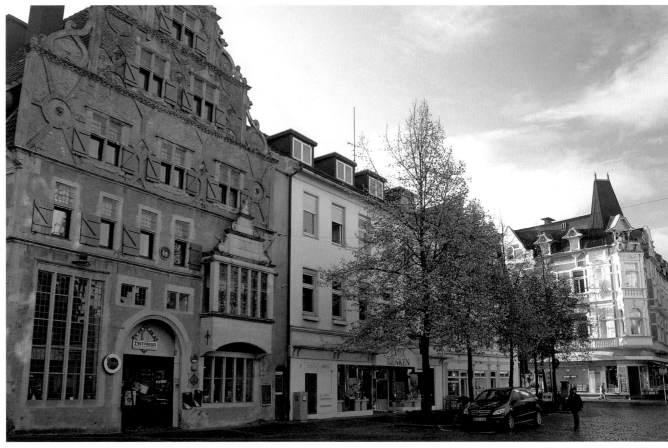

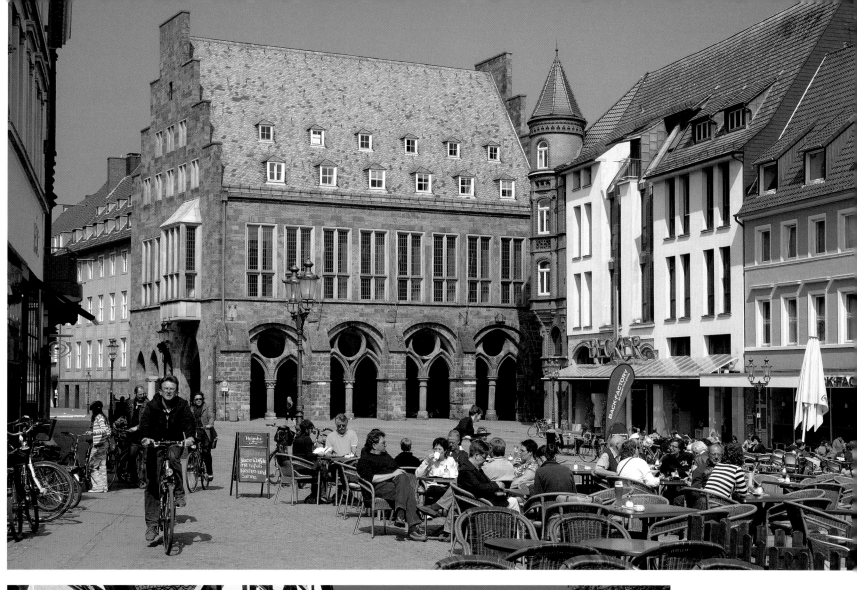

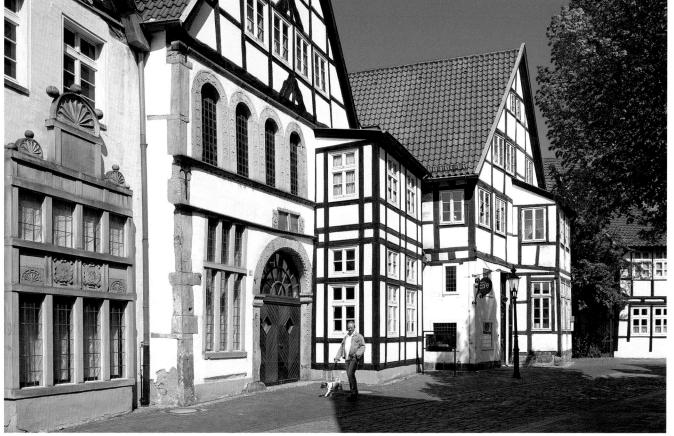

Above:
The market place of the
former diocesan town
of Minden, now over
1,200 years old. The Altes
Rathaus has a wonderful
Gothic arcade from the
13th century.

Left:
Ritterstraße in Minden is
the setting for the town's
"mile of museums",
a collection of old town
houses from the 16th and
17th centuries.

Above:
Farm with fields of rape between Vlotho and Röntorf in East Westphalia which with its fertile soil was cleared of forest and given over to farming early on in its history.

Right:
Half-timbering near Herford, framed by blossoming fruit trees. The area is rural here, with fields and meadows in abundance.

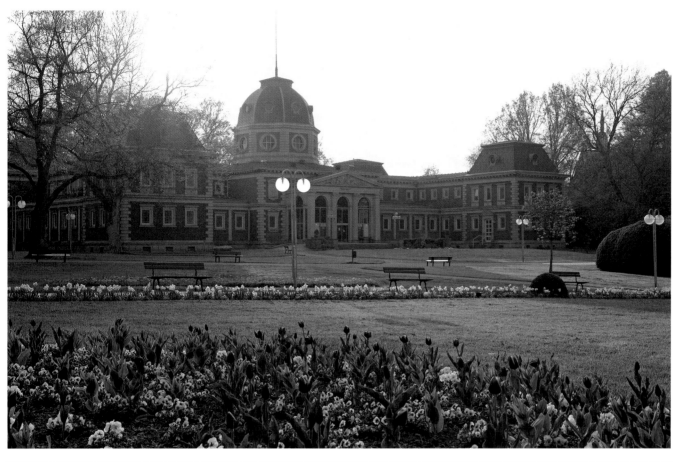

Left:
Bad Oeynhausen is on the southern edge of the Wiehengebirge. The thermal salt springs discovered in 1845 soon attracted crowned heads and various other illustrious guests to the town. Many a splendid Historicist building followed, including Badehaus II in 1885, shown here.

Below:
The salt springs of Bad Salzuflen began helping the town to riches and prosperity in the late Middle Ages. The centre of town still has many half-timbered houses from the 16th and 17th centuries.

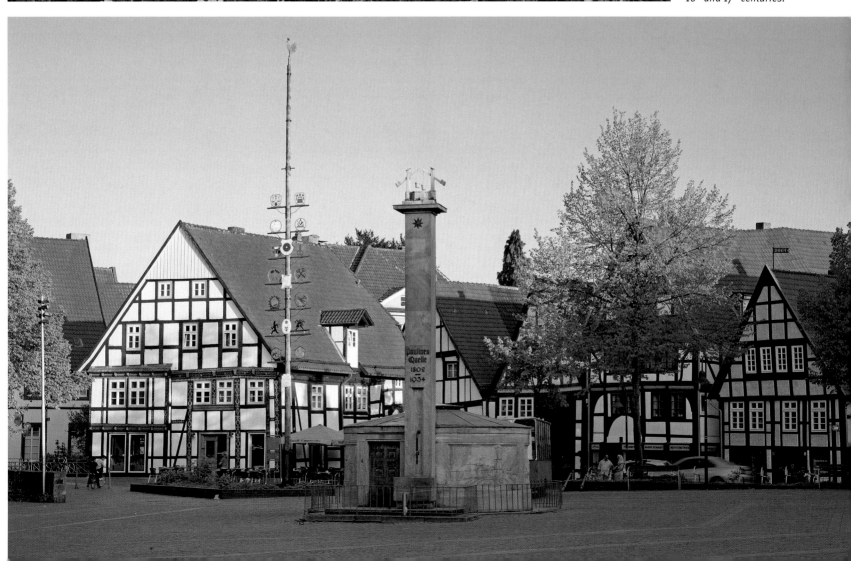

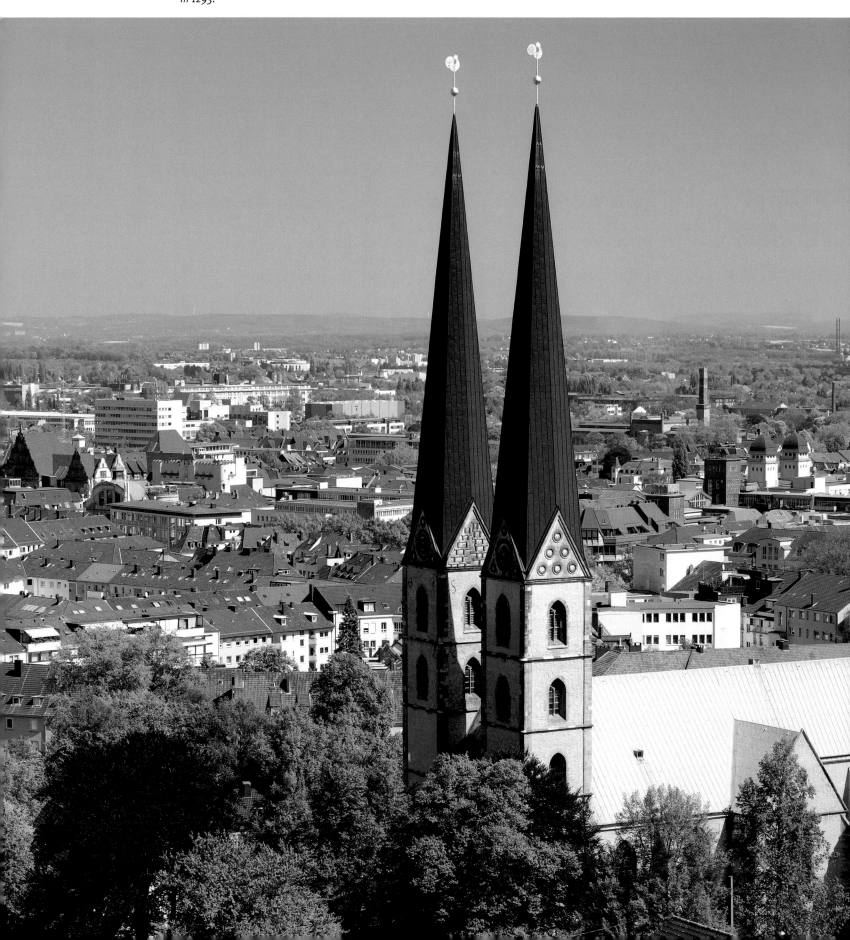

Below:
View from the Sparrenburg of the middle of Bielefeld. The biggest church in the city is the Gothic Marien-kirche in the Neustadt, on which building was begin in 1293.

Top right:
The Altes Rathaus in Bielefeld was built in the Historicist style and opened in 1904. The city theatre from the same year is next door.

Centre right:
The Sparrenburg is a restored fortress in the Bielefeld city district of Mitte. Most of the parts we can see today date back to the 16th and 19th centuries.

Bottom right:
The Alter Markt with its charming Renaissance gables forms the historical centre of Old Bielefeld.

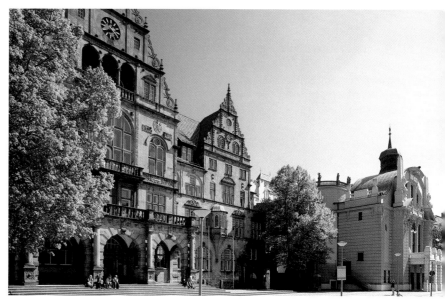

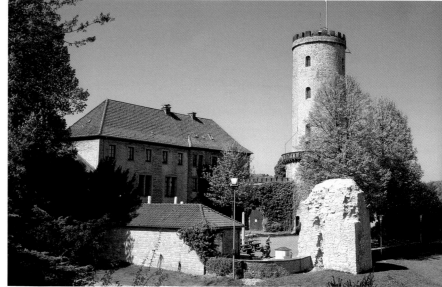

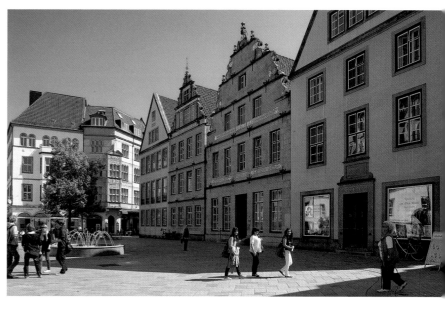

113

FROM THE ROMANESQUE TO THE PRESENT DAY – ARCHITECTURE IN NRW

As one song by Cologne band Bläck Fööss has it, "All that's missing is the view of the cathedral". Benidorm may be nice, they sing, and you can hear Colognian all over the place, but, well, the cathedral's not there ... For a Rhinelander, gazing upon Cologne Cathedral is as close to an overdose of *Heimatgefühl* as you can get. Made a UNESCO World Heritage Site in 1996, the Dom is the third highest in the world and the most popular tourist site in Germany. For the six million visitors a year from all over the globe, visiting this sacred site is one of the highlights of their trip to Germany. The first church was erected here in the late Roman period. In the year 873 the predecessor to the present cathedral was consecrated. On July 23, 1164, archbishop of Cologne Rainald von Dassel brought the relics of the Three Magi from Milan to Cologne, turning the Carolingian house of worship into a major place of pilgrimage. The church was suddenly too small; a new building was called for.

In 1248 the foundation stone was laid for a new edifice planned by master cathedral builder Gerhard von Rile. Construction spanned several centuries and was interrupted on many occasions. In 1322 the choir was finished. From 1510 onwards, for financial reasons building gradually ceased on the cathedral, fully functional despite its lack of spires and general incompleteness. In the end it was the Prussian (and Protestant!) government who in the mid 19th century strove to get the job done. On October 15, 1880, the cathedral was finally finished according to the original plans.

The nave with its four aisles is 145 metres (476 feet) long and the aisled transept 86 metres (282 feet) wide. The twin spires are around 157 metres (515 feet) tall. At 407,000 cubic metres (over 14 million cubic feet) Cologne Cathedral is the largest Gothic church in the German cultural area.

Prof Barbara Schock-Werner, the present architect responsible for the cathedral, says that "Some of the wounds inflicted during the war have still not healed and at the same time there are repairs to be done caused by the weather and pollution. The cathedral is thus a permanent building site and will hopefully remain so for a long time to come."

A second Rome

The first German monument to be included on the list of UNESCO World Heritage Sites was not the cathedral in Cologne but in Aachen, added in 1978. In c. 800 Emperor Charlemagne nominated Aachen the centre of his Frankish Empire – his second Rome. This is where he erected his main place of residence, his imperial palace or *Pfalz*, with an octagonal chapel that now forms the centre of the present cathedral. When Charlemagne died in 814 he was buried in the church. From 936 to 1531 thirty German kings were crowned here. The church's relics made Aachen an important destination for Christian pilgrims from the Middle Ages on. The cathedral took on its present guise over the course of more than 1,200 years with the addition of the Gothic choir hall in the east, the westwork and several side chapels. North Rhine-Westphalia also has many other important sacred buildings, including the late Gothic Lamberti church in Münster and the cathedrals of Paderborn and Essen.

The most important architectural site in the state capital of Düsseldorf is Schloss Benrath, built at the transition of the Rococo and the neoclassicist period and one of the most beautiful palaces on the Lower Rhine. The Thyssen Haus in the centre of the city, known locally as the *Dreischeibenhaus* or house in three slices, was erected between 1957 and 1960 and at 94 metres (308 feet) in height was long one of the most famous high-rises in Germany. The local government resides in the Stadttor on the Rhine, an office block made of steel and glass put up in the 1990s. The Rheinturm close to it is 241 metres (791 feet) high with a restaurant well over half way up that turns about its own axis within one hour.

The huge Jahrhunderthalle in Bochum was built as an exhibition hall in 1902 and is now used as an unusual festive venue for cultural events. The palaces of Augustusburg and Falkenlust in Brühl and the Zeche Zollverein colliery in Essen are also well worth a visit, the latter featuring pit buildings clearly influenced by the creative minds of the Bauhaus.

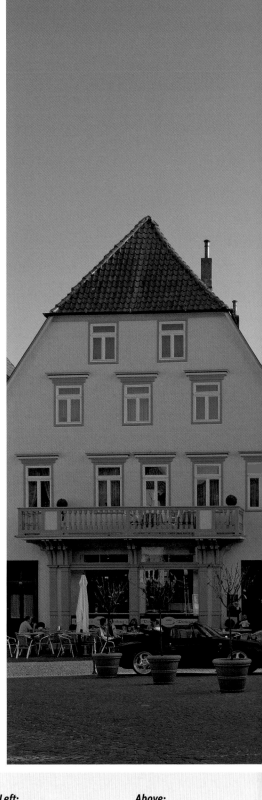

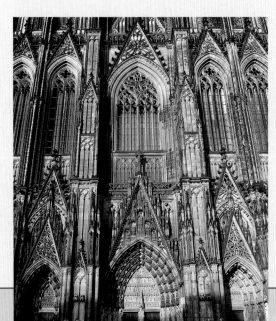

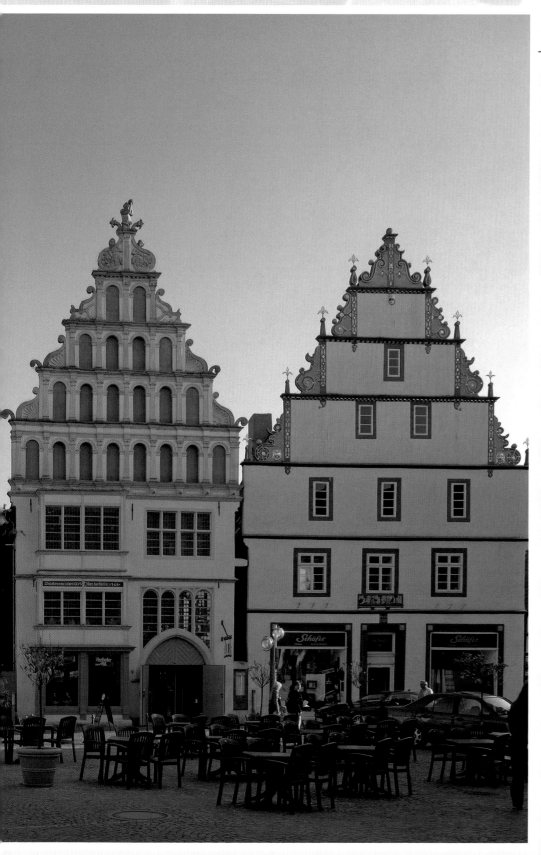

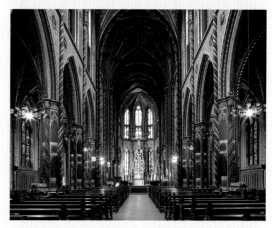

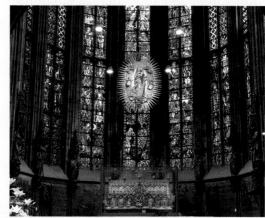

Pictures right, from top to bottom: Artistic brickwork between the timbering on a house in Steinfurt-Burgsteinfurt in the Münsterland.

The Marienbasilika in the pilgrimage town of Kevelaer was built in neo-Gothic between 1858 and 1864.

The apse of Aachen Cathedral. The windows were designed by Aachen artist Walter Benner (1912–2005) when the cathedral was rebuilt in 1949–1951.

Details of the wall cupboard (c. 1536) in the Friedenssaal of the historic town hall on Prinzipalmarkt in Münster. Here, Samson fighting with the lion and Jonas and the whale.

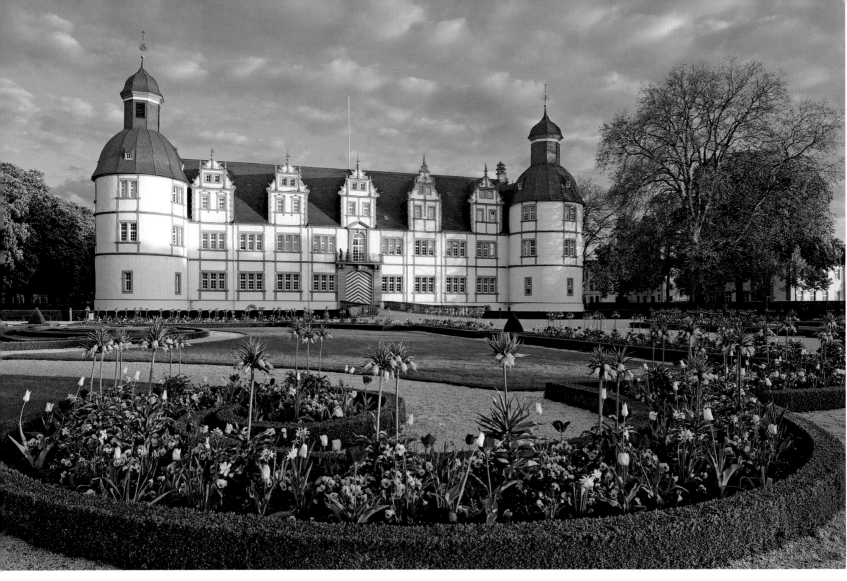

Above:
Schloss Neuhaus in Paderborn is the former residence of the prince-bishops of Paderborn and an important example of Weser Renaissance architecture.

Right:
The Adam-und-Eva-Haus, one of the oldest half-timbered houses in Paderborn, has housed the museum of city history since 1977.

Far right:
Details of the façade: above are the symbols of the four Evangelists, with the expulsion of Adam and Eve from the Garden of Eden depicted below.

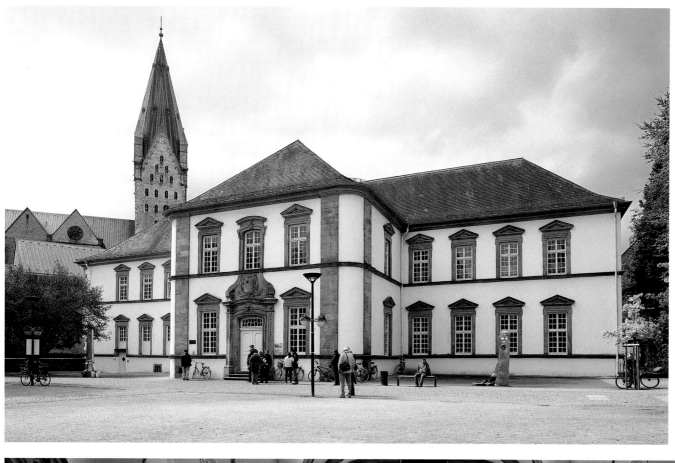

Left:
The old deaconry of the cathedral in Paderborn. The baroque building was constructed from 1676 to 1678 and now holds the city museum. In the background on the left is the cathedral itself.

Below:
What used to be the Jesuit church in Paderborn, now the Marktkirche, was erected between 1682 and 1692. The baroque altar, destroyed during the Second World War, has been carefully reconstructed.

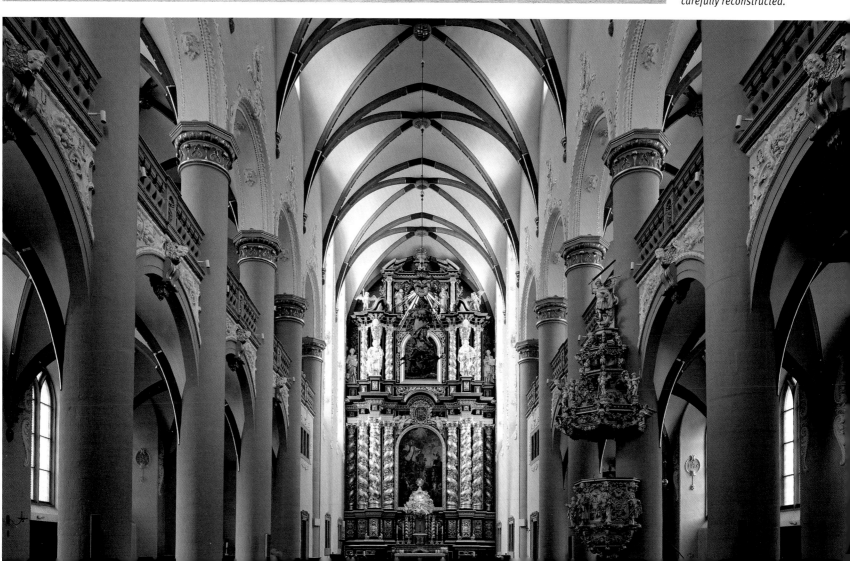

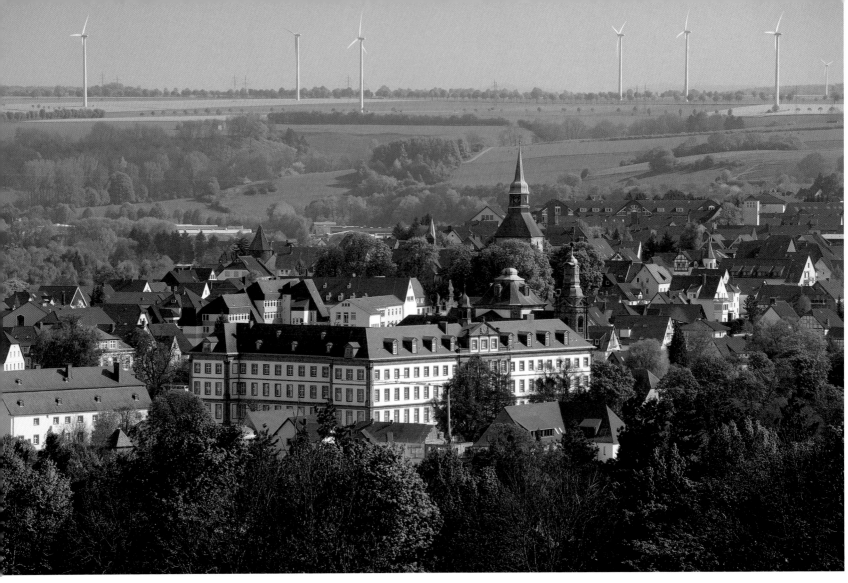

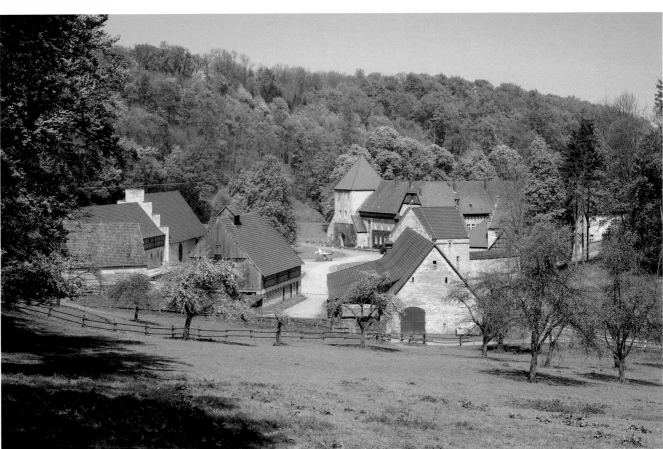

Above:
Büren is in the south of the Paderborn district. In the foreground is the capacious Mauritius-Gymnasium, now a school but originally built as a Jesuit college between 1719 and 1728. Behind it is the steeple of parish church of St Nicolas, at its core Romanesque and early Gothic.

Right:
Böddeken is a settlement to the northeast of Büren where in 836 the oldest monastery belonging by the diocese of Paderborn was established. It was secularised in 1803 and is now a boarding school.

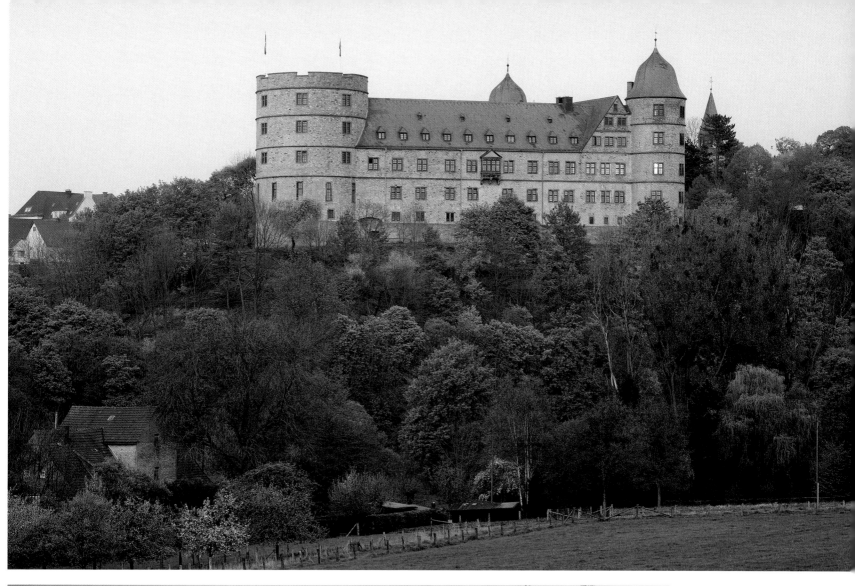

119

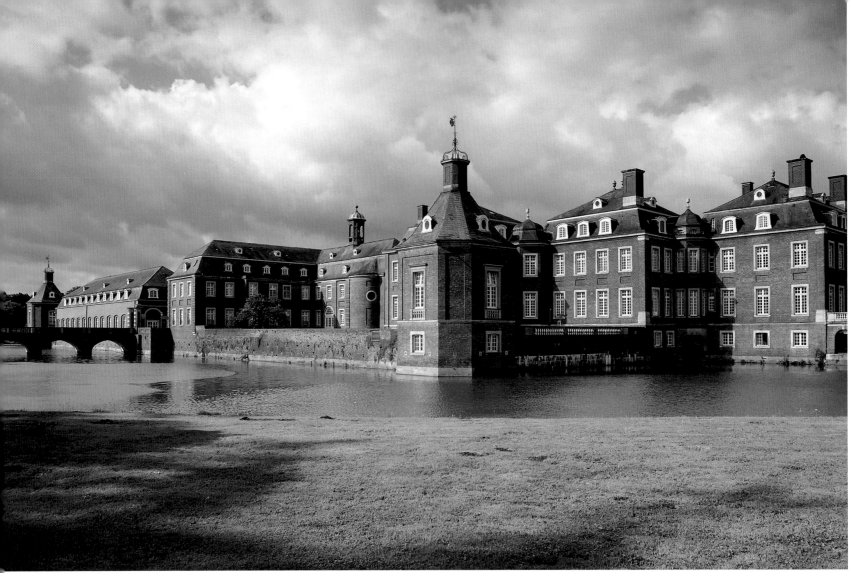

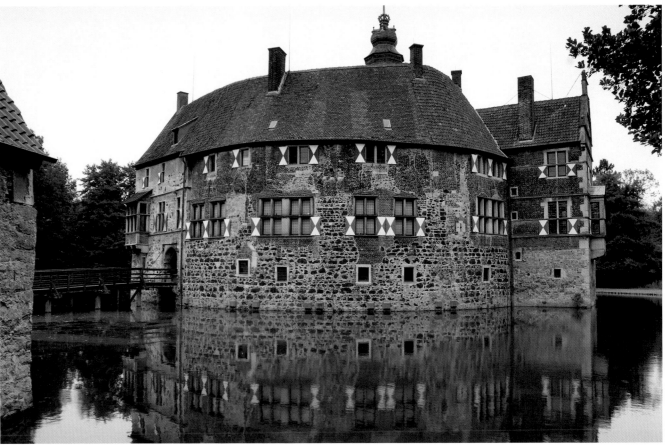

Above:
Schloss Nordkirchen, seen here from the north, was built in red brick between 1703 and 1734 by several master builders, among them Johann Conrad Schlaun. It is the largest moated castle in Westphalia.

Right:
Burg Vischering near Lüdinghausen in the Münsterland was constructed in the year 1271. It burned down in 1521 and was reborn as a fortified residence with added windows and bays. It is now used as an arts centre for the district of Coesfeld, as a museum of the Münsterland and for various exhibitions.

Left:
Raesfeld is in the southwest of the Münsterland and in the Hohe Mark national park. It also has a moated castle; here you can just see the tip of the early baroque southwest tower poking up above the trees.

Below:
Schloss Raesfeld, seen from the west. The castle is now a centre of further education for local craftsmen and women but is also used for cultural events.

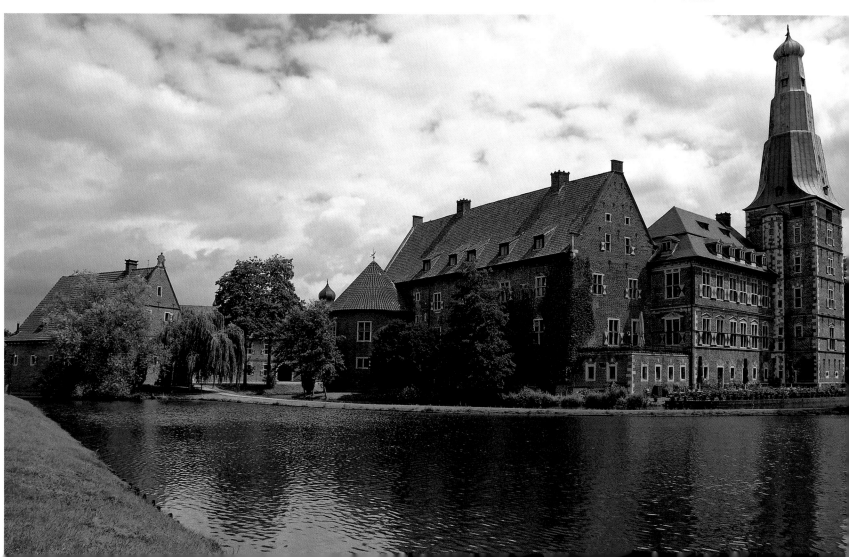

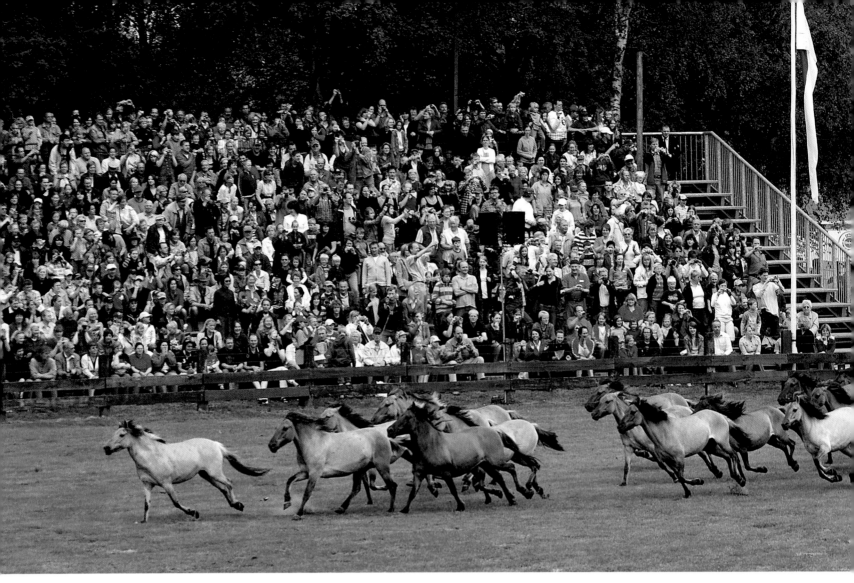

Above:
The only wild horses to be found on the European continent live in Merfelder Bruch west of Dülmen. Each year on the last Saturday in May the young stallions are singled out of the herd at an attraction also popular far beyond the local area.

Right:
There are many other activities on offer besides the actual capture of the horses. The wild stallions of Dülmen are also celebrated in the book "Jan und das Wildpferd" (Jan and the Wold Horse) by writer Heinrich Maria Denneborg (1903–1987).

Left:
*Every year at the end of
September / beginning of
October the North Rhein-
Westphalian stud farm
of Warendorf stages its
traditional stud parades.
Coach and trap drivers
also get to show off their
skills.*

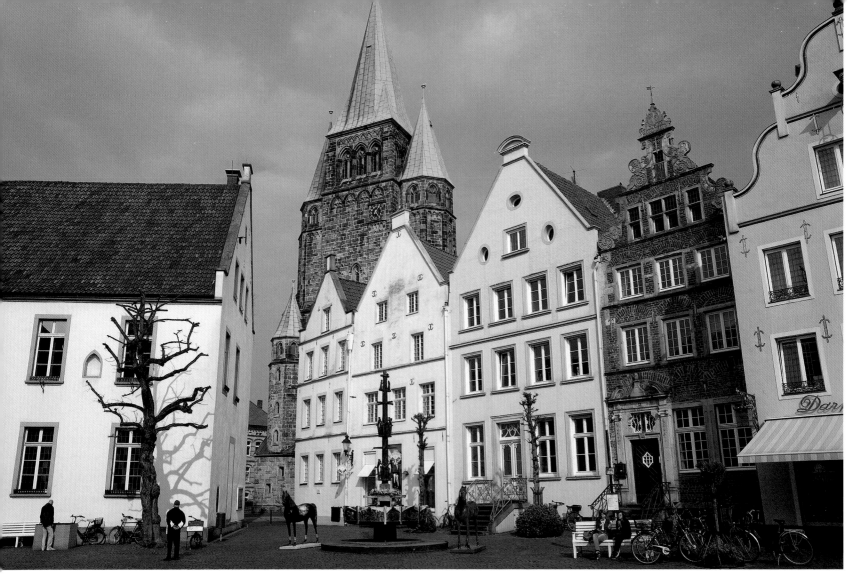

Above:
The market place in the equestrian town of Warendorf is adorned with beautiful façades. In the background is the Gothic Laurentiuskirche, erected in 1404 following the great fire.

Right:
Schöppingen is in the north of the district of Borken. The parish church is dedicated to St Brice of Tours and has been destroyed and rebuilt several times during its history. The painted winged altarpiece by the Master of Schöppingen is one of the best works attributed to the late Gothic art of Westphalia.

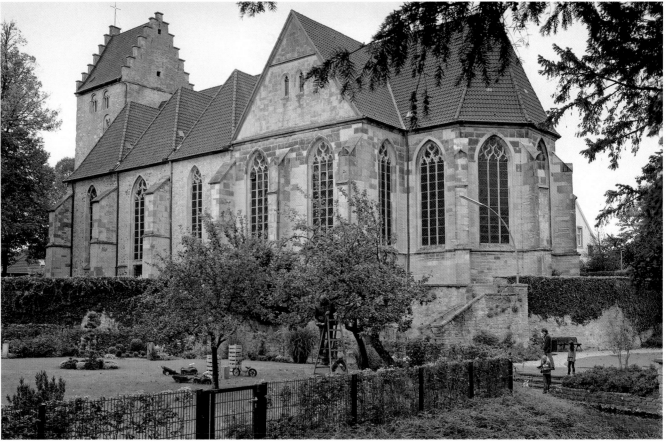

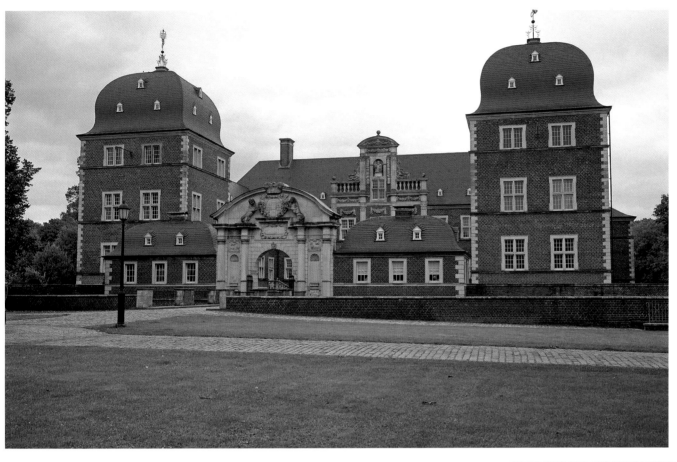

Left:
Schloss Ahaus in Ahaus in the west of the Münsterland was once the residential palace of the prince-bishops of Münster. Many ancient trees grace the spacious grounds.

Below:
Ochtrup lies tucked in between the three 'countries' of the Netherlands, Lower Saxony and North Rhein-Westphalia. Moated Haus Welbergen in the suburb of the same name was built between 1560 and 1570. The lovingly tended gardens are well worth visiting, especially when the roses are in flower.

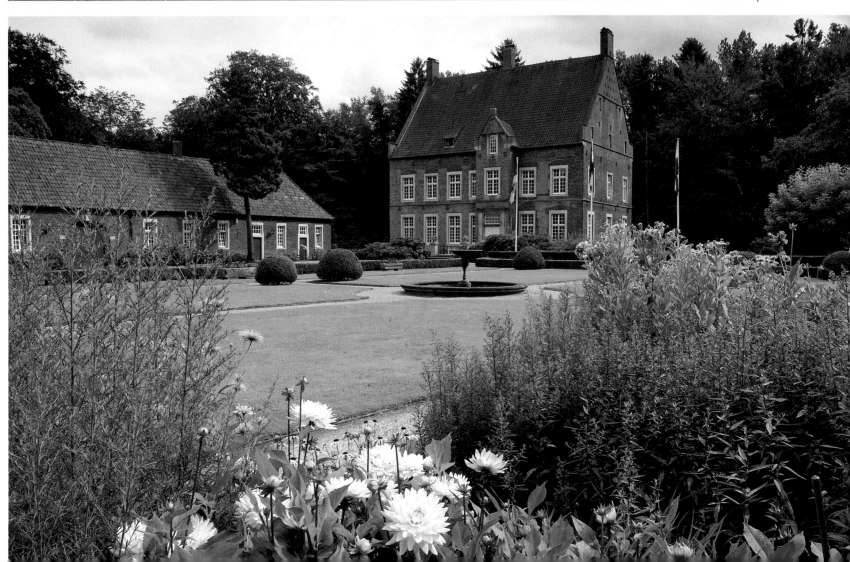

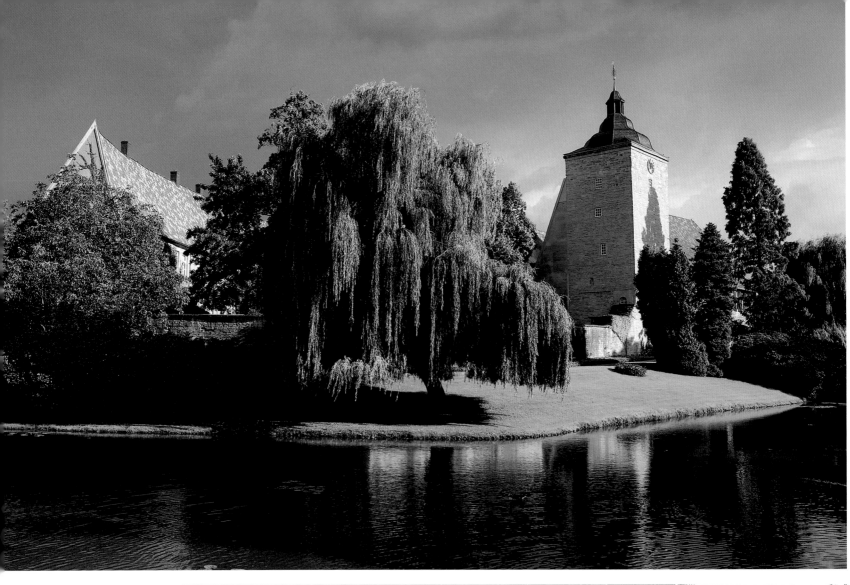

Above:
Schloss Steinfurt is the oldest moated castle in Westphalia. It goes back to the 12th century and is sited on an almost circular island surrounded by the Steinfurter Aa river.

Right:
The former Obere Mühle or upper mill near Schermbeck between the Lower Rhine and the Münsterland in the Hohe Mark national park. It was first mentioned in 1640.

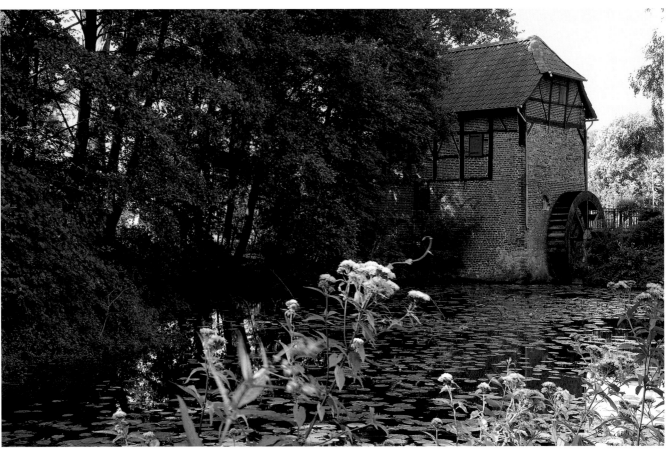

Haus Rüschhaus in Münster-Nienberge was built by the renowned baroque architect Johann Conrad Schlaun between 1745 and 1748 and first inhabited by the same. In 1825 the house was acquired by the father of poet Annette von Droste-Hülshoff who lived here until 1846.

Left:

This pedunculate or common oak (Quercus robur) in Erle in the Borken district is between 600 and 1,500 years old and thus one of the oldest oak trees in Germany. Up until the 16th century Vehm-gerichte or local criminal tribunals were held under its green boughs.

Below:
Pilgrim Haus on St-Jakobs-Pforte or St Jacob's Gate in Soest has been in existence since 1304 and is thus the oldest guesthouse in Westphalia. This is where pilgrims en route for Santiago de Compostela once rested.

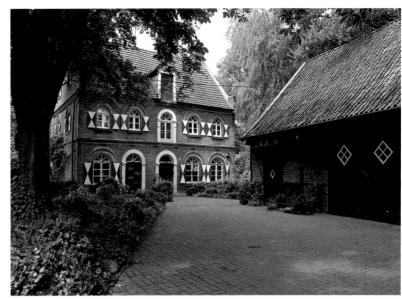

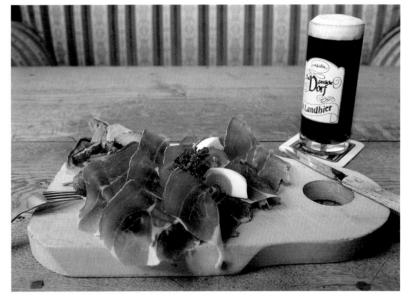

129

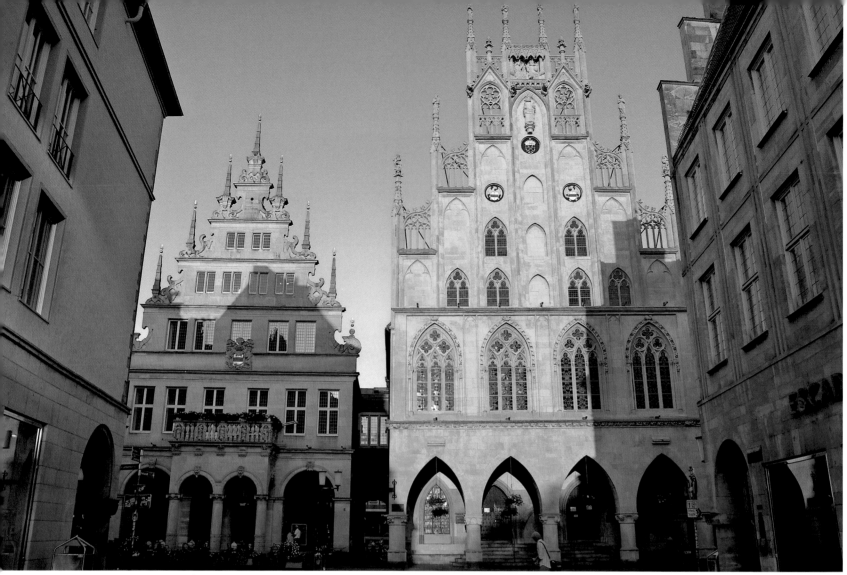

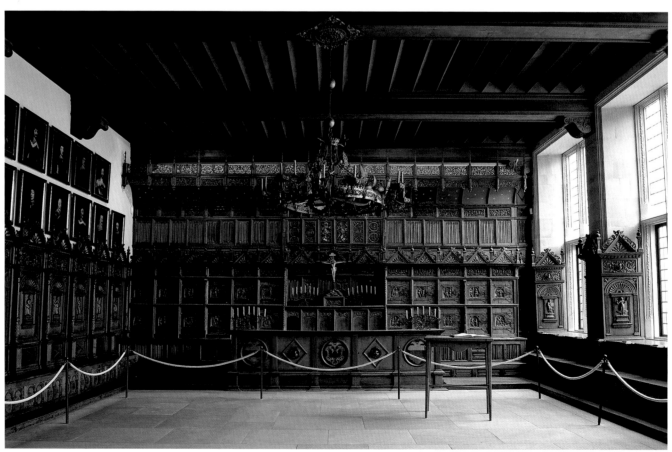

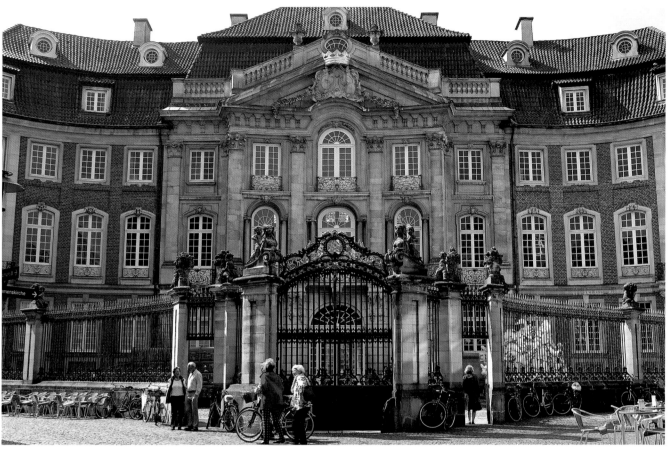

Left:
Erbdrostenhof on Salzstraße in Münster is a baroque palace built from 1753 to 1757 from plans drawn up by architect Johann Conrad Schlaun for a hereditary higher administrator in Münster.

Below:
Following its destruction in the Second World War the building was reconstructed from old plans between 1953 and 1970. The baroque ballroom and concert hall spanning two storeys is richly decorated with illusionistic art.

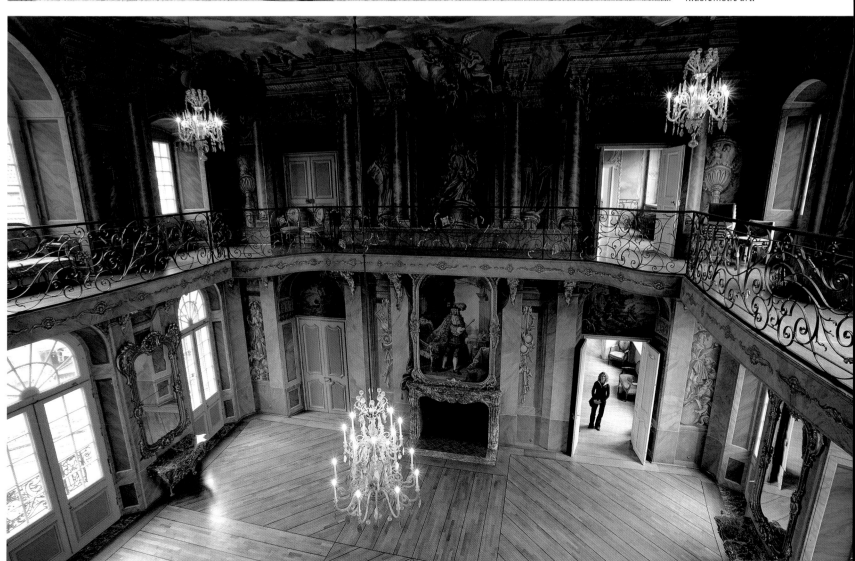

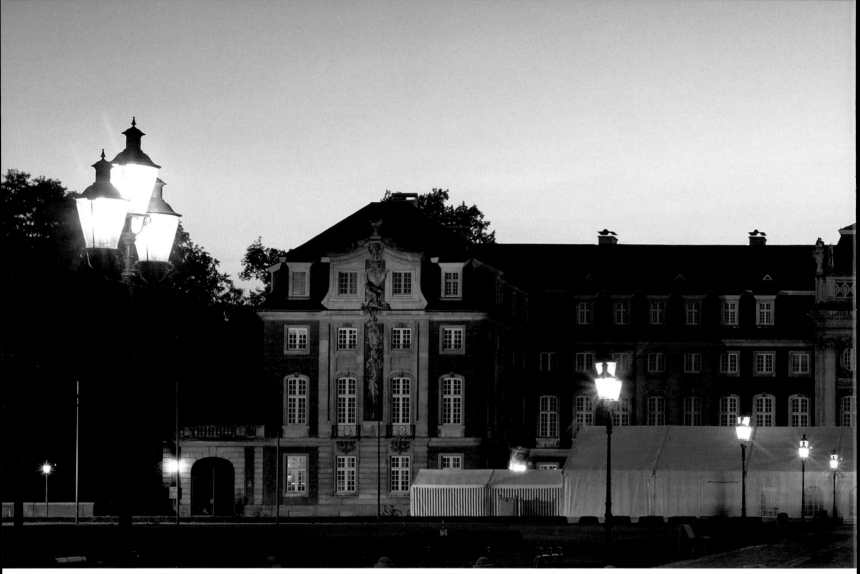

Above:
The palace of the prince-bishops, now seat and proud symbol of the university or Westfälische Wilhelms-Universität Münster, to give it its full title, was built in 1767–1787 from plans by Johann Conrad Schlaun and Wilhelm Ferdinand Lipper.

Right:
Taking a stroll at the weekly market held between the town hall and the cathedral in Münster. The main body of the latter was built between 1225 and 1264; following its destruction in the Second World War it was greatly altered.

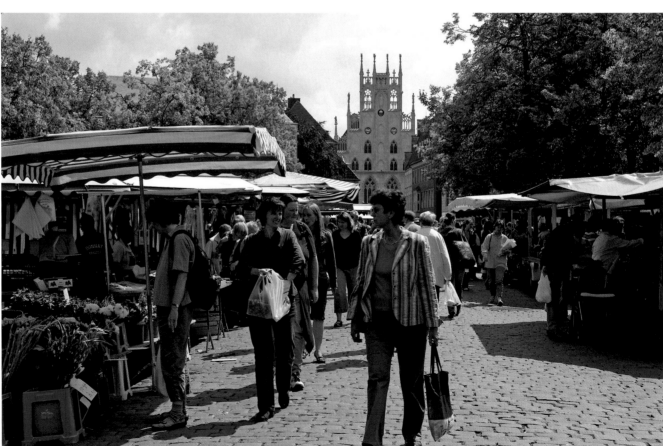

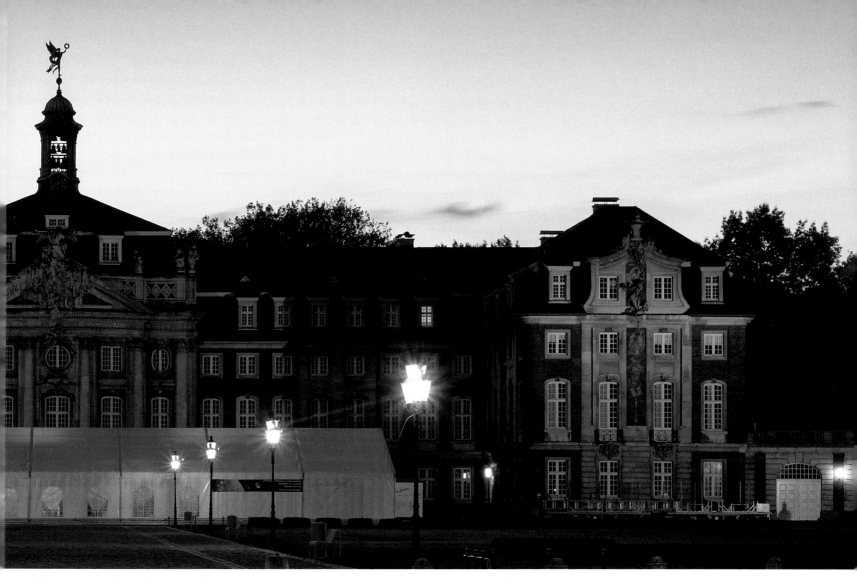

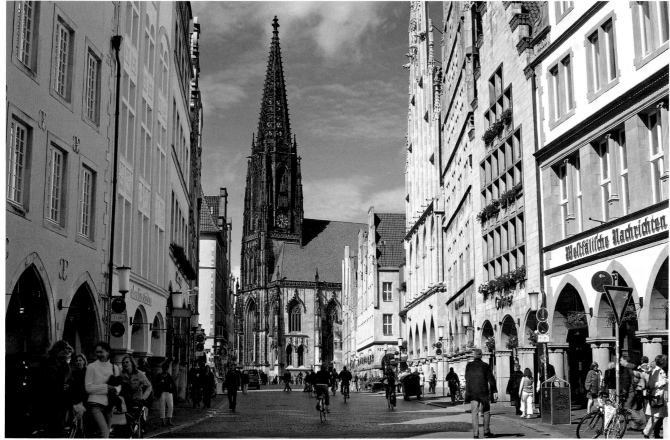

Left:
The north end of Prinzipal-markt is formed by the late Gothic and neo-Gothic Lambertikirche. Count Clemens August of Galen, known as the "lion of Münster", was parish priest here from 1929 to 1933.

INDEX

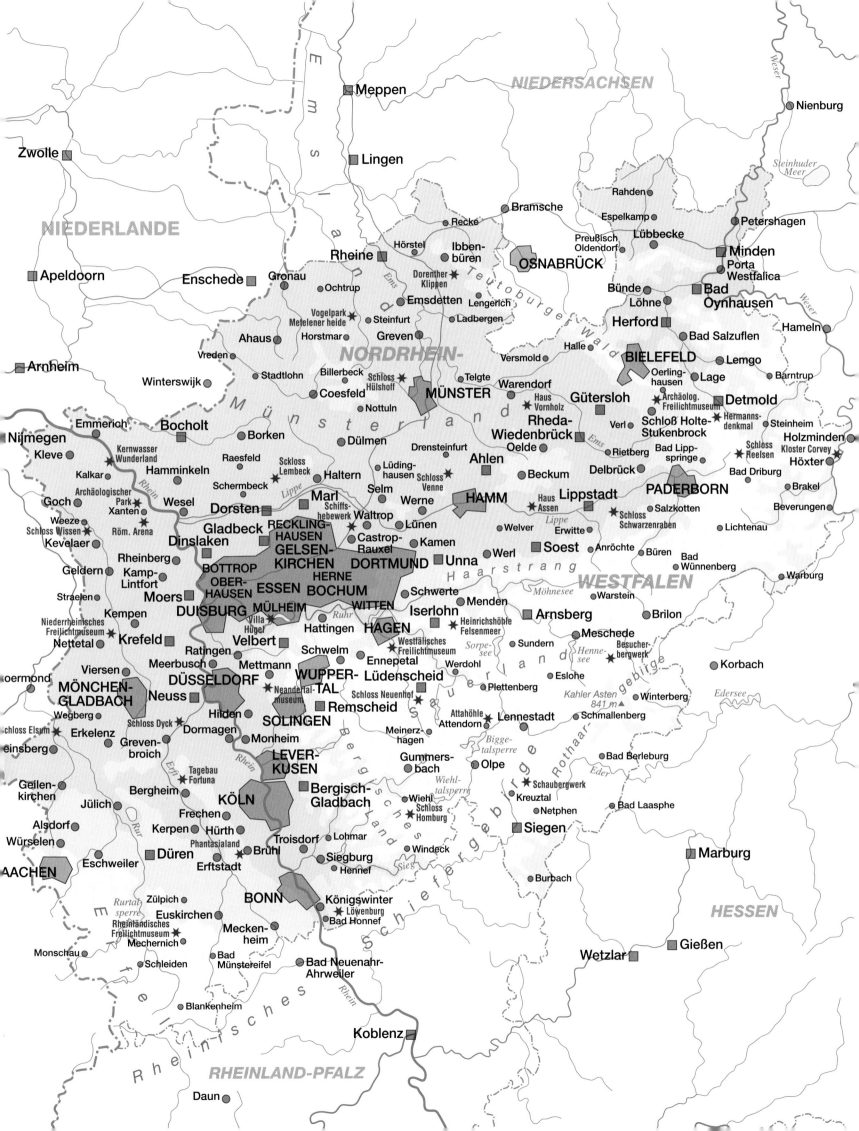

A romantic winter's morning on the River Niers near Viersen, a tributary of the Meuse.

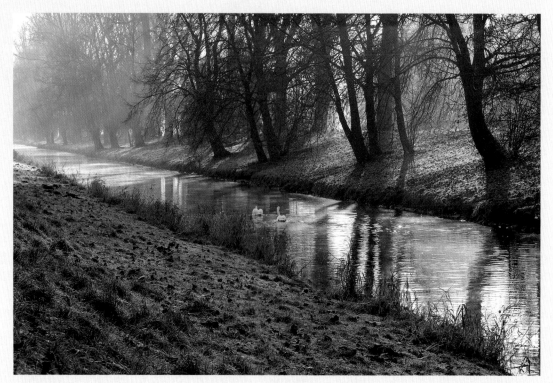

Design
www.hoyerdesign.de

Map
Fischer Kartografie, Aichach

Translation
Ruth Chitty, Stromberg
www.rapid-com.de

Printed in Germany
Repro by Artilitho, Lavis-Trento, Italy
Printed/Bound by Offizin Andersen Nexö, Leipzig
© 2009 Verlagshaus Würzburg GmbH & Co. KG
© Photos: Brigitte Merz
© Text: Georg Schwikart

ISBN: 978-3-8003-4042-2

Details of our programme can be found at
www.verlagshaus.com

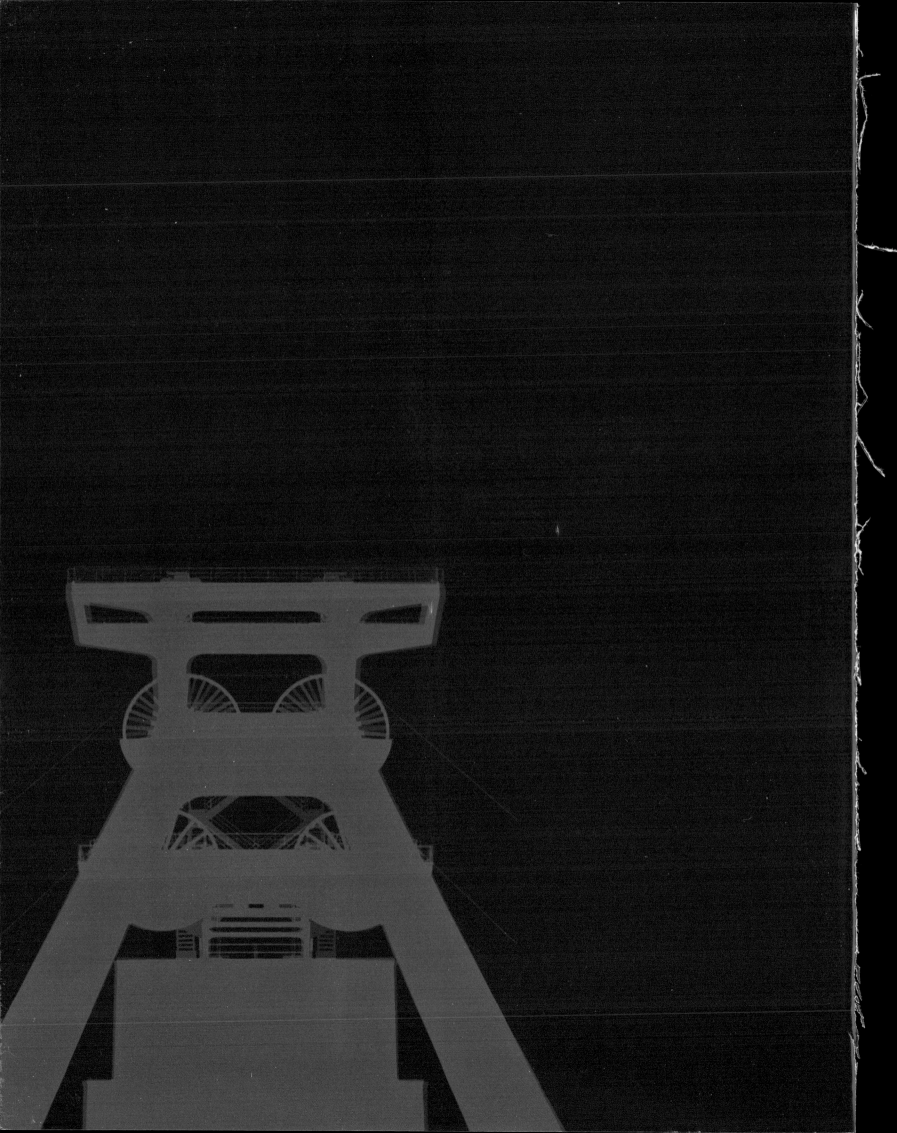

FASHION
PROMOTION IN PRACTICE

BLOOMSBURY VISUAL ARTS
Bloomsbury Publishing Plc
50 Bedford Square, London, WC1B 3DP, UK
1385 Broadway, New York, NY 10018, USA
29 Earlsfort Terrace, Dublin 2, Ireland

BLOOMSBURY, BLOOMSBURY VISUAL ARTS and the Diana logo are trademarks
of Bloomsbury Publishing Plc

First published in Great Britain by Fairchild Books 2016
This edition published by Bloomsbury Visual Arts 2019
Reprinted 2021

A catalogue record for this book is available from the British Library.

The Library of Congress has cataloged the Fairchild Books edition as follows:
Cope, Jon.
 Fashion promotion in practice / Jon Cope and Dennis Maloney.
 pages cm
 ISBN 978-1-4725-6892-2 (pbk.) – ISBN 978-1-4742-1307-3 (epdf) – ISBN 978-1-4725-6893-9
(epub) 1. Advertising–Fashion. 2. Sales promotion. 3. Fashion merchandising. I. Maloney,
Dennis (Fashion writer) II. Title.
HF6161.C44C67 2016
659.19'74692–dc23
2015010936

ISBN: PB: 978-1-3501-4547-4
 ePDF: 978-1-4742-1307-3
 eBook: 978-1-4725-6893-9

Series: Required Reading Range

Typeset by ALL CAPS
Printed and bound in Great Britain

To find out more about our authors and books visit www.bloomsbury.com and sign up for our newsletters.

FASHION
PROMOTION IN PRACTICE

JON COPE AND DENNIS MALONEY

BLOOMSBURY VISUAL ARTS
LONDON • NEW YORK • OXFORD • NEW DELHI • SYDNEY

CONTENTS

INTRODUCTION

> **" CLOTHES MEAN NOTHING UNTIL SOMEONE LIVES IN THEM."**
> MARC JACOBS

Fashion lives and dies by stories. This book is about how these stories are told, who tells them, and crucially, how they reach the right people.

The stories that first shifted clothing from necessity to desire share their origins with those of the earliest fashion designers from the mid-nineteenth century. From the time of the Industrial Revolution, these tales have been spun with increasing sophistication; more recently, the 1960s' "golden age" of advertising amplified their volume immeasurably.

But never has such rapid advancement in storytelling taken place than since the emergence of the Internet made the World Wide Web accessible to the masses in the early 1990s.

Each of the chapters that follows details fashion promotion techniques, some older, some newer, but all fundamentally altered by the new era of digital communication, which has made fashion's stories increasingly difficult to ignore.

The Internet has been a game changer for the fashion industry. While gradual improvements in manufacturing processes have exponentially increased and diversified fashion production, it is the communication of fashion that has seen the largest revolution, bringing the consumers closer to fashion's stories than ever before, in some cases, as part of the narrative themselves.

From the private viewings of collections in Parisian ateliers, first illustrated magazines and magical moving images of early cinema newsreels, to the live streaming of catwalks, holographic models, and being able to read about a collection and buy from it with a few clicks or taps, the transformation of fashion promotion has been astonishing.

For many, a fashion fix is now sated by reaching for a smartphone or tablet rather than a visit to a magazine newsstand, enabling a party frock to be ordered online in the morning, delivered in the afternoon, and worn in the evening, without the need for a frantic lunchtime of dressing room despair.

But the influence of improved communication has implications far beyond consumer convenience. It has fundamentally shifted the balance of power between brand and buyer, in turn transforming approaches to marketing and communication in the twenty-first century.

Consumer engagement and interaction is *de rigueur*. "Buy It, Wear It", is now suffixed by "blog it, vlog it, Tweet it, 'Gram it, Tumblr it." The stories of concept to catwalk are now developing epilogues to involve the stories of consumers. While offering brands a hitherto unprecedented insight into their consumers' behavior, this revolution has also handed power to the consumer, permitting on the one hand instantaneous criticism and on the other, the potential for free promotion.

Brands observe social media very closely, and although now we are approaching a point of social Darwinism amongst bloggers, Instagrammers and Tweeters, numbers of followers, friends and likes remain high on brands' evaluation metrics of choice.

Throughout this book, the irrefutable truth that all the promotional tactics covered can be enhanced through Facebook, Twitter, Instagram, Tumblr, YouTube, Vimeo, Pinterest, LinkedIn, blogs or future social media tools yet to emerge, is mentioned sparingly and specifically. This is not to disregard the influence of social media, but is rather a case of avoiding stating the obvious. Simply put, a higher degree of positive engagements across any of these channels is a useful success indicator of any fashion promotion tactic.

1.0

1.0
London Fashion Weekend,
dubbed 'Fashion's Biggest
Pop-Up' is a bi-annual focus
for fashion promotion in
the UK.

The following chapters provide a blend of historical context and contemporary applications of various promotional techniques that are prevalent in the digital age. Other historical milestones, such as enhanced garment production techniques, the mediation of fashion and its consumption through the evolution of department stores and widening of consumer choice, are crucial aspects in the understanding of contemporary fashion promotion, and it is advised these are examined before embarking on this book, or in tandem with your reading. Similarly, a grounding in traditional marketing theory is advised in order to fully appreciate how much and how rapidly the landscape of fashion promotion has changed in a very short space of time.

We begin with a guide to campaign planning in a digital age (**Chapter 1**), with fashion promotion as part of the wider marketing mix, dealing with the practicalities of planning and how the industry implement these in promoting a new product or brand.

We next examine the concepts of advertising and public relations (**Chapter 2**) and the role these play in campaign organization. The importance of brand image is explored through interaction with celebrities (**Chapter 3**) along with how a brand can benefit through collaboration with other brands or individuals that align to a brand's values, or as a tactic to entice a new market (**Chapter 4**).

The impact of the digital age is further discussed through the evolution of the fashion show (**Chapter 5**) and the emergence of a medium that has flourished through advancement in technology—fashion film (**Chapter 6**). Finally, we consider how brands further enhance their stories through both industry and public events (**Chapter 7**), continue their narratives through visual merchandising (**Chapter 8**) and how the face of the fashion media has radically altered through the magazine and the promotional opportunities that fashion publishing can provide (**Chapter 9**).

All chapters include either interviews or case studies with industry professionals (often both), and points for discussion and activities intended to encourage wider thought and research.

While writing this book, we were acutely aware of the rapidity of change within the fashion promotion industry. For this reason, we have attempted to use the most recent examples and case studies possible, and each chapter is enhanced with online materials—including historical timelines, expanded industry interviews, and useful points of reference about key brands, industry figures, and further case studies.

Jon Cope & Dennis Maloney

SMART PLANS. STUPID IMPROVISES.

BE STUPID

DIESEL
FOR SUCCESSFUL LIVING

Shop online. Diesel.com

01

CAMPAIGN PLANNING: MAKING IT HAPPEN

From understanding your target market to objective-setting, budgeting, and evaluation, effective planning is critical to the success of promotional activity. It might lack the glamour of the runway front row, but without it, there will be no runway.

1.1
Diesel's 2010 "BE STUPID" advertising campaign by New York creative agency, Anomaly, appears to mock planning. Or does it?

INTRODUCTION

This chapter sets fashion promotion in the broader context of marketing, clarifying the role of the promotional mix and illustrating how practitioners use research insights to plan promotional strategies and tactics. It highlights the practicalities of planning and offers real-world examples to inform and inspire you to mastermind your own campaigns, from petite to XXL.

LEARNING OUTCOMES

By the end of this chapter you should be able to:

» explain and differentiate between the terms "marketing mix" and "promotional mix"
» understand the importance of research for promotional campaign planning
» describe examples of promotional campaigns, understanding how and why they were effective
» understand how to plan and execute campaigns for the fashion industry
» begin to plan your own campaigns for fashion brands or products.

PLANNING PROMOTION IN CONTEXT: THE FOUR P'S

Fashion promotion is part of a sweep of marketing activities referred to as the "marketing mix." This concept was popularized in the early 1960s by Harvard Professor Neil Borden and a fellow marketing scholar, E. Jerome McCarthy, who grouped Borden's marketing "ingredients" into four convenient and memorable "P's": product, price, placement (distribution), and promotion.

1.2

1.2
Fashion promotion existed before the 4P's, but this simple categorization of marketing activites has helped inform and shape contemporary promotional practice.

THE 4P'S OF THE MARKETING MIX FOR THE FASHION INDUSTRY

WHICH "P"?	EXPLANATION	DESCRIPTION	PURPOSE
Product	What the product is, what it does, and how it satisfies customers' wants and/or needs	Product concept; design; materials; technology; quality; branding; packaging; warranties/guarantees	
Place (distribution)	How and where the customer can purchase the product	Retail availability (online/in-store); regional/national/international distribution; disposal of old inventory/distressed stock *Includes the additional three P's of the extended marketing mix:* **Physical evidence/layout** Visual merchandising and all aspects of the retail environment **People** Employee attitudes/appearance; management culture; customer service **Processes** Order handling, dealing with customer complaints	Creating product differentiation and value; creating a market
Price	How much the customer must pay for the product	Product pricing (considers manufacturing costs, competitor pricing, "premiumness" of product); discounting/sales strategy	
Promotion	How the product is promoted to the customer	All elements of the promotional mix: advertising; public relations; publicity; celebrity endorsement; sales promotion; visual merchandising; styling; sponsorship; direct marketing; personal selling	Communicating product value

1.3

PUTTING THE P'S INTO PRACTICE

In order to succeed—that is, to make profit—all businesses must ensure that their products are as desirable and satisfying to consumers as possible. For each individual, there is a product, a price point, a means of purchasing that product, and a way of communicating the availability and benefits of that product, which will be appealing enough to prompt a purchase. Whether the product in question is a can of Coke, a coat or a car, similar rules apply around product, pricing, placement, and promotion. Although this book focuses on the promotion element of the marketing mix, it is important to understand the place of promotion alongside its fellow P's.

1.4

CREATING AND ALIENATING FASHION MARKETS

To appreciate the magnitude of the P's in the context of fashion promotion, it is helpful to remember that companies not only *produce* products and services, but they also *create* the *markets*—that is, the customers —for the products and services they produce. Indeed, one of the principal aims of marketing—and particularly its promotional elements—is to create markets, which did not exist prior to the commencement of a promotional campaign. Of course, the individuals comprising these markets existed as walking, talking, thinking beings with families, jobs, friends, interests, and existing consumption requirements. But hard as it is to imagine today, there was a time when stiletto heels, culottes, bikinis, fascinators, 18-hole boots, even humble denim jeans and plain white T-shirts, were simply not on anybody's list of wants, let alone needs. Only through the focused and persistent activities of marketing have these products become desirable, and markets for them been created.

Conversely, when one or more of the P's is out of alignment, it is easily possible to damage or even destroy markets. British luxury brand Mulberry, for example, attracted much criticism between 2012 and 2013 for pricing handbags at premium levels without sufficiently increasing the products' perceived value against luxury competition. In defense of this strategy, then chief executive Bruno Guillon was reported in *The Guardian* in April 2014 to have claimed that it was part of an ongoing process of transforming Mulberry from a domestic to a global luxury brand. Guillon left the brand in 2014. Following his departure, the brand announced a range of more affordable products designed to appeal to traditional Mulberry customers.

1.3
Models at the Sophia Webster presentation during London Fashion Week Spring Summer 2015. Hard as it is to imagine, there was a time when stilettos, bikinis, and clutch bags in the shape of thought bubbles were not on anybody's want list.

1.4
Former Mulberry CEO Bruno Guillon (left, with US *Vogue* editor Anna Wintour) departed the brand in 2014 following criticism of a pricing strategy that lifted Mulberry bags out of the range of core customers.

UNDERSTANDING THE PROMOTIONAL MIX

Among the four P's, promotion stands alone as the only element of the marketing mix used to *communicate* product value *after* the product value has been established through the product itself, its pricing, and its placement. The promotional element also has a mix of its own— perhaps unsurprisingly known as the "promotional mix." This typically comprises advertising, sales promotion, visual merchandising, public relations, and personal selling, and is used to capture consumers' *attention,* raise their level of *interest,* stimulate *desire,* and drive them to take *action,* usually by purchasing the product. All activities undertaken within the promotional mix should help to influence consumers' "path-to-purchase," summarized through an acronym that takes the initial letters of attention, interest, desire, and action: AIDA.

AIDA AND THE "PATH-TO-PURCHASE"

Even an impulse buy—fashion marketers would argue— comes as a result of a range of influences, meticulously engineered to direct consumers down the path-to-purchase. An understanding of the AIDA model is helpful for fashion promoters seeking to apply some logic to the complex and shadowy realm of purchase decision-making.

1.5

1.5
Attracting attention, stimulating interest, generating desire, or prompting action? Which elements of AIDA does this Louis Vuitton store display activate?

AIDA AND THE PATH TO PURCHASE

	Aim of promotional activity	Aim	Tools	Tactics	Desired outcome
A	To attract **attention** (and/or raise **awareness**)	To attract consumers' attention, inform of a product's presence within the market, and make them aware of your message	Advertising	Paid forms of mass media communication through non-personal media or other channels, e.g., print/ TV/radio/ cinema/billboard/ Web advertisements, direct mail, in-store display, paid sponsorships, events	Target audience becomes aware of your message and is primed to receive further communications of more personal relevance
			Media relations	Press releases; social media activity (e.g., Twitter/Facebook announcements)	
			Events and publicity stunts	Exhibition sponsorships; guerilla publicity activity; stunts in retail areas	
I	To stimulate **interest**	To engage consumers by providing useful information that chiefly highlights a product's benefits	Media relations	Features; blogger liaison; participation in forums; production and distribution of fashion films and other compelling social media content	Target audience gains interest in your product messages; is stimulated to seek further information
D	To generate **desire**	To persuade customers that the product will supply their needs	Personalized messaging	Targeted messages through Twitter, Facebook and other targeted social media; direct mail (either via email or physical methods); testimonials; in-store experiences; teasers; incentives to find out more (e.g., invites to VIP shopper events)	Target audience's curiosity is piqued; they may develop a desire to see, feel, or trial your product and may discuss it with peers or trusted advisors
A	To prompt the consumer to take **action**	To draw customers to make a purchase	Sales promotions; face-to-face selling	Promotional/limited time offers; sales promotions; targeted discounts (e.g., for students); in-store personal selling	Target audience purchases product

CRITIQUES OF AIDA

The AIDA model is not perfect and it has attracted criticism in recent years, with some commentators taking issue with the linear direction of the path-to-purchase as described. This, its critics claim, describes an unachievable ideal, which lacks practical application. Contemporary interpretations of the path-to-purchase model, however, tend to assume two things. First, that AIDA is not a "funnel" moving individuals unwaveringly from complete ignorance of a brand or product to purchase, effortlessly sidestepping a wide range of uncontrollable variables. Second, that the process describes not a series of promotional activities, but instead, the way consumers behave. In other words, even the most experienced, well-informed promotion practitioners can only nudge consumers through an array of decision-making processes, rather than force them through the AIDA model with ruthless efficiency.

1.6
Happy shoppers: even the best fashion promotion can only nudge consumers, rather than force them to buy.

1.7
Window displays may include all elements of AIDA in one simple scheme.

1.6

THE PLANNING JOURNEY

1. Gain a detailed understanding of the current situation facing your brand

2. Establish where your brand wants to be as a result of promotional activity

7. Evaluate your work

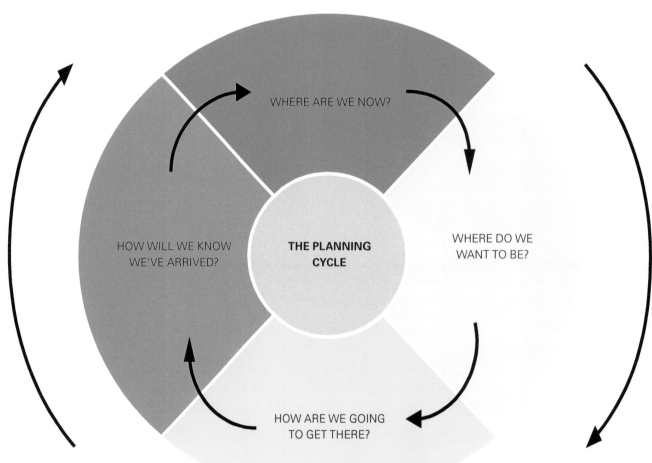

WHERE ARE WE NOW?

WHERE DO WE WANT TO BE?

HOW WILL WE KNOW WE'VE ARRIVED?

THE PLANNING CYCLE

HOW ARE WE GOING TO GET THERE?

6. Divide your budget accordingly

3. Decide who are the most useful people to communicate with to achieve your objectives

5. Decide how and when you are going to communicate your messages

4. Clarify what you are going to say to your audiences

PLANNING FOR PROMOTION

A plan is simply any list of stages with allocated timing and resources that fashion promoters use to achieve an aim. One easy way of understanding the planning process is to think of how you might make a journey. Forgetting about satnav for a moment, the first thing you'd need to know is where you are at the start of the journey. Next, you'd need an idea of where you want to be at the end of the journey. You'd also need to know how you are going to get to your destination, and crucially, how you'd know when you've arrived. These four pieces of knowledge underpin pretty much any sort of planning activity and therefore make a robust starting point for any planning process.

STAGES OF PLANNING TO PROMOTE A FASHION BRAND OR PRODUCT

1. Gain a detailed understanding of the current situation facing your brand

What are your brand's strengths and weaknesses? Where are the opportunities and threats? What are competitors doing? How does the external environment affect your brand? Where do trend forecasters envisage the potential for your brand to develop? Combine your own observations with published research, or commission your own research among individuals or organizations likely to have an informed opinion on your brand.

2. Establish where your brand wants to be as a result of promotional activity

What is it that you want to change through promotional activity? Keep this realistic but ambitious. Generally, promotional activity is best at changing awareness of, attitudes around, or behavior towards a brand, product or service among fairly tightly defined target audiences. Decide on a number of specific, measurable objectives that you can evaluate against throughout, and at the end of your promotional activity.

3. Decide who are the most useful people to communicate with to achieve your objectives

Communicating with the right people is vital to achieving promotional success. You need a clear idea not only of your target consumer audience but also the individuals and publications that influence them—journalists, bloggers, or simply influential peers. Once identified, you should prioritize these audiences to ensure you can make the best use of your campaign resources.

4. Clarify what you are going to say to your audiences

For each identified audience, develop compelling messages that you believe (and your research suggests) will generate a desired response. Ensure messages are simple statements that can be communicated easily in a variety of promotional formats.

5. Decide how and when you are going to communicate your messages

Is there a role for mass media, or are you trying to reach out to smaller, niche audiences who will only respond to individually tailored messages? Decide on the mix of promotional media types and other methods of communication (sponsorships, events, stunts, etc.) that will help you deliver your messages cost effectively, and establish when your messages will have the greatest impact—are there seasonal considerations to be taken into account, for example?

6. Divide your budget accordingly

All promotional projects have some sort of budgetary constraint. A small budget may preclude extensive use of paid-for, mass-media advertising, or high-cost celebrity endorsement, but it can help to generate extremely creative promotional tactics with significant ability to reach your target audiences.

7. Evaluate your work

Using the objectives you set at the start of your promotional activity, measure how successful you have been in communicating your messages and achieving the change that you originally desired. Has your promotional activity had any discernible impact? If so, how has this manifested itself?

1.8

1.9

1.8
It is crucial to communicate with the right people. Here, actress Jennette McCurdy and fashion blogger Jared Eng (of the blog Just Jared) take selfies at BCBG Max Azria's Grand Opening Event in April 2014 in California. (Planning stage 4)

1.9
Keep messages simple and compelling, though perhaps not quite as short as these ones included in Sophia Webster's SS2014 accessories collection. (Planning stage 5)

CASE STUDY:
THE POWER OF NOT PLANNING – NON-CELEBRITIES GO VIRAL

1.10

1.10
Wren's *First Kiss* video
generated millions of
online views within days
of launch and spawned a
host of spoofs.

In some rare instances, unplanned (or at least, less formally planned) promotional activities can still yield remarkable impact. In March 2014, a video purporting to show complete strangers kissing for the first time received more than 23 million views within 72 hours of its appearance online. Widely shared via social media, the short film offered intrigue and controversy. Three days after its first posting, came the true story: the film had been created by the fledgling LA fashion brand, Wren Studio, as part of Style.com's Video Fashion Week, as an alternative to the brand staging a traditional Fashion Week presentation.

The film's cast mixes non-celebrities (including one Wren employee) with professional musicians and actors, including Z Berg, lead vocalist of the band The Like. Commenting on the film, Wren founder Melissa Coker said: "I had set out to make something shareable that would go viral, but I never foresaw that *First Kiss* would be the most viewed branded apparel video of all time, beating out industry giants like Louis Vuitton and Chanel. The film's success had several waves. There was the initial wave when people were sharing it for the great content. Then there was the wave where the media really picked up on it and started sharing the story. This was followed by a round of business media that further pushed the news as well as several high-profile parodies like the one Jimmy Fallon did for the *Tonight Show*."

As with many online viral success stories, it is impossible to state unequivocally the exact reasons for the film's success. Coker believes its subtlety was partly responsible. "The fact that there weren't any heavy-handed 'buy me now' come-ons was integral to the success of the clip. It was about the content and relationship building rather than a pushy sales pitch, which is just a plain turn off."

Whatever the reasons for its success, impact on the brand has been phenomenal, with online sales up by 14,000 percent, and brand awareness soaring. Says Coker: "We were on the cover of the *New York Times* business section, on CNN, *Ellen*, *The Today Show*, every newspaper you could imagine, all over the Internet. All of this was earned media, though I would propose that you couldn't buy this sort of press even if you wanted to."

Search for First Kiss on YouTube to see this groundbreaking film (if you haven't already).

INTERVIEW: REBECCA GRANT –
PLANNING FASHION PROMOTION FOR NON-FASHION BRANDS

1.11

Rebecca Grant is Managing Director, Consumer Marketing for international communications and public relations agency, Cohn & Wolfe. She has extensive experience of working with major consumer brands, which includes brokering fashion partnerships to help them communicate with fashion-savvy target audiences. In this Q&A, she explains her approach to promotional planning.

Do you follow a set of planning rules, or is the process more instinctive?

Some agencies use a standardized planning process, but I believe it's critical to tailor every plan to the client's specific issue. It's increasingly rare for any single agency to handle a brief, so we always work with our partner agencies in advertising and media buying, for example, to ensure a coherent, integrated response.

How do you start a typical planning process?

We start at the end. We take a detailed look at the client's business and what they want to achieve from promotional activity. We then carefully identify our target audiences, which consist of the end-consumer, the people that influence them, and those we feel have a higher propensity to become brand advocates. Once these audiences are identified, we then mine as much data and analytics as possible. Cohn & Wolfe recently joined WPP's Data Alliance, which gives us access to actual behavioral data, which will tell us what consumers are doing, online and in the retail environment. We also use tools such as Target Group Index (TGI) research*, brand data and online listening programs. We're trying to nail down the right messages and capture "receptivity moments" when what we say is going to cut through and engage.

How do you generate "insight" about your target audiences?

Often, brands are swimming in facts and figures about their customers; our job is to find something meaningful from the data, which provides a key insight that can be used to inform campaign strategy and tactics.

1.11
Rebecca Grant, MD Consumer Marketing,
Cohn & Wolfe UK and EMEA regions.

1.12
Crowds throng the pavement as Kate Moss
attends the launch of the Kate Moss for
Topshop collection, April 29, 2014
in London, England.

1.12

Does trend forecasting help with the planning process?

Trend forecasting and analysis are at the core of planning, particularly for larger brands looking to capitalize on the communicative power of fashion. Topshop for example, realized that the trend for celebrities mixing couture and mainstream items could be used to help expand the brand's appeal and attract a broader audience of people, who wouldn't previously have considered Topshop. This ultimately resulted in the highly successful and long-running Kate Moss collaborations, with Kate giving permission for an older audience who might have felt they had outgrown Topshop to reconsider the brand.

Do you feel that a meticulously planned campaign is always fail-safe?

Not at all; the biggest danger for a well-planned campaign is failing to continue planning throughout the campaign execution and evaluation periods. We always try to think of our campaigns as being "in beta"—that it is never finished—so we continue to review them, and finesse and refine campaigns in real time.

How do you evaluate your campaigns?

The most important part of evaluation is ensuring that you set clear objectives against your clients' communications aims at the start of campaigns, and measure against them throughout. We work in partnership with each client to agree a bespoke evaluation framework that considers both communications and business metrics: Outputs (e.g., media coverage), Outtakes (e.g., brand reappraisal), and Outcomes (e.g., consideration and sales). Remember to be precise about the results you are tracking as they will drive the tone and focus of the campaign. For example, solely tracking "likes" on Facebook is not a good indicator of consumer engagement. "Likes" can be easily bought and in itself takes little effort, so even something as simple as tracking "shares," instead, would shift the focus and execution of your campaign.

*Quarterly released data collected from a representative sample of around 25,000 UK adults covering consumer attitudes, motivations, media habits, and buying behavior.

INTERVIEW: RIC HENDEE – PLANNING TO PROMOTE COTTON

Cotton Incorporated is a US organization dedicated to promoting the use of cotton within the textile industry by stimulating demand throughout the supply chain and among consumers. Much of their work focuses on the fashion industry and since 1989, Cotton Incorporated's "The Fabric of Our Lives" campaign has promoted cotton garments as stylish, comfortable, and fashionable, mainly to women aged 18–34. Here, Ric Hendee, Senior Vice President, Consumer Marketing explains how they create an effective campaign to reach this target audience.

What is the target audience for Cotton Incorporated's "The Fabric of Our Lives" campaign?

The campaign started in 1989, with Richie Havens singing our now widely recognized theme, and originally targeted a wide range of cotton consumers, male, female, young, and old. When we relaunched in 2009, our research told us that intense competition from other textiles in women's fashion made this area a particularly challenging one for cotton. This finding helped us narrow our focus so that we were spending our resources in the most challenging—but potentially also the most profitable—way. Today, we concentrate our efforts almost exclusively on young, fashion conscious women.

1.13

> **" RESEARCH INTO THE TARGET AUDIENCE IS CRITICAL. OUR CHOICE OF CELEBRITIES IS DICTATED BY WHAT WILL APPEAL TO THE TARGET AUDIENCE AND OF COURSE, OUR BUDGET."**

1.13
Hayden Panettiere poses for the 2013 Cotton Incorporated "Fabric of Our Lives" campaign.

"The Fabric of Our Lives" has always involved celebrities. How do you choose the right celebrities?

Again, research into the target audience is critical. Our choice of celebrities is dictated by what will appeal to the target audience and of course, our budget, which is relatively modest. Because the campaign is always based around our iconic song, the celebrity needs to be able to sing. We have historically used musicians, such as Colbie Caillat, Emmy Rossum, and Leona Lewis, but most recently, we've turned to cinema or TV celebrities who can also sing—individuals like Zooey Deschanel, Kate Bosworth, and Camilla Belle. This is because they have a greater social media presence. They also tend to be attractive people who have a strong profile within fashion publications, and they are seen as style leaders. Our most recent celebrity endorser is Hayden Panettiere, made famous in the NBC series *Heroes,* and the ABC musical drama, *Nashville.*

What made Hayden Panettiere the right choice? Were you concerned that the scheming Juliette Barnes character she plays in *Nashville* might restrict her popularity?

We were seeking someone with an all-American, girl-next-door quality, who could sing in a country crossover style. The commercial celebrates American style and American originals like cotton denim, country music, and, of course, US cotton growers. Hayden has these qualities and her *Nashville* character actually seems to have enhanced, rather than detracted from, her appeal to our audiences.

What are the key components of the "Fabric of Our Lives" campaign?

Our contract with Hayden requires her to perform "The Fabric of Our Lives" song for TV and online advertising, incorporating scenes from her everyday life and interactions with cotton fabrics. We also interviewed her for the campaign website and she participated in PR activities, including a day of live TV interviews.

Does corporate social responsibility play a role in this campaign?

Yes. We decided that with Hayden, we would focus her TV interviews on our "Blue Jeans Go Green" denim recycling campaign, where we encourage people to donate their old jeans to a program making building insulation out of denim, for distribution to communities in need, via the charity Habitat for Humanity.

Does the "Fabric of Our Lives" campaign incorporate social media features?

The commercial itself is highly shareable, and we also have a section on the campaign website where visitors can explore Hayden's closet and click on their favorite garments. Doing so brings up a brief clip of Hayden talking about that particular item of clothing, along with information on how to replicate and accessorize the look at a range of budget points. All of Hayden's featured garments are sharable, including via Pinterest, and we also encourage site users to upload their own Instagram shots of themselves wearing their favorite cotton look using the hashtag #CottonShowstopper.

How does the "Fabric of Our Lives" campaign rate with your target audience?

Our research shows that 65 percent of our primary target audience is aware of the campaign, which is pretty incredible, given the extent of our budget. We believe this is partly down to the consistent use of the campaign song, and our use of celebrities who have resonance with our target audiences.

CHAPTER REVIEW

As this chapter shows, consumers experience the outcomes of fashion promotion activity that is typically meticulous in its planning even when appearing unplanned and spontaneous. While there is still considerable scope for creativity and the unexpected, it is crucial for fashion promoters to think carefully in advance about what they are hoping to achieve from promotional activity, and to ensure that objectives are measurable if they are to effectively evaluate the impact of their work.

QUESTIONS FOR DISCUSSION

1. What are the advantages and disadvantages of planning promotional activity?

2. Do the marketing mix and promotional mix models help fashion promotion practitioners plan their campaigns in the real world, or are they best saved for theoretical discussions?

3. Can you think of any examples of unplanned fashion promotion activity? Do you think it was successful or unsuccessful? How do you know?

4. How is the promotional element of the marketing mix different to other elements?

5. How does a fashion brand decide to spend its promotional budget?

1.14

1.14
The ultimate goal of all fashion promotion activity: persuading people to buy into your brand from an almost infinite array of competitors.

CHAPTER EXERCISE

ONE

Working in small groups, find one example of a fashion promotion campaign where the outcomes have led to coverage in the media. Working backwards from what has appeared in media reports, try to piece together the planning process and answer the following questions:

» What were the aims of the activity?
» Who was the target audience for the activity?
» What were the key messages that the brand was trying to communicate?
» Was the activity effective?
» Who was involved in the promotional activity?

TWO

In pairs, choose a fashion designer, brand, or product of your choice. Using the planning models discussed in this chapter, attempt to put together a promotional plan that considers possible aims, target audiences, key messages, promotional tactics, and how you might evaluate the activity.

THREE

Working solo or in a small group, select a fashion item that is currently available to purchase and attempt to discover all of the ways it is currently being promoted, using the elements of the promotional mix as a checklist. Does your research give you any insight into the brand's promotional strategy?

FOUR

Working as a pair, visit the website of a brand of your choice, and then also visit one of your brand's retail outlets. Make a note of any similarities and differences between the types of promotion used online and in-store. What can you observe about the brand's promotional approach? Consider in particular the language, tone, use of color; the relative importance of product, price, place, and people. Do you feel that the store or the website is the most effective route to product sales?

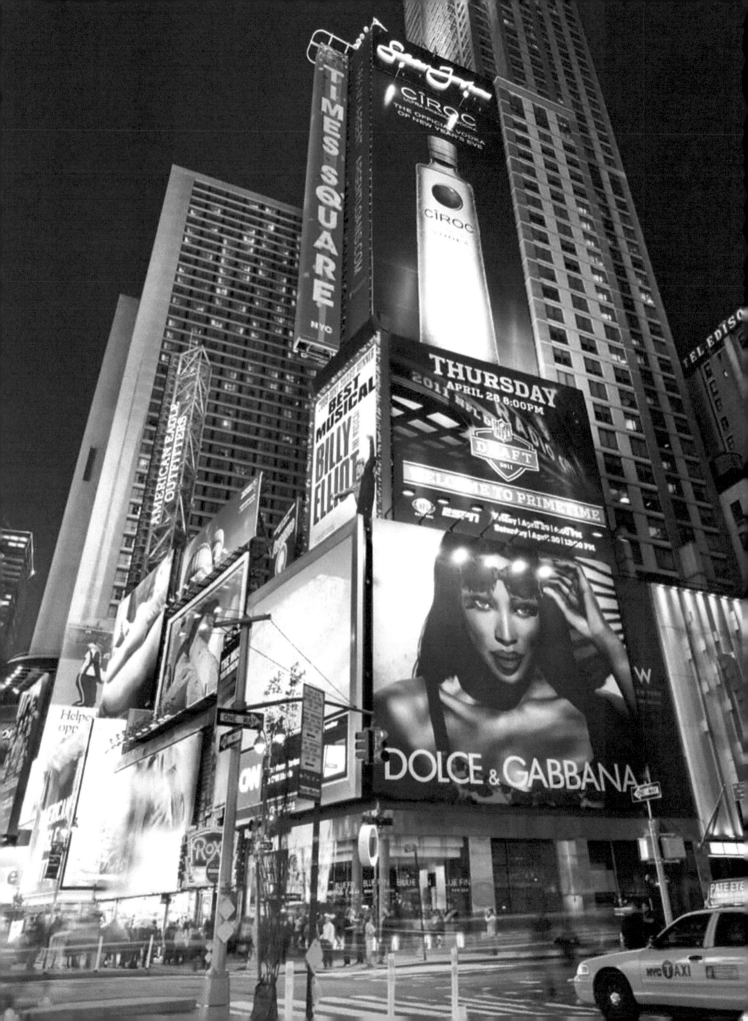

02

ADVERTISING AND PUBLIC RELATIONS: FROM VERBAL TO VIRAL

Advertising and public relations (PR) are multibillion dollar industries employing some of the world's most creative and intelligent fashion communicators. As frameworks through which the all-encompassing promotional cacophony is tuned, orchestrated, and amplified, their arresting, beautiful, often outrageous or shocking work competes fiercely for mindshare in an atomized environment where distraction is only ever a screen tap away.

2.1
Backlit Dolce & Gabbana outdoor advertisement in Times Square, New York City.

2.2

INTRODUCTION

After explaining what advertising and public relations are, how they differ, and what they do, this chapter outlines how these deeply intersecting promotional disciplines combine in integrated campaigns to exploit the proliferation of digital channels that have transformed consumer communications during the Internet era. Q&As with practitioners offer insights into these vital segments of the industry in what some have called the "post-advertising era."

LEARNING OUTCOMES

By the end of this chapter you should be able to:

>> understand the role of advertising and PR within fashion promotion
>> trace the evolution of fashion PR and advertising
>> identify a range of advertising and PR techniques
>> understand the terms "paid," "owned," and "earned" media
>> consider contemporary forms of PR and advertising as part of the promotional mix.

WHAT IS ADVERTISING?

At its most prosaic, advertising is promotional communication that uses paid-for media to attract a broad cross section of the advertiser's target audience, either for a specific product-related purpose (e.g., a launch), or to maintain or adjust brand image.

Advertisements are usually identifiable as such, through placement in public and private spaces set aside for their use. Whereas advertising media were historically limited to newspapers, magazines, radio, cinema, TV, and outdoor posters, today's advertisers must add to these options a plethora of web-based and mobile media, many of which offer consumers the opportunity to "opt out" of receiving advertising messages.

In her seminal 1978 work *Decoding Advertisements*, scholar Judith Williamson writes: "It is the first function of an advertisement to *create* a differentiation between one particular product and others in the same category," but this is not the whole story. As Iain MacRury (2009: 23) notes, advertising today is "a genre, an everyday feature and format across contemporary media." Thus, advertising is both a commercial activity, which aims to help sell products, and a way of constructing meaning within contemporary society.

2.2
American Apparel outdoor advertisement
in Shoreditch, London, 2014.

2.3

2.4

2.5

2.6

2.3
Luxury online menswear retailer
Mr Porter advertises at the heart of
London's Canary Wharf underground
station to capture the attention of
thousands of daily commuters.

2.4
Women's fast fashion online store
Fashion Union advertises to female
commuters at London's Green Park
underground station.

2.5
Outdoor advertising for Emporio Armani.

2.6
Larger-than-life outdoor advertisements
are placed in high-traffic locations to
attract thousands of passersby.

2.7

WHAT IS PR?

In the world of fashion promotion, PR is typically a part of marketing used to optimize consumers' positivity towards brands and products. Although PR activity often results in the production of tangible, promotional outputs (such as media coverage), its principal aim is to create a constructive conversation about brands, including recommendations from influential individuals whose blessing convinces potential customers to bring the approved brands into their lives.

Historically, advertising and PR were understood as separate practices. Advertising was easily identifiable through its formula of slogans and visuals, clearly demarcated ad breaks (on TV and radio), physical placement within public spaces or print media, and distinctive production values that helped it stand out from editorial content. The outcomes of PR activity were harder to spot: a brand mention in a news story or a reference to a product in a magazine feature about essential winter wardrobe items might have been coincidental, or the result of a PR practitioner's communications with editors. But because PR is concerned with so much more than this type of media relations, it is a lot easier to identify what PR does, than what it actually is.

" PR IS TYPICALLY A PART OF MARKETING USED TO OPTIMIZE CONSUMERS' POSITIVITY TOWARDS BRANDS AND PRODUCTS."

2.7
Captive audience? Mobile devices offer limitless opportunities to advertisers who understand exactly how consumers use them.

BLOGGERS: THE IMPORTANCE OF THIRD PARTIES

Parties are crucial to fashion PR, enabling media and brands to see, be seen, and schmooze in an informal setting where artfully constructed confidences can help shape editorial decisions. But more important still are "third parties"—what PR practitioners call "opinion formers" or "social influencers." These are individuals who speak on behalf of fashion brands, ideally without any direct incentive to do so. Bloggers, journalists or simply well-connected movers and shakers whose word—either in person, or via social media—can have a dramatic effect on brand reputation. Third-party endorsement is the holy grail of fashion PR, the tactful, apparently truthful counterpart to advertising's boastful bluster. As legendary US fashion publicist Kelly Cutrone told the *New York Times* in 2009: "Do I think, as a publicist, that I now have to have my eye on some kid who's writing a blog in Oklahoma as much as I do on an editor from *Vogue?* Absolutely."

2.8

2.8
Influential fashion blogger Chiara Ferragni pictured with Michael Kors at the designer's Milan store opening, December 2013.

2.9

2.9
Sneakerheads waiting for a new drop at London's Footpatrol store. Buzz built by influencers on social media will have driven some fans to camp out all night.

THE DEVELOPMENT OF INTEGRATED FASHION ADVERTISING AND PR

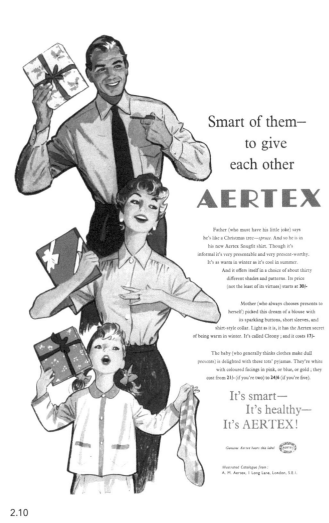

2.10

2.10
1950s UK Aertex magazine advert.

" IN THE CONTEMPORARY PROMOTIONAL REALM, ADVERTISING AND PR ALMOST UNIVERSALLY WORK HAND IN HAND"

In a 1693 English trade manual, author John Houghton recommends a wig-maker "that pretends to make perukes [wigs] extraordinarily fashionable." In 1879, the *New York Times* claims this as one of the first examples of printed fashion advertising. Today, it is more recognizable as an editorial mention generated through media relations, where a journalist writes about a brand following information received from a PR practitioner. Much like ourselves, readers of the 1693 publication would not have known if the wig-maker had paid to have his service advertised, or simply been the fortunate recipient of an influential third party's glowing praise.

Proponents of PR would argue that third-party recommendations—such as positive newspaper reviews of a designer's collection, or Instagram selfies showing celebrities sporting their latest accessories—are a more powerful means of promotion than traditional advertisements. This, they might argue, is because we are more likely to believe that a product is desirable if we are told it is so by a trusted or liked individual or publication, than if we are delivered a similar message by the product's manufacturer.

In fact, this distinction is misleading. In the contemporary promotional realm, advertising and PR almost universally work hand in hand, with the skills of their respective practitioners combining to create more compelling communications than either could produce in isolation. "Integrated" is a relatively new term used to describe this approach, but advertising and PR have been working together for many decades. For example, in 1953, a promotional campaign for the British menswear brand, Aertex, combined display advertising in more than 800 local newspapers with core PR activities: a mannequin parade in London's Savoy Hotel and a window display competition for retailers (Jobling, 2014: 39).

INTERVIEW: OLIVIERO TOSCANI – FASHION ADVERTISING'S ORIGINAL BAD BOY

2.11

2.11
Oliviero Toscani, Benetton
art director between 1982
and 2000.

Photographer Oliviera Toscani began working as art director for the Benetton Group in 1982. His campaigns were widely criticised as exploitative, offensive or otherwise inappropriate for the purpose of advertising a clothing brand. Here he discusses his approach to photography, advertising, and fashion.

You have said that photography is "the memory of human history." How does this relate to fashion photography, which is rarely documentary in approach?

Everything is documentary. Love, hate. Anything can be documentary. Fashion too is documentary, why not? It is one of the expressions of humanity.

Which of your photographs or campaigns produced for a fashion brand do you think is the most successful, and why?

I never took photographs for a fashion brand, I just made pictures of what my imagination wanted me to do. Of course, art needs power and power needs art. Industry needs imagery and imagery needs industry to express itself. Michelangelo didn't believe in God but he painted the best Madonnas. Artists need power, they need media. I didn't work for fashion, but fashion magazines gave me the opportunity to get my work published.

What do you think of fashion photography that stages grotesquely imagined scenes with the intention to shock?

People shouldn't be shocked by an image, they should be shocked by the reality. You should be aware that not everyone thinks about shock in the same way that you do.

Which photographers working in the world of fashion do you admire, and why?

I don't really care about fashion photographers, I care about images. My inspiration is the German photographer, August Sander (1876–1964), but he was working at the beginning of the twentieth century.

What fashion brands do you think are making original, exciting work?

Well, what is fashion? Is it Armani or is it Benetton? Aren't they just an industry? Cars are fashion too, food is fashion. Clothing is just one part of it.

Are there any up and coming photographic talents in the fashion world that you think are worth following?

I don't know about the future. Everybody now is conforming, looking for consensus, looking for success, looking for publication. Young people know everything about the past and the present through their computers, but if you can't imagine the future, you cannot make good pictures.

Do you think the world will ever again see a campaign as controversial as those you did for Benetton, and why?

Anything that's new generates controversy...all I can say is that I hope so.

2.12a

UNITED COLORS
OF BENETTON.

2.12b

2.12a–2.12b
Benetton's controversial images, shot by the
brand's art director Oliviero Toscani, took a
revolutionary approach to fashion advertising,
showing how it could succeed in raising brand
awareness without the need to show models,
or even garments.

CASE STUDY:
CALVIN KLEIN "SHOW YOURS. #MY CALVINS" CAMPAIGN

Calvin Klein is a globally recognized fashion brand with a long history of highly successful—and sometimes controversial—promotional campaigns. In a 1980 TV ad for the brand's jeans, a 15-year-old Brooke Shields delivered the memorable line "Do you know what comes between me and my Calvins? Nothing." And in 1992, a youthful Kate Moss posed topless with actor Mark Wahlberg for CK underwear. While these campaigns are prominent within the history of fashion promotion, all took a traditional approach: famous, attractive individuals, shot by renowned photographers with the results placed in high-value print and broadcast advertising space.

Fast forward to February 2014, and Calvin Klein debuts a global "omni-channel" campaign to promote its iconic underwear. Described as a "multi-tiered initiative that maximizes the conversation around Calvin Klein Underwear by leveraging existing consumer behavior," the campaign hijacks the "selfie" phenomenon (where a self-portrait taken with a camera phone is distributed via social media), encouraging members of the public to share photographs of themselves showing off their Calvin Klein underwear. The campaign coincides with the launch of the brand's Calvin Klein Dual Tone line.

2.13

2.13
A young Brooke Shields poses for photographer Richard Avedon in Calvin Klein's early 1980s print advertising.

2.14
Photographer Steven Klein's provocative image for the Calvin Klein 2014 "show yours. #mycalvins" campaign generated thousands of similarly saucy selfies uploaded to Instagram and Calvin Klein's dedicated campaign microsite.

show yours. #mycalvins
see the pics at mycalvins.calvinklein.com

2.14

Calvin Klein references Brooke Shields' 1980 advertisement by publicizing the hashtag "#mycalvins," and in order to "maximize the conversation":

- provides underwear to celebrities, including supermodel Miranda Kerr and musician Trey Songz, and urges them to post selfies to Twitter and Instagram using the #mycalvins hashtag
- uses the #mycalvins hashtag prominently in a limited array of billboard advertising (shot by Steven Klein) and a 16-second film, which also incorporates the semi-naked torso of an unidentifiable male model.

The tagged celebrity images are widely circulated online via social media, news websites, and blogs, and prompt (mainly male) members of the public to produce and distribute their own. In the 24 hours since the first celebrities posted their photos, the brand observed more than one million fan interactions among a target audience of over 50 million. The brand subsequently added many of the public and celebrity selfies to its social media platforms and activated a "digital campaign hub"—mycalvins.calvinklein.com—to aggregate influencer and user-generated content. The hub also allows users to shop the styles featured in the selfies.

It demonstrates an impressive grasp of contemporary PR strategy and tactics in the following ways by:

- making reference to the brand's heritage (by referencing the infamous 1980 Brooke Shields ad campaign)
- creating a memorable hashtag to enable public and brand to follow the conversation and track user interactions
- working with celebrities outside of the context of a major "above-the-line" ad campaign
- using an existing cultural phenomenon (the selfie) for promotional purposes.

Trendhunter.com, the world's largest online trend community, commented: "The combination of the prominent branding on the waistband of the underwear, the participation of public figures, sex appeal, and encouraging people to snap a selfie for a chance to be featured in the exclusive online gallery makes it a winning one."

2.15
George, the fashion line of British supermarket chain Asda (part of the Walmart group) sponsors Graduate Fashion Week in the UK as part of its corporate social responsibility activity.

2.15

TYPES OF FASHION PR ACTIVITY

PR activity takes many forms, but most activities take place under the following categories:

MEDIA RELATIONS

Creating and maintaining relationships with journalists and other commentators in order to elicit positive media coverage of a brand.

PUBLICITY

Providing information about products and/or personalities with the aim of generating targeted media coverage, often using press releases or more extensive media kits compiled specifically for the purpose.

EVENTS, STUNTS, AND SPONSORSHIP

Activities (such as catwalk shows, sponsored concerts, and sporting events) undertaken either as part of an ongoing or seasonal program of promotional activity, or as one-off "stunts" tied to other PR activities in order to boost brand image. *(Events are covered in more detail in Chapter 7).*

CRISIS MANAGEMENT

Communications activity undertaken in order to help ameliorate threats to brand image. Such threats may arise from diverse sources. Product malfunction; inappropriate or offensive remarks from key brand personnel; manufacturing problems; or culturally insensitive collections may all precipitate crises for fashion brands. Crises generally arise from unexpected sources: in 2011, French luxury brand Lacoste allegedly asked Norwegian authorities to prevent mass murderer Anders Breivik from wearing its products during trial proceedings in an attempt to reduce harm to the brand's reputation.

ADVERTISING AND MEDIA TYPES

Advertising takes many forms and is used for a variety of subtly different purposes. In addition, advertising and PR use different forms of media in different ways, defined within the contemporary promotional environment as "paid," "owned," and "earned" media. The following tables describe the different purposes of advertising and the different media types.

THE MAIN TYPES AND USES OF ADVERTISING

Type of advertising	Objective
To inform	Launching a new product Suggesting new uses for an existing product Explaining product functionality Announcing price change Correcting misinformation Allaying customer misgivings Building positive brand image
To persuade	Encouraging brand or product switch Developing brand preference Offering reasons to purchase now Changing perceptions of a product
To remind	Maintaining customer relationships Reminding that they may need a product soon Reminding where to buy Keeping product in mind when it is not seasonal

Source: Armstrong, G. and Kotler, P., *Marketing: An Introduction* (10th ed.) Prentice Hall.

2.16

PAID, OWNED, EARNED, AND SOCIAL MEDIA

In 2009, the research company Forrester defined
a simple set of terms designed to help marketers
segment their media options in an increasingly
fragmented media environment. They classified all
existing types of media as either paid (or bought),
owned or earned, providing a useful table of the
terms' meanings and examples of the role, plus the
benefits and challenges of each media type. It is
worth noting the extent to which owned and paid
media are considered to be catalysts to generate
earned media. Today's marketers also now add
social media to the mix, which typically crosses
over into all the other categories.

2.16
Vox pops and more structured interviews
can provide compelling content for paid,
owned, earned, and social media.

Media type	Definition	Examples	The role	Benefits	Challenges
Owned	Channels controlled by the brand	Websites Catalogues Mobile sites Blogs	Build longer-term relationships with existing potential customers and earn media	Control Cost efficiency Longevity Versatility Niche audiences	No guarantees the customers will engage Company communication not trusted Takes time to change the scope and scale of these channels
Paid media	Brand pays to be featured within a media channel	Banner ads Display ads TV/radio spots Paid search Sponsorships Print and outdoor advertising Advertorial Native advertising Paid endorsement	Increase brand awareness, drive sales and feed owned, earned and social media	In demand Immediacy Scale Control	Clutter Declining response rates Poor credibility Customers may opt out of viewing
Earned media	Media coverage generated outside the brand's owned or paid-for channels	PR coverage Word of mouth/ buzz Viral coverage Influencer engagement	To generate third party recommendation – earned media is often the result of well-executed and well-coordinated owned and paid media	Most credible Key role in most sales Transparent and lives on after paid-for campaigns have expired	No control Can be negative Hard to measure
Social media	Brand mentions in the full range of social media channels both within, and outside of the brand's sphere of influence	Twitter account Facebook page Message boards The blogosphere	Spread brand and/or product awareness rapidly Facilitate dialogue between customer and brand	Two-way communication Allows brand to quickly gauge customer response Immediate	No control Can be negative Hard to measure

HOW TO WRITE A PRESS RELEASE

Ever since the first press releases were sent to journalists in the twentieth century, these highly stylized forms of promotional communication have been at the core of media-relations activity. Today, they might be referred to as media or news releases, but format and content rules have remained largely unchanged in over 100 years.

Providing media with information in a way that is as close as possible in format to a news story helps PR practitioners to strip down their news to the main points, and helps journalists identify whether or not the story is relevant for their audience.

PRESS RELEASE WRITING TEMPLATE

Headline

Ref number here (e.g., PN2007/11)
Month, day and year here (in US style)
Write your eye-catching and informative headline here—try to stick to one sentence. Keeping your headline below 140 characters enables it to be used as a Tweet.

Paragraph 1
Main facts and including name of your brand/organization and whatever product/service/event you're announcing. Try to use the "5 Ws + H" rule: who, when, where, what, why, and how. Make sure you include detail—don't say "many", say precisely how many. Don't say "recently", say exactly when.

Paragraph 2
Supporting information in a descending hierarchy of importance that backs up the claims in your first paragraph. Relate the most exciting and newsworthy aspects of your event or service first.

Paragraph 3
The third paragraph in a standard press release generally adds a comment from a senior figure, which journalists can use as a quote to support their news story if they lack the time or inclination to interview someone. Make sure your quote sounds human, that you attribute it to a named person, and provide his or her job title.

Final paragraph
This is your chance to sum up the release, but never leave important information until this paragraph. Traditionally, subeditors cut material from the bottom up. Never save a "nugget" for the end—it's a press release, not a short story!

Ends *(let journalists know this is the end of the release)*

End material
Press contact: *(who should the journalists get in touch with if they want more information?)*
This is also a good place to mention if images or photographs are available. Never attach them to the release—journalists won't take kindly to receiving large files or attachments over email!

Notes to editors
1. This information is often referred to as "boilerplate" information on the company—when it was launched, where it's headquartered, any particular accolades or achievements, its main areas of activity, etc.—and any additional information not provided in the body of the release.
2. The "notes to editors" can also include information about any other companies or organizations involved in the story.

(With thanks to Anna Cope)

GOING NATIVE: THE FUTURE OF ADVERTISING AND PR

With consumers becoming increasingly selective about the types of promotional content they choose to consume (and increasingly annoyed at advertisers' ever more desperate attempts to make them consume it), marketers are adopting novel methods to grab and maintain attention. Defined by the industry as "native advertising," it is proliferating at a rapid rate, claiming to offer advertisers a better return on investment than traditional print, broadcast, or even online advertising. Broadly speaking, the term describes advertising that integrates high-quality content into users' experience of any particular digital platform, with the aim of augmenting and enhancing user experience rather than interrupting or distracting from it.

If this sounds similar to traditional advertorial content (paid-for promotional content masquerading as editorial in print magazines), that's probably because it is. Only the types of content are more varied and, crucially, more interactive than ever before. While native advertising is generally clearly branded, and therefore largely understood by consumers to be promotional material, it aims to provide content that is impossible for consumers to bypass, and it emulates whatever platform the consumer is interacting with at the time. Some of the more straightforward examples include "promoted Tweets" appearing in a user's Twitter news feed, and Google Ads—advertising that tailors itself to a user's search preferences within Google. If a brand is seen by consumers to be delivering valuable content, it is more likely to be able to achieve its other objectives of informing, persuading, reminding, and, ultimately, selling the product.

2.17

2.17
Mobile technology has facilitated radical improvements in consumer targeting.

INTERVIEW: ADAM DRAWAS –
ON THE NEW FACE OF FASHION PR

2.18

LA-based VIP services consultant, Adam Drawas, operates in an emerging promotional niche combining brand development, experiential PR, and marketing, on behalf of fashion, beauty, sportswear, and other consumer brands. Here, he describes his role and how it differs from the traditional view of fashion PR.

2.18
Adam Drawas, head of eponymous celebrity fashion PR agency, Adam Drawas PR.

How do you describe your approach to fashion PR?

Basically, the world knows fashion PR as magazines and fashion shows. Well, I do everything else but those things. My role chiefly revolves around experiential PR, and arranging and publicizing VIP or celebrity brand partnerships—persuading well-known people to wear, be seen in, and talk about brands on social media.

How does your work differ from traditional endorsement work, where celebrities are paid to promote a brand?

More than 90 percent of the partnerships I arrange do not involve paying celebrities. They are arranged through my personal relationships with celebrities and an in-depth understanding of the mutual benefits for my clients and the celebrities, or other opinion-formers, that they partner with.

How do you promote awareness of the celebrity-brand partnerships that you negotiate?

After we've persuaded the right celebrity to use our clients' products, we work with more than 600 reputable photographic agencies worldwide to gain access to images showing the celebrity wearing the garments in public. It's then our job to saturate all of the appropriate news outlets, broadcasters, bloggers, and other online publications with these visual assets. Crucially, we also ensure that all images are properly credited with our brands' details and details of how customers can buy the products.

Do you ever use celebrities' own images for PR purposes?

Often, we also tap celebrities' own images posted on Instagram or Twitter, and help boost their circulation through reposting.

How do you determine the most appropriate celebrity partners for your brands?

It's quite straightforward to build a list of desirable celebrity partners for any particular brand, based on brand values and relevance to the target audience, but the challenge is to ensure that you select an individual who is likely to have good traction in the media when you need it. We don't want to waste our brands' products by sending them to individuals who are going out of the limelight. So it's our job to stay constantly on top of the TV, film, and music industries to ensure we have a detailed knowledge of relevant release schedules and know what's happening in the celebrity word before consumers do.

How do you actually get your clients' products to celebrities?

About half of our work is through celebrity stylists, with 20 percent going direct to celebrities. The remainder involves working through celebrities' publicists, managers or—if it is a paid partnership—their agents.

Are there any fashion brands whose promotional work you currently admire?

The sports fashion brand Lululemon ticks a lot of boxes with their comprehensive approach to social media, PR, and marketing, especially their experiential strategy which lets customers sign up to yoga classes in-store. The way they connect with their target audience in unconventional ways and have claimed ownership of the positive aspects of sweating make for some compelling promotional content.

CHAPTER REVIEW

The elements of fashion advertising and PR that we observe around us are merely the tip of an iceberg-sized industry, which develops and metamorphoses at incredible speed. Every minute of every day, billions of messages are communicated via these disciplines to millions of consumers worldwide. Many—indeed most of them—pass us by, but those that stick have a significant, albeit often unrealized impact on our brand preferences and purchase behavior. Ask anyone you know why they chose to buy a particular garment or accessory, and the chances are that the powerful messages produced by advertising and PR activity won't be mentioned. But scratch beyond the surface and it's almost certain that these all-pervasive promotional techniques and technologies were ultimately responsible.

2.19

QUESTIONS FOR DISCUSSION

1. Why do you think that the Calvin Klein 2014 "show yours. #mycalvins" campaign garnered more media attention than the previous year's "Show You're Jockey" [sic] campaign?

2. Do you agree with Zahn's (2011) assertion that fashion photography is "an especially fragmented, disparate, and confused genre"?

3. Does advertising's quest to attract attention and create differentiation between competing brands justify its use of grotesque imagery and/or subject matter, which some viewers may find offensive?

4. Do you think that fashion promotion practitioners can usefully draw a distinction between advertising and public relations?

2.19
"Adshel" (bus shelter) advertising occupies prime public space in London's Oxford Street, 2014.

CHAPTER EXERCISE

ONE

Consider a recent example of an integrated or "omni-channel" campaign that you feel was successful or unsuccessful. Write down:

» the brand or product involved
» whether the campaign prioritized owned, paid, or earned media
» how earned media contributed to the success or failure of the campaign
» how advertising was used in the campaign
» how PR was used in the campaign.

Next, consider the extent to which you felt the campaign was successful and why. Think about the possible campaign aims and how the different campaign elements worked together to achieve these aims. Was there one single campaign element that you felt was particularly successful? If not, how might you have done things differently?

TWO

Working in pairs, think about a recent crisis affecting a fashion brand. Note brief details of the cause of the crisis, how it developed, whether it was resolved, and what are (or might be) the consequences for the brand concerned. Next, consider your first actions after discovering that something had gone wrong, and the steps you would take to avert catastrophe.

THREE

Look through a selection of fashion magazines and note down the names of the brands whose advertising features heavily. See if you can find any examples of these brands being mentioned in editorial copy, or garments used in editorial shoots. Do you feel there is any evidence that paid-for advertising affects a publication's editorial judgment when selecting which brands to feature in editorial?

FOUR

Influencers play a crucial role in communicating advertising and PR messages for fashion brands. For any particular fashion sector (menswear, womenswear, streetwear, or children's wear), can you identify three important influencers and state why you think they are so influential? How do you think advertising or PR practitioners might measure how influential they are?

2.20

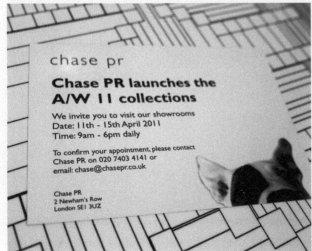

2.20
Printed invites remain integral to contemporary PR, despite the dominance of online communication.

03

THE CELEBRITY ROLE: FROM ROYALTY TO THE RAP GAME

Be they subtle or downright brash, fashion's relationships with the famous and infamous are long established as part of promotional practice. But although the use of celebrities may be a potent weapon in the fashion promoter's arsenal, research into its effectiveness is still maturing. Furthermore, the types of promotional activity undertaken by celebrities on behalf of brands have expanded significantly during the Internet era. Paid endorsements remain relevant today—often amplified via social sharing—but fashion promoters now enjoy access to a host of other ways of using celebrities to boost their brand's profile among an increasingly atomized consumer market.

3.1
Cara Delevingne (right) and DJ Chelsea Leyland (left) attend the Cara Delevingne Collection launch celebration at Mulberry Store on September 8, 2014 in New York City.

INTRODUCTION

Following definitions and a brief history of celebrity involvement in fashion promotion, this chapter probes existing research into the practice, shedding light on its effectiveness, and offering insight into how it works, with recent examples and commentary on the importance of social media in enhancing celebrity impact.

LEARNING OUTCOMES

By the end of this chapter you should be able to:

» understand the meaning of celebrity within the promotional environment
» understand the historical context of contemporary celebrity-linked promotional activity
» recognize the different reasons for using celebrities in promotional activity
» understand how celebrities may affect brand image
» understand how fashion promotion practitioners use celebrities in the real world.

THE MEANING OF CELEBRITY

Celebrity status can be attributed to a whole continuum of people within the public eye, from high-status, glamorous or skilled individuals through to the most infamous: serial killers and those best known for committing lewd acts. No longer simply a media phenomenon, celebrity is now the subject of intensive academic scrutiny, with its own classification system:

- Ascribed: derived from lineage or inheritance (e.g., Jackie Kennedy; Jade Jagger)
- Achieved: derived from exceptional achievement (e.g., Beyoncé; David Beckham)
- Attributed: "famous for being famous"—more recently described as "celebutants" (e.g., Paris Hilton)
- Celetoid: derived from reality TV but requiring continual drama and re-enactment (e.g., Kim Kardashian)
- Celactors: fictional characters (e.g., James Bond; Carrie Bradshaw from *Sex in the City*).
 (Rojek, 2001)

However, many celebrities are difficult to pigeonhole. For example, the Kardashians rose to prominence due to their father's role as defense attorney in the 1995 murder trial of American football star, O. J. Simpson, so their fame could partly be attributed to lineage (ascribed celebrity). The sisters have since featured in reality TV shows as celetoid celebrities, but Kim is now perhaps most famous for a pornographic home movie made with then boyfriend, the rapper Ray J, and subsequently, her marriage to Kanye West—typical "attributed celebrity" territory. As Ellis Cashmore (2006: 205) notes: "The distinction between ascribed, attributed, and achieved celebrity has been not so much blurred as erased."

3.2
Kim Kardashian—TV personality, fashion designer, model, actress, porn star: celebrity. Pictured with designer Riccardo Tisci attending the CR Fashion Book Issue No.5 Launch Party at The Peninsula Paris, France, on September 30, 2014.

3.3

THE ORIGINS OF CELEBRITY IN FASHION

Long before the nineteenth century emergence of fashion branding—where European couturiers first "branded" their garment using name labels—influential individuals sought out the most reputable dressmakers, milliners, and glovers as a guarantee of quality. In these relationships, both artisan and customer benefitted from making their association known by word of mouth. While celebrity involvement in fashion promotion is now commonplace, a brief overview of its roots highlights how the original, often serendipitous, associations have transformed into a distinct and virtually ubiquitous commercial promotional practice.

3.4

USING ROYAL CONNECTIONS

Charles Worth is commonly cited as an early exponent of celebrity endorsement. Having opened his first shop in Paris in 1858, the couturier lured in Princess Pauline von Metternich—wife of Austria's ambassador to France—as a client to draw the attention of the French royal court. Having noticed Pauline wearing one of Worth's creations, Emperor Napoleon's wife, Eugénie de Montijo, ordered Worth to supply her with a selection of gowns, one of which Napoleon encouraged her to wear as a means of promoting the Lyon silk industry. Eugénie's taste gained a popular following at court, and Worth's reputation was made.

3.3
Empress Eugénie of France, one of the first celebrity fashion brand endorsers.

3.4
Nineteenth-century Charles Worth garment label. Worth is credited as the first designer to use branded labels on garments.

THE VALUE OF THE ROYAL WARRANT

3.5

3.6

Arguably one of the earliest forms of celebrity endorsement, royal warrants first emerged in England in 1155, though the first known holder was haberdasher Reginald de Thunderly, who received the accolade in the year 1300 from King Edward I. Some historians believe the original purpose of royal warrants was to reward tradespeople responsible for improving the appearance and dignity of the British royal family in the face of competition from increasingly elegant European monarchies. Today, a royal warrant allows a company that has supplied any type of goods to the royal family for at least five years to display a royal coat of arms on its product and marketing materials as evidence of this relationship. Many of the historic British clothiers granted royal warrants—such as Burberry, Hunter Boots, John Lobb, Wolsey, Tricker's, and John Smedley—are now highly successful fashion brands, as heritage, quality, and provenance perform an increasingly important role in fashion promotion.

Opinions vary as to the promotional value of the royal warrant, but they may offer brands competitive advantage by signifying a satisfactory trade relationship with some of the world's most famous—and quality-conscious—individuals. However, a fashion brand need not hold a royal warrant to profit from royal associations. Aside from her Alexander McQueen wedding dress, Catherine, Duchess of Cambridge, has lent inestimable prestige to several European mainstream brands without royal warrants, including Orla Kiely, LK Bennett, Zara, and Reiss. Her fashion choices are said to have had dramatic effects on the sales of products from these and other retailers.

3.5
The royal warrant displayed prominently outside Burberry's London Bond Street store.

3.6
Wearing a sapphire blue dress by UK mainstream brand, Reiss, Catherine, Duchess of Cambridge is greeted by children as she officially opens The Treehouse Children's Hospice on March 19, 2012 in Ipswich, England.

3.7

FROM ROYALTY TO THE RED CARPET

As designers metamorphosed into brands throughout the twentieth century, they sought new ways to differentiate their products, becoming less reliant on propositions predicated on value and quality, in favor of emotional associations with talented or notorious personalities. In 1927, the Sears catalogue included a display ad for inexpensive Clara Bow Hats modeled by the Paramount actress.

However, not only was Hollywood considered somewhat vulgar by many designers and fashion followers, but until the demise of the studio system in the 1960s, virtually all United States movie stars' sartorial needs were catered for by costumiers. These included MGM Studios' Adrian Greenberg (responsible for Joan Crawford's famous 1932 *Letty Lynton* gown, which reportedly sold one million copies in America), Paramount's Travis Banton, and the most celebrated Edith Head, who worked for Paramount and Universal. Not only were studio costumiers responsible for all leading characters' on-screen attire, but also movie première and award ceremony gowns.

3.7
Edith Head, Hollywood costumier and holder of the record for the most Oscar wins by an individual woman—she received eight in total.

3.8

A notable exception to the dominance of Hollywood costumiers was designer Hubert de Givenchy who, in 1953, was introduced by Paramount studios to Audrey Hepburn, about to star in a new movie, *Sabrina*. After initial reservations, Givenchy and Hepburn developed a relationship that led to the designer providing costumes for several Hepburn movies, most famously, *Breakfast at Tiffany's*.

With the advent of television in the 1950s, and the Hollywood Antitrust Case forcing studios to sell off their cinemas, a financial downturn for the movie industry led to many studios sacking their costumiers. In addition, the creeping influence of realism in movies led to more "everyday" attire replacing chinchilla fur or sequined gowns. Luxury brands eager to benefit from these evolving representations of glamour seized upon such developments, with Giorgio Armani at the forefront. So crucial were Armani's designs to the memorable aesthetic of the cult 1980 Richard Gere movie, *American Gigolo,* that the influential website Clothes On Film wrote: "*American Gigolo* is not even about its protagonist; it is about what he wears. *American Gigolo* is about Armani."

From film costumier to celebrity stylist, Armani quickly became the go-to designer for Hollywood A-list red-carpet attire, providing outfits for twelve actors at the 1990 Oscars ceremony—an event dubbed the "Armani Awards" by trade publication *WWD*. *Vogue* editor-in-chief Anna Wintour declared it "a revolution… Armani gave movie stars a modern way to look."

3.9

3.10

3.8
Audrey Hepburn, wearing a Givenchy gown, at the 26th Annual Academy Awards at the Pantages Theater in Hollywood, California on March 25, 1954.

3.9
Giorgio Armani and Michelle Pfeiffer during the 21st Annual Night of Stars in New York City, 2004.

3.10
Richard Gere wearing an Armani ensemble in the 1980 film, *American Gigolo*.

3.11

INTO THE TWENTY-FIRST CENTURY

Since the 1990s, relationships between luxury brands' creative directors and Hollywood royalty have proliferated. Many of these relationships follow the artist-muse form exemplified by Givenchy and Hepburn. Pairings include Sofia Coppola and Marc Jacobs, with Coppola collecting an Oscar in 2003 wearing a Marc Jacobs purple dress, and posing topless the same year for an ad for the Marc Jacobs fragrance, Blush. In 2013, Jacobs invited Coppola to work on the advertising campaign for his Daisy fragrance, tweeting at the time: "Best friends make magic together: Our dearest Sofia Coppola will be directing the Daisy TV ad campaign this Fall!"

Anne Hathaway and Valentino are similarly linked, since first meeting in 2005, with Valentino designing Hathaway's dress for her 2012 wedding. Jennifer Lawrence and Dior have a long-running relationship since Dior's creative director, Raf Simons, selected her as the face of the brand's advertising in 2012. Likewise, Cate Blanchett supposedly signed a ten-million-dollar contract with Armani in 2013 to appear as the face of Armani fragrance—a deal considerably more valuable than Brad Pitt's reported seven-million fee to endorse Chanel fragrance in 2012, and dwarfing a similar three-million arrangement made in 2010 between *Gossip Girl* star Leighton Meester and Vera Wang. While these associations appear to have been healthy for the brands involved, far less successful was the arrangement between Ungaro and Lindsay Lohan. The actor's 2009 role as artistic adviser to designer Estrella Archs was roundly deemed disastrous (Odell, 2009).

3.11
Film director and actor Sofia Coppola with designer Marc Jacobs backstage at the Marc Jacobs SS2009 Fashion Show in New York City.

WHY USE CELEBRITIES?

Celebrities are used in a multitude of ways by fashion promoters for many different purposes, depending on the specific marketing needs of their brand at any particular point in time. The table below describes the most common ways in which celebrities are used to help promote fashion brands.

EIGHT TYPES OF CELEBRITY-BRAND RELATIONSHIPS IN FASHION

How celebrity is involved	Examples
Paid-for advertising to mass audiences—known as "above the line" advertising. Professional models have traditionally dominated this category of endorsement, but designers are increasingly using high-profile musicians, entertainers, and others (including a return to celebrity models) to front major advertising campaigns	SS2014 brand advertising campaigns Erikah Badu (Givenchy) Elle Fanning and Lupita Nyong'o (Miu Miu) A$AP Rocky (DKNY) Miley Cyrus (Marc Jacobs) Rihanna (Balmain) Lady Gaga (Versace)
Infomercial, advertorial, direct mail, or online advertising to niche or tailored audiences—known as "below the line" advertising	Azealia Banks for T by Alexander Wang fashion film, (2012)
Paid or unpaid product placement, where celebrities wear fashion brands in film, TV, reality shows, or in "real life" (where they may coincidentally or otherwise be "papped" by press photographers). Websites like possessionista.com make it easy for consumers to identify and emulate celebrity looks	Anne Hathaway wearing Tiffany jewelry to the 2011 Academy Awards ceremony Beyoncé appearing at Kanye West's birthday in 2013 wearing Topshop
Paying for (or otherwise taking advantage of) brand mentions in song lyrics	Jay-Z: "Tom Ford" (2013) Migos/Drake/Meek Mill/Tyga: "Versace" (2013)
Celebrity/brand design collaborations	Madonna for H&M (2007) Rihanna for River Island (2012–2013)
Naming products after celebrities	Mulberry's "del Rey" (2012) and "Alexa" (2009), and Hermés "Birkin" handbags (1982)
Social media endorsement, which may comprise part of a wider endorsement deal	Calvin Klein #mycalvins campaign (2014) Endorsed Tweets, such as those sent by Kim Kardashian about Reebok EasyTones (2009)

DOES CELEBRITY PROMOTION WORK?

Today's celebrity fashion associations span the continuum from Hollywood's highest earners to reality show "wannabees", all of whom have a specific niche of interest to fashion brands. But how do brands select their stars, measure effectiveness of endorsements, and deal with damage limitation when human frailty threatens credibility and profit?

3.12

FROM EMULATION TO MEANING TRANSFER

Many academics have investigated the reasons for the ongoing appeal of celebrity. Early research established the "source credibility" and "source attractiveness" theories, originally devised to help understand how certain individuals were able to communicate more persuasively than others, through either their level of perceived credibility, or their appearance (Howland and Weiss, 1951; Baker and Churchill, 1977). These theories were later applied to the study of endorsement effectiveness (Ohanian, 1991). However, in his 1989 critique of these theories, academic Grant McCracken proposed an alternative: the "meaning transfer" model, whereby celebrities' effectiveness as endorsers "stems from the cultural meanings with which they are endowed" (McCracken, 1989). In McCracken's model, "meaning" comes from celebrities' persona, attributes, and achievements including any stage and screen roles. This is then transferred by consumers to any products associated with the celebrity, either through endorsement contracts, or less formally—for example, when a garment is worn in a movie, or at high-profile events. The process of meaning transfer is complete when consumers use the meanings thus transferred to help construct their own identities by wearing identical (or similar, lower-priced) garments to those associated with—and given meaning by—celebrities.

MEASURING RETURN ON INVESTMENT

Since the late 1980s, research into the economic value of celebrities for apparel brands has become increasingly sophisticated. Two of the key determinants of celebrity choice—credibility and performance—are easiest to ascertain within the field of sport. For this reason, much of the academic research into the economic effectiveness of celebrity endorsement focuses on deals involving professional athletes and sport/fashion brands. In a 2012 study of 341 sports celebrity endorsement deals, Anita Elberse and Jeroen Verleun found that endorsement added on average ten-million-dollars worth of sales annually for the brands involved, raising average weekly product sales by 4 percent.

3.12
Novak Djokovic—then the world number one tennis player—endorses match wear by the Japanese fast fashion brand, Uniqlo.

3.13
Solange Knowles wearing H&M. Sport and futurism were the themes at the H&M Studio show for AW2015, held at the Grand Palais in Paris on March 4, 2015.

3.14

CHOOSING AND USING YOUR CELEBRITY

While the commercial sensitivity of brands' celebrity choices preclude accurate pronouncements on the reasons for their selections, today's brand-celebrity partnerships are likely to be derived through a combination of market research, celebrity availability, and—perhaps most importantly for paid endorsements—budget. Given the high fees involved in such deals, the extent of research into this area seems appropriate, although to date, little firm evidence exists to suggest a fail-safe formula for fashion brands seeking the perfect celebrity fit.

3.14
Photographer and celebrity David Bailey collaborated with London design agency, The Bleach Room, on a collection of T-shirts, which themselves also feature other celebrities including Grace Jones.

BRAND-CELEBRITY "MATCHUP"

Much research into celebrity endorsement focuses on how the "fit" or "matchup" between brand and the celebrity's image affects consumers' attitudes towards brand and intent to purchase. A good fit between celebrity and brand is generally considered to add to the persuasiveness of any endorsement, and it may also increase the celebrity's trustworthiness and appeal. Predictably, a bad matchup is likely to have negative consequences (Erdogan, 1999), and can also result in the celebrity's personality overwhelming the brand. In addition, events, both positive and negative, affecting the celebrity's social or professional life, are likely to have significant impact on associations with endorsed products (Till & Shimp, 1998).

> " A GOOD FIT BETWEEN CELEBRITY AND BRAND IS GENERALLY CONSIDERED TO ADD TO THE PERSUASIVENESS OF ANY ENDORSEMENT, AND IT MAY ALSO INCREASE THE CELEBRITY'S TRUSTWORTHINESS AND APPEAL."

DOES INVOLVEMENT COUNT?

Moving beyond the realm of typical endorsement activity, researchers Astrid Keel and Rajan Nataraajan have investigated other forms of celebrity marketing including celebrity-branded product lines, exploring the factors contributing to the success of celebrity-branded products. The researchers highlight the variety of celebrities' involvement in the product ranges they endorse. Victoria Beckham and Elle Macpherson are cited as examples of highly involved celebrities in their respective dVb luxury fashion and Elle Macpherson Intimates lingerie lines. As yet, there is no consensus on exactly how celebrity involvement in branded fashion products affect brand attitudes, purchase intent, sales, and the longevity of the brand (Keel & Nataraajan, 2012).

PICKING THE RIGHT PERSON

Research into the industry perspective on choosing celebrity endorsers shows that although practitioners are unlikely to consult theoretical models, they instinctively use some common criteria in making these important strategic decisions, with five main areas typically considered:

- Does the celebrity have congruent associations with the product/brand/target audience?
- Is the celebrity credible?
- What is the celebrity's profession?
- Is he or she popular?
- Can we obtain (and afford) his or her service?

3.15

NEW CELEBRITY TYPES

No doubt, celebrities by birth or by achievement still command the most lucrative endorsement deals, but just as Internet entrepreneurs have stealthily joined captains of industry atop the world's rich lists, other types of celebrity are joining the endorsement jet set. For example, celebrities engaged by Calvin Klein for its 2014 "show yours #mycalvins" campaign have included: musicians Trey Songz, Fergie and Iggy Azalea; models Miranda Kerr, Vanessa Axente, Clark Bockelman, Garrett Neff, Liu Wen, and Matt Terry; bloggers Rumi Neely (Fashiontoast), Aimee Song (Song of Style), Bryan Grey Yambao (BryanBoy), Adam Gallagher (I Am Galla), Betty Autier (Le Blog de Betty), Gala Gonzalez (Inside Am-lul's Closet), and Jennifer Grace (The Native Fox); as well as digital influencers, such as Poppy Delevingne and Hanneli Mustaparta.

3.16

3.15
Eighty-year-old novelist Joan Didion—the original cool girl—was named in 2015 as the new face of French luxury brand, Céline.

3.16
Photographer, blogger, stylist and model Hanneli Mustaparta is one of the new breed of multidimensional digital influencers much admired by fashion brands.

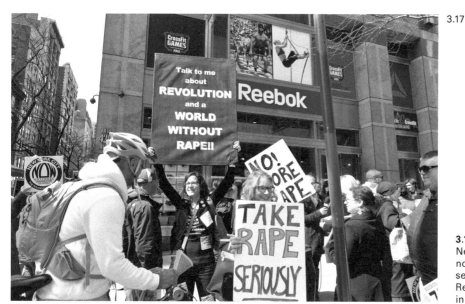

3.17

3.17
New York City protest against Reebok for not firing rapper Rick Ross over allegedly sexist and violent lyrics outside the Reebok Flagship Store on April 4, 2013 in New York City.

CELEBRITIES BEHAVING BADLY

Tales of celebrities losing multimillion-dollar endorsement contracts are not uncommon. Drug taking, marital infidelity, and other criminal activities are unlikely to endear a celebrity to a major brand, especially when that brand trades on a clean-cut, high-class image, as do most luxury and sportswear brands. The increasing use of insurance to mitigate against bad behavior by celebrities, and the mini-trend towards using deceased celebrities (e.g., Steve McQueen for Puma), or even cartoon characters, offer several indications of the extent of this issue as a concern for brands (Thwaites et al., 2012).

THE DEMISE OF RICK ROSS AND REEBOK

In April 2013, Reebok ended its partnership with US rapper Rick Ross due to concerns about lyrics on one of his tracks purported to condone date rape. In a statement, Reebok said: "Reebok holds our partners to a high standard, and we expect them to live up to the values of our brand. Unfortunately, Rick Ross has failed to do so." News reports in early 2014 continued to question the status of Ross's endorsement deal, with the rapper continuing to wear Reebok products, describing his relationship with the brand in a 2014 interview with *Huffington Post Live* as "super cool."

Research into the impact of celebrity misbehavior on the brands they endorse is in its early stages and while there is some evidence to support the assertion that criminal, or morally questionable, activities may damage a brand's reputation and profits certainly in the short term (Thwaites, et al., 2012), there is also contrary evidence to suggest that to some degree, notoriety may bring positive meaning to brands in certain circumstances (Donaton, 2002). For example, in the Reebok case above, the brand sought to distance itself from the rapper due to public outcry about one specific lyric, even though the general content of Ross's lyrics appears to celebrate a criminal lifestyle, and must be assumed to have been part of the original attraction of Ross as an endorser.

INDUSTRY PERSPECTIVE:
THE FUTURE OF CELEBRITY IN FASHION PROMOTION

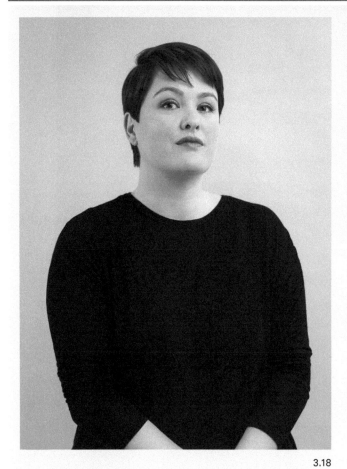

3.18

Ruth Marshall-Johnson, is an independent trend and consumer insight specialist who has previously worked for leading industry trend forecaster and brand consultancy, WGSN. Here, she suggests how the future of celebrity endorsement in fashion might appear.

"While there will always be a place for the expertly crafted ad campaign featuring beautiful people, some brands are beginning to distance themselves from using celebrities as a default approach to promotion, opting instead for more creative, narrative approaches to their promotional storytelling.

"This may take the form of producing their own literary characters or imaginary figures to front campaigns, or simply avoiding human presences altogether. US surf and lifestyle brand Hollister, for example, infamously created an imaginary heritage, using clothing labels bearing the date "1922," despite having been founded in 2000 as an offshoot of sister company Abercrombie & Fitch.

"Where brands continue to involve well-known individuals in their promotional campaigns, it seems likely that these could be creative people who are well known because of genuine achievements in diverse areas outside the realm of sport and entertainment: political activists, visual artists, craftspeople, and scientists. Some of these are likely to be older, and more experienced—already older female actors, models, even authors—are emerging in fashion brand advertising, such as 64-year-old actor Jessica Lange fronting Marc Jacobs Beauty and 82-year-old Jacquie Tajah Murdock appearing for Lanvin.

"Brands may also elevate more non-celebrities to promotional roles—using people involved in their manufacturing, for example—such as the older female knitters Margaret and Valerie featuring in Mulberry's 2012 film *Spinning a Yarn*."

3.18
Ruth Marshall-Johnson is co-founder of COIN Research, a research and insight consultancy specializing in brand development and marketing innovation. She has previously worked for leading fashion industry trend forecaster, WGSN.

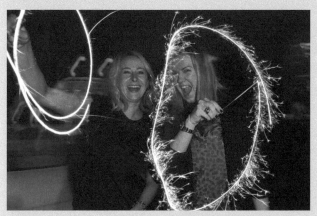

3.19

3.20

Mulberry and Cara Delevingne
Founded in 1971, British luxury brand Mulberry first linked with celebrities in 2009, when then Creative Director Emma Hill persuaded Alexa Chung to put her name to a handbag. Since then, Mulberry has successfully attracted A-list celebrities to its catwalk shows and used renowned British fashion photographer, Tim Walker, to photograph its iconic advertising campaigns.

Working with celebrities: Vanessa Lunt, Group PR & Events Director, Mulberry
"Celebrities are hugely important to fashion brands because consumers seem to identify with the notion of patronage. It's crucial, therefore to work with real luminaries who are 'on brand' and share similar values to yours. At Mulberry, we have followed our 'del Ray' and 'Alexa' bags with a range created in partnership with iconic British celebrity model, Cara Delevingne.

"Cara epitomizes the Mulberry brand values of British heritage combined with London cool, and unlike our earlier collaborations, which were inspired by Lana and Alexa, the Cara range is a genuine design collaboration between the celebrity and our team. Cara was very hands on, visiting our archives, choosing leathers, sketching ideas, and discussing our customers' practical needs. She was really obsessive about every detail. For example, she wanted each bag to be like opening a letter and discovering a special surprise, which is why the interior reveals a lion rivet and a heart-shaped patch based on one of her tattoos. In addition, because all of the bags are made in England, and Cara has 'Made in England' tattooed on the sole of her left foot, we stamped the same wording on the bottom of each bag.

" IT'S CRUCIAL TO WORK WITH REAL LUMINARIES WHO ARE 'ON BRAND' AND SHARE SIMILAR VALUES TO YOURS"

"Cara's Instagram photo of her foot tattoo alongside our 'Made in England' wording, really built up anticipation of the range prior to launch at London Fashion Week 2014. It's a good example of how celebrities' social media activity can enhance awareness of this sort of collaboration, creating intrigue and awareness."

3.19
Vanessa Lunt (L), Group PR & Events Director for British luxury brand, Mulberry.

3.20
Model Cara Delevingne poses at a photo-call to launch the Mulberry Cara Delevingne Collection during London Fashion Week at Claridge's Hotel on February 16, 2014 in London, England.

CHAPTER REVIEW

As this chapter shows, the extent and scope of celebrity involvement is vast and wide ranging. While academic research has to date failed to show conclusively the financial value to fashion brands of using celebrities in promotional campaigns, it would seem that the practice is cemented into the professional fashion promoter's repertoire. Celebrities may fire the promotional imagination, but precisely how, why, and for how long remains steadfastly open to question.

QUESTIONS FOR DISCUSSION

1. What do you think is the future for celebrity involvement in fashion?

2. Are non-celebrities more valuable as fashion brand endorsers than celebrities?

3. How would you evaluate the success of a celebrity endorsement?

4. Do you believe that your purchase decisions are affected by celebrities?

5. Does your understanding of fashion promotion affect your likelihood of being swayed by celebrities towards or against fashion brands?

3.21

3.21
Kanye West attends the Maison Martin Margiela x H&M launch event, New York City, 2012.

3.22

Arthur Ashe
COLLECTION

THE FIRST
AFRO-AMERICAN
PLAYER
TO WIN A
GRAND
SLAM
IN 1968

CHAPTER EXERCISE

ONE

Consider one successful and one unsuccessful example of celebrity endorsement. For each write down:

» celebrity name
» brand involved
» what the celebrity did
» why you feel the endorsement was (un)successful
» how the endorsement affected your perception of the brand
» whether you feel the endorsement was likely to have provided value for money.

Next, consider whether you would have chosen a different celebrity for each example. Upon what criteria would you base your choices and why?

TWO

Research examples of celebrities who have lost endorsement deals due to illegal or immoral activities. Consider whether you feel that the reasons given for them losing their endorsement deals warranted the brand's response. Do you feel that each celebrity's alleged or actual activity would have had a positive or negative effect on the brand? State how different audiences may have perceived these actions.

THREE

Working in a small group, jot down your five most memorable instances of celebrity involvement with a fashion brand, stating why you found each instance memorable. Compare your choices with those of your friends. Note whether there are any similarities or differences in your choices, and consider why some celebrity endorsements might be more memorable or influential than others.

FOUR

Working in a small group, research the most incongruous celebrity fashion endorsement you can think of. Was the celebrity-brand matchup successful or unsuccessful?

3.22
Tennis legend Arthur Ashe, who died in 1993, retains celebrity power in a recent campaign for French sports-fashion brand, Le Coq Sportif.

04

COLLABORATIONS: "X" MARKS THE SPOT

The heat around designer collaborations has fallen by degrees since crowds queued through the night to experience H&M's first capsule collection with Karl Lagerfeld in 2004. Today, collaborations are now so widespread that some commentators question their promotional power. Yet more than a decade after their first flush, these sometimes weird, often wonderful alliances still command ongoing attention from media and consumers alike.

4.1
Sonia Rykiel x H&M—launch event
at the Grand Palais in Paris, 2009.

INTRODUCTION

In this chapter, we explore the collaboration phenomenon, defining key terms, and offering a brief history of seminal alliances. We describe the role of collaboration in making high fashion more accessible—even democratic—and outline the different collaboration types, clarifying their promotional and commercial value. Interviews with practitioners offer details on how to broker the perfect brand match, and how the collaboration trend can maintain its momentum.

4.2

LEARNING OUTCOMES

By the end of this chapter you should be able to:

>> understand the meanings of "collaboration" when applied to fashion promotion
>> recognize the different types of collaboration and understand their aims
>> name a range of seminal collaborations both between fashion brands, and between fashion brands and other organizations
>> understand the reasons for, and measures of, success for fashion collaborations
>> outline the process of planning for and promoting a fashion collaboration.

WHAT IS A COLLABORATION?

In the context of fashion promotion, "collaboration" refers to a product, collection, or brand emerging from an alliance between at least one fashion brand or designer, and another entity. Frequently truncated to "collab", such partnerships are often recognizable by the metalinguistic use of the character "x" placed between the names of collaborators (e.g., Stussy x Yo! MTV Raps; Mulberry x Cara Delevingne).

4.3

4.4

4.5

4.2
Kate Moss modeling pieces
from her 2014 Topshop
capsule collection.

4.3
T-shirt from the 2014 Original
Penguin x Pepsi "Live for
Now" capsule collaboration.

4.4
2014 collaboration between
British model Agyness Deyn
and Dr Martens promoted in
Dr Martens' store window.

4.5
APC window display
promoting APC x Kanye West
collaboration, 2004.

A TIMELINE OF SIGNIFICANT DESIGNER COLLABORATIONS

" IF HAUTE COUTURE IS THE MOST SUBLIME FORM OF FASHION, H&M IS FASHION AT ITS MOST DEMOCRATIC…FOR US IT'S A GREAT OPPORTUNITY TO COMMUNICATE OUR VISION WITH SUCH A LARGE AUDIENCE OF H&M DEVOTEE."
VIKTOR & ROLF, 2006

4.7

1983	2002–2008	2004	2006	2007
Halston x JC Penney	Isaac Mizrahi x Target	Karl Lagerfeld x H&M; Longchamp x Tracey Emin	Viktor & Rolf x H&M	M by Madonna x H&M; Roberto Cavalli x H&M

1997	2003–present	2005	2006–2011	2007–2009
Stussy x G-Shock	Yohji Yamamoto x Adidas; Jeremy Scott x Adidas	Fiorucci x Target; Stella McCartney x H&M	Target x Go International	Christopher Kane x Topshop

4.6

4.6
Stella McCartney x H&M
launch, St Olaves House,
London, 2005.

4.7
Roberto Cavalli x H&M launch,
Salone delle Fontane, Rome,
Italy, 2007.

4.8

4.10

| **2007–2011** | **2009** | **2009–2011** | **2011** | **2013** |
| Pierre Hardy x Gap | Matthew Williamson x H&M | Jil Sander x Uniqlo | Versace x H&M | Rihanna x River Island |

| **2008** | **2009–2010** | **2010** | **2012** | **2014** |
| Phillip Lim x Gap; Comme des Garçons x H&M | Sonia Rykiel x H&M | Lanvin x H&M | David Beckham x H&M underwear; Maison Martin Margiela x H&M; Mary Katrantzou x Topshop | Riccardo Tisci x Nike; Man Repeller x Nina Ricci; Kate Moss x Topshop; Alexander Wang x H&M |

4.9

4.8
Matthew Williamson
x H&M Summer Collection
launch, 2009.

4.9
Lanvin x H&M Haute Couture
Show, New York, 2010.

4.10
Versace x H&M launch,
New York, 2011.

WHY COLLABORATE?

While many of the most recent fashion collaborations have achieved a spectacular level of global visibility, the practice of creative collaboration has a rich history, dating back to at least the early twentieth century. One of the earliest known fashion collaborations took place during the 1930s, between Spanish artist Salvador Dalí and Italian fashion designer Elsa Schiaparelli. The pair produced several notable pieces including a trompe l'oeil, "Tears" print evening gown and head veil, artfully torn to suggest ripped flesh as part of Schiaparelli's 1938 "Circus" collection. This was thought by some fashion historians to reflect the era's political instability, a precursor to the Second World War.

Fashion collaboration today exists to facilitate the creation of something new, exciting, and innovative—a third brand—specifically something that neither of the involved brands could have created as successfully acting alone. The range of collaboration types have various aims, which are discussed below, but broadly speaking, collaborations happen to help brands gain promotional media coverage, reach new audiences and benefit from the "cool factor" of producing something novel and unexpected.

For collaborations to succeed, it is crucial that all brands involved gain something from the endeavor. As H&M's then Brand and New Business Director Jörgen Andersson commented to the *Business of Fashion* website in 2008, "It has to be win-win, otherwise no designers would do it, except for financial reasons. But the collaborations we have done…it has been a sincere wish [of the designers] to reach out to a wider audience."

Partnerships ending in dissatisfaction are unlikely to be repeated, as Karl Lagerfeld vowed when he found H&M producing his capsule collection in larger sizes than he had anticipated. H&M later called for the designer to apologize for his remarks. Here, we outline some of the reasons why collaborative partnerships might be formed.

> " COLLABORATIONS HAPPEN TO HELP BRANDS GAIN PROMOTIONAL MEDIA COVERAGE, REACH NEW AUDIENCES AND BENEFIT FROM THE 'COOL FACTOR' OF PRODUCING SOMETHING NOVEL AND UNEXPECTED."

4.11
The "Tears" Dress (1938)
by Elsa Schiaparelli and Salvador Dali.

DELIGHTING THE CUSTOMER

Although it is unlikely that most collaborations would occur if they were not profitable, one of the reasons for their recent surge in popularity may stem from a subtle but distinct change in corporate management culture. Traditionally, the main goal of business was to make money. A new and more radical view contends that profits are more likely to be improved where the goal of business shifts from simply making money, to the creation of innovative and satisfying products and services, which improve customers' lives (and create improved profits as a result).

> " PROFITS ARE MORE LIKELY TO BE IMPROVED WHERE THE GOAL OF BUSINESS SHIFTS FROM SIMPLY MAKING MONEY, TO THE CREATION OF INNOVATIVE AND SATISFYING PRODUCTS AND SERVICES, WHICH IMPROVE CUSTOMERS' LIVES (AND CREATE IMPROVED PROFITS AS A RESULT)."

DEMOCRATIZING FASHION

Many high-end designers claim to have collaborated with mainstream brands as a way of making their brand more accessible to a greater number of consumers, but although such "high/low" collaborations enable consumers to buy into luxury brands at lower cost, it is debatable whether or not high-end brands intend such collaborations to result in improved access generally.

Most high-end designers make a clear distinction between the outputs of collaborations and their significantly more expensive (and therefore exclusive) "main line". In statements around the launch of high/low collaborations, some luxury designers have even adopted a slightly patronizing tone suggesting that purchasing these pieces distances consumers from the luxury brand by revealing their inability to afford main line prices.

In addition, many such collaborations are produced in extremely limited runs, which sell out immediately upon release and end up being resold at inflated prices, therefore remaining inaccessible for many. Conversely, some high/low collaborations end up heavily discounted and difficult to sell, resulting in a potentially negative effect on the reputations of both brands concerned.

4.12
H&M x Viktor & Rolf men's
trench coat 2006.

4.12

HIGH-END DESIGNERS COMMENT ON H&M COLLABORATIONS

"With this lingerie collection, the house's signature chic and seduction is available for all women."
Nathalie Rykiel, President and Artistic director of Sonia Rykiel, 2009 (H&M press release)

"Ninety-five percent of women cannot afford [Lanvin], so let them have a taste. It's like if I was living in a palace and opened some doors and said, 'Have tea with me, taste the food.'"
Alber Elbaz, Artistic Director of Lanvin, 2010 (*The Guardian*, Sept 2011)

POINT OF MARKET ENTRY

For luxury brands, part of the appeal of high/low collaborations may be to create a useful "point of market entry"—an opportunity to attract younger, less wealthy consumers to the brand, in the hope of building an ongoing relationship.

PROFITING FROM THE "COOL FACTOR"

Where a large, mainstream brand collaborates with a niche artist or designer for a capsule collection, the costs of production, launch, and other promotional activity may exceed the value of total sales generated. However, the larger brand will almost certainly have calculated that ongoing collaboration with niche artists or designers will, over time, result in increased brand awareness and credibility, growing the overall market for the brand.

ENHANCING CORPORATE REPUTATION

In collaborations between fashion brands and charities, the brand's motive is typically to enhance corporate reputation (and hence in the long term, gain or maintain consumers' "permission" to make money), and the charity's aim is to raise awareness, and in most cases to increase donations.

FEES AND FAME

The appeal of collaborations for big brands may be linked to kudos, enhanced reputation, and, ultimately, profit. On the other hand, smaller brands involved may be attracted by a fee and the increase in brand visibility achieved.

Fees paid to emerging designers for work on mainstream brands' capsule collections may contribute significantly to the designer's costs of producing their own collections for presentation at fashion weeks.

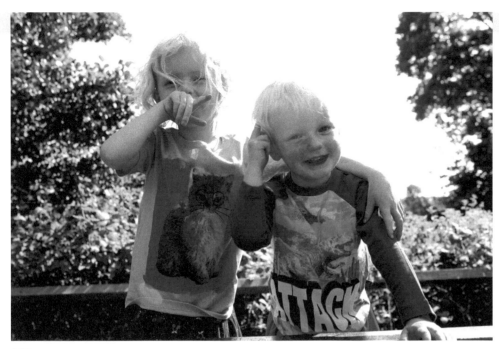

4.13

4.13
Models Dolores and Lucien
wearing items from Stella
McCartney's SS2014 collection.

A TEST BED

Some designers may use a mainstream retailer
collaboration to test an idea, such as a brand extension.
Stella McCartney debuted a successful capsule collection
for Gap Kids in 2009, which may have influenced
her decision to proceed with her own kids' range the
following year. Speaking of the Gap Kids collaboration in
an interview for *The Guardian* newspaper in October 2010,
Frederick Lukoff, president and chief executive at Stella
McCartney said it "showed us that there was a demand
for Stella in the kid's world."

THE NEW DIFFUSION

While many luxury brands continue to produce extensive
diffusion lines (secondary lines of merchandise retailing
at lower prices points to increase sales volumes such
as Marc by Marc Jacobs; McQ by Alexander McQueen;
and See by Chloé), collaborations may offer a more
versatile, quicker-to-market alternative to reach different
consumer sectors.

CO-MARKETING ALLIANCES

Ahn et al. (2010) identify a distinct form of collaboration
in alliances between tech companies and fashion brands,
in which tech firms obtain "improved global connectivity
to mainstream luxury and innovative markets," and
fashion brands "expand their influence into an innovative
technology-related market identified as a creative
trendsetter." They refer to these partnerships as "co-
marketing alliances" where effectively, the status of both
partners is similar in their respective sectors, and each
gains significantly from association with the other partner
in terms of broadening audience and altering perception.

4.14

4.15

4.16

CATEGORIZING FASHION COLLABORATIONS

According to Ahn et al. (2010), fashion collaborations can involve a wide range of alliances, from "sleeping with enemies" (i.e., collaborating with direct competitors) to "talking to strangers" (working with completely unrelated products/brands). Here, we describe the range of collaboration types.

4.14
Japanese artist, Yayoi Kusama (center), with Louis Vuitton Chairman and CEO, Yves Carcelle (left) and incoming CEO Jordi Constans (right) attend the Louis Vuitton and Yayoi Kusama collaboration unveiling at Louis Vuitton Maison on Fifth Avenue in July 2012 in New York City.

4.15
Knit bomber neck T-shirt from the Fred Perry x Raf Simons SS2014 collaboration collection.

4.16
Nike x Riccardo Tisci collaboration, unveiled in January 2014, features the Givenchy creative director's four takes on Nike's iconic Air Force 1 style, including a knee-high boot.

THE DIFFERENT COLLABORATION TYPES

Collaboration type	Description	Examples
Fashion brand and fine artist	In recent years, fine art and fashion collaborations have proliferated, perhaps best exemplified by Louis Vuitton under the stewardship of Marc Jacobs between 1997 and 2013.	Longchamp x Tracey Emin Levis x Damien Hirst Jimmy Choo x Rob Pruitt Louis Vuittona x Yayoi Kusam
Mainstream fashion brand with niche fashion brand	Increasingly common, generally involving a mainstream (occasionally luxury) brand working with a niche brand on a capsule collection.	Carhartt x APC Banana Republic x Marimekko
Mainstream brand with guest fashion designer capsule collection	Although not the originators of the concept, H&M is probably responsible for popularizing this global fashion phenomenon. In H&M's words, the collaborations "boost the H&M brand and create buzz by presenting customers with surprising and exciting fashion meetings" (H&M).	All H&M x designer collaborations Nike x Riccardo Tisci River Island x Joseph Turvey Target x Rodarte Target x Proenza Schouler
Mainstream brand with guest celebrity designer capsule collection	Celebrities benefit through fashion collaborations mainly in terms of profile raising and PR opportunities, with brands benefitting from the "cool factor" associated with celebrities who, in some cases (e.g., River Island x Rihanna), can completely transform the brand's credibility.	H&M x Kylie Minogue River Island x Rihanna
Mainstream brand with guest designer capsule collection (blogger)	Brands may collaborate with fashion bloggers in order to secure a direct connection with bloggers' audiences, for whom the blogger is a trusted style leader and fashion advisor.	Louis Vuitton x Chiara Ferragni H&M x Elin Kling Coach x Emily Johnston
Mainstream brand with non fashion-related professional	Occasionally, fashion brands seek to collaborate with a famous individual who is better known for his or her professional achievements than for celebrity status. The effectiveness of such alliances is increased where there is a clear synergy between brand and individual.	Uniqlo x Novac Djokovic Superga x Harmony Korine

THE DIFFERENT COLLABORATION TYPES *CONTINUED*

Ingredient collaboration	Where fashion brands choose to incorporate well-known—often high-performance or heritage—textiles or other "ingredients" in their collections, the alliance is often marked as a collaboration.	Nanamica x Gore-Tex Clarks x Horween leather
Pop-up dual retail collaboration	Relatively uncommon form of collaboration in which two (or more) retailers join forces to offer their products for sale from a single pop-up retail location.	Comme des Garçons x Louis Vuitton pop-up store The Gap x Colette
Fashion brand with non-fashion brand	For major, non-fashion brands (often in the tech or lifestyle sectors), fashion collaborations are a simple and effective way of adding quirkiness and "cool," while the fashion partner benefits from association with an internationally recognized brand and the challenge of being creative within a different industry.	Intel x Opening Ceremony Dyson x Issey Miyake Royal Doulton x Zandra Rhodes Kellogg's x Anya Hindmarch
Fashion brand with fashion-related professional	Costume designers have produced collections for retail brands since at least as far back as the early 1930s, when MGM wardrobe director Adrian's "Letty Lynton" dress (worn by Joan Crawford in the film of the same name) sold nearly half a million copies at Macy's department stores in the US. Today, contemporary costume designers are working with fashion brands on high-profile collaborations that use the profile of the costume designer, and the popularity of their corresponding films or TV series as promotional collateral.	Banana Republic x Janie Bryant (*Mad Men*) Net-A-Porter x Trish Summerville (*The Hunger Games*)
Fashion brand with automotive industry	Since at least the late 1960s, the automotive industry has collaborated with fashion brands and designers on limited edition models or exclusive options and accessories.	Pierre Cardin x American Motors Corp Peugeot x Lacoste Fiat x Diesel Range Rover x Victoria Beckham

4.17

4.18

4.19

4.20

4.17
Rihanna wearing part of her eponymous collection for River Island.

4.18
The Fiat 500 collaboration with Diesel.

4.19
Issey Miyake's SS2008 wind-themed catwalk show uses a wind tunnel designed by British engineer and vacuum-cleaner tycoon, James Dyson. Miyake later endorsed a special edition Dyson vacuum cleaner.

4.20
Kellogg's collaborates with accessories designer Anya Hindmarch in 2014 for a limited edition "Handbags at Dawn Flakes" to launch London Fashion Week SS2015.

THE WEIRDEST COLLABORATION?

4.21

Released on April Fool's Day 2012 and promoted as a way to neutralize the malodorous aftermath of vigorous activity in the bathroom, surely the Post Poo Drops collaboration between French streetwear brand APC and luxury Australian toiletries brand Aesop is one of a kind?

4.21
A contender for the world's weirdest fashion collaboration: high-end Australian skin, hair, and body care company Aesop partners with French streetwear brand APC to produce its Post Poo Drops.

PROMOTING COLLABORATIONS

For the most part, promoting collaborations follows a fairly typical promotional path. Various opportunities for media coverage of the partnership occur throughout the process, from the first announcement, through the design stage, to launch, and post-launch activity. For example, the partners may announce the collaboration via social media and media release. Teaser images depicting the design process may then be released either direct to media, or via the brand or collaborative partner's Instagram account. A launch event (either specially convened, or attached to another event such as a fashion show or festival) provides the first opportunity to see the fruits of the collaboration in the flesh, followed by the product or collection being made available through retail stores, possibly resulting in further coverage opportunities of early adopters queuing to make purchases, and additional opportunities to communicate with media provided by sales figures achieved. Increasingly, collaborations command the attention of bloggers and style-oriented websites, which in some cases actively build hype for collaborations. Leading sites of this type include Hypebeast, Selectism, Highsnobiety, Freshness Mag, FashionBeans, Complex, and WhoWhatWear.

INDUSTRY PERSPECTIVE:
COLLABORATING WITH BLOGGERS

4.22

Commanding the interest of thousands of fashion-conscious readers, bloggers offer brands seeking collaborative partners a useful route to critical target audiences. Here, Emily Johnston, whose blog Fashion Foie Gras has many thousands of subscribers and still more followers across various social media platforms, offers her view on collaborations.

"I can't get enough of collabs. I love how mainstream and high-end designers are coming together to bring lower-priced design to the masses. I'm not sure there's an exact definition for an effective collab, but in my opinion, it would have to allow for both brands to maintain their ethos.

"Collabs work best for PR purposes, and when bloggers talk about what we love, people really know we love it. If we didn't love it, we wouldn't write about it. That's the greatest promotion for brands—having a normal person say, 'I love this brand or product.'

"I loved Karl Lagerfeld for H&M back in the day, and Target is also doing a good job of keeping up with the designer fever hitting the world at the moment. I can't think of any collabs that I didn't like, to be honest.

"I've been lucky enough to work with some amazing brands over the years, but I haven't said yes to everything. Fashion Foie Gras gets a lot of approaches, but I like to keep things in the arena where I can justify the collaboration. If I don't love the concept or the brand, it's a no-go area. My most successful collaboration to date was a bag for Coach. It sold out instantly, and I still get emails asking if I have another one in the works."

4.22
Fashion Foie Gras founder Emily Johnston holding the tote bag she designed for US brand, Coach.

INDUSTRY PERSPECTIVE:
CHARITIES COLLABORATING WITH FASHION

4.23

Established in 2001, the Environmental Justice Foundation (EJF) campaigns to improve human rights and the environment in some of the world's most challenging regions. The charity's fashion industry patrons include model/activist Lily Cole and designer/activist Katharine Hamnett. Since 1999, EJF has collaborated with fashion designers on its ethical T-shirt project, which has raised more than £300,000 ($450,000), and also generated an almost inestimable value in awareness raising for the charity and its work. Here, EJF's Executive Director, Steve Trent, explains why the charity focuses some of its campaigning effort on fashion.

"Originally, the project linked very literally with EJF's campaign to end forced labor and unsustainable water use in cotton production in Uzbekistan. EJF collaborated with Katherine Hamnett on this issue, and the first ethical T-shirt line reflected the charity's commitment to carbon-neutral products made with organically grown cotton that generates no waste water and causes no harm to those involved in its production. EJF's hope is that by persuading people to stop buying clothing that is produced unethically or unsustainably, producers will be forced to adopt only the sort of ethical, sustainable practices that the market will tolerate.

4.23
Steve Trent, Executive Director of the Environmental Justice Foundation.

4.24
Model Lily Cole and designer Vivienne Westwood make a personal appearance at Selfridges' London department store to talk about their work for the Environmental Justice Foundation in January 2014.

4.24

"Everyone has an interest in fashion, whether they admit it or not, and this helps us in three important ways. First, it helps us reach a broad market with a simple message, which often translates into action, even something simple like a supportive Tweet to a chief exec or MP, or a decision to avoid retailers that use an unethical supply chain. Second, it helps our charity stand out among a plethora of bigger charities with greater resources—recognition of the "Just For" brand that we use for our clothing range is strong and growing. Third, our clothing range helps us raise funds. It's important that EJF works in an entrepreneurial way in order to become financially sustainable.

"Although EJF is not alone in working on awareness-raising and fundraising projects with the fashion industry, the charity believes that by collaborating closely with up-and-coming designers, it offers products that consumers will actually want to own and wear, rather than garments that people simply feel obliged to purchase. In order to make its clothing ranges as desirable as possible, we hand-pick designers who share the charity's outlook on human rights and environmental issues, and are also aspirational brands whose work people want to own. These have included Vivienne Westwood, Katharine Hamnett, Christian Lacroix, Giles Deacon, Kenzo Takada, Luella, Eley Kishimoto, Jenny Packham, Emma Cook, Serge DeNimes, and Patternity. I believe what we sell needs to sit comfortably within a cutthroat commercial market. It's high end, high quality and also high value."

CHAPTER REVIEW

In this chapter, we have shown how the concept of collaboration within fashion is fast moving and ever changing. While the idea of creative brands and individuals coming together to produce new products, collections and even new brands is not necessarily a post-internet phenomenon, the ephemeral nature of social media has boosted its visibility hugely. In line with this, the exponential proliferation of collaborations during the past five years suggests that it plays a crucial role in keeping fashion foremost in the minds of consumers and media commentators alike. Will the trend continue to grow at such a rapid rate? We don't know. But whatever happens in the next five years will be truly fascinating if the practice is to maintain its ability to stimulate curiosity and consumer satisfaction.

QUESTIONS FOR DISCUSSION

1. Is the term "collaboration" appropriate to describe all occasions where fashion brands or designers partner with other brands to produce new products or collections?

2. Do you feel that the different types of collaboration involving the fashion industry have clear aims that differ depending on the type of collaboration created?

3. Can you name one of each type of collaboration outlined in this chapter, without using our examples?

4. How much do you feel that high/low capsule collection collaborations "democratize" the consumption of fashion?

5. What are the key elements of a successful collaboration?

4.25

CHAPTER EXERCISE

ONE

Identify a collaboration that you feel failed to benefit the brands involved. Explain why you feel that the project was unsuccessful.

TWO

Identify a collaboration that led you to purchase a product from a brand that you were not previously familiar with. State which aspects of the collaboration were the most compelling.

THREE

Name a high-end brand that has not participated in any sort of collaboration. Consider why the brand has avoided collaborations.

PROJECT

ONE

This project involves devising a collaboration strategy for a brand of your choice. Working in small groups, start by identifying a fashion brand that you feel might benefit from the promotional energy of a collaboration but does not currently engage in such alliances. Then undertake the following steps:

» Identify two or three possible collaborative partners, and propose suggestions to the group outlining potential benefits of each.
» Select the partner most likely to yield benefits for the brand.
» Devise and describe a collaboration project (e.g., product, capsule collection, other form of co-marketing alliance).
» Devise a promotional plan for the completed collaboration, focusing particularly on target audiences (both consumer and media).

4.26

4.25
Puma x Brooklyn We Go Hard 2015 collaboration on display at Sneakersnstuff in Shoreditch, London.

4.26
G-Shock x Maharishi: one of the many Casio G-Shock fashion and technology collaborations.

05

THE FASHION SHOW: FROM COUTURIER TO CATWALK

The fashion show is a defining event in a designer's career. For newcomers and veterans alike, nothing quite matches the twenty minutes in which a creative soul is laid bare to the industry and the public. From late nineteenth-century Paris salons to today's "big four" fashion weeks of New York, Milan, Paris, and London, what started as sales promotion has evolved into seasonal spectaculars whose budgets often exceed even the most optimistic sales predictions.

5.1
Naomi Campbell loses her balance
on the Autumn/Winter Vivienne
Westwood catwalk in 1993.

INTRODUCTION

This chapter examines types of fashion shows and their essential components. We discuss the evolution of the show, and how online technologies and social media have accelerated promotion before, during, and after the event. Finally, we look to the future and ask whether a wider audience reach means the end of the front row.

LEARNING OUTCOMES

On completion of this chapter you will be able to discuss:

» how the fashion show developed into what it is today
» the different types and elements of a fashion show
» the role the fashion show plays in fashion promotion
» the changing shape of the fashion show
» the opportunities that lie in the future.

5.2

THE ORIGINS OF THE CATWALK SHOW

To examine how the fashion show has evolved, it is important to examine its function. Although the principle has remained the same, there are significant shifts in the history of fashion promotion that have shaped the fashion *défilé,* or parade, into its current form. The first fashion show took place in nineteenth-century Paris, where designer Charles Worth started to present collections to elite clientele. Prior to this, customers typically dictated the design of garments—now, the designer created a selection of designs that could be customized to clients' specifications. Invitations to Worth's salon presentations began to denote status and style. The growing demand for fashion articles in newspapers and fledgling magazines (including *Vogue*) saw journalists also invited. This Parisian trend moved to London, courtesy of Lady Duff-Gordon, presentations of whose label, Lucile, drew bigger audiences, used bigger production values, and gained bigger press coverage. America experienced the phenomenon thanks to Edna Woolman Chase, and these fashion presentations gathered pace—widening audiences: the wealthy clients of US department stores.

5.3

5.2
A model in Yves Saint Laurent,
Paris Fashion Week, 1987.

5.3
Pringle of Scotland's AW2014
presentation was reminiscent
of the salon shows of the early
twentieth century.

5.4

THE FASHION WEEK

Another significant shift occurred in New York in 1943. With the Second World War preventing journalists from traveling to Paris to report on the couture collections, US publicist Eleanor Lambert arranged for a series of fashion presentations celebrating American fashion in New York City, effectively creating the modern fashion week. Like twenty-first-century fashion weeks, press were invited and provided with all the information and images they needed to report on the shows. The event was a runaway success. Italy took note, and in 1952, a similar event was held in Florence, moving eventually to Milan. Paris brands continued to show, although not as part of an officially organized schedule until 1973, when the city also welcomed American designers. London followed with the creation of London Fashion Week in 1984, supported by the British government, thus helping secure its footing as one of the "big four".

There are now hundreds of fashion weeks around the world. Some, like Australia, focus on exhibiting local or culturally significant talent, in their case Australian and Asia Pacific designers; some a particular style (such as swimwear in the case of Mercedes Benz Fashion Week Miami). While others like Copenhagen, although predominantly geographically focused, follow the standard fashion week format. Although a globally connected industry, it can be difficult to promote designers outside of the big four, and it is a testament to the success of the fashion week format that its blueprint has been adapted all over the world.

5.4
Eleanor Lambert, organizer of the first American fashion press week, which evolved into "fashion weeks" as we know them.

ON AND OFF SCHEDULE

Exhibiting a collection represents, for most designers, the pinnacle of industry involvement. However, having established a show presence, designers can't afford to miss a season. Missing a season signals that your label is not performing well or, worse, that you have disappeared. For fledgling labels, getting there and staying there is a huge challenge.

Being listed on an official fashion week schedule sends another message: that yours is a brand to invest and believe in. The financial implications are massive, and the emergence of "off-schedule" shows and presentations offer cheaper alternatives, which in some cases garner something of an underground or alternative reputation.

Whether on or off schedule, the concentration of shows, exhibitions, presentations, and other events that take place over a very short period of time presents a series of challenges for a designer's promoter or PR—finding the right reception, the right audience, and crucially, the right coverage.

> " BEING LISTED ON AN OFFICIAL FASHION WEEK SCHEDULE SENDS ANOTHER MESSAGE: THAT YOURS IS A BRAND TO INVEST AND BELIEVE IN."

THE MAIN OBJECTIVES OF A FASHION SHOW

» To generate sales

» To exhibit a new collection reflective of a theme or inspiration that is of interest to press and consumers

» To increase awareness of a designer or brand

» To produce a show that is distinctive and memorable

» To reassure buyers that the collection is worth investing in through favorable reception

» To attract potential new sources of sales, revenue, and investment

» To help generate expectation for the success of the exhibited collection, future seasons, and further activities from the designer or brand.

THE MOST POPULAR TYPES OF FASHION SHOW

Trunk shows: where designers exhibit their collections to shoppers, often over a short period, in shopping malls or in brands' own flagship stores.

Trade shows: take place specifically for retailers or buyers (see Chapter 7).

Thematic shows: feature a group of designers whose collections fall under a certain theme (such as swimwear) or focus (such as ecology).

Charity shows: undertaken as fundraisers rather than to direct sales.

Salon shows: originate from the couturiers' salons of the 1800s and early 1900s; these tend to be more intimate affairs, with smaller audiences. Models, often at ground level, may walk among, or interact with, the audience.

Haute ("high") couture shows: traditionally exhibit entire collections of up to 150 pieces; this term describes certain luxury brands showing in Paris. Historically, a fashion house that was unable to present a biannual exhibition of their collections was called *moyenne* ("middle") *couture*. Haute couture shows typically involve some of the most elaborate production values and narratives.

Prêt-à-porter shows: literally, "ready-to-wear" shows from brands and designers whose collections are factory produced in standardized styles and sizes rather than bespoke one-off pieces. The term is typically applied to collections with a higher price point than mass-produced commercial brands due to the production quality.

Showroom shows: mainly for buyers—and on occasion, media—these are closest to the traditional salon shows. Small groups come into contact with collections to help influence buying decisions. This can be a low-cost alternative to the fully fledged fashion show.

Scheduled catwalk shows: where a schedule or list of designers has shows throughout the days of a particular fashion week. Due to the high number of participating designers, the turnaround time is very quick, leading to the venue being a "blank canvas" that remains essentially constant show after show.

Spectacle catwalk shows: often in distinctive or creatively relevant venues, these extravagant shows may form part of fashion week schedules. Ambitious and often innovative, these focus on communicating a brand message or lifestyle, rather than meticulously showing collections.

Trend shows: typically part of trade or fashion fairs, these shows represent groups of designs as trends for current and future seasons, rather than individual designers—for example, around color palette, fabric, or style. Wedding shows are an example.

5.5

5.5
Live streaming has
meant fashion shows can
attract global audiences
instantaneously.

5.6
Images from the AW2010
collection from Marc by Marc
Jacobs were available online
minutes after the finale.

THE CHANGING SHAPE OF THE CATWALK

**The Internet and social media have had a more
significant impact on the way fashion shows are
presented, reported, and attended than any other
phenomenon since shows first emerged, including
the rise of commercial television.**

In the age where shows are now live-streamed and
immediately available online, brands have to act equally
as quickly, with some such as Burberry and Topshop even
going to the lengths of making collections available to buy
or pre-order immediately after the last model has left the
stage. Speed of accessibility is just one of a multitude of
very recent advancements that are shaping the fashion
shows of the future.

5.6

5.7

THE FRONT ROW

Once the purview of socialites and wealthy clients, the population of the front row is as intriguing today as it was when the first guests were invited to nineteenth-century Parisian salon shows: a fascinating snapshot into the ethos and mind of a designer or brand, or by default, its promoters. Presence in a front row can generate more headlines than the collection itself. For example, the UK press always debates furiously whether or not Anna Wintour will appear at London Fashion Week. The influence of the Internet is reflected here also— former American *Style Rookie* blogger Tavi Gevinson made her fashion week debut at the age of eleven. "Friends" of the brand or the designers, whether personal or ambassadorial, can elicit a large amount of interest. Politicians' wives, rock stars, even royalty have been photographed waiting for collections, with many show times being held for their arrival. Rather than usurping the importance of what is happening on the catwalk, the correct balance of the right faces can compliment it and radically alter the face of a brand to an observing public.

5.8

5.7
Anna Wintour on the front row
at London Fashion Week, 2002.

5.8
Tavi Gevinson attends the SS2010
shows. Her bow drew complaints
from the press seated behind her.

5.9

THE PRODUCTION

BACKSTAGE

Typically zoned, backstage is divided into hair and make-up toward the back; dressers and garment rails in the middle; and the stylists, producers, and choreographers at the front—closest to the stage, floor, or catwalk. This hitherto closed world was deliberately hidden for decades and is seized upon by many as another promotional opportunity, in addition to the designers and brands. Increasingly, behind-the-scenes footage is made available to the public as part of a wider promotion of a fashion show, also to the sponsors or collaborators— make-up companies, hairstylists, accessory suppliers, even drinks companies that supply the water.

" A MEMORABLE SHOW CAN HELP A DESIGNER GENERATE EXPECTATION—A STANDOUT SHOW ONE SEASON CAN HELP ANTICIPATION, AND INTEREST, IN THE NEXT."

5.9
Exacting organization backstage is key to a successful show, like here at Tokyo Fashion Week.

5.10

5.10
Fendi hold their SS2008 show
on the Great Wall of China.

MAKING MEMORIES

Whereas the climax of a fashion show was traditionally
associated with a wedding gown or finale showpiece
to cement the uniqueness and craft of a designer's
collection, show productions themselves are today crucial,
often spectacular promotional tactics for brands, elevating
show producers to star status.

For example, Karl Lagerfeld is renowned for overseeing
seasonal fashion spectacles, including using the Great
Wall of China as a catwalk for Fendi in SS2008, and
supermarket aisles for Chanel staging (AW2014). Other
designers have incorporated unusual accessories: Isaac
Mizrahi used poodles for AW2011, Alexander McQueen
a robotic spray-painting arm for SS1999, and in the
case of Marc Jacobs, the NY Penn State marching
band in SS2006.

Technology has played a massive part in enhancing the
production values of shows especially with the use of
augmented reality and holographic technology, whether as
part of the collections, part of the staging, or in Alexander
McQueen's case in AW2006, a computer-generated
appearance by Kate Moss. Global economic recession
has seen a paring down in production values in more
recent seasons, but there are some fantastical exceptions
to this rule. One is H&M's decision to break the mold of
its mainstream roots by showing at Paris Fashion week
for AW2013 with a production reminiscent of a series of
rooms in a house on an extraordinary scale, or Dolce &
Gabanna's AW2014 show—a fairytale forest in Milan.

The spectacle of the show has become a crucial part of
its success, determined by memorability. The transience
of the seasonal show can avoid being quickly forgotten
by having a quality or production that would enable it to
be used as exemplars for years to come, staying in the
public's collective memory. Further, a memorable show
can help a designer generate expectation—a standout
show one season can help anticipation, and interest,
in the next.

ON AND OFF THE CATWALK

5.11

THE MODELS

The role of the model has seen just as many changes as any other element of the catwalk show. In the Paris salons, the main prerequisites were that you fitted the garment and could walk well. The rise of creative interpretation in fashion imagery stimulated by the growth of the fashion photographer signaled an osmotic change in the models—their movements brought the designs to life, but an injection of personality was required to project a lifestyle. Each decade has its own faces, but it was 1990 and the famous five—Naomi Campbell, Tatjana Patitz, Christy Turlington, Linda Evangelista, and Cindy Crawford—that cemented the reputation of the supermodel, both on and off the catwalk.

A combination of factors saw the fall of the supermodel—economically, these girls were expensive, especially in a time of financial uncertainty for many brands and designers. Also, some brands were concerned the faces were overshadowing the collections. Opting for cheaper, lesser-known girls seemed to answer both questions, and further enabled designers and show producers to cast a group of models with similar attributes to compliment a mood and ethos of a collection, rather than one face being the defining moment of a season's collection.

To an extent, the famous face (model or otherwise) down the catwalk still has relevance and is a heavily used tactic today—Naomi Campbell and Kate Moss still open shows, and models such as Cara Delevingne, Saskia de Brauw, and Joan Smalls are sought after as some of the latest faces of choice. However, this is no longer the essential part of a show that it was in the 1990s. Some designers make a different sort of statement with the selection of their models—from street-cast models (Oliver Spencer, SS2013), to celebrity (Thierry Mugler AW2012). Famous or not, models are often used as a fuller reflection of the type of person the designer is inspired by, and can imagine in his or her designs.

5.11
Kate Moss smokes on the Catwalk at Louis Vuitton's AW2011 show, causing controversy.

5.12
Lady Gaga appears as part of the Thierry Mugler AW2012 show.

THE PRESS

Press reaction and reception is the lifeblood of a successful fashion show. Certainly, the front row, models, and the production values of a show are prime areas for the fashion media to cover during fashion weeks, but when it comes to more in-depth critique of collections themselves, as Angela McRobbie puts it, coverage can suffer from "conservatism and timidity" (2003:152). The interesting dichotomy between the often radically different representation of collections through imagery between designer and press, and the often comparatively safe, descriptive wording of the written show reports (in some cases, brazenly lifted from the press releases and show notes distributed as part of the collection's promotion) can be linked to the fashion press acting not as journalists in the traditional sense, but as transmitters of information that at once keep both readers informed and advertisers (potential or actual) happy.

This is not to devalue the importance of the fashion press—as McRobbie observes, if it wasn't for the support of magazines such as *iD, The Face,* and *Elle* in the UK, it is questionable whether the success of London Fashion Week and of the British fashion industry in general during the 1980s and 1990s would have been so emphatic. Further, many individuals have contributed to the fashion media with distinct, informed, and eloquent voices— Hilary Alexander, Suzy Menkes, Laura Craik, Jess Cartner-Morley, Colin McDowell, Lynn Yaeger, Robin Givhan, and the late Anna Piaggi to name a but few.

5.13

5.13
Suzy Menkes (right) is a regular front
row fixture.

5.14
Printed invitations remain the
preferred method of promoting
a catwalk show.

CATWALK AS A PROMOTIONAL VEHICLE: THE COMMUNICATION

As Polly Guérin notes about fashion shows, "The venue, invitation, show program, the models, the hair and make-up, must all present a unified image…" (2005:268), and this often starts with the invitation. Despite the financial savings possible with e-invites, many brands still produce elaborate hard copy invitations (despite the fact that press and buyers are already aware of the time slot, date, and venue of the show), often couriered to recipients—suggesting a level of personal selection and exclusivity that can be lost through email.

However, the logistics of RSVPing aside (email confirmation is still the most popular method) it is crucial that whatever the format, the invitation should link to the show's ethos, another way of generating expectation. Often, press offices follow up with calls or emails to ensure safe receipt as the benefits of a full venue over a half empty one are obvious. As Vilaseca points out, "normally, some 70 percent of invitations that have been sent can be disregarded. Out of the 30 percent who respond, approximately one-third may not appear" (2010:151). PR offices and agencies have the unenviable task of ensuring a good turnout, and subsequently a great atmosphere, bolstered by an organized and diplomatic seating plan. Show notes (an outline of the collection, often followed by a look-by-look description) and credits should be on as many seats as possible, and a keen observation of all media channels during and after the event is essential to ensure all press coverage is captured.

Social media has played a slightly unexpected role in the changing shape of the fashion show—its instantaneousness has facilitated opportunities for brands, designers, and PR officers to communicate just about everything about a show—building expectation, re-transmitting immediate reactions, and attempting to keep it in the public consciousness, trending or otherwise, for as long as possible. Whereas in the past, show communication relied heavily on the fashion press, today anyone present may share information, images, and thoughts. As social media's primary function is to share information among communities of interest, fashion has grasped this as another marketing opportunity—reflecting the speed, pace, and excitement that has always been attributed to a fashion presentation.

5.14

5.15
A full photographer's pit is a familiar sight at the end of the catwalk.

5.16
Live streaming reaches a much larger audience, although it can cost tens of thousands of dollars.

5.15

THE END OF THE CLIQUE?

The fashion industry contingent at fashion shows is changing as rapidly as everything else around it. The photographer's pit, traditionally populated by men vying aggressively for the definitive catwalk image, has been replaced by agency-commissioned photographers, along with the brands' own representatives; such is the ease and convenience of transmitting imagery that newspapers and magazines rarely run their own images any more. As for who gets on the much-coveted front row—arguably, it is the press who take it most as a reflection of status than any other part of the industry audience—some events and brands are embracing the democracy that technological advances supply.

For example, a current venue for London Collections: Men—the menswear offshoot of London Fashion Week—is a vast expansive warehouse in an old postal sorting office. When it comes to designing a show, many brands have dispensed with a traditional catwalk in favor of a snaking route that covers as much floor space as possible—here, every seat is on the front row, leading to positive brand association from all sectors of the press and, potentially, much more coverage.

" WHEN IT COMES TO DESIGNING A SHOW, MANY BRANDS HAVE DISPENSED WITH A TRADITIONAL CATWALK IN FAVOR OF A SNAKING ROUTE THAT COVERS AS MUCH FLOOR SPACE AS POSSIBLE."

5.16

In addition, two opportunities have arisen that have further opened the doors to what was once a very private event. Traditionally, transmission and communication of a catwalk show was a selective edit of what was deemed appropriate by the relevant parties—newspapers and magazines might have room for one, maybe two images, selecting a key image that reflects a collection, or attracts the reader (often something unexpected or outlandish, depending on the focus of the title). Even online, immediate space is limited, with few blogs and e-zines slavishly reproducing the images of an entire collection in favor of a top page that communicates essential information with an opportunity to click through to read and see more. Whatever the space allowed, it did and still does offer an edit, selected by a reporter or editor.

The decision from some brands to live-stream their entire shows online has effectively dispensed with the need to do this, dependent upon the level of enthusiasm from the viewer. While not replacing the overall experience of attending a show, this has allowed unprecedented access to a fashion show, and the more technology develops, the more absorbing the experience will become. Financial aspects are also an issue—at the moment, live streaming is expensive—almost as much as an average show budget itself, but as the technology becomes cheaper, the higher is the likelihood for a more widespread adoption. While the end of media reporting on the fashion show is unlikely to be in sight, it is a reflection of brands taking further leaps to engage directly with its consumers, reflected in the second opportunity, the opportunity to buy or order direct from the brand as soon as the show ends.

5.17

THE FUTURE OF THE CATWALK

Just as the desired effect of the first salon presentations in Paris some 150 years ago was to sell direct to the client, the principles of the fashion show, throughout its evolution, have never been more closely aligned to this as they are today. The difference being, of course, that the eventual aim is to sell pieces in their hundreds or thousands, rather than a one-off outfit. As more brands employ this tactic, the more the catwalk as we know it will continue to change. The role of the promoter, however, will remain crucial to the success of the outcome, as whether it be on the front row or in the front room at home, catwalk shows need an audience in order to be successful. The challenges facing those whose responsibility it is to raise awareness and secure these audiences remain constant—finding, obtaining, and maintaining the spotlight for and on the brand for as long as possible.

5.17
The New York Penn State
Marching Band featured in
Marc Jacobs' show
for SS2006.

INTERVIEW: FIONA FARNSWORTH – THE CATWALK PR

Fashion PR consultant Fiona Farnsworth works with a variety of international menswear and womenswear clients assisting in the production of fashion shows as part of their promotional campaigns.

Can you explain the PR's role in creating and producing a fashion show?

Our main role is to support the designer throughout the course of the show season and create as much publicity as possible around the show and the new collection.

We are involved in a wide range of areas, including sponsorship, casting, styling (hair/make-up), and production. Occasionally, we will assist with time allocation for the show and advise on artwork for pre-publicity materials through "save the date" emails and invitations, once the show is confirmed and announced. We also organize previews of the collection with key journalists in the run up to the show.

Having a solid guest list is key. We log all attendance requests and use them to produce a seating chart. After the seating chart has been signed off, invites are issued. As well as journalists, we need to consider VIPs and celebrities. Generally, outreach on this starts quite a while before the show. Press releases, both before and after the show, must also be created and issued after discussing the designer's inspiration for the collection. We also monitor coverage before, during, and after the show.

What do you think makes a successful fashion show?

Organization is critical, and fantastic attendance with a great crowd on the day. Positive and well-informed media coverage after the show is a benchmark for success. Having your clients included in key publications during fashion weeks is always a key objective, though it can be difficult to obtain, with incredible designers packing schedules and all competing for media coverage.

5.18

Where do you think the future lies in the fashion show?

Brands are looking at social media and online interaction—moving further into the digital sphere, adopting different ways to interact with the audience. Huge companies, such as Microsoft, are positioning themselves as more "fashion" [oriented], (such as their collaboration with Fyodor Golan SS2015 at London Fashion Week) associating themselves with high-fashion brands, thinking of innovative ways to interact and execute a show.

5.18
Fyodor Golan taking a bow after their SS2015 catwalk show.

CHAPTER REVIEW

In this chapter we have examined the direct links between the fashion show and its uses within fashion promotion. By discussing its key elements, types and origins, along with the changes it has embraced in recent years, we have discovered that although its face might have changed, its fundamental aims and objectives have remained constant.

QUESTIONS FOR DISCUSSION

1. What do you consider to be the significant historical developments of the fashion show? Why?

2. What do you think is the most effective type of fashion show for a luxury brand, a commercial brand, and a young designer?

3. How would you rank the elements of a fashion show in order of importance?

4. Where would you place a fashion show within a brand or designer's overall promotional strategy?

5. What do you think will be the shape, type, and essential elements of a fashion show of the future?

5.19
Chanel's AW2008 carousel.

5.19

5.20

CHAPTER EXERCISE

ONE

Select a particular season of one of the "big four" fashion weeks—what sort of coverage and news headlines were generated? Identify the advantages and disadvantages for the brand in question.

TWO

Watch a pre-recorded/live stream of a fashion show and generate a press release to promote the show, considering a show's main aims and objectives.

THREE

In small groups, put together a brief overview of a proposed show for a selected brand or designer, considering both the types and essential elements to form an overall proposal, performing a SWOT on your selections.

5.20
Kate Moss's virtual appearance during Alexander McQueen's AW2006 show.

FASHION FILM: FROM HOLLYWOOD TO HOXTON

Over the past decade, an unexpected guest has appeared at international fashion weeks. Initially unwelcome, particularly amongst fashion purists, it has steadily gained respect and popularity, and it is now a regular fixture on the schedules. This is the fashion film, emerging from catwalk backdrop to become an essential part of every brand's seasonal offering. Today, fashion films have become, according to legendary fashion editor Suzy Menkes, "the hottest new accessories" (2010).

6.1
Prada's *Beyond Therapy* is among a new breed of cinematic fashion film (directed by Roman Polanski).

INTRODUCTION

The relationship between fashion and moving image is long established and exhaustively documented, particularly in cinema. Countless "defining style moments" exist, from *Annie Hall* to *Zoolander*, and similarly there is a wealth of academic research on the subject, often debating the role of costume not only on our psyche, but also in wider culture and consumption.

Moving away from cinema to more commercial aspects of moving image, this chapter looks specifically at the sub-genre of fashion film, exploring its evolution, its democracy, the importance of its creative direction, and the role it can play in promoting a brand or designer in the digital age.

LEARNING OUTCOMES

On completion of this chapter you will be able to discuss:

» why film is a suitable vehicle for promotional activity
» the different styles and types of fashion film and their suitability for particular brands
» the role of fashion as character in fashion film
» the importance of creative collaboration in fashion film
» whether fashion film might replace the catwalk/ runway as the optimum vehicle for increasing awareness of a brand or collection.

THE ORIGINS OF FASHION FILM

Although it has become more prevalent since the start of this century, fashion film's beginnings can be traced almost as far back as the emergence of cinema. Marketa Uhlirova (2013) noted "fashion newsreels" being part of the cinematic experience as far back as 1909, more recognizable as part of Pathé news programs.

The 1950s and 1960s saw a period of cultivation of fashion and film as an art form, often created by fashion photographers keen to experiment in a moving medium. The increasing popularity (and accessibility) of television also helped catalyze a fascinating hybrid of artistic expression and commercial communication throughout the 1970s and 1980s. In 1981, MTV—a TV channel dedicated to the emerging genre of music videos— exploited and also helped to generate the public's appetite for short-format visual spectacle.

A NEW DEMOCRACY

Until the 1990s, the privileged guests at live catwalk shows would report on them, offering their edited interpretations with selected still imagery to consumers through magazines and newspapers. Film, on the other hand, enabled the public to view whole collections through the designer's curatorial vision. Gradually, the communication of fashion was becoming even more democratic and accessible, with the digital age offering consumers the choice between edited, mediated forms of communication and the fuller story from the designer, allowing for greater depth of information and message.

6.2

6.2
Newsreels, including fashion's latest
designs, were part of the majority of
early cinema's feature presentations.

6.3a

THE CONTEMPORARY FASHION FILM

When fashion film first emerged into the contemporary promotional milieu, some commentators criticized its inability to communicate the level of detail visible in live performance, clouding decisions on craft, cut and quality through the use of filters, lighting and other visual effects. For most designers, however, the advantages of being able to transmit a wider message outweighed these drawbacks, and by the turn of the twenty-first century, film was principally being used to supplement rather than replace live presentations.

6.3a–6.3b
Brands, such as Australia's Hardwick, have increased global awareness through fashion film collaboration.

6.3b

STRAIGHT TO THE CUSTOMER

The rise of YouTube (2005), Vimeo (2004) and other video-sharing platforms meant that low-budget films—and the fashion contained within that might otherwise remain unseen—can easily be viewed and shared.

Together with the possibilities for distribution widening, the technology facilitating the transmission of digital data was progressing at a steady rate. Guerrero (2010) notes the development of Apple's QuickTime software from 1990 and the subsequent increase in the quality of playback through MPEG standards and advancements in direct digital recording as facilitating the rise of quick, simple online video communication. This created a commonality amongst the growing medium—the typical length of the fashion film, or to put it more accurately, the fashion short.

THE FASHION SHORT

While the fashion short was not designed solely for online distribution, there is a coincidence of practicalities. Despite technological advances at the start of the twenty-first century, it remained time-consuming to stream or download lengthy films. Whether this was responsible for the short-length format of fashion film, the snappy length has, on the whole, stuck, and a maximum run time of five minutes remains the norm, with some cinematic exceptions such as Karl Lagerfeld's *Tale of a Fairy* (2011), featuring Chanel's 2011/12 cruise collection, which ran to over 25 minutes.

6.4

TYPES OF FASHION FILM

Fashion film can be roughly divided into three categories: moving "look books", moving editorial, and creative film. The first simply reflects a particular season's collection; the second a representation of a brand in a more artistic/editorial context; and the third a more intricate, artistic—at times narrative-driven and sometimes abstract— reflection of a collection, designer, or brand. As a creative outlet, there are always exceptions to the rule, but whatever the length or style of the output, there should always be one common denominator: the need to promote a brand or collection through something memorable and, crucially, shareable.

MOVING "LOOK BOOK"

The moving "look book", while prevalent from 2000 to 2005, seems to have fallen by the wayside. These moving catalogues, although not as dynamic as contemporary fashion film, allowed brands to broadcast a collection more widely, often with a soundtrack and, for example, in European brand Monki's case for AW2009, some animation, that helped convey a collection's "attitude". This comparatively "low-fi" approach persists, often with emerging financially restricted brands.

6.4
Brands, such as Monki, utilized film through moving "look books" to promote their collections in the infancy of contemporary fashion film.

MOVING EDITORIAL

These are editorially oriented representations of collections, with a similar "fixed" promotional scope to print fashion editorial—concentrating on garment promotion in a visually appealing manner. Halston's 2009 decision to produce film rather than catwalk resulted in Dree Hemingway running in slow motion against a backdrop of models wearing their AW2009 collection, which sits somewhere between look book and editorial. The film of Kate Moss's SS2010 collection for Topshop consisted of her interacting with the camera, and although the focus was more on her as a "face of" than the collection itself, it reflected the use of her as the key selling point of the collection. Lanvin went one step further in AW2010 with an apparent redux of Steven Meisel's campaign photography into a stop-motion feel promotional film short.

CREATIVE FILM

This is perhaps the type of fashion film that more truly represents the practice as a distinct genre, and it is becoming the most prevalent in contemporary promotion. Creative film is often more artistically approached than the other types, largely driven by narrative and storyline, or reflecting on a brand's ethos or mood through nuance or visual symbolism and representation.

6.5

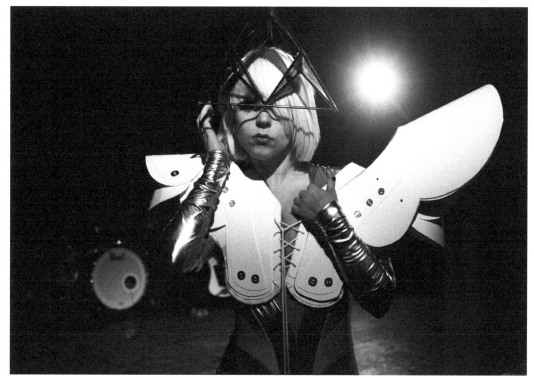

6.5
This collaboration between Lady Gaga and fashion filmmaker Kathryn Ferguson for *Dazed and Confused Magazine*'s online counterpart Dazed Digital is a good example of creative fashion film.

6.6

6.6
Fashion plays an abstract role in promoting Temperley London.

6.7
Marion Cotillard is featured in a number of fashion films for Dior, including the Hitchcock-inspired Lady Dior series.

CREATIVE FILM AND NARRATIVE

Discussing the role film plays within the launch of a brand or designer's collection, Khamis and Munt (2010) identify the differences between more cinematic approaches often adapted by bigger brands, and the more avant-garde approaches of smaller brands and individuals. They claim film facilitates opportunity for more personalized approaches, and using Gareth Pugh as an example —ones that "elevate abstraction over narrative." While big brands utilize narrative to sell a story, smaller ones attempt to communicate a mood or a subtler ethos.

This certainly resonates in contemporary practice. The first of the Lady Dior series, *The Lady Noire Affair* (2008) sees Marion Cotillard teamed with her *La Vie en Rose* director Olivier Dahan in an Alfred Hitchcock-inspired short. This was not just random referencing—Christian Dior himself worked on the Hitchcock movie *Stage Fright* in 1950—and it is an example of brands using a cinematic narrative vehicle to promote their products. In comparison, Temperley London's SS2010 *Zoetrope Circus* is an example of a more avant-garde approach—the collection very much in the background as a part of an elaborate machine generating a visual spectacle.

However, there is evidence of brands and designers at all levels adopting either or both techniques. Similarly, many brands and filmmakers have taken the flow of traditional fashion editorial and adapted it within creative film, but using a promotional perspective.

6.7

INDUSTRY PERSPECTIVE:
A FASHION FILMMAKER'S PERSPECTIVE

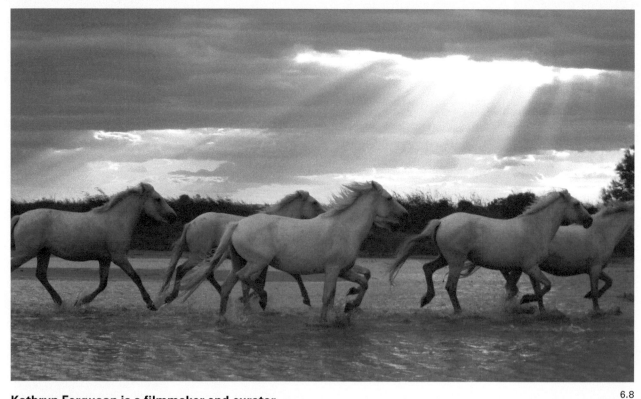

6.8

Kathryn Ferguson is a filmmaker and curator originally from Northern Ireland. She has made many films for fashion designers, brands, and musicians including Chloé, Selfridges, Sinéad O'Connor, Lady Gaga, and Charlie Le Mindu.

6.9

"I think I have been very fortunate with the way my career has developed in terms of creative freedom. There seems to be an element of radical experimentation within the genre, which may be lacking in some other short-form or commercial formats.

"What stimulates me in fashion film has changed quite dramatically over the past ten years since I first became aware of the emerging genre. While I will always be overawed by the spectacle of fashion image-making and the fantasy it creates, I think the filmmaking needs to be paramount. I now find myself most drawn to films with a purpose, a story, even if it's a linear narrative. I feel storytelling is key with the garments in a supporting role rather than in the lead."

6.8
Kathryn's collaboration with Chloé—H/Horses, commissioned by Chloé as part of *The Alphabet*, a digital heritage project coinciding with Chloé Attitudes—an exhibition at Paris's Palais de Tokyo 2012, France.

6.9
Kathryn's collaboration with Selfridges.

FASHION FILM AS A PROMOTIONAL VEHICLE

With all the suggested types of film previously mentioned, the context of the film's purpose is important to consider. After all, it is still exceptionally rare for a designer or brand to depend on a film for an entire season's promotion. Just as much as fashion plays a role within film, in a wider campaign the recognition of film's role itself is crucial to its success.

FASHION AS ACTION

The second approach to which Berry alludes is more abstract, but nonetheless as essential to an effective marketing mix. By alluding to the creative style, wit, or image of a brand or designer through their creative influence on a short-film format, the desired perception or image of a brand or designer is communicated. This might elicit positive feelings about the brand, or, indeed, even change prior perceptions, so rather than a specific product, a viewer gains perspective or develops an affinity to an entire brand ethos—"that was a cool film, therefore this is a cool brand."

FASHION AS CHARACTER

Berry (2012) identified two approaches to the fashion film (or creative film as we've termed it here). She called them "fashion as character"—where the viewer observes a "commercial product" and "fashion as action" where fashion is more hidden, driving a narrative but not necessarily being instrumental to that narrative. This is an interesting distinction, which could be aligned to a brand or designer's creative objectives—capturing a product in a certain light can certainly make that product more desirable. It may follow that the consumer wants it, and therefore this can influence their purchasing decisions— particularly if initial exposure to that product is framed in a highly desirable context. Therefore, brands or designers that adopt this approach, it could be seen, are marketing their goods in a direct manner.

ASSOCIATION AND COLLABORATION

This idea of reinforcing or reconstructing perceptions of a brand isn't necessarily limited to what we see on screen. In fact, often it can be by association. The most obvious is the decision to cast a well-known individual. A popular tactic, this can be seen in all types of fashion film and in the promotional spots used by mainstream giant H&M to promote its designer collaborations—the likes of Karl Lagerfeld, Donatella Versace and Roberto Cavalli have appeared as themselves.

6.10

6.10
Not only brands, but filmmakers like
Monica Menez have platforms to
showcase their creativity.

FASHION PHOTOGRAPHY AND FILM

Partnering with an artistically inclined fashion
photographer for a film can direct viewers' assumptions
about the film towards art as opposed to advertorial,
which is reflective of Berry's idea of "fashion as action."

For example, one of the most well-regarded names
within fashion film, fashion photographer and director
Nick Knight has become globally synonymous with
creative experimentation in the medium through his
SHOWstudio initiative in the UK, which began in 2000.
Starting as a way to enable emerging designers to
communicate their collections through film, the initiative
captured the imaginations of like-minded creatives
globally, and it is unlikely that fashion film would have
developed without Knight's influence. Not surprising,
then, that the word "SHOWStudio" often acts as a
promotional catalyst before a project is even shown.

6.11

6.12

6.11–6.12
Berlin's underground club scene was
the dark and evocative setting for Ralf
Schmerberg's film with label Moga e Mago.

THE DIRECTOR'S CHAIR

Just as linking with photographers can be a highly
useful promotional endeavor in itself, the bigger brands
have embarked on similar relationships with respected
film directors. Again, we must consider the promotional
value of this before shooting even begins, as there is
often much to be made in building anticipation. Baz
Luhrmann, David Lynch, Kate Bosworth, Sofia Coppola,
and Martin Scorsese are just a few directors adding
cinematic gravitas to (inevitably) well-established brands.
However, an emerging generation of film auteurs are
collaborating with a wide range of brands from all
sectors—particularly useful in terms of capturing
a younger, cooler creative market.

GETTING THE RIGHT MESSAGE ACROSS

As a part of a brand or designer's promotional package,
film has become a highly effective promotional tool, not
just for showcasing a collection but for reflecting vision,
ethos, lifestyle, or even the personality of a brand and its
designers, in the hope that the audience will identify with
the film and its style or characters, and by association
identify with the brand. It can also avoid the hard sell of
advertising. Vanessa Friedman, reporting on a new raft of
films in late November 2013 for the *Financial Times* noted
"fashion films that are, finally, fun to watch. There's not a
constant awareness of the director's mandate to sell…
all that talk about the marketing of no marketing being
the marketing of the future has, apparently, sunk in."
No overtly visible marketing, at least.

INDUSTRY PERSPECTIVE:
THE FUTURE OF FASHION FILM

6.13

Diane Pernet, founder and director,
A Shaded View On Fashion Film (ASVOFF), Paris.

"How to monetize fashion film is the 'next big thing' in the fashion industry and retail so we should all watch this space very carefully as brands increasingly make fashion films 'shoppable'. There are plenty of exciting opportunities out there as the digital landscape changes, but no one is entirely sure which business models are going to work yet and which aren't, so it will be a lot more trial and error, I think, before we see a clear path to fashion film earning money—I mean besides the obvious outlets like being hired for a brand to do a video campaign."

6.13
Behind the scenes at the Berlin
Fashion Film Festival (BFFF).

Bon Duke, co-founder,
New York Fashion Film Festival (NYFFF)

"It excites us all. Most likely, technology will be an interesting player for how fashion films will be seen or used. As it allows the viewer to walk away with an insight/emotion/inspiration/piece of the brand/designer that puts in the video, I feel the creativity should always elevate the brand message and compliment it. The brand/company or message should never overcome the creativity."

RIVER ISLAND

Josie Roscop,
Marketing Director, River Island

"I think it will continue to develop and innovate as a medium, and it's an exciting area of marketing to be a part of. Film allows consumers to see and feel a brand's product and personality."

Niccolò Montanari, co-founder,
Berlin Fashion Film Festival (BFFF)

"It's important to consider how many industries, including the fashion one, have had to veer towards new forms of media to stay relevant. Whereas before the whole industry was based around fashion weeks and needed to be present at fairs and catwalks, designers now have the potential to present their collections the whole year round, be that via fashion film or via online shops or online showrooms. Don't get me wrong: I am not saying fashion film is set to replace catwalks, as you will never replace the live fashion element of a catwalk or presentation, but fashion film represents a relatively inexpensive and prolonged way to present your brand."

KATHRYN FERGUSON

Kathryn Ferguson,
Filmmaker and Curator

"I would like to think that narrative will feature more in the future of fashion film. High-fashion presentation traditionally can be incredibly exclusive, and while this works in editorials, this can have less impact in film when you see the living breathing person in moving image without some form of narrative. Fashion films that create more of an emotional response would be a good start. New technologies will naturally change how we experience fashion film, as we've seen already in the past few years with holographic fashion shows and augmented-reality fashion week presentations."

INTERVIEW: GEORGIA HARDINGE AND JOSIE ROSCOP – USING FASHION FILM: BRAND AND DESIGNER PERSPECTIVE

6.14

UK mainstream brand River Island started a film sponsorship program—Fash/On Film—with the British Fashion Council in 2012, as a film showcasing opportunity at London Fashion Week. Emerging designer Georgia Hardinge, was selected for the collaboration in SS2013 and AW2013. Georgia and Josie Roscop, Marketing Director for River Island, both give their perspective on their SS2013 collaboration and the resulting fashion film.

6.14–6.16
Stills from the film showcasing the first collaboration between Georgia Hardinge and River Island (Director: Alex Turvey).

6.15 6.16

About the film

Josie Roscop: "The aim was to showcase Hardinge's collection for River Island to press and consumers, so the film had to illustrate the product, communicate the designer's inspiration, and tell the story behind it. We aim to keep these type of films relatively short as they are mainly viewed online and we find short, punchy pieces to be more powerful and engaging."

Using fashion film for their brands

Georgia Hardinge: "The film allowed us to work closely with a group of talented people, which was inspiring not only from a creative point of view, but also on the business side. Working on the fashion film not only meant creating a visual expression, but also thinking about how we can engage with a new audience to ultimately create interest in our own brand [Georgia Hardinge] and collaboration."

On creativity and brand message

GH: "I feel like with films you have to work harder to be engaging and keep the audience's attention. As fashion designers, we want to think in visuals first, which can lead to a beautiful but pretty one-dimensional result. To reap the benefits of films in comparison to images, we want to use it as a form of storytelling to communicate our brand. In order to achieve this, we have to consider both our brand identity and our audience throughout the creation process."

On fashion film and emerging brands

GH: "I wouldn't say that fashion film is essential for the success of a small brand. At the end of the day, we are fashion designers, so first and foremost our products need to do the talking for us. However, I strongly believe that it can support the growth and accelerate the success. If done well, fashion films can reach a worldwide audience and engage with it more deeply and for a longer time than other media forms."

INTERVIEW: DIANE PERNET –
INTERNATIONAL FILM FESTIVALS

6.17

Annual film festivals emerging in London, Paris, New York, Berlin, and San Diego in recent years are a marker of how popular and commercially successful fashion films can be. Diane Pernet, the founder and director of the highly influential festival A Shaded View On Fashion Film (ASVOFF) in Paris offers her perspectives on fashion film.

Why did you start the ASVOFF festival?

Back when I first started, I think there was just 'something in the air' that told me the timing was right to finally marry my two passions—fashion and film. Fashion film is an intriguing artistic genre and a valuable new commercial outlet, all rolled up into one medium. I launched A Shaded View on Fashion Film (ASVOFF) in Paris in September 2008 at the Jeu de Paume. It has since moved to the Centre Pompidou where it has remained for the past five years and screened for the sixth edition in October 2013.

6.17
Diane Pernet founded ASVOFF.

6.18
A screening at the New York
Fashion Film Festival (NYFFF).

What do you think fashion film can do for a brand or designer?

Fashion film can be widely accessed without any additional cost to the brand, meaning that brands need only to pay for production, not advertising space. The spirit of fashion film is typically one where the consumer expects brands to push the boundaries a bit more and not be quite so precious about things.

What makes a "good" fashion film?

Fashion film is a film where fashion is the protagonist rather than a prop. Fashion is a high-impact, fleeting concept by its very nature so usually they are short films. My festival focuses mainly on fashion films that are between 30 seconds and 5 minutes long.

Social media has inarguably had an impact on the visibility of fashion film, but how do you think wide accessibility translates to success? Is there a saturation point?

Fashion films—like all short films—are often geared toward the idea that people will watch and share them over social media platforms. So, to some extent, I suppose filmmakers of fashion films should be conscious of social media as one of their important outlets. But making a ten-second YouTube hit about a talking dog or a dancing baby is not the same thing as making a 30-second fashion film capturing the depths of the imagination and soul of a designer like Gareth Pugh. So, unless the brief of a fashion film is purely commercial with very specific objectives and metric targets, I don't think that fashion filmmakers should let social media be the driving force.

6.18

CHAPTER REVIEW

In this chapter, we see that the technique of using film to promote fashion is hardly a new phenomenon. While the contemporary fashion film has morphed into its own sub-genres, these have provided great flexibility in the manner, style, and environment in which a designer or brand can communicate its message. While it shouldn't be a singular strategy in promoting fashion, it has facilitated a far deeper and more memorable conversation—one that takes place more freely and directly between brand and consumer. With the right team on board, it can help complete the perfect promotional package.

QUESTIONS FOR DISCUSSION

1. What fashion films have you seen that give you an insight to the designer or the brand? Have any changed the way you view a designer or brand?

2. What are the advantages of using film as part of promotional and marketing activity?

3. What are the different styles and types of fashion film? Give examples of brands or designers that you think would use each.

4. Give examples of three fashion films where fashion acts as character, and where fashion is action.

5. Identify as many of roles as possible involved in the making of a fashion film.

6. Could fashion film ever replace the catwalk? How?

6.19

6.19
Whatever trend or, indeed, technology dictates, the relationship between fashion and film is unlikely to weaken.

CHAPTER EXERCISE

ONE

In small groups, select a brand or designer and create storyboards for a short fashion film in the styles of moving look books, moving editorial, and creative film.

Consider:

>> the message you want to send—what is the brand ethos, the film's purpose?
>> the role fashion plays—fashion as character or as action?
>> the inspirations—does it reference a genre of film? Is it reflective of the brand's prior promotional activities?
>> the team involved—which models, notable actors, directors, or other creatives would you choose?
>> the investment involved—is it for a big brand or emerging designer?
>> the role it would play as part of a campaign—its own positioning, marketing, how it would be publicized?
>> the advantages and disadvantages of creating a film for your brand or designer.

TWO

In small groups, select an existing fashion film from an emerging brand or designer.

Discuss:

>> the style of film
>> the role fashion plays
>> the team involved
>> the current promotional strategies employed by the brand or designer
>> how they could use fashion film in the future.

THREE

In pairs, watch an existing fashion film separately and identify:

>> the "message" of the film
>> its references and/or inspirations
>> your key moment in the film
>> the most memorable element
>> the least effective element.

Compare your answers—do they match? If not, do you think this affects how successfully the brand has communicated their message? What would you both suggest to improve it?

07

EVENTS: FROM PRIVATE PARTIES TO PUBLIC PERFORMANCE

Fashion historian Christopher Breward's assertion that fashion itself is an event (2004), looms large over a promotional environment in which launches and parties involve much more than just champagne, goody bags, and balloons. No longer simply privileged networking grounds, today's fashion happenings are locked in to the promotional mix, meticulously planned to support brands by providing immersive experiences for industry types and the public, which must provide a healthy return on their substantial financial investment.

7.1
Models Jourdan Dunn and Rosie Tapner help launch Selfridges Denim Studio in June 2013.

INTRODUCTION

Sidestepping fashion shows and fashion weeks (covered in depth in Chapter 2), this chapter focuses on other events: press days, trade shows, and public happenings aimed directly at consumers. We examine the use of spectacle, and the importance of phenomena such as the "pop-up" and shopper evenings. We also find out how and why events work for fashion brands, and ask what impact virtual events might have on attendance at "real" happenings in the future.

LEARNING OUTCOMES

By the end of this chapter you should be able to:

>> understand the significance of events to the practice of fashion promotion
>> explain the importance of experiential activities to fashion brands, media, and the public
>> describe some of the noteworthy events in the fashion calendar
>> identify the differences between "trade" and "public" events
>> suggest ways in which events might help to promote fashion brands.

WHAT IS A FASHION EVENT?

Part of a growing trend towards "experience marketing", the field of fashion events is now so vast that for the purposes of this chapter, we refer to events simply as created and planned occasions outside the everyday field of experience that are in some sense "special", even if—like many fashion events—they are repeated on a cyclical or seasonal basis.

Fashion promoters use events to saturate brands and products with qualities that surpass our everyday interactions with them, and in so doing, communicate messages in specially created, multisensory environments. Successful events should affect attendees emotionally, psychologically, and physically, at least partly through contact with other people and objects. While these effects are usually best produced among those in attendance, they are also communicated vicariously, through reports in trade or consumer publications, or via social media. While journalists and the public still clamor for invites to each season's most remarkable happenings, their impact now reaches far beyond the fortunate few able to "be there" on the day.

7.2

7.2
Professional and amateur
photographers alike jostle for
pictures of models Jourdan Dunn
and Rosie Tapner at the launch of
Selfridges Denim Studio, July 2012.

EVENTS AND THEIR AUDIENCES

Fashion events fall into several categories, depending on whom they are attempting to attract and communicate with. Target audiences are broadly categorized as either industry (buyers responsible for selecting each season's retail stock; stylists and other insiders) and the public, but ultimately, all seek to generate media coverage beyond their immediate reach. Some events are arranged solely for media: photo-calls, launches, and press days. Media events are generally invite-only and may be listed on subscription fashion industry web portals such as Centaur Media's *Fashion Monitor*.

INDUSTRY EVENTS

Many of the most prominent events in the fashion calendar are produced exclusively for industry insiders, with members of the public only occasionally catching a fleeting glimpse behind firmly closed doors. These include trade shows, photo-calls, press days and launches.

TRADE SHOWS

Typically trade shows act as major exhibitions and showcases for fashion brands and affiliated industries (such as textiles manufacturers). The primary role of trade shows is to connect producers with retailers. With few exceptions, they are open only to buyers and the media. As well as enabling fashion producers to demonstrate their wares, trade shows facilitate competitor research, trend analysis, and other opportunities such as recruitment. For fashion promoters, trade shows are some of the most important events in the fashion industry calendar, offering opportunities for connecting brands with essential trade target audiences rivaled only by the major international fashion weeks.

7.3b

7.3c

7.3a-c

7.3a–7.3c
Founded by Karen Radley in February 2011, Scoop International is fast emerging as one of the UK's most influential and innovative annual fashion trade shows. The show's publicity is handled by Donna Lambert at PR agency Lamb to Slaughter.

TEN KEY INTERNATIONAL FASHION TRADE SHOWS

Event name	Event type	Location
Patti Immagine Uomo	Menswear	Italy
Bread & Butter	Menswear	Germany
Jacket Required	Menswear	UK
Capsule	Womenswear and menswear	France; Germany; USA
Scoop International	Womenswear	UK
Premiere Vision	Womenswear	France; USA
Pure	Womenswear	UK; China
Moda	Womenswear and menswear	UK
Panorama	Womenswear and menswear	Germany
Who's Next	Womenswear and menswear	France

PHOTO-CALLS

Photo-calls take several formats, with the most popular either involving celebrities, or incorporating novel features designed to attract press photographers to generate captioned picture stories. Depending on format, timing, and participants, successful photo-calls may offer fashion promoters anything: from nothing, to a transitory appearance in a single day's news pages, or even ongoing coverage over many years, where—for example—a celebrity involved in the shoot subsequently increases in popularity or notoriety.

PRESS DAYS

Typically corresponding with major fashion weeks, press days allow guests to experience up-close collections that they have recently viewed at catwalk shows. Held at PR agencies, brand HQs, or external venues, these invitation-only presentations are where stylists, bloggers, and fashion editors can uncover trends and plan features for forthcoming publication. Often, collections appearing at press days have already been assessed by buyers, enabling brands' PR representatives to present to media-only elements from collections that are likely to be available to consumers through retail outlets.

In addition to single brand press days, PR agencies also hold regular events showcasing collections from all their (often smaller) brands under one roof to interested media. These offer agencies a convenient way of introducing their brands and themselves to journalists, developing and maintaining relationships that may result in positive media coverage—including requests for samples to photograph in editorials, or comment from brand representatives.

7.4
Photo-call for outdoorwear brand Orvis featuring a trompe l'oeil, three-dimensional pavement drawing in London's Leicester Square.

7.5
A selection of invites to press days and other press events.

7.6

7.7

LAUNCHES

Launches are the quintessential fashion media event, where months of fastidious planning culminates in happenings with various degrees of spectacle intended to submerge attendees in brand DNA and provide a reason to write, film, or photograph the event in the media. Regardless of whether for new products, new brands, new stores, or more commonplace phenomena—such as new ways of displaying existing ranges in store—launches offer several benefits for fashion promoters and brands. First, they provide a fixed point in time that acts as a marker for media to cover whatever is being launched. This helps coalesce media coverage into a critical mass, which is more likely to be noticed by consumers than smaller bursts of intermittent mentions in print or online. Second, they present promoters with a fixed space in which to communicate verbally with journalists, who themselves, by attending, undertake a tacit agreement to cover whatever stories that may be presented to them. Third, and most importantly, they provide "angles" for media—the priceless reasons that journalists require in order to cover whatever is being promoted, in ways that are most relevant for their respective target audiences.

Launches are arguably most impactful when they take place in reality, in physical spaces designed (or at least styled) specifically for the purpose. Increasingly, however, the concept of the virtual launch is gaining currency, where an event is planned to take place online, featuring some or all of the activities designed to generate news angles for journalists, which might be expected at a physical event. More interesting are variations on the mixed physical/virtual event such as jewelry designer Hannah Martin launching her "Comte's Pyramid Ring" at a physical event at London's Dover Street Market in 2011. It included an augmented reality installation that could also be experienced via the designer's website.

7.6–7.7
Jeweler Hannah Martin's 2011 "Comte's Pyramid Ring" launch event at London's Dover Street Market blended a physical event with augmented reality.

7.8

7.9

PUBLIC EVENTS

Public events take a wide variety of forms, from one-off stunts, to pop-up shops, exhibitions, or more long-term installations.

7.8
TV interview at one of Amsterdam Fashion Week's "10 Days Downtown" public events in 2014.

7.9
The launch of Selfridges' "No Noise" event in 2013.

7.10
Members of the public take selfies at a Burberry Christmas outdoor promotional event in London's Covent Garden, December 2014.

7.11
Promotional poster for the 2014 Jean Paul Gaultier retrospective at London's Barbican Centre.

7.12
Christopher Raeburn retrospective exhibition held within the menswear department of London department store, Liberty.

7.10

7.11

7.12

EXHIBITIONS: FEATURING AND SPONSORING

Fashion as an expression of contemporary culture has long occupied the exhibition repertoire of public museums and galleries. Between October 2000 and January 2001, Giorgio Armani featured as the subject of a major retrospective at New York's Guggenheim Museum, and since then many major designers have been celebrated in this way. Between 2012 and 2014, in London alone, retrospectives took place featuring Christian Louboutin, Isabella Blow (focusing largely on Alexander McQueen's work), Paul Smith, and Jean Paul Gaultier. Such shows generally offer an uncritical view of a designer's work and, therefore, offer significant opportunities to generate positive publicity for the brand.

In addition, fashion exhibitions offer valuable sponsorship and profile-raising opportunities for those eager to acquire the cultural capital associated with the museum. In 2014, for example, Italian luxury jeweler Bulgari sponsored the Victoria & Albert Museum's touring exhibition "The Glamour of Italian Fashion 1945–2014", and US department store chain Barneys New York was lead sponsor of the Dries van Noten exhibition at the Musée des Arts Décoratifs in Paris. To celebrate the exhibition opening, Barneys hosted a cocktail party during Paris Fashion Week, with attendees including *Vogue* Japan editor at large Anna Dello Russo, model Anja Rubik, and designers Rick Owens and Phillip Lim. Making the most of this promotional opportunity, Barneys used content generated by the exhibition and cocktail event on social media and its content site, The Window.

On a smaller scale, exhibitions are increasingly popular within retail premises, particularly department stores. They offer a point of interest within specific departments for shoppers, and they also provide opportunities for retailers and brands involved to hold launches to generate media coverage and subsequent consumer interest.

INTERVIEW: ANDREA LEONARDI –
EVENT PRODUCER, WITHOUT PRODUCTION

Andrea Leonardi and his wife, Gabriella Mazzei opened Without Production in Milan, Italy in 1999. Since then, the company has combined architect Andrea's appreciation of space and location with Gabriella's fashion production experience, to stage hundreds of events for luxury fashion brands worldwide. Here, Andrea describes how they work.

7.13

What does your work involve?

Quite simply, our work consists of conceiving and realizing events for major fashion brands. Whatever the needs of the brand, we make the event happen.

Can you name some of your clients?

We work for many of the biggest luxury brands including Prada; Gucci; Burberry; Bottega Veneta; Jimmy Choo; Louis Vuitton; Tod's and Belstaff, also major Italian designers such as Marco De Vincenzo; Ermanno Scervino; Aquilano e Rimondi; and Kiton.

Can you describe the event production process?

We first establish the client's aims, so that together we can decide how best to achieve them. Needs vary from case to case; and budgets are both a limiting factor and a driver of creativity. Early on, we focus on choosing the right location for an event as this influences all other aspects. When we've scouted possibilities, we present them to the client and once a decision is made, we proceed with the project design. For this, we produce detailed drawings, even rendering specific views to help the client visualize exactly how the event will look. We make a list of materials required, a light plot to explain the kind of light we propose and, if needed, make up samples to show particular materials or colors we want to use. We present the whole to the client and once approved, we move to the next step: finding specialized suppliers for each event element. Then we organize the construction plan and supervise the set up. On the day of the event, we provide the direction.

What have been some of your favorite projects to work on and why?

One recent highlight was for the Gucci Museum in Sao Paulo, Brazil. For this, we designed a temporary exhibition of pieces from the Gucci Museo that were presented for the first time outside Florence. I've also loved working on all of Prada and Miu Miu's events in China, these brands always make art a high priority. As Suzy Menkes wrote, "Miuccia's skill is to make the commercial seem artistic," the truth is, it doesn't just seem artistic—it is artistic.

Do you think filmed shows or live streaming of events will ever replace live shows?

This is a little like asking if a film of a city or a music concert can replace the live experience. Yes it can, but only partially. Being there is always different and … well … better!

7.13
International fashion events creator
Andrea Leonardi of Without Production.

7.14

7.15

SHOPPER EVENTS

Shopper events, intended to create excitement and a sense of spectacle around the otherwise mundane process of shopping, are today a firm fixture on the public fashion events circuit. Some of the most significant examples include the UK's Clothes Show Live, the Vodafone-sponsored London Fashion Weekend, and the international Vogue Fashion's Night Out, although similar, smaller events take place nationally, regionally, and in specific shopping districts worldwide.

7.14
Crowds gather outside TOD's in London's Bond Street for a 2014 Vogue Fashion's Night Out event.

7.15
Fashion blogger Louise Ebel attends the Vogue Fashion's Night Out 2014 at John Galliano in Paris, France.

VOGUE FASHION'S NIGHT OUT

Vogue Fashion's Night Out (VFNO) began in 2009 in New York City as a response to a retail downturn linked to the era's financial depression. By September 2014, it had expanded to 32 cities in 19 countries. In each location, the event format follows a similar pattern, with entire shopping districts participating and offering extended opening hours plus a wide range of in-store entertainment, styling demonstrations, makeovers, and special offers.

As a result of the 2013 VFNO in Manchester, UK, footfall in the city center was doubled for the event duration, which generated in an estimated £570,000 ($852,000US) of media coverage (calculated against the equivalent cost of paid advertising space). Perhaps more significantly, the events generate thousands of social media mentions, with the 2014 VFNO events trending strongly across Twitter and Instagram before, during, and after each event. Although VFNO appears to be growing in popularity internationally, 2013 saw the New York City event placed "on hiatus" as participants attempted to assess its return on investment, with some reports citing store overcrowding, and even criminal activity, as a result of the massive influx of shoppers entering a relatively constricted area for the event duration.

LONDON FASHION WEEKEND

Taking place immediately after the UK's biannual London Fashion Weeks, London Fashion Weekend offers around 20,000 members of the public each season the opportunity to purchase tickets for catwalk shows, shop for discounted merchandise, attend panel discussions with industry figures, and participate in other sponsor-led initiatives—such as experiencing life as a catwalk model by using a virtual reality headset. Like VFNO, London Fashion Weekend offers sponsorship opportunities for non-fashion brands: in 2010, mobile phone network Vodafone signed a deal with the event as headline sponsor, to coincide with its "VIP" customer reward scheme. This trend is also observable in reverse, with major events not traditionally related to clothing fashion (such as the Milan Furniture Fair) being infiltrated by fashion brands.

7.16
Swiss fashion watch brand Swatch attracts attention with a mini event at "London Fashion Weekend", 2014.

7.17
Selfridges' window displays help to promote their "Masters" event in 2014.

7.18
Casio G-Shock Scratch Academy is an event held to strengthen the link between the utility watch brand and creative music professionals who depend on perfect timing to produce showstopping DJ sets.

7.19
Private events, such as this invite-only media event for US headwear brand New Era, help brands retain a sense of exclusivity.

7.16

7.17

7.18

THE USE OF SPECTACLE: STUNTS, POP-UPS, AND EXPERIENTIAL EVENTS

Each year, thousands of stunts, installations, and "experiential" events take place, which allow consumers to interact physically with brands, offering brands face-to-face opportunities to communicate their messages and help create shareable online content. Smaller, niche events—such as the Casio G-Shock Scratch DJ Academy—are likely to appeal to core brand targets, particularly those likely to wield significant influence as third-party endorsers via social media. Larger, more spectacular mass-market stunts—such as Selfridges' London "Masters" event, which featured a 25-foot-high sculpture of Rick Owens looming over the store's Oxford Street main entrance—are designed to generate high footfall at the event itself, although they also benefit from subsequent social media engagements.

7.19

With today's unquenchable requirement for online content production, experiential events—which allow members of the public to either "experience" a product first hand, or participate in a more holistic "brand experience"—are increasingly popular ways of reaching out to consumers, either directly, or vicariously through social media image sharing. In many cases, experiential events may also involve participants in contributing to the evolution of a brand, as their actions and reactions to the event help shape the brand's future activities.

7.20 7.21

POP-UPS

There is no doubt that the "shock and sense of surprise" that Comme des Garçons founder Rei Kawakubo believed should accompany a shop opening in her original "guerrilla stores" manifestation (2004) is no longer guaranteed by a fashion pop-up. Today, in major metropolitan areas, these temporary retail spaces appear each year in their dozens, used by brands from mainstream to high end, offering products from fashion to food.

Kawakubo's original vision for a retail space that "open without warning…pops up…and closes just as rapidly" offering "an array of interesting and creative merchandise in a new way that is not beholden to seasons, or other industry dictates" (Mores, 2006: 147–150) has developed into a retail and promotional phenomenon to such an extent that numerous websites exist solely to list new openings.

Despite this, they remain able to generate publicity by providing media with an angle—a reason to feature the brands involved in listings or fashion "news in brief" sections of print and online publications. Only the most innovative or unexpected garner more than a brief mention, such as Hermes' pop-up silk bar at New York's Grand Central Terminal.

Furthermore, some pop-ups—such as London's first pop-up mall, BOXPARK, and Kawakubo's own permanent but guerrilla-style high-end department store Dover Street Market (also in London)—have evolved into established fixtures.

7.20
BOXPARK, London's groundbreaking "pop-up mall" is now an established test bed for niche stores and big brands seeking to experiment with product launches and new styles of minimal visual merchandising.

7.21
When high-end estate agents start offering retail spaces as pop-up opportunities, it's likely that the concept's original energy may be on the wane.

7.22

7.23

7.24

7.25

EXPERIENTIAL EVENTS

House of Vans, London

In August 2014, US skatewear brand Vans opened "House of Vans," London's first indoor skate park, located within the cavernous complex of former railway arches beneath Waterloo Railway Station. The fashion label allegedly outbid Apple and Nike to win the lease, and it has created a potent youth-culture venue complete with skater-designed concrete bowl, mini ramp and street course, a performance space, art gallery, cinema, café/bar area, and "VansLab artist incubator space."

While only a small minority of Vans consumers who actually purchase the brand's products are committed skateboarders, the brand recognizes the value of nurturing an activity at the core of its DNA. As Lorna Hall, head of market intelligence at the trend forecaster WGSN commented to *The Guardian* newspaper at the installation's launch in August 2014, "the brand is owned by the community who use it and they can sniff out inauthenticity."

The House of Vans's launch received extensive, positive news coverage not only within the fashion media, but also among regional, national and specialist publications, broadcasters, and blogs including *The Guardian, The Standard, The Independent, ITV News, Creative Review, Londonist, Wavelength, Complex,* and *Huh* magazine. One of the first events to take place within the space was a photography exhibition hosted by iconic skate magazine *Thrasher.* The partnership offers an example of how appropriate brands collaborating on highly targeted events can strengthen their consumer appeal for mutual benefit.

7.22–7.25
House of Vans: a potent youth culture venue, purpose designed to serve the community at the core of the Vans brand.

INTERVIEW: KATIE BARON –
THE IMPORTANCE OF EVENTS

7.26

Katie Baron is an author and Head of Retail for global innovation research and advisory business, Stylus. She is also fashion editor for *VOLT* magazine, and a former Fashion Production and Bookings Editor for *Harper's Bazaar*. Here, she explains the value of fashion events to brands and considers how they may develop in future.

Why do brands still use events in the digital era?

Because they can't afford not to! The demand for content to drive brands' multiple social media platforms, and the importance to brands of consumers talking about them online makes events essential. They are the ultimate conversation-starters in an era where consumers increasingly feel entitled to multiple-brand access points, particularly the ability to explore behind the scenes.

So important are events that many brands are investing heavily in flagship stores and other spaces that have dedicated event space built-in. In addition, events also offer huge opportunities for brands to research their target audiences by observing how consumers interact with products in-store and in other environments. This is a crucial point: while online communities are thriving, there seems little chance that our human instinct for physical communities where were can talk, touch, and interact in real life will ever go away. House of Vans (see case study p.153) is a fantastic example of this.

7.26
Author and retail guru Katie Baron (pictured with Ben Cox) attends the *VOLT* magazine x The Kooples event in London, 2014.

7.27
Installation at the *VOLT* magazine x The Kooples event in London, 2014.

7.27

How can brands evaluate the success of events?

While some measures of event success are instinctive, it is easily possible for brands to set up metrics to tell them not only how many people have attended events, but also how attendance has affected subsequent consumption. For example, if all attendees at an event receive an exclusive coupon code for online shopping, the brand can quickly tell how many have used the code and, therefore, assess the relatively immediate return on investment.

Some brands are separating event attendance from shopping, giving attendees the opportunity to place items viewed at an event on a "wish list" that they could transact online later. The major shopper events, such as Fashion's Night Out, enable retailers to instantly track sales' spikes, but after pretty much any event, simple online tools make it possible to count social media interactions and compare these to sales data to identify any links between the event and subsequent sales. Brands are also likely to collect data on, for example, Twitter or Instagram users who interact with their events, as well as being able to monitor the nature of the conversations being wrapped around the brand—another piece of useful feedback, potentially more authentic than traditional marketing focus groups.

What is the role of virtual events?

Virtual events have their uses. For example, a boutique or buyer in a far-flung part of the world might be unable to attend presentations at the major international fashion weeks, but they can still get a sense of access to collections via online catwalk shows. We're also increasingly seeing virtual events as a direct route to purchase, with brands from luxury to mainstream all using real-time, interactive link-ups to their shows to connect with consumers.

What direction do you think fashion events will take in the near future?

Social media has afforded us all a sense of being able to get far more "up close and personal" with the brands and designers we admire, which is in turn generating a greater thirst for knowledge and insight from fashion insiders, perceived as creatively inspiring figures. This has led to a resurgence of more intimate, intellectual events in which small audiences get the opportunity to hear industry experts discussing various aspects of the fashion industry.

Even quite major launches will include such discussion panels, which have long been a feature of other cultural events such as film and theater screenings. We can see this as the emergence of event "editorialization," emulating the way in which fashion magazines curate content so that readers can choose to delve deeper into detailed features to find out more about creative and production processes, as well as the products they may want to buy. For luxury brands in particular, this sense of enrichment or "edutainment" can also, to an extent, help justify a high price tag.

CHAPTER REVIEW

As this chapter shows, events offer an almost infinite variety of ways for fashion promoters to gain exposure for brands and communicate their undiluted brand essence to consumers, often directly, but also via third-party opinion formers both within and outside the fashion media. While today's events may generate significant footfall in their own right, truly spectacular happenings also serve to create great content enabling events, and their sponsors to benefit from the global reach of digital reporting.

QUESTIONS FOR DISCUSSION

1. Name three ways in which events are significant to the practice of fashion promotion.

2. Why is it important for brands to get "up close and personal" with consumers using experiential activities?

3. Excluding the "big four" fashion weeks, name five important events within the international fashion calendar.

4. How do "trade" events differ from public events?

5. How might an emerging designer use an event to promote their little-known brand?

7.28

7.28
Stylists and hairdressers arrive for one of the London Fashion Week events in 2015.

7.29
Fashion events aimed at the public offer a rich source of content for bloggers, brands and event sponsors alike.

7.29

CHAPTER EXERCISE

ONE

Consider any event that you have recently attended, which involved a fashion brand as either event host/organizer or sponsor. Follow up your impressions by searching the Internet for mentions of the event on fashion, news, or social media sites. Consider the following aspects of the event and come to a conclusion about whether or not the event was likely to have been considered a success by the brand involved: aim; target audience; number of attendees; extent (if any) of media coverage achieved; messages communicated.

TWO

Using a fashion brand or retailer of your choice, research their previous event activities and use your research to determine their most likely target audience and an approximation of their budget available for events. Based on your findings, try to devise a one-off public event that would draw the attention of members of their key target audience and generate media coverage. When you have done this, try the exercise again, but this time imagine that you have (a) a £1 million (or $2 million) budget and (b) no budget.

THREE

Identify a fashion-related event for media that has recently taken place in your locality. Using the guidance on press-release writing in Chapter 2, produce a press release and a media invite for the event. You can attempt either a physical invite or an e-invite.

08

VISUAL MERCHANDISING: FROM STORE TO SCREEN

Online or on the high street, from flagship stores to pop-ups, the visual exhibition of fashion has never before been so meticulously crafted and curated. Gone are the days of displays designed to extol the purpose of clothing and accessories, replaced by miniature brand worlds that shape persuasive fashion narratives. As legendary Barney's Creative Ambassador Simon Doonan said in his address to the 2002 Visual Merchandising and Display Conference, visual merchandising must "weave a spell around the customer…make her fall in love."

8.1
"In the center of the window, about four feet high, there can be something conspicuous, to catch the eye, turn the head and stop the feet of passersby"—Mattia Biagi's "Teddy 212" installation for Bergdorf Goodman in New York City (2013) perfectly fulfills one of Herbert Casson's *Twelve Tips for Window Display,* published in 1924.

8.2

INTRODUCTION

This chapter examines how visual merchandising has evolved from a way of making clothes look good off the body, to a curatorial practice where garments are characters in multisensory tales of sex, wealth, and power. It outlines seminal moments, explores the use of window display and virtual space, and questions practitioners on the best ways to show and tell the stories of fashion not only visually but also viscerally.

LEARNING OUTCOMES

By the end of this chapter you should be able to:

➤ explain how visual merchandising has evolved from the basic display of garments into a multisensory discipline combining art, design, theater, and psychology
➤ understand the curatorial role in the presentation of fashion and its importance to promotion
➤ describe seminal moments in visual merchandising, and comment on current and future trends
➤ understand how window display might itself be the subject of promotional activity
➤ suggest ways of presenting fashion brands to their various target audiences, online, in-store, and outside typical fashion spaces.

8.2
Window display at Dover Street Market,
London, July 2014.

8.3

8.4

8.5

WHAT IS VISUAL MERCHANDISING?

Visual merchandising is the process of collecting, sorting, editing, displaying, and performing products, to attract customers toward retail spaces, draw them in, and persuade them to purchase. It plays a crucial role in creating and communicating brand experiences, which for luxury brands help justify premium pricing and maintain perceptions of exclusivity.

In physical spaces, visual merchandising combines window display, store layout, and other interior visual elements to foster emotional connections to brands that customers carry into the e-commerce environment. Online, the obvious "visual" elements (website design, navigation, and product categorization) are increasingly complemented by features that enhance emotional connections: high quality, zoomable, three-dimensional photography; runway video; and other digital content including shows, events, and mini-documentaries detailing manufacturing processes. In turn, these features of virtual visual marketing are making their way into stores to create "seamless" retail experiences.

8.3
Japanese artist Yoshiyasu Tamura reinterprets McQueen's "Angry Bunny" motif with a manga-themed collaboration collection at Selfridges, London, 2014.

8.4–8.5
A Levi's concept store in London displays the Bing Crosby Tuxedo in its store window, continuing the Bing Crosby theme inside.

8.6

VISUAL MERCHANDISING IN HISTORY

Today's mannequins link back to one of the earliest forms of visual merchandising. Originally used by seamstresses for fitting garments, by the fifteenth century, "bust forms" were being used to demonstrate fashions to customers. By the mid-nineteenth century, these forms—by then known as "mannequins"—were more sophisticated, approximating the whole body (with or without head) and produced with articulated limbs. With US engineers perfecting the manufacture of large plate glass windows (originally invented in the seventeenth century) and electricity more widely available in cities, the key components of what became known as "window trimming" were falling in to place, giving rise to a series of miniature stages on city streets. Starting life as the tailor's blank canvas, the mannequin gradually assumed the lead role in nineteenth-century store windows, revolutionizing the presentation of merchandise.

8.7

8.6–8.7
Traditional mannequins continue to play a crucial role in the store windows of one of London's oldest department stores, Selfridges, and the Lanvin boutique on London's Savile Row.

8.8
The independent boutique, Ruskin, in Whitstable, UK uses open-backed window display as pioneered in the UK by Gordon Selfridge in 1909.

8.9
The iconic Chantal Thomass lingerie store in rue Saint Honoré, Paris shows merchandise and props "so welded together that the interest of the shopping public is aroused and goods are sold" (Ashford Down, 1931: 1).

8.8

8.9

Alongside the transformed retail environment, rapid growth in the popularity of window-shopping as a social activity prompted the professionalization of window display. In 1909, US retailer Gordon Selfridge brought innovative and controversial methods of "open" window display to the UK, which left the back of the window open, enabling passersby to see in to the store.

Around this time, window display began to be regarded more scientifically as retailers grasped its power to transform passersby—who would not otherwise be attracted to the goods on display—to browsers and, ultimately, customers. In 1921, the first National Association of Window Display Men held its inaugural conference in America. In a compendium—*The Art of Window Display*—H. Ashford Down described the display man as both advertiser and "born artist," with sufficient showmanship to conceive and create "pictures" from merchandise or props "so welded together that the interest of the shopping public is aroused and goods are sold" (1931: 1).

One of the new profession's pioneers, L. Frank Baum (later immortalized as the author of *The Wizard of Oz*), started his career as editor of *The Show,* the first trade publication on window display. Throughout the early twentieth century, a proliferation of guides appeared in the US and UK, providing advice for ambitious retailers eager to optimize the sales potential of their store windows.

Following the Paris Exposition of 1925, interest rose in the "modernist" window display, in which fussy detail was eliminated, and a greater reliance placed upon masses of units "placed in the severest possible setting" (Ashford Down, 1931: 7). Just five years later, the Great Depression stimulated increased creativity in window display, as reduced resources forced retailers to take ingenious approaches to their work, and many unemployed Hollywood set designers found work in retail.

8.10

By the 1950s, the transformation from stores as "cluttered and unattractive factory outlets to magnificent, exciting, and opulent shopping worlds, where goods were not just displayed but celebrated" was largely complete (Parker, 2003: 360). Since then, although the exponential growth in technology has facilitated a range of sophisticated approaches to both window display and interior visual merchandising, the ability to enchant the customer remains of paramount importance; and many of the ideas and techniques pioneered by early visual merchandisers are regularly reimagined and reused by contemporary practitioners. This includes the humble mannequin, still omnipresent, though today just as likely to be used online, or as a 3D screen for projections that enable instant outfit changes and a degree of lifelike movement—better equipped than ever to play the lead role in artfully constructed window-display theater.

8.10
A Comme des Garçons pop-up store interior appearing during Amsterdam Fashion Week 2014 echoes the modernist approach window display with masses of units "in the severest possible setting" (Ashford Down, 1931: 7).

8.11
"Mannequins are the high-octane gasoline that fuel the throbbing engine of my window-dressing Lincoln Continental" (Doonan, 1998: 211). Louis Vuitton, London flagship store window, July 2014.

8.11

> " CONTROVERSIAL RETAILER
> AMERICAN APPAREL
> DISPLAYED MANNEQUINS
> WITH PUBIC HAIR IN SOME
> STORE WINDOWS AROUND
> VALENTINE'S DAY, BUT THIS
> WAS LARGELY DISMISSED AS
> A PR STUNT RATHER THAN A
> GENUINE ATTEMPT TO SHOW
> THE DISCREPANCY BETWEEN
> MANNEQUINS AND REAL
> WOMEN."

THE CHANGING FACE (AND BODY) OF MANNEQUINS

Female mannequins are typically created in petite sizes 8 to 10 (4 to 6 in the US), at around 5ft 10 inches (175 cm) tall, but with average US and UK clothes sizes significantly larger than this (and the average height of women significantly shorter), some brands and retailers are experimenting with larger, more voluptuous designs such as Pucci's "Goddess." In the US in 2014, controversial retailer American Apparel displayed mannequins with pubic hair in some store windows around Valentine's Day, but this was largely dismissed as a PR stunt rather than a genuine attempt to draw attention to the discrepancy between mannequins and real women. The London-based company Rootstein produces more than 100 different styles, including the "Erin" and "Agyness" designs, immortalizing the models Erin O'Connor and Agyness Deyn.

8.12

DEPARTMENT STORES

If any single type of fashion retail establishment is
responsible for the physical manifestations of visual
merchandising and display that we recognize today,
it is the department store. Ken Parker (2003) describes
how the early department store refined and perfected
visual merchandising techniques in four important
ways. First, they incorporated the spectacular display
techniques used in the World Expositions as a normal
part of everyday shopping, offering sensory experiences
never previously experienced by the shopping public.
Second, they used luxurious store interiors to denote
wealth and abundance. With their immense scale, use
of light and glass, multiple floors, chandeliers, marble
and wood, the scenery and spectacle provided an
astonishing backdrop to the third factor: chaotic and
excessive displays of merchandise. Fourth, and finally,
they used themed displays, such as Japanese gardens
and the North Pole, to transport shoppers to exotic
destinations. By doing so, they ensured that shopping
was no longer a "verbal engagement between merchants
and customers, contesting the value and quality of
goods," but instead "a sensory experience...and new
social practice" (Parker, 2003).

8.13

MERCHANDISING THE
DEPARTMENT STORE BRAND

One of the principal challenges for visual merchandisers in today's department stores involves displaying individual concessions to their best advantage while maintaining and promoting the department store's own brand image. Following in the footsteps of the world's first department store, Bon Marché in Paris, whose nineteenth-century "white out" themed events necessitated the removal of all non-white goods, the UK's Selfridges' stores faces this challenge with a range of regular, store-wide events that promote both Selfridges, and by extension, the brands housed within. One recent example is The Festival of Imagination, with six weeks of talks, workshops, and interactive activities hosted by poets, scientists, fashion designers, and trend analysts held in a specially created "imaginarium" amphitheater designed by renowned architect, Rem Koolhaas. Arresting window displays help draw attention both to the store itself and the merchandise stocked within. Today, Selfridges' window displays are just as likely to incorporate stocked items as they are to show intriguing, occasionally baffling, objects such as Heinz baked beans cans with their branding removed.

" SELFRIDGES' WINDOW DISPLAYS ARE JUST AS LIKELY TO INCORPORATE STOCKED ITEMS AS THEY ARE TO SHOW INTRIGUING, OCCASIONALLY BAFFLING, OBJECTS SUCH AS HEINZ BAKED BEANS CANS WITH THEIR BRANDING REMOVED."

8.12
A 25-foot statue of designer Rick Owens adorns the main entrance of Selfridges department store in London's Oxford Street, to celebrate the store's "Masters" event, September 2014.

8.13
Scheme for Selfridges' "No Noise" event featuring unbranded but still instantly recognizable Heinz baked beans cans.

8.14

8.15

8.15b

8.15c

WINDOW DISPLAYS: ATTRACTING ATTENTION

Combining Macy's 1937 publicity director's mix of "a poster, a newspaper advertisement, a stage set, a speech, and a scarf dance", window displays act to draw attention to a store's wares, and offer insights into a brand's "DNA." In many cases, window displays—particularly those used by major "destination" stores during the Christmas holiday season—generate significant footfall in their own right, but window displays that are innovative, even potentially insulting or offensive, have always been used to communicate to a broader audience through PR and media-relations activity. Often, the grand "reveal" is used by department stores as the fulcrum of a major PR stunt.

8.14
"Windows in Progress" at Ralph Lauren's London flagship store in Bond Street.

ANTI-MERCHANDISING

While a key measure of the success of visual merchandising is its ability to draw customers in to stores, encourage browsing, and increase customer spend, the attitude of some brands appears to contradict this. Opening in 1983, the first Comme des Garçons store in New York, for example, barely resembled a clothing store—with merchandise "almost invisible" and the austere appearance acting as "more of a deterrent to people entering than anything else" (Mores, 2006: 142). Such approaches, while apparently disingenuous, tend to reveal a consistent methodology in which brands are prepared to sacrifice customer footfall for the sake of a retail environment that remains in line with an ultra-minimalist design aesthetic.

TYPOGRAPHY AND #FASHTAGS

While shopkeepers have long daubed "Sale" notices on their display windows using tempera or poster paint (a written manifestation of the market stall trader's sales patter), contemporary visual merchandisers combine meticulous calligraphy and acrylic lettering to create arresting, often retro, display styles. A linked trend is the use of hashtags within window displays, using the physical medium to direct browsers to online social media campaign activities.

8.16

PROMOTING WINDOW DISPLAYS

Leading US department store Bergdorf Goodman is one of many destination stores to generate extensive press coverage each year from its holiday windows. For its 2013 displays, the store imagined traditional holidays throughout the year as a series of five "icy, snowy dioramas." In November 2013, the window display "reveal" formed the centerpiece of a major public event, with performers descending upon the store's Fifth Avenue building, followed by a private shopping event in support of charity New Yorkers for Children. A press release for the event also drew attention to the store's "Little BG" Sundays with Santa activities and a range of social media activities including a YouTube video of the window reveal, a series of holiday-themed blog posts, and the launch of a Bergdorf Goodman personal shopper Tumblr account.

8.15a–8.5c
The use of Twitter and Instagram-style hashtags is incorporated in window displays for virtually every mainstream and niche retailer. Examples include River Island, Diesel, and Dr. Martens.

8.16
One of Bergdorf Goodman's 2013 holiday windows, deliberately staged upside-down, depicting ice-bound celebrations of April Fool's Day – complete with gravity-defying Oscar de la Renta gown.

8.17

8.18

THE BOUTIQUE AND THE EDIT

Visual merchandisers have long been responsible for selecting garments and accessories from each season's collections to give the greatest prominence. Contemporary practice, however, requires careful consideration of the entire promotional mix to ensure that what customers see in window displays and in-store coincides with the items also being promoted outside of the store environment, via social media, advertising, and PR activities. The skills required to display items in such increasingly complex contexts blends a high level of visual dexterity with the exhibition curator's art.

A relative newcomer to the visual merchandiser's arsenal, "the edit" is an intriguing concept transferred into both in-store and online environments from fashion magazines. "Edits" began as collections of complementary items selected by fashion editors as the basis for magazine features. The term has swiftly gained currency within fashion retailing, appearing in 2013 as the title of online retailer Net-A-Porter's print and shoppable online magazine, and featuring prominently on many online retailers' websites. It also occurs within in-store displays, including the UK's John Lewis. The concept appeals to retailers attempting to replicate the editorial authority of magazines, where curated outfits provide shoppers with confidence in their ability to select appropriate garments and accessories from work capsule wardrobe to festival wear.

DOES VISUAL MERCHANDISING WORK?

Surprisingly little academic research exists to confirm the effectiveness of visual merchandising as a promotional technique within fashion retail. One 2006 study concluded that "atmospheric stimuli which please the actual and emotional needs of consumers enhance the degree of customer participation in a store, leading to favorable purchasing behaviors" (Wright, 2006). More equivocally, a 2003 paper asserted that "current research does not adequately cover the influence of visual merchandising on affective response or then on subsequent behavior" (Kerfoot et al., 2003).

In terms of the effectiveness of online visual merchandising, Ha et al. (2007) describe the aim of "non-store" visual merchandising as providing "experiences that are as close to the in-store experience as possible to reduce perceived risk related to the lack of physical contact with the store and merchandise". However, a concrete link between a favorable response to visual merchandising and increased purchase intention remains elusive within the research literature.

" A CONCRETE LINK BETWEEN A FAVOURABLE RESPONSE TO VISUAL MERCHANDISING AND INCREASED PURCHASE INTENTION REMAINS ELUSIVE WITHIN THE RESEARCH LITERATURE."

8.17–8.18
Independent boutique Our Daily Edit in Brighton, UK, takes the "edit" concept literally (bottom); while the womenswear floor of a John Lewis department store replicates the magazine "edit" format (top).

8.19

8.20

ONLINE VISUAL MERCHANDISING: END CLOTHING CO.

Established in 2005 in Newcastle-upon-Tyne, UK, contemporary menswear retailer END operates a simple, but effective approach to its e-commerce visual merchandising, focusing on highlighting the regularity of its twice-daily stock updates to a loyal following of "hobbyists"—men who check the END site several times a day as part of their regular web-browsing habits.

For less regular visitors and men seeking advice and inspiration about how to construct an entire outfit, END's stylists create and photograph seasonal looks, which are posted to the store's blog and fed to influential menswear blogs, such as Hypebeast, as ready-made content. END also maintains an active social media presence on Facebook, Twitter, and most importantly, Instagram, and is currently planning a new physical retail store whose design will emulate the clean, monochrome aesthetic of its website.

All of END's online visual merchandising efforts are designed to make the selection and purchase process as clear and transparent as possible, including meticulously measuring items to reduce the likelihood of stock returns. "Most men don't have the time to browse dozens of stores trying to piece together a wearable outfit for whatever occasion," explains END's marketing manager, Simon Lister. "If we can display our products online clearly and honestly, and keep stock regularly updated, we benefit from customer satisfaction and, subsequently, increased loyalty and recommendations."

8.21

A.P.C.
Casual Check Shirt

Parisians A.P.C. are the masters of timeless wardrobe essentials and this check shirt proves this point. Constructed from premium cotton, this shirt looks at its best tucked in with a tailored pant.

WORN WITH

Paul Smith Straight Fit 5 Pocket Pant

Paul Smith Leather Belt

Comme des Garçons SA5100LG Luxury Wallet

8.19
Evisu's window display featuring controversial photographer Terry Richardson and model Enikö Mihalik succeeds in turning heads in London's Newburgh Street.

8.20
Located in a courtyard, through an alluring arch, Margaret Howell's Paris store at rue de la Madeleine draws in intrigued browsers.

8.21
Online menswear boutique END Clothing attracts customers by collating items into coherent, wearable outfits.

8.22

THE FUTURE OF VISUAL MERCHANDISING

In a recent survey of visual merchandisers, academics, and retail journalists (Baker, 2011), opinion about the future of visual merchandising was split between a quest toward increasingly sophisticated technology, versus a move away from "technical" solutions towards warmer, more "human" interaction.

All those surveyed, however, predicted an increase in the use of "spectacle"—approaches conceived not only to sell, but to astonish, entertain, and amuse in the process.

8.22
A warmer approach: COS in London incorporates a diminutive reading space in the ground floor of its London Regent Street flagship store.

8.23a–8.23b
Technological solution: Banana Republic urges the public to Instagram holiday snaps to be shown live in its London flagship store during summer 2014.

8.23a

8.23b

8.24

8.25

THE USE OF SPECTACLE
–VM BECOMES THE STORY

At its September 2012 launch, Burberry's flagship store on London's Regent Street had journalists fawning over its scale and technological sophistication. The spectacular 44,000-square-foot space was equipped with oversized video screens, curated displays of classic Burberry apparel, a trench coat customization facility, and "magic mirrors." These mirrors provide shoppers with catwalk footage, detail shots, and a garment manufacture video about any product available in the store, using radio frequency identification (RFID) technology built into each garment's display tag. Digital "rain showers" created using audio-visual technology and a hydraulic stage used for live in-store performance add a sense of theater to the store, which was designed to "bring the Burberry.com digital experience into the physical space" (Burberry press release).

8.24
The opulent and technologically sophisticted interior of Burberry's London flagship store opened in 2012. It features oversized screens, curated displays, and live performance area.

8.25
The grand exterior of Burberry's London flagship store.

INTERVIEW: JOANN TAN –
ON CURATING THE FASHION SPACE

8.26

As art director for Italian luxury brand Moschino between 1994 and 2013, JoAnn Tan held overall responsibility for all the brand's window and interior store design. In 2011, she founded Joann Tan studio, which is located between Stockholm and Milan. Her team now work here with clients including Hermès, Pucci, H&M, Excelsior Milano, De Padova, and the leading Swedish department stores, Nordiska Kompaniet to create window displays, installations, fashion shows, and set designs with a playful approach. She offers her view on the role of visual merchandising in the contemporary fashion promotion environment.

How important is visual merchandising to the promotion of fashion?

A bag is a bag and a shoe is a shoe unless you build up a world around it. So the display is key because it allows you to create that ever so ephemeral thing called "style."

How do you come up with ideas?

I don't have a very clear process, although I have to say that washing the dishes seems to help…

To what extent are you free to exercise your creativity?

It varies from client to client, but in general I have a lot of freedom—all clients want me to be as creative as possible. Some clients require me to stay within a certain theme that represents a collection.

Are some windows/premises more difficult to work with than others?

All briefs are challenging, but there are definitely spaces that are much more difficult. All the spaces inside Excelsior Milano are complicated to work with: for example, the atrium space is extremely tall, and we use a pulley system to lower the anchor grid from the ceiling. In addition, the space is very dark, and there are a million video walls calling out for attention.

Who are the game-changing legends of the visual merchandising world?

I can't say enough about the work of [legendary Tiffany New York visual merchandiser] Gene Moore.

Who do you find professionally inspiring?

I originally studied animation, so a lot of the people I admire come from that world such as Tim Burton, Lucrèce Andreae, and Henry Selick.

Can you name any displays/installations of your own that you are particularly proud of?

The first set of spring windows for NK Stockholm.

Are the challenges of interior visual display different to those of window display?

Yes, primarily because the window is usually a closed box and an interior display is open and unprotected. In the closed box, everything can be put together precariously, whereas in an open display everything has to be bolted down.

Have you noticed any differences in the way you work since online retail came to prominence?

The way I work has not changed. But I have noticed that there is a lot more work now. I think it has something to do with brands trying to attract customers to the "destination."

You make most of your own props in your studios, known as the "Factory"—why do you feel this level of artisanship is so important?

Because perfect execution is part of the magic.

8.27

8.28

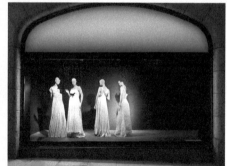

8.29

8.26
A portrait of JoAnn Tan.

8.27
"Ballerina" window display for Excelsior East at Excelsior Milano.

8.28
Spring 2011 window display for Nordiska Kompaniet, Stockholm by JoAnn Tan Studio.

8.29
Props and installations being created at JoAnn Tan Studio's "Factory."

CHAPTER REVIEW

As this chapter shows, visual merchandising has evolved from the basic display of available stock to a sophisticated promotional practice combining technology, storytelling, and theater to maximize the appeal of garments, accessories and, more broadly, brands to the shopping public. Opinion is divided on future directions for the practice, with some supporting increased digitization, while others predicting a shift towards more tactile, traditional practices that help to differentiate the in-store shopping experience from e-commerce. Whatever the outcome, it seems likely that visual merchandising will remain at the forefront of fashion's most immediate and compelling promotional tools, continuing to engage and enthrall—whether through spectacle or subtlety.

QUESTIONS FOR DISCUSSION

1. Can you name three reasons for visual merchandising and give examples of each?

2. Why do you think stores frequently object to members of the public taking photographs in store?

3. Why do you think it is difficult to quantify the effects of visual merchandising on sales?

4. Do you feel that department stores are still innovative in their approaches to visual merchandising?

5. Who do you feel are the most important visual merchandisers working today?

8.30

8.30
The "Here I am" logo created by typographer Andrei Robu for Fenwick Bond Street in London, based on the first three words spoken by John James "Jim" Fenwick when he first stepped through the doors of his Bond Street store in 1891.

8.31
A passerby stands mesmerised by a christmas window at Selfridges, London.

CHAPTER EXERCISE

ONE

Visit a boutique or department store of your choice. Observe the following elements of the store's visual merchandising and make notes on what effects you think it is intended to have on consumers:

a. Lighting
b. Furniture and display units
c. Amount of stock on display
d. Music or sound effects
e. Fragrance
f. Use of video or other moving image elements
g. Staff presentation
h. Interactive elements
i. Use of mannequins
j. In-store messaging
k. Pathfinding

From your notes, are you able to produce a pen picture of the intended target consumer? Would you still know where you were if you couldn't see the brand logo anywhere? What can you say about the brand's DNA from your observations?

TWO

Imagine yourself as an independent fashion boutique. Construct a guide to your boutique's visual merchandising concept, including an idea for an arresting window display to launch the store. Consider all of the elements listed in the previous exercise, and add any others you feel are appropriate. It may be helpful for you to consider the following elements:

a. What are the stories your brand wants to tell?
b. What are your brand's most important messages?
c. What atmosphere should the space create?
d. What are your brand's design criteria?

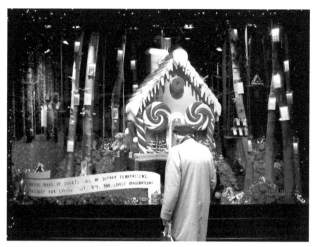

8.31

THREE

Working in a small group, select a fashion garment or accessory of your choice from a recognizable brand. This should ideally be a garment with some recognizable features such as a functional fabric, interesting manufacturing technique, or product heritage. Create a list of details about the product that you want to communicate to your intended consumer. Working together, sketch a visual merchandising display that communicates all the details and their associated benefits to your intended consumer, then present your ideas to the other groups.

FOUR

Choosing either February, May, or September, prepare a calendar of events during your chosen month which you feel could present topical opportunities for an online fashion retailer's visual merchandising.

VOGUE

NOVEMBER $

**the real
cost of
looking
good**

**paris
couture**
*haute but
not haughty*

men
the new bimbos?

fashion

**color
catches on**

37132

09

THE FASHION MAGAZINE: FROM PRINT TO PIXEL

The late twentieth century saw an extraordinary shift of power. Fashion magazines—the bibles of style—saw their commandments crumble and advertisers flee as print gave way to pixels. With so many laments for the death of fashion magazines as we know them, the debate around the future of one of the key fashion communication channels is one that cannot be ignored.

9.1
Anna Wintour's first cover for *Vogue* in 1988 broke with convention by featuring a model wearing jeans—sending a message that fashion magazines are as much about inspiration as aspiration.

9.2

9.2
Magazines created by brands sit
shoulder to shoulder with those
from traditional publishing houses.

INTRODUCTION

This chapter looks at the emergence fashion magazines, how they achieved their promotional power, and how they evolved into multiplatform entities. Defining the roles and processes of the magazine, it discusses whether printed matter is becoming obsolete, and outlines how contemporary promoters may exploit the opportunities for brands created by new magazine formats. It also delves into the challenges of new formats, and explores the future of fashion publishing.

LEARNING OUTCOMES

On completion of this chapter you will be able to discuss:

» the emergence and heyday of print magazines, and their uses as promotional tools
» the evolution of online entities as virtual alternatives to the traditional magazine
» the debates surrounding the contemporary and traditional magazine model
» promotional opportunities that exist through the contemporary magazine market
» possibilities that lie in the future of digital publishing.

DEFINITIONS

Both the traditional magazine and its contemporary physical and virtual counterparts can be defined as collections of written and visual content that revolve around interests or themes reflective of the philosophy of their creators and contributors.

Terminology relating to contemporary publishing can be confusing. Many magazines refer to themselves as "digital," and others "online." For the purposes of this discussion, "online magazines" relate to entities that require a live Internet connection to access, whereas "digital magazines" refer to those that are viewable offline.

9.3

9.3
The newsstand continues to
hold a wide range of titles.

MAGAZINES AS PROMOTIONAL TOOLS

**Throughout history, the magazine has been
continually reimagined alongside technological
developments. Advances in print production
permitted more extensive distribution; photography
replaced illustration, and dressmaking patterns
made way for more advertisements encouraging
readers to purchase ready-made, rather than create,
adapt, or copy.**

The post-Second World War consumer boom triggered
a golden age for fashion titles. It is important to
remember that, other than cinema advertising (see
Chapter 6) magazines offered the only method of widely
disseminating fashion communication. Desperate to
escape the limitations brought about by war, the public
looked to the future. Although not always able to buy,
the population remained curious about their consumption
options, with fashion being one of the main lifestyle
industries to capitalize.

Reflecting popular culture and social change, fashion
magazines proved lucrative, both for featured and
advertised brands, and magazine publishers. The market
exploded, and the latter half of the century saw magazines
become the key resources for fashion. Even the advent
of television failed to eclipse magazines, which often
promoted what TV advertising had introduced to the
public psyche.

One of the reasons for magazines' ability to resist
television was the perceived permanence of the medium,
which allowed the reader to digest and observe in-depth
information at their own pace, forming solid relationships
that advertisers and brands wanted to exploit. The high
costs of advertising in many titles reflected the value of
this special bond.

Publishing houses, newspapers, and other magazines
quickly saw the validity of these relationships and
opportunities for enhancing advertising revenue in their
own titles, leading to the creation of fashion sections,
specials, and dedicated regular coverage. The reader,
being previously restricted to a small number of titles,
increasingly benefitted from one of the founding principles
of consumerism. Choice.

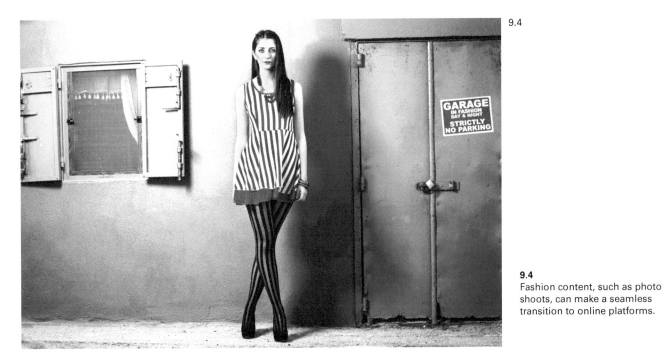

9.4

9.4
Fashion content, such as photo shoots, can make a seamless transition to online platforms.

THE DICTATOR AND DICTATED

Particularly in the late twentieth century, brands also benefitted from this surge of options, which enabled them to more accurately target particular consumer groups by age, gender, and interests. Armed with sales, distribution, and circulation data of magazines, brands were able to shop around and allocate their promotional budgets with increased likelihood of success. However, like any market, there were hierarchies, and some titles wielded greater power than others. For example, *Vogue* isn't just considered the "fashion bible" for its content. Being one of the longest-running fashion and lifestyle titles in the world, its name has built a strong basis of trust amongst its readership, bolstered by over 20 national editions. For brands, inclusion in *Vogue*—one of the most powerful voices in fashion—provides unrivalled cachet.

For promoters, coverage in fashion magazines is crucial to any campaign. For fashion magazines, the revenue generated from advertising is crucial for their survival. Thus, in addition to the relationship between magazines and their readers, there is a second relationship between brands and the title. In this relationship, for many years unseen by the reader, the magazine pages do not simply report—they instruct—and by doing so, directly sell. Not all titles engage in this illicit relationship and those that do, do so to varying degrees. But it is this hidden agenda that forms the basis of popular criticism of the fashion magazine. Through this partnership, the golden age of the fashion magazine could equally be seen as the golden age of straightforward fashion promotion—for the brands willing to pay for the privilege.

The increase in choice provided by the Internet has to some extent returned power to consumers. No longer limited to selected titles, publication dates, or even the need to pay, readers may now form multiple relationships simultaneously. With this shift in power, the traditional magazine revenue models have weakened, both in terms of sales and loyalty. Similarly, brands benefitted from this widening of options, and like every aspect of fashion promotion and technology, a massive increase in opportunities lay ahead.

9.5

Style: Celene Colour: Gold Material: Crushed Silk Size: 10

9.5
The World Wide Web has facilitated
immediate fashion content rather
than waiting for the next issue.

GOING ONLINE

The mid-1990s saw an increased number of websites carrying images and graphics. Fashion. net claims to be the first fashion-specific website, launched in France in 1995; lumiere.com, the first fashion magazine, launched the same year. Around this time, weblog platforms, such as blogspot.com and blogger.com, were also launched. Websites, online magazines, and blogs have rapidly developed from small beginnings to the dominating force in fashion, not least by sheer audience reach.

Putting this expansion into context, Rocamora (2000) cites there were around 50 blogs in total by 1999. This had increased to eight million in 2005, and 184 million by 2008. Today, at least 14 million fashion-specific blogs currently exist. In terms of numbers, online publishing has dwarfed its print equivalent in an extraordinarily short period of time.

Indeed, many print titles have floundered in the digital age, ostensibly due to financial reasons—brands and advertisers are motivated toward maximum coverage, and with the exception of ensuring inclusion in certain titles as an issue of prestige, many have migrated to where they determine the largest audience to be—in many cases, online. Financial pressures also relate to the reader themselves, given the option of obtaining information for free in many cases, which leads to lower sales and consequentially lower circulation and audience reach, knocking on to brand and advertiser incentive to place themselves in a title.

It is easy to see the popular belief that print titles are becoming increasingly obsolete—they cannot physically keep up with the increasing requirement for immediacy, nor can they compete with free resources. We will discuss these points toward the end of this chapter, but first it is important to examine what this competition actually entails, and what opportunities exist for promoters.

9.6

TYPES OF ONLINE SOURCES

As a collective term, fashion websites can broadly be categorized into one of three categories: magazine-style websites, blogs, or electronic commerce. The last of the three is discounted for the purposes of this chapter, as their aim is predominantly for direct sales of fashion, as opposed to an editorial philosophy (some e-tailers, such as net-a-porter.com, asos.com, and harrods.com, have bridged this gap through melding a magazine-style format as part of their online presence, known as "commercial convergence," but these relate to a predefined set of brands that they stock).

9.6
Whilst the opportunities for digital representation continue to expand, print magazines still remain with a wide array of titles present on the newsstand, alongside an increasing number of independent and niche titles.

MAGAZINE-STYLE WEBSITES

Magazine-style websites are a collection of live pages only accessible online and are the closest comparative to the print magazine. Three types of these websites exist: the stand-alone, the mirror, and the enhanced. The standalone website is an online resource that has no print equivalent—this can be either an offshoot owned by an existing title, such as style.com—owned and operated by Conde Nast, or a title that is solely online such as fashion156.com. These sites adopt the print model hierarchy, with features, reports, editorial, and news with a similar editorial organizational structure; they often take advantage of available technologies such as iconique.com, which is designed using Flash software.

9.7
Alongside content generation and representation, the increased commercial opportunities of an online presence can benefit smaller publishers by facilitating direct (and therefore cheaper) global distribution, such as this portal for JÓN Magazine, based in London but shipped internationally.

The "mirror" website was an early forerunner of the enhanced fashion magazine website, where many titles in the race to go online for the most part replicated elements or key content that was part of their print content. This reflects to the reader what is in store in the print version, for example, earlier versions of vogue.com or elle.com. Perhaps more of a detailed advertisement than a standalone resource, in the late 2000s these sites were often operated under the remit of the print version's editorial team. These mirror sites have declined in popularity and existence in favor of reinvention to an enhanced version.

The enhanced version is, as its name suggests, often home to exclusive content, behind-the-scenes footage, video content, and interactive elements, such as the current elleuk.com. This type of website is not to be confused with digital magazines, which will be discussed later. Acting in partnership with the print version, some are subscription only, where access is sometimes bundled with a print subscription. It is not confined to the space limitations of its print counterpart and can offer more detail, depth, or additional information and contributions.

ISSUE 9 ARTICLE EDITORIAL BUY WITH PAYPAL STOCKISTS

JÓN
Issue 9 'PIN' - Kunal Nayyar & Russell Tovey
Cover
Limited Re-Release
£12.00

JÓN
Issue 9 'PIN' - James Van Der Beek Cover
£8.00

JÓN
Issue 8 'PET' - RJ Mitte Cover **LIMITED
ISSUES AVAILABLE**
£10.00

9.7

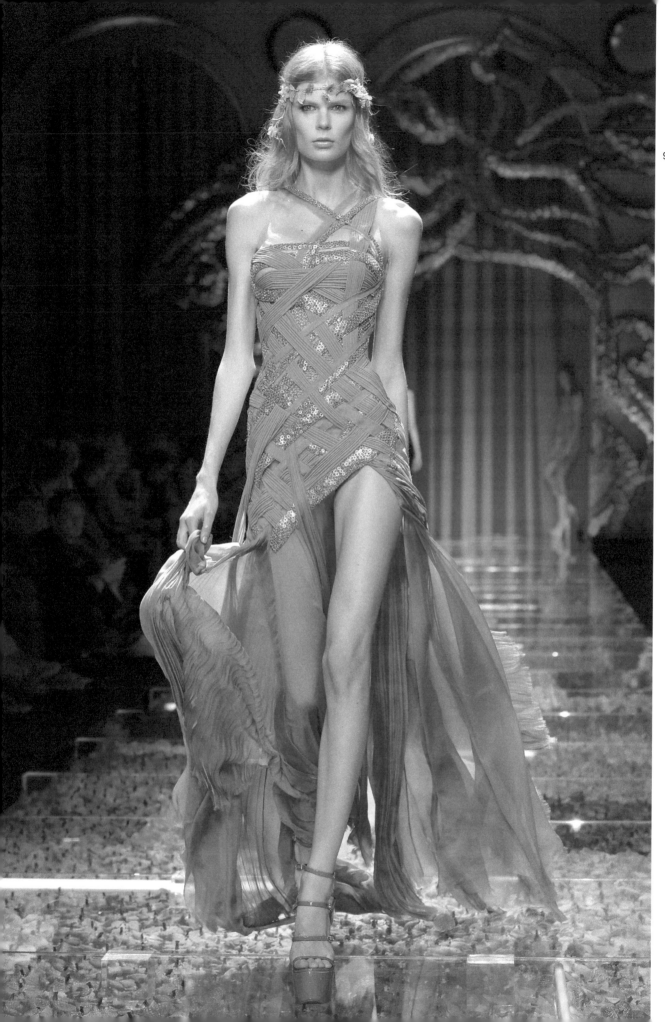

OPPORTUNITIES IN MAGAZINE-STYLE WEBSITES

There are multiple well-utilized opportunities for brands and their promoters in magazine-style websites. They could provide exposure to a target audience in a comparatively cost-effective manner—many of these types of websites are smaller and independent, and thus don't carry as high a cost for banner-ad placement or embedded links. Many of these sites carry the opportunity for e-tail convergence, hosting shops, promotions, or competitions, and have the obvious advantage of the reader simply clicking a link to look at a retailer as opposed to traditional print, which at least involves going online to look at a website, or even physically going to a store.

Prestige placement (deliberately obtaining coverage or advertising with a trusted source) is also more cost effective than its print counterparts, or it could present opportunities for aligning a brand or campaign with an untested but "young" and "cool" magazine brand. There are also the opportunities for provision of expanded coverage through multimedia, and exclusive content specifically for the title, which in itself can generate more coverage. Unfettered by space constraints or print deadlines, there are a wide range of opportunities to engage with a title's audience with immediate effect.

9.9a

9.9b

9.9c

9.8
Without the restriction of space, websites can provide much more detail in information, both in terms of written and visual content such as catwalk show galleries.

9.9a–9.9c
Lifestyle brands, such as fragrances and cosmetics, also benefit from the opportunity of space, with more room for still-life imagery, often captured in highly creative ways.

9.10

BLOGS

The term "blog" was first used in 1997, derived from "weblog", to categorize individually created online journals, with the aid of platforms launched to enable a user to publish their individual perspectives on whatever they wished. They came to prominence in the early 2000s, with the first fashion blogs emerging around 2003. The rise of the blog has been stratospheric and reflects the digital age's role in democratizing fashion —the blogger, as consumer, can participate in (and sometimes even directly influence) fashion and trends. Within three years, *Women's Wear Daily* estimated the number of fashion-related and shopping blogs to be in the region of around two million, a figure that has doubtless multiplied since then. Although small in number compared to the total number of blogs in existence, some recognize their blogs as full-time careers, perhaps further incentivizing even more would-be bloggers into the blogosphere.

9.10
While it still important to catch the eye, the onus on blogs is in the content, hence the popularity of generic, simple-to-use blogging platforms.

9.11
The rise of blogs has facilitated a growth of communication opportunities for well-established and also emerging titles, such as *Betty Magazine*.

TYPES OF BLOGS

However, there are differing types of blogs and bloggers, as there are different types of magazines and fashion journalists. Engholm and Hansen-Hansen (2013) differentiated types of blogs, arising from the first private blogs, created by individuals as a platform to share thoughts and ideas. They call the four types the "professionals," the "fashiondustrias," "street style," and "narcissus."

The professionals are defined as blogs that grew out of previously existing magazines, emerging in the mid 2000s from fashion journalists and from then, independent writers. Often reflective of the content and ethos of the "parent" magazine, they are supplemented by the writer's own language and photography.

The so callled "fashiondustrias" are run by both amateurs and fashion industry professionals, such as freelance journalists, stylists, and photographers. They focus on fashion events such as new launches, campaigns, and fashion shows.

Street-style blogs are, as their name suggests, documentaries of people on the street who capture the eye of the blogger because of the way they dress or represent their style—often reflective of the interests of the blogger. Image-led, they pertain to be more credible and real than styled fashion imagery.

9.12

9.12
Capturing "street style" is now
commonplace as either a part of
or a central theme of blogs.

The final and most popular of the four is the narcissus, a form of fashion diary that logs what the blogger wears, often with a multitude of self-portraits or images within a particular group.

It is perhaps this last type of blog that causes general criticism. In her 2013 article, "The Circus of Fashion," Suzy Menkes commented on the quantity of bloggers vying for attention in the surrounds of New York Fashion Week, saying how "two things have worked to turn fashion shows into a zoo: the cattle market of show-off people waiting to be chosen or rejected by the photographers, and the way that smart brands, in an attempt to claw back control lost to multimedia, have come in on the act." Referring to the increase of bloggers, she claimed, "fashion to an extent has become a mob rule." Leandra Medine, on her blog manrepeller. com, rebutted that bloggers belong to a group that "has been dubbed the entrepreneurial generation. Many of us couldn't land the jobs we wanted, so we just made our own. Sure, the training isn't traditional, but my generation is brilliant."

It remains to be seen whether the rapid rise of blogs is sustainable. A case of quantity over quality, sheer numbers mask the power that has only been gained by a handful of individuals, and it will be interesting to see how many will survive, particularly in terms of financial survival and in the face of generalized criticism from members of the traditional media. But for now, blogs hold the attention of millions of readers—an audience reach that is too large for brands and promoters to ignore.

" FOR NOW, BLOGS HOLD THE ATTENTION OF MILLIONS OF READERS—AN AUDIENCE REACH THAT IS TOO LARGE FOR BRANDS AND PROMOTERS TO IGNORE."

OPPORTUNITIES IN BLOGS

Using Engholm and Hansen-Hansen's identification of the different types of blogs that can help brands and promoters target certain blog readers—numbers and followers aren't everything in seeking opportunities. PR and publicists, for example, may not only base their invitees for events and shows simply on how popular a blog is, they might consider weeding out the narcissus in favour of fashiondustrias. However, for potential brand ambassadors, a narcissus with a large following might work well.

Research into the blog is also crucial for optimizing opportunities. Fandrich (2007) suggests four components that constitute a "legitimate" blog. Her suggestions relate to suitability for fashion history research, and they can similarly apply to a promoter's assessment of a blog: its motivations—where it doesn't appear directly to be shaped by commercial gain; its content focus—whether the majority of content is fashion related; its originality—a strong, informed independent voice being a point of difference; and its immediacy—how often and consistently it is updated. As a combination of factors—the content, ethos, and philosophy being the optimum blend—we are brought back to the definition of the traditional magazine, and for brands and promoters, rather like sales and circulation of a magazine, level of audience reach is a determining factor. Therefore, the same opportunities for blogs exist as they do for magazine-style websites.

9.13
Street-style blogs, such as The Sartorialist, enable communication of a different side of fashion, away from staged imagery.

A QUESTION OF TRUST

The key similarity between magazine-style websites and blogs is fundamentally the same as with print—trust. Blogs, by the nature of their creation and often by the language used, have commonly been assumed to be truly independent, reminiscent of the print magazine in the post-Second World War years. Many bloggers point out print and online magazines have editorial agendas due to their close relationships with brands and advertisers to ensure financial survival. Blogs don't have boards of directors, publishing houses, or high costs to answer to, so they can be truly independent, and in this, along with blogs' approachability and accessibility, lies the appeal. They can be trusted.

Conflicting with this perception is the ambition of many new bloggers to emulate the handful of financial successes that have gone before—if blogging is to be a career, there are financial needs to be met, and while this is an opportunity for brands and advertisers to exploit, it can tarnish the image of the independent voice. Blogs run the risk of becoming another form of advertorial, whether it be from incentives through trips, gifts, free clothes from a collection, a model of car to transport you around fashion weeks, or the latest smartphone. However, it is how this is represented to the reader that either cements or destroys that trust. For example, the blogger Susie Lau often uses social media to promote her receipt of such incentives, but this doesn't mean that the trust readers have in her blog has diminished, most likely because she is honest about them.

Any successful blogger who claims no editorial agenda or commercial gain (a blogosphere's criticism of the print magazine) perhaps should not be automatically and unconditionally trusted. The growth of incentive-generating sites—such as brandbacker.com, where brands and PR agencies are matched with bloggers for coverage in return for compensation—are increasingly indicative of this. From a promotional perspective, this is all opportunity, but a delicate balance is required, otherwise an apparently low-risk relationship can potentially indirectly cause mistrust and alienate a blog's readers, and consequently, potential consumers.

" **BLOGS RUN THE RISK OF BECOMING ANOTHER FORM OF ADVERTORIAL, WHETHER IT BE FROM INCENTIVES THROUGH TRIPS, GIFTS, FREE CLOTHES FROM A COLLECTION, A MODEL OF CAR TO TRANSPORT YOU AROUND FASHION WEEKS, OR THE LATEST SMARTPHONE."**

9.14
Blogger Susie Lau has engaged in a number of promotional partnerships with brands, demonstrating the strength of her influence through blogging.

9.14

9.15a

9.15b

9.15c

GOING DIGITAL

Having identified the types of magazine-style websites and blogs, and highlighted their opportunities, there is one additional area that is in the early stages of its evolution—the digital magazine. This differs fundamentally from other developments in fashion media through advances in technology by its type of access. While websites and blogs require the reader to be online, the digital magazine, as we term it here, is downloaded and viewed offline.

This type of medium is the closest resemblance to the traditional print magazine format for multiple reasons—it fits the outlined definition of the magazine, but it also goes some way to emulate the experience that a reader can derive from a print magazine. It is accessed though specific selection, rather like going to a store and browsing the magazine rack—facilitated through the introduction of virtual newsstands such as Apple's 2011 newsstand. The reader can flick through samples, rather like browsing. It can be carried (via tablet or smartphone) and accessed anywhere at any point, and it operates in an immersive environment that is solely for looking at that specific title (the temptation of opening another tab on a browser does not exist; the user has to physically close the magazine to look elsewhere). However, it additionally benefits from a higher degree of interactive potential, sometimes approaching a three-dimensional experience that the two-dimensionality of print cannot match. Therefore, the potential of the digital magazine is a hybrid of the convenient experiential qualities of a print magazine with the technological opportunities that a magazine-style website or blog can provide.

The notion of a digital magazine is not new—in 2006, David Renard's book, *The Last Magazine,* discusses the decline in print and the opportunities that exist through digital publishing. Robert Sacks wrote that digital magazines and websites differ through the reader experience, with the digital magazine having, like a print version, a beginning, middle, and end, calling them "magazines on steroids."

When downloadable offline content—such as PDFs—became commonplace, many publishers assumed that digital magazines were simply a replication of the print version, that the reader would be content with this, but that wasn't the case—the benefits of going digital are equal to going online, but instead a paper-free copy was offered. Some established titles have more successfully integrated the opportunities such as *Elle* and *Vogue*'s video content, but it is independent titles such as *HARDI, Katachi, Sister,* and *Post Gravity* that perhaps more fully reflect the potential for fashion media. For now, the hybrid is more prevalent in magazine-style websites that utilize multimedia functions in an online environment such as *Dazed Digital.* One of the challenges of the digital magazine is the cost in research and development, but in comparison to continual print, and as technology develops further, there is a great amount of scope in its evolution, for creators, readers, and particularly through brands and promoters, who have the opportunity to work with titles such as these and represent their products in innovative ways.

9.15a–9.15c
Magazines, such as *HARDI,* capitalize on the opportunities for enhanced interactivity the platform provides.

THE FUTURE OF THE MAGAZINE

The debate on the survival of print over the predominance of online presence and digital publishing is extremely noisy. If there is one thing these shifts and the evolution of publishing has demonstrated, it is that all these platforms have far more in common than at first glance, with one unifying constant—the importance of content. Print is far from dead, online is far from perfect, and digital is far from its own potential. For now at the very least, and possibly for the foreseeable future, there should be no arguments or debates regarding stand-alone success or failure, but instead an acceptance of a multiplatform, hybrid model across all types of publishing to ensure the broadest possible appeal. After all, that is what the relationship between the publishing and promotional industries is based upon—communicating fashion as specifically, comprehensively, and effectively as possible.

9.16
Sébastien Rouchon's
HARDI magazine was highly
commended in the 2013 Digital
Media Awards.

Sébastien Rouchon is based in France and is the creator of *HARDI* magazine. He runs the family business, Studio Rouchon, one of France's biggest photo studios. Sébastien and his team created *HARDI* in 2010 as a "lab to experiment" new types of magazine content and interactive photography, and it is also "a demo of what is possible," culminating in the title being highly commended in the 2013 Digital Media Awards.

From your perspective, how do you think a digital magazine differs from one that is solely printed?

A digital only magazine probably needs to reinvent the link with its readers. I am thinking about content, periodicity, the business model... There is no reason why digital magazines should be just like print magazines with a different distribution channel. It is a perfect opportunity to rethink the whole model.

What is your impression of the current digital magazine market?

Apart from a few digital-only magazines, we are seeing way too often print-like versions with the exact same content, plus a few bonuses that do not take full advantage of what tablets have to offer. The digital publication solutions used today by most brands do not give too many possibilities, and digital versions are still seen as a sub-version of the print. I am expecting things to change in the next few years.

9.16

How do you think the relationships with brands and designers differ with a digital publication in comparison to a print title?

Digital design brings a new aspect, ergonomics, and interactivity. It allows brands and designers to stand out and create exclusive content that readers will not find elsewhere. In an era where you can see the same images almost everywhere, this is a great opportunity to establish your brand as a leader of this new upcoming digital industry. It does mean big investments with a little risk. But isn't the risk of staying put an even bigger one?

Where do you think the future lies in digital publishing?

My guess is that in the end, print will be exclusively for high-end publications and limited editions, while most brands will mostly work on digital content. This will probably take more than 10–15 years, and a few more amazing innovations to happen, but it will eventually happen. There is no way the industry will turn its back on this evolution. The same way photography replaced illustration as soon as technology made it possible, the industry will embrace the new technological possibilities.

CHAPTER REVIEW

This chapter examined the emergence and heyday of the fashion magazine, and its power as a promotional tool. Charting the migration to cheaper, more widely accessible platforms, it discussed the different types and promotional opportunities arising from online entities. It proposes digital publishing as a potential evolution for fashion magazines, and while the debate of print versus online is an important one, it is found that many in the industry see the future as one of a hybrid or multiplatform strategy, which must continue to hold the reader and distinct content at its heart.

QUESTIONS FOR DISCUSSION

1. Are there any other opportunities for brands or promoters in publishing not outlined in this chapter? How could you take advantage of these?

2. Taking each specified type of magazine-style website and blog, discuss which would provide the most effective coverage for a specific brand or designer, considering the entity's target audience and market sector.

3. Discuss the advantages and disadvantages of print, online, and digital publishing respectively from a consumer perspective.

4. Taking all the above, develop a proposal for a brand or designer campaign that only involves fashion publishing. Provide the success indicators you would use to determine the campaign's effectiveness.

5. Discuss in groups your thoughts on the future of publishing, specifically in fashion.

9.17
Magazines are designed to attract fashion lovers from an early age.

9.17

CHAPTER EXERCISE

Opposite is a list of enhancements that can be applied to online and digital magazines compared to their print counterparts. From a brand or designer's perspective, give examples and expand on these, and discuss the promotional opportunities that could arise. Are there others that you can identify? What does print provide that online or digital formats cannot emulate?

Video and audio
Animation
Behind the scenes
Embedded hyperlinks
Exclusive/bonus material
Live or near-new updates
Direct consumer/reader engagement
Size and amount/length of imagery/content
Opportunities to seamlessly "cross" from one portal/title to another
Portability
Front-cover enhancement
360-degree imagery
Physical reader interactivity (e.g., swipe, pinch, zoom)

RESOURCES

01—CAMPAIGN PLANNING: MAKING IT HAPPEN

Borden, N. "The Concept of the Marketing Mix." *Journal of Advertising Research* (1964) Vol. 4, No. 2.
McCarthy, E. J., *Basic Marketing. A Managerial Approach.* Homewood, IL: Richard D. Irwin, 1960.

Benetton '40 years' press website
www.benettongroup.com/40years-press
/img_our_campaigns.html
Brandchannel
www.brandchannel.com
Business Case Studies
www.businesscasestudies.co.uk
(search for "marketing mix" or "fashion")
Business of Fashion
www.businessoffashion.com
Cotton Inc "The Fabric of Our Lives"
www.thefabricofourlives.com
Luxury Daily
www.luxurydaily.com
WGSN
www.wgsn.com

02—ADVERTISING AND PUBLIC RELATIONS: FROM VERBAL TO VIRAL

Armstrong, G. and Kotler, P., (2004) *Marketing: An Introduction* (10th ed.) Prentice Hall.
Jobling, P. *Advertising Menswear: Masculinity and Fashion in the British Media Since 1945.* London: Bloomsbury Academic, 2014.
Johnson, S. *The Idler,* 40 (1759).
MacRury, I. *Advertising.* London: Routledge, 2009.
Sivulka, J. "Selling Mr. and Mrs. Consumer." *Advertising & Society Review,* Volume 9, Issue 4, (2008).
Williamson, J. *Decoding Advertisements.* London: Boyars, 1978.

Advertising Age
www.adage.com
Calvin Klein "show yours. #mycalvins"
http://explore.calvinklein.com/en_GB/page/mycalvins/
Fashionising
www.fashionising.com
Harpers Bazaar
www.harpersbazaar.com/fashion/fashion-designers
Telegraph
www.fashion.telegraph.co.uk

03—THE CELEBRITY ROLE: FROM ROYALTY TO THE RAP GAME

Baker, M. J. and Churchill, G. A. Jr. "The Impact of Physically Attractive Models on Advertising Evaluations." *Journal of Marketing Research,* 14 (1977): 538–555.

Cashmore, E. *Celebrity Culture* (Key Ideas). London: Routledge, 2006.

Donaton, S. "Nice guys? Who care? Naughty Celebs Get the Bucks." *Advertising Age,* 73 (2002): 15.

Elberse, A. and Verleun, J. "The Economic Value of Celebrity Endorsements." *Journal of Advertising Research* 52, No. 2 (2012): 149–165.

Erdogan, B. Z. "Celebrity Endorsement: A Literature Review." *Journal of Marketing Management,* 15 (1999): 291–314.

Hovland, C. I. and Weiss, W. "The Influence of Source Credibility on Communication Effectiveness." *Public Opinion Quarterly* 15 (1951): 635–650.

Keel, A. and Nataraajan, R. "Celebrity Endorsements and Beyond: New Avenues for Celebrity Branding." *Psychology & Marketing,* Vol 29 (9) (2012): 690–703.

McCracken, G. "Who is the Celebrity Endorser? Cultural Foundations of the Endorsement Process." *Journal of Consumer Research* 16 (1989): 310–321.

Ohanian, R. "The Impact of Celebrity Spokesperson's Perceived Image on Consumers' Intention to Purchase." *Journal of Advertising Research* 31(1) (1991): 46–53.

Rojek, C. (2001) *Celebrity.* London: Reaktion Books, 2001.

Till, B. & Shimp, T. (1998) Endorsers in Advertising: The Case of Negative Celebrity Information. *Journal of Advertising*, Volume XXVII, Number 1 Spring 1998.

Thwaites, D., Lowe, B., Monkhouse, L. L. and Barnes, B. R. "The Impact of Negative Publicity on Celebrity Ad Endorsements." *Psychology & Marketing,* 29 (2012): 663–673. doi: 10.1002/mar.20552.

Celebrity Endorsement Advertisements
www.celebrityendorsementads.com

Coolspotters
www.coolspotters.com

Elle UK Celebrity Fashion Trends
www.elleuk.com/star-style/celebrity-fashion-trends

The Fashion Spot
www.thefashionspot.com

Outfit Identifier
www.outfitidentifier.com

US Magazine Celebrity Spot Features
www.usmagazine.com/celebrity-style

RESOURCES

04—COLLABORATIONS: "X" MARKS THE SPOT

Ahn, S., HaeJung, K. and Forney, J. "Fashion Collaboration or Collision? Examining the Match-up Effect in Co-marketing Alliances." *Journal of Fashion Marketing & Management,* Vol. 14, no. 1 (2010).

Complex magazine
www.complex.com
GQ collaborations listings
www.gq.com/about/collaborations
Highsnobiety
www.highsnobiety.com
Hypebeast
www.hypebeast.com
Selectism
www.selectism.com/category/fashion
Trendhunter
www.trendhunter.com

05—THE FASHION SHOW: FROM COUTURIER TO CATWALK

Guérin, P. *Creative Fashion Presentations* (2nd ed.). London: Fairchild, 2005.
McRobbie, A. *British Fashion Design: Rag Trade or Image Industry?* London: Routledge, 2003.
Vilaseca, E. *Runway Uncovered: The Making of a Fashion Show.* Barcelona: Promopress, 2010.

British Fashion Council
www.britishfashioncouncil.co.uk
Copenhagen Fashion Week
www.copenhagenfashionweek.com
London Collections: Men
www.londoncollections.co.uk
London Fashion Week
www.londonfashionweek.co.uk
MADE Fashion Week
www.milkmade.com
Mercedes-Benz Fashion Week Australia
mbfashionweek.com/australia
Mercedes-Benz Fashion Week New York
mbfashionweek.com/new-york
Mercedes-Benz Fashion Week Swim
mbfashionweek.com/miami
Mercedes-Benz Fashion Week Tokyo
tokyo-mbfashionweek.com/en
Milan Fashion Week
www.cameramoda.it/en
On|Off
www.onoff.tv
Paris Fashion Week
www.modeaparis.com/en

06—FASHION FILM: FROM HOLLYWOOD TO HOXTON

Berry, J. *Unfolding Fashion's Fictions: Fashion Film and the Narrative Possibilities of Dress.* www.inter-disciplinary.net, 2012. (Accessed November 26, 2013.)

Friedman, V. *Fashion Learns The Art Of Film.* www.ft.com, 2013. (Accessed November 28, 2013.)

Guerrero, J. *New Fashion and Design Technologies.* London: A&C Black, 2010.

Khamis, S. and Munt, A. "The Three Cs Of Fashion Media Today: Convergence, Creativity & Control." *Scan Journal of Media Arts Culture* 8 (2) (2010).

Uhilrova, M. "100 years of the Fashion Film: Frameworks and Histories." *Fashion Theory: The Journal of Dress, Body & Culture,* 17(2) (2013): 137–158.

A Shaded View on Fashion Film (ASVOFF)
ashadedviewonfashionfilm.com

Berlin Fashion Film Festival (BFFF)
berlinfashionfilmfestival.net

British Pathé
www.britishpathe.com

Georgia Hardinge
www.georgiahardinge.co.uk

Kathryn Ferguson
www.kathrynferguson.co.uk

Music Television (MTV)
www.mtv.com

New York Fashion Film Festival (NYFFF)
www.nyfff.com

River Island www.riverisland.com

ShowStudio http://showstudio.com

Whitelodge TV www.whitelodge.tv

07—EVENTS: FROM PRIVATE PARTIES TO PUBLIC PERFORMANCE

Breward, C. *Fashioning London: Clothing and the Modern Metropolis.* Oxford and New York: Berg, 2004.

Mores, C. *From Fiorucci to the Guerilla Stores: Shop Displays in Architecture, Marketing, and Communications.* Marsilio: Venice, 2006.

Drapers online events diary
www.drapersonline.com/events

London Fashion Weekend
www.londonfashionweekend.co.uk

Not Just a Label
www.notjustalabel.com/fashion-events

Vogue's Fashion Night Out
www.condenastinternational.com/initiatives/vogue-fashions-night-out

WWD events calendar
www.wwd.com/fashion-calendar

RESOURCES

08—VISUAL MERCHANDISING: FROM STORE TO SCREEN

Ashford Down, H. (ed.) *The Art of Window Display*. London: Pitman, 1931.

Baker, J. *Visual Merchandising 2020* [PowerPoint slides]. Retrieved from http://www.slideshare.net/retailstorewindows/visual-merchandising-2020, 2011.

Casson, H. *Twelve Tips on Window Display*. London: The Efficiency Magazine, 1924.

Doonan, S. *Confessions of a Window Dresser*. London and New York. Penguin Studio, 1998.

Ha, Y., Kwon, W. S. and Lennon, S. J. "Online visual merchandising (VMD) of apparel web sites." *Journal of Fashion Marketing and Management*, 11 (4) (2007): 477–493.

Kerfoot, S., Davies, B. and Ward, P. "Visual Merchandising and the Creation of Discernible Retail Brands." *International Journal of Retail & Distribution Management*, 31 (2/3) (2003): 143–152.

Parker, K. "Sign Consumption in the 19th-century Department Store: An Examination of Visual Merchandising in the Grand Emporiums (1846–1900)." *Journal of Sociology*, 39 (4) (2003): 353–371.

Wright, L., Newman, A. and Dennis, C. "Enhancing consumer empowerment." *European Journal of Marketing*, 40 (9/10) (2006): 925–35.

Best Window Displays blog
www.thebwd.com

The Bergdorf Goodman blog
http://blog.bergdorfgoodman.com

Retail Store Windows
www.retailstorewindows.com

Visual Merchandising and Store Design (VMSD)
www.vmsd.com

The Window Shopper blog
www.thewindowshopper.co.uk

09—THE FASHION MAGAZINE: FROM PRINT TO PIXEL

Corcoran, C. T. "The Blogs That Took Over the Tents." *Women's Wear Daily,* February 6, 2006.

Engholm, I. and Hansen-Hansen, E. "The Fashion Blog As Genre – Between User Driven Bricolage Design and The Reproduction of Established Fashion System." *Digital Creativity* (ahead-of-print), 1–15.

Fandrich, M. W. "La Dernière Mode: Blogging Fashion." In Rouse, E. (2008) Extreme Fashion: Pushing the Boundaries of Design, Technology and Business: Conference Proceedings 2007." *International Foundation of Foreign Technology Institute,* 2007.

Medine, L. "Blogging Is A Dirty Word." www.manrepeller. com, 2013 (Accessed August 18, 2014).

Menkes, S. "The Circus Of Fashion." http://tmagazine. blogs.nytimes.com/2013/02/10/the-circus-of-fashion/, 2013 (Accessed August 18, 2014).

Renard, D. "The Last Magazine." Universe, 2006.

Rocamora, A. "Personal fashion blogs: Screens and mirrors in digital self-portraits." *Fashion Theory: The Journal of Dress, Body & Culture,* 15(4) (2011): 407–424.

Betty Magazine
www.bettymagazine.co.uk

Brandbacker
www.brandbacker.com

Company Magazine
www.company.co.uk

Dazed Digital
www.dazeddigital.com

Elle Magazine
www.elle.com

Fashion 156
www.fashion156.com

The Fashionista
www.fashionista.com

HARDI Magazine
www.hardimagazine.com

Lumiere Magazine
www.lumiere.com

MPA Association of Magazine Media
www.magazine.org

Professional Publishers Association (UK)
www.ppa.co.uk

The Sartorialist
www.thesartorialist.com

Sister Magazine
www.sister-mag.com

Style Bubble
www.stylebubble.co.uk

Vogue UK Blogs
www.vogue.co.uk/blogs

INDEX

INDEX

INDEX

ACKNOWLEDGEMENTS

Dennis would like to thank Leigh for his patience and support, offer immense gratitude to his family—particularly his mother, Irene, and dedicate his work in this book in memory of his father, Gerard.

Jon would like to thank his parents, Dawn and Peter, for bringing him up in a creative environment, and dedicate his work in the book to Anna, Dolores, and Lucien for providing him with the time and space to research and write.

Both authors also extend their gratitude to the many contributors without whose insight this book would not have been possible and to all those who devoted their time, effort and creativity to the production of this book. Particular thanks to our Commissioning Editor, Colette Meacher and Editorial Assistant, Sophie Tann at Bloomsbury Publishing; picture researcher Helen Stallion; and designers Rob Brown at Saxon Graphics and Daniel Stubbs at ALL CAPS.

Finally huge thanks to Sheelagh Wright and the BA (Hons) Fashion Media & Promotion team at University for the Creative Arts for their wit, wisdom and unwavering support!

The publishers would like to thank Melinda K Adams, Alyssa Adomaitis, Eve Michelle Astle, José Blanco, Charlotte Goldthorpe, Andrew Grieve, Gill Stark, and Carol Tuntland.

PICTURE CREDITS